Doin' Texas With Your Pooch

WHERE TO STAY
Choose a place to snooze for you and the furface from more than 1,500 Texas hotels, historic inns, ranches, 5-star resorts, motels and B&Bs in 400 Texas cities. From the Panhandle to Padre Island, El Paso to Texarkana, you'll find accommodations in every price range to suit every taste.

WHAT TO DO
Impress your dog with thousands of hikes, parks, lakes, forests and other dog-friendly recreation.

HOW TO DO IT
Check out the extensive training section for some handy traveling tips including:

- How To Pack For Your Pooch.
- Traveling By Plane.
- Travel Training.
- Crate Training Is Great Training.
- 10 Ways To Prevent Aggression.
- Training Do's And Don'ts.
- 36 Ways To Have A Better Vacation.
- First-Aid Emergency Tips.

Other Titles By Eileen Barish

Eileen's Directory of Dog-Friendly Lodging & Outdoor Adventure in Texas

Pet-Friendly Publications
P.O. Box 8459, Scottsdale, AZ 85252
Tel: (800) 638-3637

DOIN' TEXAS WITH YOUR POOCH
by Eileen Barish

Pet-Friendly Publications
P.O. Box 8459, Scottsdale, AZ 85252
Tel: (800) 638-3637 / www.travelpet.com

ISBN #1884465-21-8
Library of Congress Catalog Card Number: 2004093168
Printed and bound in the United States of America.
Second Edition

Eileen's directories are available at special discounts when purchased in
bulk for premiums and special sales promotions as well as for fund-
raising or educational use. Special editions or book excerpts can also be
created to specification. For details, call 1-800-638-3637.

CREDITS

Author & Managing Editor — Eileen Barish

Associate Editor — Harvey Barish

Lodging & Research Editor — Phyllis Holmes

Research/Writing Staff — Alison Dufner
Tiffany Geoghegan

Illustrator — Gregg Myers

Graphic Designer — Tawni Hensley

Photographer — Ken Friedman

ACKNOWLEDGEMENTS

Doin' Texas with my smooch Harvey
has been the best.

Special thanks to a doggone great staff.

With loving thoughts of Rosie and Max
and all the wonderful adventures we shared.
You shall remain in our hearts and minds forever.

And for Sam, the "best friend"
who is always with us.

SPECIAL ACKNOWLEDGEMENTS

I would like to thank the management of the following
lodging establishments for the gracious hospitality extended to me
during the research phase of this book.

ALPINE
Best Western Alpine Classic Inn
Sunday House Inn

AUSTIN
Four Seasons Hotel

FORT STOCKTON
Best Western Swiss Clock Inn

GALVESTON
La Quinta Inn

HOUSTON
Four Seasons Hotel

IRVING
Four Seasons Hotel

LUFKIN
Expo Inn

SAN ANTONIO
Plaza San Antonio

VAN HORN
Best Western Inn

TABLE OF CONTENTS

TEXAS DIRECTORY OF DOG-FRIENDLY LODGING AND OUTDOOR ADVENTURE

GET READY TO TRAVEL

HOW TO USE THIS DIRECTORY

Pooch comes along

If you're planning to travel in Texas with your pooch or if you live in Texas and would like to enjoy more of the state with your canine buddy beside you, **Doin' Texas With Your Pooch** is the only reference source you'll need. Included are thousands of dog-friendly accommodations and outdoor adventures as well as chapters covering everything from travel training to travel etiquette.

Simplify vacation planning

The user-friendly format of **Doin' Texas With Your Pooch** combines lodging and recreation under individual city headings. Pick a city, decide on lodging and then reference the outdoor activities listed under that city.Or if you've always wanted to hike a certain trail or visit a particular park, just reverse the process. Using the index, locate the activity of your choice, find the closest lodging and go from there. It's that easy to plan a vacation you and your pooch will enjoy.

No more sneaking Snoopy

Choose lodging from hotels, B&Bs (aka Bed & Biscuits), motels, resorts, inns and ranches that welcome you and your dog - through the front door. From big cities to tiny hamlets, **Doin' Texas With Your Pooch** provides the names, addresses, phone numbers and room rates of dog-friendly accommodations. Arranged in an easy-to-use alphabetical format, this directory covers the entire state of Texas, from Abilene to Zavala.

Just do it

Okay, now you've got your pooch packed and you're ready for the fun to begin. How will you make the most of your travel or vacation time? *Doin' Texas With Your Pooch* details thousands of adventures you can share with your canine. If you're into hiking, you'll find descriptions for hundreds of trails. The descriptions will tell you what to expect - from the trail rating (beginner, intermediate, expert) to the trail's terrain, restrictions, best times to hike, etc. If laid-back pastimes are more to your liking, you'll find green grassy areas ideal for picnics or plain chilling out. For parks, monuments and other attractions, expect anything from a quickie overview to a lengthy description. Written in a conversational tone, it'll be easy for you to visualize each area. Directions from the nearest city are also included.

No matter what your budget or outdoor preference, with this directory you'll be able to put together the perfect day, weekend or month-long odyssey.

Increase your options

Many of the recreational opportunities listed in *Doin' Texas With Your Pooch* can be accessed from more than one city. To expand your options, check out the activities located in cities adjacent to your lodging choice.

How to do it

Numerous chapters are devoted to making your travel times safer and more pleasurable. Training do's and don'ts, crate use and selection, carsickness, driving and packing tips, desert survival, doggie massage, pet etiquette, travel manners, what and how to pack for your pooch, first-aid advice, hiking tips, emergency telephone numbers, a pet identification form and tons of additional useful information is covered.

Not just for vacationers. A "must-have" reference for every Texan who owns a dog

Owning a copy of **Doin' Texas With Your Pooch** will mean you won't have to leave your trusted companion at home while you explore the beautiful state of Texas. Remember that exercise and outdoor stimulation are as good for your dog's health as they are for yours. So include old brown eyes when you decide to take a walk, picnic in a forest glade, hike a mountain trail or rent a boat for the day. Armed with this guide, Texans who love their hounds can travel with their pooches and discover all that Texas has to offer. No matter where you hang your ten gallon hat, you'll find dozens of places in your own backyard just perfect for a day's outing. **Doin' Texas With Your Pooch** answers the dilemma of what to do with the pooch when you travel - take him along. Increase your travel horizons and give your devoted companion a new leash on life.

Do hotel and motel policies differ regarding pets?

Yes, but all the accommodations in **Doin' Texas With Your Pooch** allow dogs. Policies can vary on charges and sometimes on dog size. Some might require a damage deposit and some combine their deposit with a daily and/or one-time charge. Others may restrict pets to specific rooms, perhaps cabins or cottages. Residence-type inns which cater to long-term guests may charge a long-term fee. Some also require advance notice. But most accommodations do not charge fees or place restrictions in any manner. As with all travel arrangements, it is recommended that you call in advance to confirm policies and room availability.

BE AWARE THAT HOTEL POLICIES MAY CHANGE. AT THE TIME YOUR RESERVATIONS ARE MADE, DETERMINE THE POLICY OF YOUR LODGING CHOICE.

Lodging Guidelines For You and Your Pooch

Conduct yourself in a courteous manner and you'll continue to be welcome anywhere you travel. Never do anything on vacation with your pooch that you wouldn't do at home. Some quick tips that can make traveling with your canine more enjoyable.

1. Don't allow your dog to sleep on the bed with you. If that's what your dog is accustomed to doing, take along a sheet or favorite blanket and put that on top of the bedding provided by your lodging.

2. Bring a towel or small mat to use under your dog's food and water dishes. Feed your dog in the bathroom where cleanup is easier should an accident occur.

3. Try to keep your dog off the furniture. Take along a lint and hair remover to eliminate unwanted hairs.

4. When you walk your dog, carry plastic bags and/or paper towels for cleanup.

5. Always keep your dog on a leash on the hotel and motel grounds.

Can my pooch be left alone in the room?

Only you know the answer to that. If your dog is not destructive, if he doesn't bark incessantly and the hotel allows unattended dogs, you might consider leaving him in the room for short periods of time — say when you dine out. In any case, hang the "Do Not Disturb" sign on your door to alert the chambermaid or anyone else that your room shouldn't be entered.

Consider doing the following when you plan to leave your dog unattended:

1. Walk or otherwise exercise your pooch. An exercised dog will fall asleep more easily.

2. Provide a favorite toy.

3. Turn on the TV or radio for audio/ visual companion- ship.

4. Make sure there is an ample amount of fresh water available.

5. Calm your dog with a reassuring goodbye and a stroke of your hand.

Go Take A Hike

Hundreds of the best day hikes in Texas are detailed in ***Doin' Texas With Your Pooch*** Each hike indicates degree of difficulty and round-trip distances. Unless otherwise indicated, trailhead access is free and parking is available, although it is sometimes limited. To assist you in your travel plans, phone numbers are included for most recreation sites.

When leashes are mandatory, notice is provided.

Please obey local ordinances so dogs continue to be welcome

Hike ratings

The majority of the hikes included in this book are rated beginner or intermediate. As a rule of thumb, beginner hikes are generally easy, flat trails suited to every member of the family. Intermediate hikes require more exertion and a little more preparation, but can usually be accomplished by anyone accustomed to some physical exercise, such as fast-paced walking, biking, skiing, swimming, etc. Some expert trails have also been included. Many times, their inclusion signals some outstanding feature. Expert hikes should only be considered if you feel certain of your own and your dog's abilities. But whatever your ability, remember, if the hike you've undertaken is too difficult you can always turn around and retrace your steps. You're there to have a good time, not to prove anything.

Seasons change, so do conditions

Seasonal changes may effect ratings. If you're hiking during rainy season, you might encounter slippery going. Or if you've decided to hike during the winter and there's snow underfoot, that can up the difficulty rating. In the spring, small creeks can become rushing, perhaps impassable rivers. Whenever you're outdoors, particularly in wilderness areas, exercise caution. Know yourself and know your dog.

Hike time

If you're short on time or energy, hike as long as you like. Never push yourself or your canine beyond either's endurance. Never begin a hike too late in the day, particularly in canyon areas where the sun can disappear quickly.

Directions

Directions are generally provided from the closest city. Odometer accuracy can vary so be alert to road signs. Unless specifically noted, roads and trailheads are accessible by all types of vehicles. In winter, some areas experience inclement weather conditions where 4WD or chains are required. Remember too that national forest roads can be narrow and twisting and are often used by logging trucks. Exercise caution. Slow down around blind corners.

Permits/Fees

Wilderness permits are needed for most hikes in USFS wilderness areas. In addition, most state parks and some national parks charge a nominal fee.

Common sense, don't hike without it

Consider potential hazards. Know your limitations. The overview descriptions included with hikes and other activities are provided for general information. They are not meant to represent that a particular hike or excursion will be safe for you or your dog. Only you can make that determination.

Weather, terrain, wildlife and trail conditions should always be considered. It is up to you to assume responsibility for yourself and your canine. Apply common sense to your outings and they'll prove safe and enjoyable.

Leashes

Some hikes and other recreation do not require that dogs be leashed, but wildlife exists in all outdoor areas so always exercise caution and use common sense. When a leash is not mandatory, notations will be made. Restrictions, if any, are also noted. In any case, keep a leash accessible. You never know when the need can suddenly arise.

Basic Dog Rules

THEY CAN'T BE AVOIDED AND THEY'RE REALLY QUITE EASY TO LIVE WITH. BE A RESPONSIBLE DOG OWNER AND OBEY THE RULES.

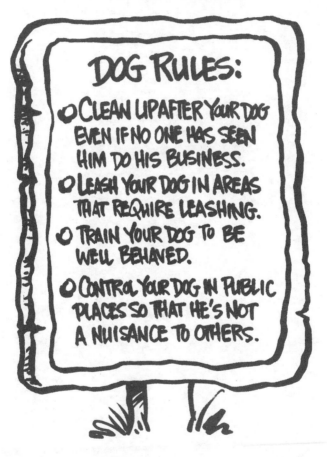

DOG RULES:

○ CLEAN UP AFTER YOUR DOG EVEN IF NO ONE HAS SEEN HIM DO HIS BUSINESS.

○ LEASH YOUR DOG IN AREAS THAT REQUIRE LEASHING.

○ TRAIN YOUR DOG TO BE WELL BEHAVED.

○ CONTROL YOUR DOG IN PUBLIC PLACES SO THAT HE'S NOT A NUISANCE TO OTHERS.

Note: When leashes are required, they must be six feet or less in length. Leashes should be carried at all times. They are prudent safety measures particularly in wilderness areas.

PREFACE

 "The sun has riz, the sun has set and here we is in Texas yet."

The Lone Star State

From arid deserts to subtropical scenery, sparkling cities to swamplands, oil barons to ranchhands, treasure seekers to treasured pets, Texas is a land of breathtaking diversity and boundless attractions. In keeping with the popular image, dust storms do curl, tumbleweeds do roll and tornadoes do rip through vast, flat plains. However, the terrain of Texas is surprisingly varied and as you journey through this enormous state, you'll discover a constantly changing landscape. You and your wagalong can paw-dip in the warm waters of the gulf, climb a desert mountain, hike through an aromatic forest or float your boat across a sun-drenched lake. History-sniffing canines can explore Spanish missions, visit Victorian mansions, ogle an adobe fortress, frolic on the grounds of frontier forts, investigate a living history farm or salute their snoot at a revolutionary battleground. Whatever tickles your fancy, you and your canine companion will find it waiting for you in the Lone Star State.

Big is definitely better in Texas. From the world's largest pecan to the vastness of the sprawling King Ranch, when it comes to colossal, Texas simply won't be outdone. So pack your FiFi and say si si to doing Texas with your pooch.

TEXAS

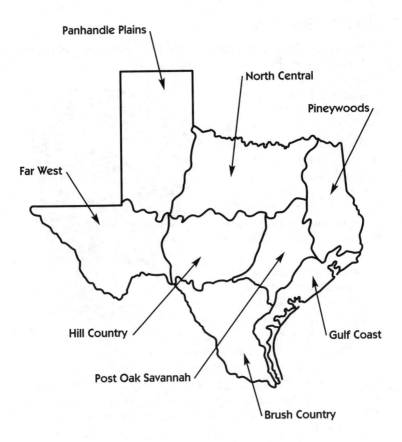

Brush Country

Cities in Brush Country: Brownsville, Callahan, Kingsville, Laredo, Mathis, McAllen, Mission, San Antonio, Three Rivers, Uvalde

Of Martyrs and Men

In 1836, 187 courageous Texans repelled 5,000 Mexican troops for eleven days in an heroic battle that opened a significant chapter in the history of Texas and the United States. At San Jacinto, seven weeks after the battle, the chant "Remember the Alamo! Remember Goliad!," fueled Texans with the indomitable will to gain their independence from Mexico. Today, the Alamo in San Antonio remains as a testament to the bravery and spirit of the Lone Star State and its dauntless inhabitants.

Saunter Through Subtropical Terrain

Surprising to many, the southernmost tip of Texas is the only naturally occurring subtropic in the continental United States. Within 2.5 degrees of the Tropic of Cancer, this steamy and sultry region is filled with lots of waterful fun for Fido. Home to rare and unusual plant species, the Texas Tip offers an astounding display of nature for adventuresome canines to explore. Take for example the unusual chorus of squeaking and squawking avians you'll hear when you visit the Santa Ana National Wildlife Refuge. Chachalacas, Inca doves and four species of parrots flap and whoop their way through this birder's paradise.

Far West

Cities in Far West: Alpine, Balmorhea, Comstock, El Paso, Fort Davis, Fort Stockton, Monahans, Odessa, Pecos, Presidio, Sheffield, Van Horn

Legends and Lore

Truly the "wild west," this once bawdy region of Texas sports a colorful history chock-full of quirky characters, both true-to-life and exaggerated. From legends of violence and intrigue at Fort Leaton to stories of mile-high hidden treasure, this formerly lawless area boasts some of the tallest tales in Texas. Much of the flavor of yesteryear is still alive in the smaller, sparsely-populated mountain and desert communities where ranches are often miles apart and keeping to yourself is a way of life. Even El Paso, with a population of half a million, offers many opportunities for quietude and reflection far from the maddening crowd. The Far West definitely qualifies as a numero uno refuge for solitude-seeking Texas travelers.

Chihuahua is for the Dogs

When the season is just right and the sun's not too bright, top off your water bottles and share a day in the desert with your hot dog. The Chihuahuan Desert boasts majestic mountain peaks and the unusual Hueco Tanks. These tanks, remarkable granite formations that rise from the desert floor, were an important water source for semi-nomadic tribes 10,000 years ago. Today, rock climbers and rockhounds flock to this stunning region for outdoor fun and unclouded sun. Camera snappers will have plenty to click about in the inherently beautiful desertscape of west Texas.

Gulf Coast

Cities in Gulf Coast: Aransas Pass, Clear Lake, Corpus Christi, Edna,Fulton, Galveston, Goliad, Houston, La Porte, Port Aransas, Port Isabel, Port Lavaca, Rockport, Sabine Pass, South Padre Island, West Columbia

Hightail it to Houston

A captivating city, Houston is filled with contrasts and amusements; a city ready to entertain at the drop of a ten-gallon hat. You and your Sherlock can investigate neighborhood parks and ponds, savor saltwater marshes, perk up your ears to the melodic sounds of songbirds in hushed pine forests, or break biscuits in a dreamy bayou. This amazing urban expanse boasts a population of over 4 million, making it the largest city in Texas and the fourth largest in the United States. If you're into bespangled nights and bright lights, pick a perch and behold Houston's star attraction - its mauve and blue, gleaming glass and steel skyline.

Get Along to the Gulf Little Doggies

Beach bums, sea breeze lovers and dune devotees will adore the sandy coast of Texas. Characterized by endless ocean vistas, windswept beaches and inland saltwater marshes, this salty air territory is perfect for mellow fellows pursuing some sunshine and serenity. Padre Island National Seashore offers 80 miles of uninterrupted and easily accessible shoreline, enhanced by several wildlife refuges established to protect the primitive beauty of the Gulf Coast.

Hill Country

Cities in Hill Country: Bandera, Bend, Blanco, Boerne, Burnet, Castroville, Comfort, Concan, Fredericksburg, Georgetown, Johnson City, Kerrville, New Braunfels, Smithville, Vanderpool

A Land of Enchantment

Once you and the pooch experience Hill Country's breezy summer days, rolling hills and sublime beauty, you'll understand the seductive power of this territory. Fall finds the Lost Maples ablaze with color while springtime is heralded by thousands of vividly colored wildflowers. Visit magical Enchanted Rock, a must-see Hill Country treasure. Its pink granite dome glistens in the moonlight while eerie creaks and groans fill the night air with strange sounds. Early tribes worshiped the rock, believing it was haunted. New Agers now gather during full moons, certain that the rock is a source of spiritual power. Geologists offer a more scientific explanation. They argue that the granite contracts as it cools during the night causing the spooky sounds. For an otherworldly experience, head on out for one howl of an evening and see what you and the hound make of it.

Frolic Around Fredericksburg

This charming Germanesque town is surrounded by some of the most extraordinary landscape and appealing towns you'll encounter in Texas. Rushing rivers, crystal blue lakes, camera-worthy canyons and lush forests combine to create a countryside of inspiring scenery. Find tiny villages set high in the hills and uncover your own small slice of heaven. Or get a kick out of the strong western flavor of Bandera. Don your Stetson and scurry with your furry buckaroo to the "Cowboy Capitol of the World."

North Central

Cities in North Central: Abilene, Albany, Arlington, Bonham, Bowie, Caddo, Cleburne, Dallas, Denison, Denton, Eustace, Fort Worth, Glen Rose, Grand Prairie, Irving, Jacksboro, Meridian, Mineral Wells, Paris, Quanah, Queen City, Sherman, Waco, Wichita Falls

A Tale of Two Cities

Dallas and Fort Worth are considered part of the same sprawling Metroplex, but they're really as different as night and day. Often referred to as the "Manhattan of the Southwest," Dallas displays an eastern-style sophistication. Complete with a Fortune 500 skyline and a yuppie population of one million, Dallas has earned the nickname "Cadillac of Texas Towns." It is most certainly a city that lives in the fast lane. So strap in your floppy-eared sidekick, cruise the downtown areas and affluent suburbs and check out the plentiful furface-friendly adventures you'll come across throughout this urban setting.

The engaging quality of Fort Worth lies in its open-hearted spirit and friendly feel of the old west. From rodeos to chuck-wagon races, stockyard auctions to chili cook-offs, a weekly cowboy church to the annual Pioneer Days Celebration, Fort Worth caters to the cowboy in all of us. So rope in your doggie and strut your stuff, western style. When you've had your fill of Wranglers and ten-gallon hats, steer yourself to one of the countless city parks. Second only to Chicago in total park acreage, Fort Worth goes out of its way to guarantee a green scene suitable for every breed.

Panhandle Plains

Cities in Panhandle Plains: Amarillo, Big Spring, Canyon, Colorado City, Lubbock, Midland, Shamrock, Quitaque

The Canyon and the Caprock

Palo Duro Canyon, fondly referred to as Texas' own Grand Canyon is a remarkable geologic break in the flatlands. Its crayola-colored walls loom over meandering tributaries of the Red River and create an uncommon window into geologic ages dating back 320 million years. Unlike its Arizona counterpart, Palo Duro provides insight into Quartermaster, Tecovas, Trujillo and Ogallala soil formations. The Caprock Escarpment separates the rugged, cutting canyon terrain from the vast open plains of the Panhandle and literally offers a glimpse deep in the heart of Texas. Fascinating and resplendent, a sojourn to this section is the perfect antidote for any hang dog day.

Great Ball of Fire

If you've never seen the sun slowly dip below the distant horizon of an endless highway, you won't want to miss the sunset in the Panhandle Plains. You'll be hypnotized by the giant, reddish-orange hazy orb as it melts into the landscape, spreading fiery color across the plains as it disappears from sight. Delight your senses with the softness and serenity of this gorgeous natural experience. And if you're aiming to complete the day-to-night cycle, spend the evening in charming Amarillo, set your alarm for 6 am and behold the beauty of an inspiring sunrise. Bowwow!

Pineywoods

Cities in Pineywoods: Alto, Atlanta, Beaumont, Henderson, Huntsville, Jasper, Longview, Lufkin, Marshall, Mount Enterprise, Nacogdoches, Quitman, Rusk, Tatum, Texarkana, Tyler, Zavalla

Frolic Through the Forests

Recreational pupportunities abound for you and the hound in the Pineywoods. Enveloping more than 675,000 acres of lofty pines and flowering dogwoods, the national forests of Texas all lie within this extremely varied region. The beautiful landscape is replete with trails, fish-filled lakes and dense woodlands. Naturalists won't know where to look first. These sylvan thickets are inhabited by a plenitude of wildlife and an extraordinary array of birdlife. You can paddle your pal to a secluded spot in a rented canoe, dip your line where the fishing's fine, get an aerobic workout on a cushy, pine-needled pathway or just immerse yourself in the vast, fragrant forestland. Pleasing to all breeds, from social waggers to serenery seekers, the Pineywoods is a glorious testament to the conservation ethic of the National Forest Service.

Hound Out Some History

Exploring East Texas is as informative and interesting as it is handsome. Smaller towns brimming with restored and original architecture dot this rural scene and offer a peek into the lifestyle of the early settlers. Take the historic walking tour of quaint Nacogdoches or have a gander at Marshall's colonial past. Don't miss the legacy left by the Caddo Indians at Caddoan Mounds State Park. And when it's quietude you're craving, Caddo Lake and Lake Livingston provide the quintessential retreat.

Post Oak Savannah

Cities in Post Oak Savannah: Austin, Bastrop, Bryan, Cameron, College Station, Fairfield, Gonzales, Groesbeck, Hearne, La Grange, Lockhart, Mexia, Moody, Navasota, Somerville

Amble on Down to Austin

Austin's appeal can be attributed to its unique blend of small-town style and urban sophistication, offering visitors the best of both worlds. Historic districts, universities, government buildings and musical meccas come together to make the capitol city a fascinating destination. Active breeds can plan an exploration of Town Lake and its remarkable trail system, while laid-back types can get their fill of lush, grassy parks. For an unusual happening, join the crowd at Batty Bridge and go bonkers when the wee mammals come out at night for din din à la insects. Or bound on down to Barton Springs for some cooling recreation. Set your sights on Austin for a pooch-friendly adventure combining scenery, greenery and good old-fashioned fun.

Carouse the Countryside

Laden with history and lavished with oak-clad hills, this part of Texas marks the transitional zone between the eastern pine woodlands and the western plains. Discover a hidden stand of lost pines in Bastrop, sniff out a bit of history at Washington-on-the-Brazos and Old Fort Parker State Parks, or just relish in some R&R on a rolling hillside, your best buddy beside you. Get moving in any direction and you'll be enthralled by the mix of recreation and history that greets you at every turn in the Post Oak Savannah.

Texas Facts, Folklore & Trivia

Capital: Austin

State Nickname: Lone Star State

State Motto: Friendship

State Song: "Texas, Our Texas"

State Bird: Mockingbird

State Flower: Bluebonnet

State Tree: Pecan

State Fish: Guadalupe Bass

State Dish: Chili Con Carne

State Pest: Mosquito

Highest Point: Guadalupe Peak, 8,751 feet

Lowest Point: Gulf of Mexico, sea level

Population: Nearly 17 million people

- In 1845, the Republic of Texas signed a treaty and became part of the United States. At that time, Texas reserved the right to subdivide into as many as five smaller states. Texas still retains this right.

- In March 1861, Texas voted to secede from the Union and join the Confederacy. It didn't officially rejoin the United States until February 15, 1876.

- Every year, 3 million tourists visit the Alamo.

- Texas has 90 mountains, each over a mile high.

- The town of Southmost, Texas is only 169 miles north of the Tropic of Cancer.

- In Texas, if you don't like the weather, stick around a few minutes, it's bound to change.

- Texas reports an average of 100 tornadoes per year. Most twisters occur from March to May.

- The armadillo, "little armed one" in Spanish, is protected by law.

- The Texas horned lizard can shoot a stream of blood from its eyes as far as four feet.

- The word Texas is originally derived from the Caddo Indian word "Taysha," meaning friend. The Spanish colonists eventually referred to the area as "Tejas" or "Texas," their version of the Caddo word.

- 250 million years ago, a massive tropical ocean covered what is now Texas and New Mexico.

- The town of Pecos is regarded as the birthplace of the American rodeo. On July 4, 1883 the first rodeo settled a bar dispute among local cowhands regarding riding and roping skills. The purse was $40.

- Amarillo provides approximately 90% of the world's helium.

- Buddy Holly was born in Lubbock on September 7, 1936.

- The city of Dallas began as one log cabin in 1840. Today, Dallas ranks third in the United States as headquarters for Fortune 500 companies.

- Waco is the birthplace of comedian Steve Martin and the soft drink, Dr. Pepper.

- The capitol building in Austin has 8.5 acres of floor space and occupies 3 acres of land. It is 7 feet taller than the U.S. Capitol in Washington, D.C.

- Austin is home to the largest urban bat population in the world. These night feeders consume about 20,000 pounds of bugs each evening. One bat devours up to 600 mosquitoes per hour.

- Austin is regarded as the live music capital of the world.

- Dating back 225 million years, fossil remains of the earliest dinosaurs were found on the high plains of the Panhandle.

- The first known residents of Texas were the Clovis Indians.

- Davy Crockett was killed at the Alamo in 1836.

- On January 10, 1901 the Lucas Gusher blew, marking the beginning of the Texas oil boom.

- Barbara Jordan, a Houston native, was the first black woman elected to the State Senate and the first black southern congresswoman elected to the U.S. House of Representatives.

- With over 1,000 stalls, the Dallas Farmer's Market is one of the largest in the United States.

- Texas BBQ tip: For a stronger, more aromatic mesquite flavor, toss some mesquite pods on your coals before cooking.

- Texas chili aficionados have a saying: If you know beans about chili, then you know chili has no beans.

- Milk is the quickest remedy for a mouth fire caused by hot chili peppers. Yogurt, buttermilk, olive oil, fruit syrup and peanut butter are other remedies.

- In the 1870s, Levi Strauss blue jeans and Stetson hats became the official cowboy outfit.

- The 1860s to the late 1880s marked the heyday of the cowboys. Cowboys now account for less than one percent of the Texas population.

- Measuring 20 feet long and 11 feet tall, Fort Stockton's Paisano Pete is the world's largest roadrunner.

- "Mission Control, Houston" were the first words spoken from the moon on July 20, 1969.

- The 66-foot Sam Houston statue in Huntsville is the world's tallest statue of an American hero.

- The 2-mile Shoreline Boulevard seawall in downtown Corpus Christi was designed by Mount Rushmore sculptor Gutzon Borglum.

- Texas is the second largest state, both in landmass and population. Encompassing over 260,000 square miles, Texas can hold all of New England, New York, Pennsylvania, Ohio and Illinois within its borders.

- Houston is considered the energy capital of the U. S.

- American astronauts receive their training at NASA's Johnson Space Center in Clear Lake, Texas.

- Until a 1900 hurricane devastated the coastal city of Galveston, it was known as the "Wall Street of the Southwest." The hurricane is still recognized as the worst natural disaster in the United States. 100 mph winds ripped through the area, causing 20-foot tides and killing over 6,000 people.

- El Paso is closer to Los Angeles than it is to Houston.

- Corpus Christi is the windsurfing capital of the continental United States and is one of the top ten windsurfing spots in the world.

- The last battle of the Civil War was fought near Brownsville; Confederate troops were unaware that the war had ended.

- Conrad Hilton opened his first hotel in the tiny town of Cisco, Texas.

- In 1836, 187 Texas revolutionaries defended the Alamo in a 13-day battle against nearly 5,000 Mexican troops.

- Under Texas law, it is illegal for any private party to own shoreline property. The state owns all beachfront property.

- King Ranch in southern Texas contains 1.2 million acres, making it the largest privately owned ranch in the world.

INTRODUCTION

Doing Texas with your pooch can be a fun-filled adventure. It doesn't require special training or expertise. Just a little planning and a little patience. The rewards are worth the effort. This directory is filled with information to make traveling with your dog more pleasurable. From training tips to what to take along, to the do's and don'ts of travel, virtually all of your questions will be addressed.

Vacationing with dogs

Not something I thought I'd ever do. But as the adage goes, necessity is the mother of invention. What began as a necessity turned into a lifestyle. A lifestyle that has improved every aspect of my vacation and travel time.

Although my family had dogs on and off during my childhood, it wasn't until my early thirties that I decided it was time to bring another dog into my life. And the lives of my young children. I wanted them to grow up with a dog; to know what it was like to have a canine companion, a playmate, a friend who would always be there, to love you, no questions asked. A four-legged pal who would be the first to lick your teary face or your bloody knee. Enter Samson, our family's first Golden Retriever.

Samson

For nearly fifteen years, Sammy was everything a family could want from their dog. Loyal, forgiving, sweet, funny, neurotic, playful, sensitive, smart, too smart, puddle loving, fearless, strong and cuddly. He could melt your heart with a woebegone expression or make your hair stand on end with one of his pranks. Like the time he methodically opened the seam on a bean bag chair and then cheerfully spread the beans everywhere. Or when he followed a jogger and ended up in a shelter more than 20 miles from home.

As the years passed, Sam's face turned white and one by one our kids headed off to college. Preparing for the

inevitable, my husband Harvey and I decided that when Sam died, no other dog would take his place. We wanted our freedom, not the responsibility of another dog.

Sammy left us one sunny June morning with so little fanfare that we couldn't believe he was actually gone. Little did we realize the void that would remain when our white-faced Golden Boy was no longer with us.

Life goes on...Rosie and Maxwell

After planning a two-week vacation through California, with an ultimate destination of Lake Tahoe, Harvey and I had our hearts stolen by two Golden Retriever puppies, Rosie and Maxwell. Two little balls of fur that would help to fill the emptiness Sam's death had created. The puppies were ready to leave their mom and come home with us only weeks before our scheduled departure. What to do? Kennel them? Hire a caretaker? Neither felt right.

Sooo...we took them along

Oh, the fun we had. And the friends we made. Both the two-legged and four-legged variety. Having dogs on our trip made us more a part of the places we visited. We learned that dogs are natural conversation starters. Rosie and Maxwell were the prime movers in some lasting friendships we made during that first trip together. Now when we revisit Lake Tahoe, we have old friends to see as well as new ones to make. The locals we met made us feel at home, offering insider information on little known hikes, wonderful restaurants and quiet neighborhood parks. This knowledge enhanced our trip and filled every day with wonder.

Since that first trip, our travels have taken us to many places. We've visited national forests, mountain resorts, seaside villages, island retreats, big cities and tiny hamlets. We've shared everything from luxury hotel rooms to rustic cabin getaways. I can't imagine going anywhere without our dogs.

Only one regret remained. Why hadn't it occurred to me to take Sammy along on our travels? He would have loved the adventure. That regret led to the writing of this book. I wanted others to know how easy it could be to vacation with their dogs.

When I watch Rosie and Maxwell frolic in a lake or when they accompany us on a hike, I think of Sammy and remember the legacy of love and friendship he left behind. So for those of you who regularly take your dog along and those who would if you knew how, come share my travel knowledge. And happy trails and tails to you and yours.

Is my pooch vacation-friendly?

Most dogs can be excellent traveling companions. Naturally, the younger they are when you accustom them to traveling, the more quickly they will adapt. But that doesn't mean that an older dog won't love vacationing with you. And it doesn't mean that the transition has to be a difficult one.

Even if your dog hasn't traveled with you in the past, chances are he'll make a wonderful companion. You'll find yourself enjoying pensive moments watching him in new surroundings, laughing with others at his antics. But most of all, you'll find that spending quality time with your dog enhances your vacations. So get ready for a unique and rewarding experience-filled with memories to last a lifetime.

A socialized pooch is a sophisticated traveler

Of course, every pooch is different. And you know yours better than anyone. To be sure that he will travel like a pro, accustom him to different situations. Take him for long walks around your neighborhood. Let him accompany you while you do errands. If your chores include stair climbing or using an elevator, take him along. The more exposure to people, places and things, the better. Make your wagger worldly. The sophistication will pay off in a better behaved, less frightened pet. It won't be long until he will happily share travel and vacation times with you.

Just ordinary dogs

Rosie and Maxwell, my traveling companions, are not exceptional dogs to anyone but me. Their training was neither intensive nor professionally rendered. They were trained with kindness, praise, consistency and love. And not all of their training came about when they were puppies. I too had a lot to learn. And as I learned what I wanted of them, their training continued. It was a sharing and growing experience. Old dogs (and humans too) can learn new tricks. Rosie and Maxwell never fail to surprise me. Their ability to adapt to new situations has never stopped. So don't think you have to start with a puppy. Every dog, young and old, can be taught to be travel friendly.

Rosie and Maxwell know when I begin putting their things together that another holiday is about to begin. Their excitement mounts with every phase of preparation. They stick like glue - remaining at my side as I organize their belongings. By the time I've finished, they can barely contain their joy. Rosie grabs her leash and prances about the kitchen holding it in her mouth while Max sits on his haunches and howls. If they could talk, they'd tell you how much they enjoy traveling. But since they can't, trust this directory to lead you to a different kind of experience. One that's filled with lots of love and an opportunity for shared adventure. So with an open mind and an open heart, pack your bags and pack your pooch. Slip this handy book into your suitcase or the glove compartment of your car and let the fun begin.

TEXAS DIRECTORY
OF DOG-FRIENDLY LODGING
& OUTDOOR ACTIVITIES

Hotel Pet Policies May Be Subject To Change

ABILENE

LODGING

AMBASSADOR SUITES HOTEL
4250 Ridgemont Dr (79606)
Rates: $99-$109
(325) 698-1234

ANTILLEY INN
6550 S Hwy 83 (79606)
Rates: $43-$70
(800) 959-1001

BEST WESTERN MALL SOUTH
3950 Ridgemont Dr (79606)
Rates: $61-$68
(325) 695-1262; (800) 528-1234
(800) 346-1574

BEST WESTERN INN & SUITES
350 W IH-20 (79601)
Rates: $59-$89
(325) 672-5501; (800) 528-1234

BUDGET HOST COLONIAL INN
3210 Pine St (79601)
Rates: $42-$50
(325) 677-2683; (800) 283-4678

CIVIC PLAZA HOTEL
505 Pine St (79601)
Rates: $49-$125
(325) 676-0222

COMFORT SUITES
3165 S Danville Dr (79606)
Rates: $84-$164
(325) 795-8500; (800) 228-5150

DAYS INN
1702 E I-20 (79601)
Rates: $45-$60
(325) 672-6433; (800) 329-7466

ECONO LODGE
1633 W Stamford (79601)
Rates: $40-$60
(325) 673-5424; (800) 553-2666

EXECUTIVE INN
1650 E I-20 (79601)
Rates: $35-$70
(325) 677-2200

KIVA HOTEL & CONFERENCE CENTER
5403 S 1st (79605)
Rates: $67-$79
(325) 695-2150

LA QUINTA INN
3501 W Lake Rd (79601)
Rates: $70-$85
(325) 676-1676
(800) 687-6777

MOTEL 6
4951 W Stamford (79603)
Rates: $33-$43
(325) 672-8462; (800) 466-8356

REGENCY INN & SUITES
3450 S Clack St (79606)
Rates: $49-$79
(325) 695-7700

ROYAL INN
5695 S 1st St (79605)
Rates: $27-$55
(325) 692-3022; (800) 588-4386

SUPER 8 MOTEL
1525 E I-20 (79601)
Rates: $45-$70
(325) 673-5251; (800) 800-8000

WHITTEN INN EXPO
840 E Hwy 80 (79601)
Rates: $45-$64
(325) 677-8100

WHITTEN INN UNIVERSITY
1625 SR 351 (79601)
Rates: $39-$65
(325) 673-5271

Hotel Pet Policies May Be Subject To Change

<u>RECREATION</u>
ABILENE STATE PARK - Leashes

Info: Pack up the pup and head out to this pretty park for a day of peace and quiet. Watch for white-tailed deer, fox, armadillos and other critters scurrying about as you make your way through the scenic surroundings. Hopscotch along Elm Creek and through shady woodlands on the nature trail. Or just pack some snacks and relax with Max in the vast open area. For more information: (325) 572-3204; (800) 792-1112; www.tpwd.state.tx.us.

Directions: From Abilene, take FM 89 southwest approximately 16 miles to the park.

Note: $3 entrance fee/person. Dogs must be leashed at all times and are not allowed in buildings.

The numbered hike that follows is within Abilene State Park:

1) ELM CREEK NATURE TRAIL HIKE - Leashes

Beginner/2.0 miles

Info: Let your hot diggety dog cool his tootsies on this picturesque creekside trail where nature is the name of the game. Tote your binocs, you won't be disappointed. But take care not to disturb the native plants and wildlife - this area contains a valuable ecosystem. After your hike, partake in a little paw dipping and rock skimming before you turn the hound around and head for home. For more information: (325) 572-3204.

Directions: From Abilene, take FM 89 southwest approximately 16 miles to the park.

BUFFALO GAP HISTORIC VILLAGE - Leashes

Info: History hounds will have a howl of a good time exploring this living history village. Towering oaks shade your path as you skedaddle among 18 historic buildings, including a log cabin, wagon barn, blacksmith shop, barber shop, courthouse, jail, bank, post office and the Buffalo Gap Mercantile. For more information: (325) 572-3365.

Locate Other Dog-Friendly Activities...Check Nearby Cities

Directions: From Abilene, take Highway 89 south for 14 miles to Buffalo Gap.

Note: Hours vary. Entrance fee.

CAL YOUNG PARK - Leashes

Info: Wag away the afternoon hours as you frolic lakeside with Fido. Or pack a biscuit basket, find yourself a grassy spot within this 73-acre community green scene and do lunch.

Directions: Located off Highway 36 about halfway between Treadway Boulevard and Loop 322.

Note: Dogs are not permitted on trails.

LAKE FORT PHANTOM HILL - Leashes

Info: Dotted with parks, Lake Fort Phantom Hill makes for a relaxing afternoon excursion. Except for Seabee and Johnson Parks, there are no amenities, so tote your own water and supplies. Tow a boat and float atop the cool blue waters or bring a good book, a tough chew and enjoy some quality time with your best pal. For more information: (325) 676-6217.

Directions: From Highway 351, head north on East Lake Road to the lake. Seabee Park is located at the southern tip of the lake off FM 600. Johnson Park is located at the northwestern tip of the lake off FM 600.

Note: Dogs are not permitted on trails.

LAKE KIRBY PARK - Leashes

Info: The banks of the pretty lake offer lots of chill-out opportunities. Scamper over 133 acres of open space in this delightful park.

Directions: Located at the intersection of South 14th and Maple Streets.

Note: Dogs are not permitted on trails.

Hotel Pet Policies May Be Subject To Change

MLK PARK - Leashes

Info: This park offers 50 acres of greenery for you and pooch-face to explore (but no dogs on the trails).

Directions: Located at the end of South 7th Street.

NELSON PARK - Leashes

Info: This popular green scene is a pleasant place for a picnic or a leisurely leg stretch. You'll find lots of open fields and a pretty pond (but no dogs on trails).

Directions: Located off Highway 36 (South 11th Street) at Loop 322, adjacent to the Abilene Zoo.

REDBUD PARK - Leashes

Info: Treat Fletch to a game of fetch in this expansive 127-acre park, equipped with several softball fields. Then pull up a bit of green and watch the amusing antics of playful and abundant prairie dogs (but no dogs on trails).

Directions: Located on South 32nd Street at Willis.

ROSE PARK - Leashes

Info: This pleasant urban park fills the bill for your morning or afternoon constitutional (but no dogs on trails).

Directions: Located at 2600 South 7th Street.

SCARBOROUGH PARK - Leashes

Info: 32 acres of open space provide plenty of room for a pleasant afternoon stroll (but no dogs on trails).

Directions: Located on the banks of Elm Creek off South 7th Street west of Highway 83 Bypass.

Locate Other Dog-Friendly Activities...Check Nearby Cities

SEARS PARK - Leashes

Info: Get along with your little doggie to this simple 28-acre urban parkland (but no dogs on trails).

Directions: Located at 2250 Ambler Avenue.

WILL HAIR PARK - Leashes

Info: This 25-acre parkland is just the place for a bit of frisbee fun or a quickie jaunt.

Directions: Located on Ambler Avenue at Cedar Crest.

Note: Dogs are not permitted on trails.

OTHER PARKS IN ABILENE - Leashes

For more information, contact the Abilene Parks & Recreation Department at (325) 676-6217.

- BOWIE PARK, 20th Street between Butternut & Sayles
- C.W. GILL PARK, Willis & 14th
- CARVER PARK, North Treadway between 6th & 10th
- COBB PARK, 10th between Mockingbird & Grape
- JACKSON PARK, Buffalo Gap Road between South 27th & Highway 83 Bypass
- KIRBY PARK, Maple Street & South 14th
- LEE PARK, 1318 North Pioneer
- MINTER PARK, off North 1st St. between Mockingbird & Grape
- NORTH PARK, Grape Street north of Highway 20
- REYES FLORES PARK, off 7th between 1st & 10th
- SOUTH PARK, Treadway & 11th
- STEVENSON PARK, 541 North 7th
- VAUGHN-CAMP PARK, off Highway 83 Bypass southeast of Buffalo Gap Road

Note: Dogs are not permitted on trails.

Hotel Pet Policies May Be Subject To Change

ADDISON

LODGING

BEST WESTERN HOTEL & SUITES
15200 Addison Rd (75001)
Rates: $69-$129
(972) 386-4800; (800) 528-1234

COMFORT INN GALLERIA
14975 Landmark Blvd (75240)
Rates: $49-$99
(972) 701-0881; (800) 228-5150

COMFORT SUITES
4555 Belt Line (75001)
Rates: $69
(972)-503-6500; (800) 228-5150

CROWNE PLAZA GALLERIA
14315 Midway Rd (75244)
Rates: $109-$199
(972) 980-8877; (800) 227-6963

HOMEWOOD SUITES BY HILTON
4451 Beltline Rd (75244)
Rates: $109-$129
(972) 788-1342; (800) 225-5466

LA QUINTA INN & SUITES
14925 Landmark Blvd (75244)
Rates: $60-$100
(972) 404-0004; (800) 687-6777

MAINSTAY SUITES
15200 Addison Rd (75001)
Rates: $49-$99
(972) 340-3001; (800) 660-MAIN

MOTEL 6
4325 Beltline Rd (75244)
Rates: $46-$61
(972) 386-4577; (800) 466-8356

RESIDENCE INN BY MARRIOTT
14975 Quorum Dr (75254)
Rates: $89-$179
(972) 866-9933; (800) 331-3131

SUITES OF AMERICA
4004 Belt Line Rd (75001)
Rates: $59-$99
(877) 822-5272

SUMMERFIELD SUITES HOTEL
4900 Edwin Lewis Dr (75244)
Rates: $129-$159
(972) 661-3113; (800) 833-4353

SUPER 8 MOTEL
4150 Beltway Dr (75001)
Rates: $39-$89
(972) 233-2525; (800) 800-8000

RECREATION

ADDISON DOG PARK
Info: You and the dogster will find this small piece of greenery just right for your daily constitutional. The park is generally uncrowded and the fenced dog run provides leash-free frolicking for Rover - or just sit on a bench and experience some quiet time with your best pal. For more information: (972) 450-2851.

Locate Other Dog-Friendly Activities...Check Nearby Cities

Directions: Located along the walking trail east of Marsh, south of Beltway and north of Spring Valley.

Note: Dogs should always be leashed outside of the Off-Leash area.

ALAMO

LODGING

ALAMO INN B&B
801 Main St (78516)
Rates: $45-$89
(866) 7821-9912

SUPER 8 MOTEL
714 N Alamo Rd (78516)
Rates: $39-$79
(956) 787-9444; (800) 800-8000

ALBANY

LODGING

ALBANY MOTOR INN
Hwy 180 @ 283 N (76430)
Rates: $47-$69
(888) 525-2269

OLE NAIL HOUSE INN
357 S 3rd St (76430)
Rates: $50-$80
(800) 245-5163

RECREATION

FORT GRIFFIN STATE PARK & HISTORICAL SITE - Leashes

Info: 500 acres of paw-stomping terrain await you and pup-face at this park. Nature lovers can birdwatch, fish or simply chill with Lil in the grass, while history sniffers can investigate the ruins of the fort or see the historic State Longhorn Herd. For more information: (325) 762-3592; (800) 792-1112; www.tpwd.state.tx.us.

Directions: From Albany, take Highway 283 north for 15 miles to the park entrance.

Note: Entrance fee.

The numbered hikes that follow are within Fort Griffin State Historical Park:

1) FORT GRIFFIN INTERPRETIVE TRAIL HIKE - Leashes

Beginner/2.0 miles

Info: Pick up a trail guide and do an exploration of the ruins and restored structures of this century-old military fort along this gravel surface trail. For more information: (325) 762-3592.

Directions: From Albany, take Highway 283 north for 15 miles to the park entrance.

2) FORT GRIFFIN RIVERWALK TRAIL HIKE - Leashes

Beginner/0.5 miles

Info: If the sight and sound of water sends your pup's tail into wagging overdrive, this is one hike you don't want to miss. The natural surface trail is a short, but scenic jaunt along the Clear Fork of the Brazos River. For more information: (325) 762-3592.

Directions: From Albany, take Highway 283 north for 15 miles to the park entrance.

Note: The bank of the Clear Fork River can be very steep in some areas.

3) MILL CREEK NATURE TRAIL HIKE - Leashes

Intermediate/1.0 miles

Info: This recently opened nature trail will take you deep into heavily wooded areas of Fort Griffin where you and the dog-meister might spy deer, wild turkey and a bevy of other wildlife. Benches are strategically placed along the trail for wildlife viewing. As you continue your trek, the trail also passes by the Clear Fork of the Brazos River where you and Snoopy can watch frogs and other aquatic wildlife frolicking. For more information: (325) 762-3592.

Directions: From Albany, take Highway 283 north for 15 miles to the park entrance.

Locate Other Dog-Friendly Activities...Check Nearby Cities

4) MOUNTAIN TRAIL HIKE - Leashes

Intermediate/3.0 miles

Info: Since Fort Griffin is home to the official state herd, it's no wonder that Texas Longhorn are the main attraction of this hike. The trail starts at the park's paw stomping grassy campgrounds, travels to the scenic overlook and passes several historic ruins. From the park's highest point, you'll enjoy a spectacular view of the surrounding countryside. For more information: (325) 762-3592.

Directions: From Albany, take Highway 283 north for 15 miles to the park entrance.

5) WOHOW TRAIL HIKE - Leashes

Beginner/0.75 miles

Info: You'll get a little exercise and an eyeful of wildlife in its natural setting on this easy-does-it trail, complete with interpretive signs. For more information: (325) 762-3592.

Directions: From Albany, take Highway 283 north for 15 miles to the park entrance.

ALICE

LODGING

DAYS INN
555 N Johnson St (78332)
Rates: $55-$81
(361) 664-6616; (800) 329-7466

KINGS INN MOTEL
815 Hwy 281 S (78332)
Rates: $35-$40
(361) 664-4351

RECREATION

ANDERSON PARK - Leashes

Info: Cloudgaze from the gazebo or repose with Rosie on one of the benches in this lovely park. Active breeds will wag about the walkway that loops through the beautiful landscape.

Directions: Located at the intersection of Alto and Adams Sts.

Hotel Pet Policies May Be Subject To Change

BUENA VISTA PARK - Leashes

Info: You and the pupster can stroll the grassy ballfield in this small neighborhood park.

Directions: Take South Texas Boulevard to Loma Street. Head west on Loma Street to Park Street. Go north on Park Street. You'll see the park on the east side of the road before you reach Lucero Street.

CRAIG PARK - Leashes

Info: You and the pooch can find splendor in the grass and shade beneath the oaks in this small undeveloped park.

Directions: Take North Aransas Street to 3rd Street. Head west on 3rd Street to Peter Street. Go north on Peter Street to the park.

HELDT PARK - Leashes

Info: Smack dab in the center of town, Heldt Park offers two city blocks of stomping ground for you and Fido. Saunter along the sidewalk for awhile or spread your blanket in the shade of an oak tree and laze the day away.

Directions: Located on the corner of Main Street (Front Street) and Cameron.

LAKE ALICE PICNIC AREA - Leashes

Info: Pack a snack and make tracks to one of the shaded picnic tables that line the lakeshore for a relaxing day in this charming area. Oak trees, lush green grass and the shimmering lake present a pretty picture.

Directions: From the center of town, head north on Texas Boulevard for about five minutes until you reach the lake.

Locate Other Dog-Friendly Activities...Check Nearby Cities

ALLEN

LODGING

AMERIHOST INN
407 S Central Expwy (75013)
Rates: $55-$68
(972) 396-9494
(800) 434-5800

ALPINE

LODGING

ANTELOPE LODGE
2310 W Hwy 90 (79830)
Rates: $34-$64
(800) 880-8106

BEST WESTERN ALPINE CLASSIC INN
2401 E Hwy 90 (79830)
Rates: $70-$80
(432) 837-1530; (800) 528-1234

THE CORNER HOUSE B&B
801 E Avenue (79830)
Rates: $27-$65
(432) 837-7161; (800) 585-7795

GRANDMA & GRANDPA'S TRAILS B&B
P. O. Box 1207 (79831)
Rates: $85-$100
(432) 386-3382

HIGHLAND INN & APARTMENTS
1404 E Hwy 90 (79830)
Rates: $40-$66
(432) 837-5811

HISTORIC HOLLAND HOTEL
209 W Holland Ave (79830)
Rates: $45-$175
(800) 535-8040

LONGHORN RANCH MOTEL & RV PARK
HC 65, P. O. Box 267 (79830)
Rates: $45-$55
(432) 371-2541

MOTEL BIEN VENIDO
809 E Holland Ave (79830)
Rates: $29-$36
(432) 837-3454

OAK TREE INN
2407 E Hwy 90 (79830)
Rates: $65-$78
(432) 837-5711

RAMADA INN
2800 W Hwy 90 (79830)
Rates: $80-$140
(432) 837-1100; (800) 272-6232

SUNDAY HOUSE INN MOTEL
2010 E Hwy 90 (79830)
Rates: $35-$80
(432) 837-3363; (800) 510-3363

WILD HORSE STATION CABINS
HC 65, Box 276 C (79830)
Rates: $60-$120
(432) 371-2526

Hotel Pet Policies May Be Subject To Change

<u>RECREATION</u>
REATA RESTAURANT

Info: Not only does the Reata Restaurant offer some of the best food to be found in Texas, but you're welcome to bring your pooch and snag an outdoor patio table - for lunch or dinner. Bone appetite! For more information: (432) 837-9232.

Directions: Located at 203 North 5th Street.

WOODWARD AGATE RANCH

Info: Rockhounds, rejoice. Over 3,000 mineral-splashed acres are yours for the taking at this popular agate ranch. You and Digger can spend hours hunting and collecting jasper, red plume agate, opal, calcite, pom-pom agate, labradorite feldspar and agate geode, just for starters. As an added bonus, if your pooch is voice obedient, he can go leash-free. Happy hounding. For more information: (432) 364-2271.

Directions: From Alpine, head south on Highway 118 approximately 18 miles to the ranch.

Note: Charge by the pound for agates.

ALTO

<u>RECREATION</u>
CADDOAN MOUNDS STATE HISTORIC SITE - Leashes

Info: Pick up a pamphlet and learn as you sojourn through this historical site. Caddoan Mound Builders inhabited the area about 800 years ago until they suddenly abandoned the site in the 13th century, leaving behind artifacts and impressive earthen mounds. Hightail it along the .75-mile self-guided trail and be prepared to be impressed. Lucky dogs may encounter an archeological excavation in progress. Feel free to observe and ask questions. For more information: (936) 858-3218; (800) 792-1112; www.tpwd.state.tx.us.

Directions: Located 6 miles southwest of Alto on Highway 21.

Note: Entrance fee charged. Hours vary, call ahead. No picnicking.

The numbered hike that follows is within
Caddoan Mounds State Historic Site:

1) INTERPRETIVE TRAIL HIKE - Leashes

Beginner/0.75 miles

Info: Intellectual types will have a tailwagging good time on this trail around the prehistoric Caddoan Mounds. An interpretive guide corresponds with the trail's numbered posts, providing descriptive information on the two temple mounds, a burial mound and the Caddoan village. Go ahead, learn away and make your day. For more information: (936) 858-3218.

Directions: Located 6 miles southwest of Alto on Highway 21.

MISSION TEJAS STATE PARK - Leashes

Info: Embark on a history laden adventure through the East Texas Pineywoods and sniff out the remnants of a time gone by. Several pamphlets are available that detail the history of Mission Tejas, the first Spanish mission established in the province of Texas. You can find serenity in the shade of towering trees or enjoy a hike through nature. For more information: (936) 687-2394; (800) 792-1112; www.tpwd.state.tx.us.

Directions: From Alto, take Highway 21 (the Old San Antonio Road) southwest approximately 12 miles to the park entrance at the intersection of Park Road 44 and Highway 21.

Note: $2 entrance fee/person.

The numbered hikes that follow are within
Mission Tejas State Historical Park:

1) MISSION TEJAS HIKING TRAIL SYSTEM - Leashes

Intermediate/4.0 miles

Info: Kiss your cares goodbye and say hello to an afternoon of fresh air and outdoor fun. You'll leave the crowds behind and spend hours of blissful solitude in a beautiful wonderland of nature. Thanks to the canopy of mature pines and various hardwoods, you and Fido will have it made in the shade as you step lively over the hilly terrain. During your travels, be sure to stop and check out the historic Rice Family Log Home. For more information: (936) 687-2394.

Directions: From Alto, take Highway 21 (the Old San Antonio Road) southwest approximately 12 miles to the park entrance at the intersection of Park Road 44 and Highway 21.

2) TEJAS TIMBER NATURE TRAIL HIKE - Leashes

Beginner/1.0 miles

Info: Traverse dense forests and gallivant over hilly terrain to a 3-acre pond. For the most part, you and the pupster are in for a rather easy go of it on this hike with the exception of a few hills that could get the juices flowing. Dense groves of pine, oak, dogwood, sweetgum and redbud shade the trail and offer a cool respite from the hot sun. Fishing hounds, bring your gear and snag a bagful, the pond is full of perch and bream. Pick up an interpretive pamphlet before you head out, it will help identify the trail's flora along your route. For more information: (936) 687-2394.

Directions: From Alto, take Highway 21 (the Old San Antonio Road) southwest approximately 12 miles to the park entrance at the intersection of Park Road 44 and Highway 21.

ALVIN

LODGING

COMFORT INN
1535 S Bypass 35 (77511)
Rates: $59-$99
(281) 756-8800; (800) 228-5150

DAYS INN
110 E Hwy 6 (77511)
Rates: $49-$69
(281) 331-5227; (800) 329-7466

COUNTRY HEARTH INN
1588 S Hwy 35 Bypass (77511)
Rates: $50-$58
(281) 331-0335; (888) 325-7815

RECREATION

ALBERT FINKLE MEMORIAL COUNTY PARK - Leashes

Info: Check out the Chocolate Bayou as you wander along its rolling banks and drop in on the fish at this quaint park. If you're a lucky dog, you might catch a tasty treat for a fish and kibble cookout. For more information: (979) 864-1541.

Directions: Take Highway 35 south to 2917. Left on 2917 (about 2 miles) to CR 171. Turn right on CR 171 and the park will be on the right (on CR 171 & Chocolate Bayou in Liverpool).

BRAZOS RIVER COUNTY PARK - Leashes

Info: Leash up that Laddie and make tracks to this incredibly scenic 75-acre park on the banks of the Brazos. Keep a snout out for wildlife including deer, rabbit and squirrel which can often be spotted in the dense forest. You and the lickmeister can dine alfresco in a shaded picnic glade, or take to the .25 miles of paved trail. Other pathways lead to a duck pond and a two-story lookout tower. Be sure to tote your camera for this excursion, you'll want to capture some memories. For more information: (979) 864-1541.

Directions: From Alvin, take Highway 35 south to the park which is located in the Planter's Point Subdivision near Angleton.

Hotel Pet Policies May Be Subject To Change

HANSON RIVERSIDE COUNTY PARK - Leashes

Info: Paddle your pooch down the river or lead him along the nature trails in this amazing 42-acre park. You can picnic by the water, fish off the pier, play in the field, or chill out just about anywhere in this lovely setting. For a panoramic view of your surroundings, make haste to the observation tower. For more information: (979) 864-1541.

Directions: Located off Highway 35 between West Columbia and Sweeny, on the San Bernard River.

HUGH ADAMS PARK - Leashes

Info: 25 acres of unbridled scenery and funnery await you and furface. Pack a snack and enjoy an afternoon picnic and a bit of playtime.

Directions: Located on Mustang Road behind Alvin Community College.

MORGAN PARK - Leashes

Info: Impress your pooch by leading him through this 10-acre green scene. Tote a frisbee or a tennie for a game of fetch.

Directions: Located on South Street.

NATIONAL OAK PARK - Leashes

Info: Ogle the oaks and savor some shade in this 8-acre park.

Directions: Located at Sidnor and Disney Streets.

PEARSON PARK - Leashes

Info: Dog tired of couch potato afternoons? Pack a tennie and bring a grin to the ballmeister's face in this expansive 24-acre park.

Directions: Located at Westpark and Ryan Streets.

Locate Other Dog-Friendly Activities...Check Nearby Cities

QUINTANA BEACH COUNTY PARK - Leashes

Info: This park offers 51 acres of fun for you and the pupster. History sniffers will enjoy the historical sights that punctuate the park. Nature lovers can frolic on the beach and cool their paws in the Gulf. In springtime, wildflowers abound and enliven the landscape with brilliant colors.

Sporting breeds will enjoy the many fishing spots. Migratory birds and a variety of seabirds entertain birdwatchers. Of course, hiking hounds will want to hit the trails for a bit of Texercise. Spectators can usually catch a volleyball game while Sunday strollers will love the boardwalks and shaded pavilions. Whatever your pleasure, you'll find it here. For more information: (979) 233-1461; (800) 8-PARK-RV.

Directions: From Alvin, take Highway 35 south to Hwy 288 and continue south to Highway 332. Head south on Hwy 332 to Hwy 288B. Follow Hwy 288B to Hwy 36 and go left until it deadends into FM 1495. Turn right on FM 1495 and follow signs for Quintana Island.

Note: $4 entrance fee for day use.

RESOFT COUNTY PARK - Leashes

Info: Happy days start with a visit to this park. Set tails a-wagging with a walk on one of the nature or loop trails around the lake. Break some bread and biscuits with Bowser under the shade of fragrant pines. If you prefer the sound of wind rustling through the leaves rather than whistling through the needles - no problem. Just set your sights on the Hardwood Forest. Dollars to dog biscuits, no matter where you roam in this park, you won't go home disappointed. For more information: (979) 864-1541.

Directions: Located north of Alvin off CR 281 and Hwy 35.

SAN LUIS PASS COUNTY PARK - Leashes

Info: Fishy tails are waiting to wag at this seaside park, aka the hottest fishing spot on the Texas coast. Drop a line and hope to

Hotel Pet Policies May Be Subject To Change

dine with the doggie under one of the park's covered pavilions. Nature lovers can stroll over the bridge and follow the trail to the wetlands to experience an interesting riparian outing. For more information: (979) 233-6026; (800) 3-PARK-RV.

Directions: From Alvin, take Highway 35 south to Highway 288 and continue south to Hwy 332. Head east on Highway 332 to Surfside Beach. From Surfside Beach, take CR 257 north for 15 miles to the Galveston Toll Bridge and the park.

Note: Parking fee for day use charged.

SURFSIDE JETTY COUNTY PARK - Leashes

Info: You'll want to include a biscuit basket when you visit this seaside park where a deck and patio provide lovely lunching spots. Birdwatchers - pack your binoculars, the park's man-made lagoon attracts mucho species worthy of a look-see. For a birds-eye view of the surrounding area, climb the lookout tower. Or shake a leg with your wagalong on the paved walkway which skirts the lagoon or along the granite jetties. For more information: (979) 864-1541.

Directions: From Alvin, take Highway 35 south to Highway 288 and continue south to Hwy 332. Head east on Highway 332 to Surfside Beach. From Surfside Beach, turn right on CR 257 (Bluewater Highway). The park is located at the south end of CR 257.

OTHER PARKS IN ALVIN - Leashes

For more information, contact the Alvin Parks & Recreation Department at (281) 388-4299.

- MARINA PARK, Highway 6 behind Alvin Bowling Alley
- NEWMAN PARK, North Second and Newman Streets
- PRAIRIE DOG PARK, House and Bayou Drives
- RUBEN ADAME PARK, Avenue D and Shaw
- SEALY PARK, Sealy Street and South Durant
- TALMADGE PARK, Talmadge and Sixth Streets

AMARILLO

LODGING

AMBASSADOR HOTEL
3100 W I-40 (79102)
Rates: $69-$169
(806) 358-6161; (800) 817-0521

BEST WESTERN AMARILLO INN
1610 Coulter Dr (79106)
Rates: $72-$92
(806) 358-7861; (800) 528-1234

BEST WESTERN SANTA FE INN
4600 I-40 E (79120)
Rates: $75-$85
(806) 372-1885; (800) 528-1234

BIG TEXAN INN
7701 I-40 E (79120)
Rates: $40-$65
(806) 372-5000; (800) 657-7177

BRONCO MOTEL
6005 Amarillo Blvd W (79106)
Rates: $37-$45
(806) 355-3321

CLARION HOTEL AIRPORT
7090 E I-40 (79104)
Rates: $60-$80
(806) 373-3303; (800) 252-7466

COACHLIGHT INN #3
2115 I-40 E (79102)
Rates: $38-$55
(806) 376-5911

COACHLIGHT INN #4
6810 I-40 E (79104)
Rates: $45-$52
(806) 373-6871

COMFORT INN AIRPORT
1515 I-40 E (79102)
Rates: $49-$119
(806) 376-9993; (800) 228-5150

DAYS INN EAST
1701 I-40 E (79102)
Rates: $49-$79
(806) 379-6255; (800) 329-7466

DAYS INN SOUTH
8601 Canyon Dr (79110)
Rates: $50-$79
(806) 468-7100; (800) 329-7466

ECONO LODGE
2915 I-40 E (79104)
Rates: $45-$75
(806) 372-8101; (800) 553-2666

HAMPTON INN
1700 I-40 E (79103)
Rates: $49-$109
(806) 372-1425; (800) 426-7866

HOLIDAY INN EXPRESS
3411 I-40 W (79109)
Rates: $109-$139
(806) 356-6800; (800) 465-4329

HOLIDAY INN I-40
1911 I-40 at Ross-Osage (79102)
Rates: $119-$125
(806) 372-8741; (800) 465-4329

LA KIVA HOTEL
2501 I-40 E (79104)
Rates: $89
(806) 379-6555

LA QUINTA INN EAST/AIRPORT
1708 I-40 E (79103)
Rates: $69-$89
(806) 373-7486; (800) 687-6667

LA QUINTA INN WEST/MEDICAL CENTER
2108 S Coulter St (79106)
Rates: $69-$89
(806) 352-6311; (800) 687-6667

Hotel Pet Policies May Be Subject To Change

MICROTEL INN & SUITES
1501 S Ross St (79102)
Rates: $59-$99
(806) 372-8373

MOTEL 6-CENTRAL
2032 Paramount Blvd (79109)
Rates: $33-$45
(806) 355-6554; (800) 466-8356

MOTEL 6-EAST
3930 I-40 E (79103)
Rates: $31-$39
(806) 374-6444; (800) 466-8356

MOTEL 6-WEST
6030 I-40 W (79106)
Rates: $31-$39
(806) 359-7651; (800) 466-8356

QUALITY INN & SUITES
1803 Lakeside Dr (79120)
Rates: $79-$159
(806) 335-1561; (800) 228-5151
(800) 847-6556 (TX)

RAMADA LIMITED
1620 I-40 E (79103)
Rates: $47-$76
(806) 374-2020; (800) 272-6232

RESIDENCE INN BY MARRIOTT
6700 I-40 W (79106)
Rates: $130-$164
(806) 354-2978; (800) 331-3131

SLEEP INN
2401 I-40 E (79104)
Rates: $65-$120
(806) 372-6200; (800) 753-3746

SUPER 8 MOTEL
2909 I-40 E (79104)
Rates: $35-$75
(800) 800-8000

TRAVELODGE-EAST
3205 I-40 E,
Tee Anchor Blvd (79104)
Rates: $48-$70
(806) 372-8171; (800) 578-7878

TRAVELODGE-WEST
2035 Paramount Blvd (79109)
Rates: $30-$62
(806) 353-3541; (800) 578-7878

RECREATION

CADILLAC RANCH - Leashes

Info: Ten Cadillacs are buried snout down in the middle of a field at this unusual "bumper crop" attraction. Interestingly, the flamboyant fins are angled the same as the Cheops Pyramids. Check them out and see if you come up with any theories of your own. You can do a drive-by, but then you'd miss the graffiti that adds a touch of character to these auto sculptures.

Directions: Located off Interstate 40, 7 miles west of Amarillo.

ELLWOOD PARK - Leashes

Info: Your pooch will love starting any day with a saunter through the savannah where you can enjoy an afternoon of nature study and reflection. Benches and drinking water are provided along the one miler within the park.

Directions: Located at Southwest 11th and Washington Streets.

LAKE MEREDITH NATIONAL RECREATION AREA - Leashes

Info: Nestled in the dry and windswept plains of the Panhandle, Lake Meredith is a waterdog's dream come true. Limestone canyons, scenic buttes, wind-carved caves and pinnacles surround the water, creating a magnificent backdrop for boaters. Landlubbers can enjoy hiking trails, picnic areas and a tranquil setting away from city life. Fishing, hunting and birdwatching are also popular activities, so pack a pole and your binocs. For more information: (806) 857-3151.

Directions: From Amarillo, head north on Highway 136 for 30-35 miles to Fritch and park headquarters.

Note: Dogs are not allowed in Alibates Flint Quarries National Monument, or on the beach, or in the water at Spring Canyon.

PALO DURO CANYON STATE PARK - Leashes

Info: 18,438 acres of awe-inspiring scenery await you and Tex in this enchanting park. Colorful and serene, the region is a haven for city escapees. Fascinating geologic formations, shaded open areas and picnic facilities combine to make Palo Duro Canyon a very special place. Hop on the nature trail to the "Lighthouse" and scope it out. For more information: (806) 488-2227; (800) 792-1112; www.tpwd.state.tx.us.

Directions: From Amarillo, take FM 1541 south approximately 12 miles to Highway 217. Head east on Highway 217 for 8 miles to the park.

Note: Entrance fee charged.

Hotel Pet Policies May Be Subject To Change

The numbered hike that follows is within Palo Duro Canyon State Park:

1) LIGHTHOUSE TRAIL HIKE - Leashes

Beginner/Intermediate/4.6 miles

Info: You and the dawgus are in for an interesting hike to the park's famous rock formation - the 75-foot Lighthouse. The beginning of the trail follows a relatively easy course to the base of a towering geologic pillar composed of soft shale and topped with a layer of sandstone. The last stretch is a somewhat steep climb, but the views from the top are worth the effort. Don't forget your camera. You're sure to encounter a Kodak moment or two. The scenic badlands and red-walled canyons are pawsitively photo worthy. For more information: (806) 488-2227.

Directions: From Amarillo, take FM 1541 south approximately 12 miles to Highway 217. Head east on Highway 217 for 8 miles to the park.

ANAHUAC

RECREATION

ANAHUAC NATIONAL WILDLIFE REFUGE - Leashes

Info: A birdwatcher's paradise, over 255 species of birds make their home in this refuge habitat. Take the pooch out for a day of skygazing and see what feathered friends you can identify. Stop by the refuge headquarters for a pamphlet that lists the birds you can expect to see as well as when to look for them. The best viewing spots are Shoveler Pond and Teal Slough. Keep the leash on - alligators are common to the area. Hikers can take their pick from a number of designated trails that lace this beautiful area, but be sure to tote your own water. Wildlife is most commonly seen in the early morning and late evening. If you're short on time but long on yearning, there are twelve miles of gravel roads that offer alternative viewing of the marsh and its wildlife. For more information: (409) 267-3337.

Locate Other Dog-Friendly Activities...Check Nearby Cities

Directions: Enter at the Refuge Headquarters located at the corner of Trinity and Washington in Anahuac. From there, follow Bolton Lane east to 562 south. Take 562 south to FM 1985. Go east to a gravel road leading to the refuge.

There are 2 other options for entering the refuge:

1) From Houston: Take I-10 east to Exit 812 (TX61 or Anahuac/Jankamer exit). Travel south on 61 for 4.0 miles to stop sign. Continue until road becomes Hwy 562. Travel 8.5 miles to a fork in the road (FM 1985). At the fork, turn left onto FM 1985 and continue for 4.0 miles to the main entrance of the refuge.

2) From Beaumont: Take I-10 east, exit 829 (Hwy 73/124 or Winnie/Galveston exit). Travel south on 124 for 11.0 miles to FM 1985. Turn right onto FM 1985 and head west for 11.0 miles to the main entrance of the refuge.

Note: Use caution when walking with your dog. Alligators, snakes and fire ants are common in the refuge. Bring bug repellent - you will be in a marsh habitat where mosquitos thrive. Contact: Anahuac National Wildlife Refuge, P.O. Box 278, Anahuac, TX 77514.

ANGELINA NATIONAL FOREST

ANGELINA RANGER DISTRICT
111 Walnut Ridge Rd, Zavalla, TX 75980,
(936) 897-1068

Info: The Angelina may be the smallest national forest in Texas, but it packs a large recreational punch. Named for the legendary Indian woman who befriended early Spanish and French missionaries, this forest encompasses over 154,000 acres with 10 developed recreation areas and 560 miles of shoreline, making it a naturalist's dream come true. Lace up for an invigorating hike through thick pine forests or set sail for a waterful adventure on Texas' largest lake- 114,000-acre Sam Rayburn Reservoir. When play's the thing, this forest is the stage. For more information: (936) 897-1068.

Directions: The forest lies within the boundaries of Angelina, San Augustine, Jasper and Nacogdoches counties and is accessible from a handful of secondary highways in Zavalla. Refer to specific directions following each recreation area and hiking trail.

For more information on recreation in the Angelina National Forest, see listings under Lufkin.

ANGLETON

LODGING

BEST VALUE INN
1235 N Velasco (77515)
Rates: $55-$68
(979) 849-2465

BEST WESTERN ANGLETON INN
1809 N Velasco (77515)
Rates: $60-$110
(979) 849-5822; (800) 528-1234

RECREATION

BRAZORIA NATIONAL WILDLIFE REFUGE - Leashes

Info: With over 40,000 acres of prairies, marshlands, lakes and salt/mud flat sites, it's no wonder that more than 425 wildlife species make their home in the Brazoria National Wildlife Refuge. From Canadian geese, mottled ducks, herons and sandpipers to reddish egrets, American bitterns, sandhill cranes and hawks, over 270 species are guaranteed to keep diehard birders busy for hours. If you're fascinated by alligators, you might catch sight of one at Big Slough. The refuge also offers over 6 miles of gravel roads where you and the pupster will have plenty of wildlife viewing opportunities. For more information: (979) 849-6062 or (979) 239-3915.

Directions: From Angleton, take Highway 288 south to Lake Jackson and turn left on FM 2004. Follow FM 2004 to the 4-way stop and make a right on FM 523. Continue on FM 523 approximately 5.5 miles to County Road 227. Turn left for just under 2 miles to the refuge gate.

Note: Refuge hours vary, call first.

ANTHONY

LODGING

HOLIDAY INN EXPRESS
9401 S Desert Blvd (79821)
Rates: $79-$89
(915) 886-3333; (800) 465-4329

SUPER 8 MOTEL WEST
100 Park North Dr (79821)
Rates: $41-$60
(915) 886-2888; (800) 800-8000

ARANSAS PASS

LODGING

HOMEPORT INN
1515 W Wheeler Ave (78336)
Rates: $35-$42
(361) 758-3213

TRAVELODGE
545 N Commercial (78336)
Rates: $38-$58
(361) 758-5305; (800) 578-7878

ARLINGTON

LODGING

AMERISUITES
2380 East Rd to Six Flags Dr (76011)
Rates: $59-$129
(817) 649-7676; (800) 833-1516

COUNTRY INN & SUITES BY CARLSON
1075 West N Wild Way (76011)
Rates: $59-$149
(817) 715-3292; (800) 456-4000

BAYMONT INN & SUITES
2401 Diplomacy Dr (76011)
Rates: $49-$99
(817) 633-2400; (877) 229-6668

DAYS INN
1901 Pleasant Ridge (76011)
Rates: $55-$79
(817) 557-5828; (800) 329-7466

BEST WESTERN GREAT SOUTHWEST INN
3501 E Division St (76011)
Rates: $49-$95
(817) 640-7722; (800) 528-1234
(800) 346-2378

**DAYS INN BALLPARK AT
ARLINGTON-SIX FLAGS**
910 N Collins St (76011)
Rates: $35-$95
(817) 261-8444; (800) 329-7466

Hotel Pet Policies May Be Subject To Change

HAWTHORN SUITES HOTEL
2401 Brookhollow Plaza Dr (76011)
Rates: $79-$199
(817) 640-1188; (800) 225-5466
(800) 527-1133

HOMESTEAD STUDIO SUITES
1221 N Watson Rd (76011)
Rates: $44-$59
(817) 633-7588; (888) 782-9473

HOMEWOOD SUITES
2401 East Rd to Six Flags Dr (76011)
Rates: $109-$159
(817) 633-1594; (800) 225-5466

HOWARD JOHNSON EXPRESS
2001 E Copeland Rd (76011)
Rates: $49-$99
(817) 461-1122; (800) 446-4656

LA QUINTA INN CONFERENCE CENTER
825 N Watson Rd (76011)
Rates: $70-$115
(817) 640-4142; (800) 687-6667

LA QUINTA INN & SUITES
4001 Scott's Legacy (76011)
Rates: $96-$131
(817) 467-7756; (800) 687-6667

LESTER MOTOR INN
2725 W Division St (76012)
Rates: $28-$42
(817) 275-5496

MICROTEL INN
1740 Oak Village Blvd (76013)
Rates: $50-$85
(817) 557-8400; (888) 771-7171

MOTEL 6
2626 E Randol Mill Rd (76011)
Rates: $42-$58
(817) 649-0147; (800) 466-8356

OASIS MOTEL
818 W Division St (76011)
Rates: $26-$50
(817) 274-1616

PARKWAY INN
703 Benge Dr (76013)
Rates: $50-$60
(817) 860-2323; (800) 437-7275

RESIDENCE INN BY MARRIOTT
1050 Brookhollow Plaza Dr (76006)
Rates: $129-$199
(817) 649-7300; (800) 331-3131

SLEEP INN-MAIN GATE/SIX FLAGS
750 Six Flags Dr (76004)
Rates: $66-$110
(817) 649-1010; (800) 753-3746

STUDIO 6-SOUTH
1980 W Pleasant Ridge Rd (76011)
Rates: $47-$64
(817) 465-8500; (888) 897-0202

TOWNEPLACE SUITES BY MARRIOTT
1709 E Lamar Ave (76006)
Rates: $79-$89
(817) 861-8728; (800) 257-3000

RECREATION

BOB COOKE PARK - Leashes

Info: The sun shimmers and beckons on the dewy lush grass in this 22-acre community park. Find a spot to call your own and cloudgaze the afternoon away. Or grab your gadabout and do a roundabout on the one-mile walkway.

Locate Other Dog-Friendly Activities...Check Nearby Cities

Directions: Located at 2025 East Lovers Lane.

BOWMAN SPRINGS PARK - Leashes

Info: Linger lakeside with your lapdog and savor the sunshine in this lovely 14-acre park.

Directions: Located at 7001 Poly Webb Road on Lake Arlington.

CLARENCE FOSTER PARK - Leashes

Info: Happy days start with a stroll along the .6-mile pathway in this 15-acre neighborhood park.

Directions: Located at 4400 Woodland Park Boulevard.

CLARENCE THOMPSON PARK - Leashes

Info: Change your morning routine and watch tails wag on the beautiful nature trail that zigzags through this pleasant 15-acre parkland. Beat the heat by finding a shaded spot trailside where you can break biscuits with Bowser.

Directions: Located at 701 Brown Boulevard.

CLIFF NELSON PARK - Leashes

Info: Lounge with your hound and soak up all that this 15-acre expanse has to offer. Sun-dappled greenery and lovely picnic grounds combine for aesthetic pleasure, while a half-mile path offers the opportunity for some Texercise.

Directions: Located at 4600 West Bardin Road.

DUNSWORTH PARK - Leashes

Info: Tie those tennies and hightail it with your tagalong on the .5-mile trail in this 8-acre park.

Directions: Located at 1100 Waverly Drive.

Hotel Pet Policies May Be Subject To Change

FISH CREEK PARK - Leashes

Info: Mellow fellows will love this 10-acre undeveloped park. There are no amenities, so tote your own supplies.

Directions: Located at 2133 Havenwood.

FOUNDERS PARK - Leashes

Info: Get lost in your thoughts as you and the dawgus stroll the grounds in this undeveloped region.

Directions: Located at 600 West Arkansas.

GIBBINS PARK - Leashes

Info: Make the most of the cool morning air as you strut with the mutt in this 10-acre neighborhood park.

Directions: Located at 2101 Margaret.

MARTHA WALKER PARK - Leashes

Info: Take a break from your busy day and do lunch with fur-face at this 13-acre green scene.

Directions: Located at 7509 Sharon Lee Road.

PARKWAY CENTRAL PARK - Leashes

Info: Go ahead, make your dog's day by taking him for an afternoon picnic in this pretty 10-acre expanse.

Directions: Located at 600 Van Buren.

RANDOL MILL PARK - Leashes

Info: Sniff around the open space, sup with the pup at a picnic place or ponder the pond in this expansive, 149-acre greenland.

Directions: Located at 1901 West Randol Mill Road.

Locate Other Dog-Friendly Activities...Check Nearby Cities

RED KANE PARK - Leashes

Info: Say goodbye to the summer doldrums and head for this 25-acre parkland. If fishing is your ticket to relaxation, take your rod and try your luck. End your outing with a couple of turns on the short but sweet quarter-mile trail.

Directions: Located at 4900 Youpon Drive.

RIVER LEGACY PARKS - Leashes

Info: Give the pooch something to bark home about with an excursion to this green oasis. Located along the banks of the Trinity River, this area encompasses 380 acres of unbridled scenery for you and the wagalong to enjoy. Be a lazy bones riverside or explore the pretty woodlands. Bring binoculars, there's lots of wildlife. For more information: (817) 459-5474.

Directions: Located at 701 N.W. Green Oaks Boulevard.

STOVALL PARK - Leashes

Info: 49 acres spell fun for you and your sidekick. Make tracks on the one-mile trail or find a shady nook and chill out for the day.

Directions: Located at 2800 Sublett Road.

THORA HART PARK - Leashes

Info: For a lickety split bit of exercise, take to the .1-mile track in this urban parkland.

Directions: Located at 3510 West Green Oaks Boulevard.

VANDERGRIFF PARK - Leashes

Info: You and Sport can catch a local ball game or sniff your way through the open grassy fields in this 84-acre region.

Directions: Located at 2801 Matlock Road.

Hotel Pet Policies May Be Subject To Change

VETERANS PARK - Leashes

Info: Dine à la blanket with your buddy on the shores of lovely Lake Arlington. Kick back and spend a wondrous water-filled day far from the hustle and bustle of city life in this pleasant 103-acre park. For more information: (817) 459-5474.

Directions: Located at 3600 West Arkansas Lane.

WIMBLEDON PARK - Leashes

Info: Prance over the practice fields or pound those paws on the 1.3-mile trail in this 14-acre expanse.

Directions: Located at 2300 Wimbledon Drive.

WOODLAND WEST PARK - Leashes

Info: Pack a fun attitude and an old tennie before you set out for this 11-acre neighborhood park

Directions: Located at 3200 Lynnwood Drive.

OTHER PARKS IN ARLINGTON - Leashes

For more information, contact the Arlington Parks & Recreation Department at (817) 459-5474.

- ALLAN SAXE PARK, 3501 Curry Road
- BC BARNES PARK, 3000 Daniel Drive
- BRANTLEY HINSHAW PARK, 2121 Overbrook
- BURL WILKES PARK, 2000 Reever Street
- CHILDRENS PARK, 2001 Wynn Terrace
- COLLEGE HILLS PARK, 151 University Drive
- CRAVENS PARK, 400 Nahan Lowe Road
- DOUG RUSSEL PARK, 801 West Mitchell Street
- DUNCAN ROBINSON PARK, 2100 West Tucker Street
- FIELDER PARK, 1100 South Fielder
- GEORGE STEVENS PARK, 400 West Sanford
- HELEN WESSLER PARK, 2200 Greenway Street
- HOWARD MOORE PARK, 1018 West Tucker Boulevard
- HUGH SMITH PARK, 1815 New York Avenue

Locate Other Dog-Friendly Activities...Check Nearby Cities

- PIERCE BURCH PARK, 1901 Lakewood
- PIRIE PARK, 1818 Cedar
- RICHARD SIMPSON PARK, 6300 West Arkansas Lane
- RIVER RIDGE PARK, Burney Road
- SENTER PARK, 700 Mary Street

ATHENS

LODGING

BUDGET INN
305 Dallas Hwy (75751)
Rates: $35-$40
(903) 675-5194

SPANISH TRACE INN MOTEL
716 E Tyler St (75751)
Rates: $44-$95
(903) 675-5173; (800) 488-5173

SUPER 8 MOTEL
205 Dallas Hwy 175 (75751)
Rates: $39-$85
(903) 675-7511; (800) 800-8000

VICTORIAN INN
1803 E Hwy 31 (75751)
Rates: $34-$70
(903) 677-1470

RECREATION

CAIN PARK - Leashes

Info: Take your hot diggety dog to the ball park for some exercise and a chance to catch a fly ball. Or for a quick escape, exercise Rex on the half-mile paved trail in this shade-dappled, woodsy park. For more information: (888) 294-2847.

Directions: Cain Park is located at 214 Loyola and can also be accessed from Robbins Road.

ATLANTA

LODGING

THE BUTLER'S INN
1100 W Main St (75551)
Rates: $29-$37
Tel: (903) 796-8235; (800) 338-0297

Hotel Pet Policies May Be Subject To Change

RECREATION

ATLANTA STATE PARK - Leashes

Info: Fill your snouts with the crisp scent of pine and find a shaded lakeside spot where you and the dawgus can share a brown bagger. Then get some Rexercise on one of two trails. Anglers, try your fly on catfish, crappie, bass and stripers. No matter what floats Fido's boat, you'll find plenty to do and see at this beautiful woodland park. For more information: (903) 796-6476; (800) 792-1112; www.tpwd.state.tx.us.

Directions: From Atlanta, head north on Highway 59 to Queen City, then take FM 96 west for 7 miles to FM 1154. Follow FM 1154 north for 2 miles to the park entrance.

Note: Entrance fee charged.

The numbered hikes that follow are within Atlanta State Park:

1) ARROWHEAD TRAIL HIKE - Leashes

Beginner/1.2 miles

Info: You and your furry sidekick are in for a "piney" excursion on this looping forested trail. Nature photographers, pack plenty of film - you'll be hiking through a section of the park that's a favorite with bird and wildlife inhabitants. For more information: (903) 796-6476.

Directions: From Atlanta, head north on Highway 59 to Queen City, then take FM 96 west for 7 miles to FM 1154. Follow FM 1154 north for 2 miles to the park entrance.

2) HICKORY HOLLOW NATURE TRAIL HIKE - Leashes

Intermediate/5.8 miles

Info: Combine an energetic hike with a slice of education on this interesting interpretive trail where nature reigns supreme. You and the soon-to-be-dirty dog will encounter an abundance of birds, dense pine forests, woodland plants and Wilkins Creek, a delightful riparian oasis, aka puppy paradise.

If you're short on time but long on desire, try the 1.2-mile self-guided looping trail. It will give you a good overall feel for the place. For more information: (903) 796-6476.

Directions: From Atlanta, head north on Highway 59 to Queen City, then take FM 96 west for 7 miles to FM 1154. Follow FM 1154 north for 2 miles to the park entrance.

AUSTIN

LODGING

AMERICAN INN
7300 I-35 N (78752)
Rates: $45-$57
(512) 452-9371

AMERISUITES-AIRPORT
7601 Ben White Blvd (78741)
Rates: $79
(512) 386-7600; (800) 833-1516

AMERISUITES-ARBORETUM
3612 Tudor Blvd (78759)
Rates: $149-$179
(512) 231-8491; (800) 833-1516

AMERISUITES- NORTH CENTRAL
7522 N I-35 (78752)
Rates: $99-$129
(512) 323-2121; (800) 833-1516

AUSTIN EXECUTIVE LODGING
809 W MLK Blvd (78701)
Rates: $49-$175
(800) 494-2261

AUSTIN FOLK HOUSE B & B
506 West 22nd St (78705)
Rates: $79-$139
(512) 472-6700; (866) 472-6700

BAYMONT INN & SUITES
150 Parker Dr (78728)
Rates: $69-$129
(512) 246-2800; (877) 229-6668

BEST VALUE INN
2525 I-35 S (78741)
Rates: $45-$50
(512) 441-0143

BEST VALUE INN & SUITES
6911 I-35 N (78752)
Rates: $60-$80
(512) 459-4251; (800) 306-4629

BEST WESTERN ATRIUM NORTH
7928 Gessner Dr (78753)
Rates: $49-$99
(512) 339-7311; (800) 528-1234
(800) 468-3708

BEST WESTERN SEVILLE PLAZA INN
4323 I-35 S (78744)
Rates: $55-$89
(512) 447-5511; (800) 528-1234

BRAVA HOUSE B&B
1108 Blanco St (78744)
Rates: $89-$195
(512) 478-5034; (888) 545-8200

CANDLEWOOD SUITES-NW
9701 Stonelake Blvd (78759)
Rates: $72-$89
(512) 338-1611; (800) 465-4329

CANDLEWOOD SUITES-SOUTH
4320 S I-35 (78745)
Rate: $105-$157
(512) 444-8882; (800) 465-4329

Hotel Pet Policies May Be Subject To Change

CARRINGTON'S BLUFF B&B
1900 David St (78705)
Rates: $89-$149
(888) 290-6090

CLARION INN & SUITES CONF CTR
2200 S I-35 (78704)
Rates: $69-$139
(512) 444-0561; (800) 252-7466

CORPORATE HOUSING/APT RENTALS
2007 Mountain View (78734)
Rates: n/a
(800) 845-6343

COUNTRY COTTAGE
2008 Travis Hghts Blvd (78765)
Rates: $100-$400
(512) 479-0073

CROWN PLAZA HOTEL
500 N I-35 (78753)
Rates: $109-$159
(512) 480-8181; (800) 227-6963

DAYS INN NORTH
820 E Anderson Ln (78752)
Rates: $49-$67
(512) 835-4311; (800) 329-7466

DAYS INN UNIVERSITY-DOWNTOWN
3105 N I-35 (78722)
Rates: $55-$99
(512) 478-1631; (800) 329-7466

DOUBLETREE CLUB HOTEL
1617 I-35 N (78702)
Rates: $79-$149
(512) 479-4000; (800) 222-8733

DOUBLETREE GUEST SUITES
303 W 15th St (78701)
Rates: $109-$249
(512) 478-7000; (800) 222-8733

DOUBLETREE HOTEL
6505 I-35 N (78752)
Rates: $89-$179
(512) 454-3737; (800) 222-8733

THE DRISKILL
604 Brazos St (78701)
Rates: $185-$340
(512) 474-5911

DRURY INN HIGHLAND MALL
919 E Koenig Ln (78751)
Rates: $72-$102
(512) 454-1144; (800) 378-7946

DRURY INN & SUITES NORTH
6511 I-35 N (78752)
Rates: $79-$109
(512) 467-9500; (800) 378-7946

ECONO LODGE
6201 Hwy 290 E (78723)
Rates: $49-$99
(512) 458-4759; (800) 553-2666

EMBASSY SUITES HOTEL
300 S Congress Ave (78704)
Rates: $109-$219
(512) 469-9000; (800) 362-2779

EXEL INN
2711 I-35 S (78741)
Rates: $40-$79
(512) 462-9201; (800) 367-3935

FOUR POINTS HOTEL BY SHERATON
7800 N I-35 (78753)
Rates: $112-$128
(512) 836-8520; (800) 325-3535

FOUR SEASONS HOTEL
98 San Jacinto Blvd (78701)
Rates: $245-$395
(512) 478-4500; (800) 332-3442

GREENSHORES ON LAKE AUSTIN
6900 Greenshores Rd (78730)
Rates: $70-$130
(512) 346-0011

HABITAT SUITES HOTEL
500 Highland Mall Blvd (78752)
Rates: $127-$187
(512) 467-6000; (800) 535-4663

Locate Other Dog-Friendly Activities...Check Nearby Cities

HAMPTON INN NORTHWEST
3908 W Braker Ln (78759)
Rates: $79-$109
(512) 349-9898; (800) 426-7866

HAWTHORN SUITES LTD-AIRPORT
7800 E Riverside Dr (78744)
Rates: $69-$149
(512) 247-6166; (800) 527-1133

HAWTHORN SUITES CENTRAL
935 La Posada Dr (78752)
Rates: $79-$164
(512) 459-3335; (800) 527-1133

HAWTHORN SUITES-NORTHWEST
8888 Tallwood Dr (78759)
Rates: $79-$129
(512) 343-0008; (800) 527-1133

HAWTHORN SUITES-SOUTH
4020 I-35 S (78704)
Rates: $59-$138
(512) 440-7722; (800) 527-1133

HEART OF TEXAS MOTEL
5303 US 290 W (78735)
Rates: $50-$65
(512) 892-0644

HEARTHSIDE SUITES BY VILLAGER
12989 Research Blvd (78729)
Rates: $59-$99
(512) 652-4300

HEARTHSIDE SUITES BY VILLAGER
7101 N I-35 (78752)
Rates: $59-$99
(512) 452-9332

HILTON AUSTIN NORTH
6000 Middle Fiskville Rd (78752)
Rates: $89-$179
(512) 451-5757; (800) 445-8667
(800) 347-0330

HOLIDAY INN AIRPORT SOUTH
3401 I-35 S (78741)
Rates: $89-$99
(512) 448-2444; (800) 465-4329

HOLIDAY INN NORTHWEST PLAZA
8901 Business Park Dr (78759)
Rates: $59-$109
(512) 343-0888; (800) 465-4329

HOLIDAY INN TOWN LAKE
20 N I-35 (78701)
Rates: $129
(512) 472-8211; (800) 465-4329

HOMESTEAD STUDIO SUITES
507 S 1st St (78701)
Rates: $69-$84
(512) 476-1818; (888) 782-9473

HOMESTEAD STUDIO SUITES/ARBORETUM
9100 Waterford Centre Blvd (78758)
Rates: $49-$64
(512) 837-6677; (888) 782-9473

HOMEWOOD SUITES-SOUTH
4143 Governors Row ((78744)
Rates: $119-$129
(512) 445-5050; (800) 225-5466

HYATT REGENCY
208 Barton Springs (78704)
Rates: $109-$239
(512) 477-1234; (800) 233-1234

LA QUINTA INN-BEN WHITE
4200 I-35 S (78745)
Rates: $65-$86
(512) 443-1774; (800) 687-6667

LA QUINTA INN-CAPITOL
300 E 11th St (78701)
Rates: $90-$130
(512) 476-1166; (800) 687-6667

LA QUINTA INN-HIGHLAND MALL/AIRPORT
5812 I-35 N (78751)
Rates: $65-$86
(512) 459-4381; (800) 687-6667

LA QUINTA INN-NORTH
7100 I-35 N (78752)
Rates: $65-$86
(512) 452-9401; (800) 687-6667

Hotel Pet Policies May Be Subject To Change

LA QUINTA INN-OLTORF
1603 E Oltorf Blvd (78741)
Rates: $65-$86
(512) 447-6661; (800) 687-6667

LA QUINTA INN & SUITES
11901 N Mo-Pac Blvd (78759)
Rates: $76-$120
(512) 832-2121; (800) 687-6667

LA QUINTA INN & SUITES-AIRPORT
7625 E Ben White Blvd (78704)
Rates: $70-$100
(512) 386-6800; (800) 687-6667

LA QUINTA INN SOUTH WEST
4424 S Loop 1 (78735)
Rates: $110-$140
(512) 899-3000; (800) 687-6667

LAKE AUSTIN SPA RESORT
1705 Quinlan Park Rd (78732)
Rates: $295-$450
(512) 266-2444; (800) 847-5637

LAKEWAY INN CONFERENCE RESORT
101 Lakeway Dr (78734)
Rates: $99-$250
(800) LAKEWAY

THE MANSION AT JUDGE'S HILL
1900 Rio Grande (78705)
Rates: $99-$295
(512) 495-1800; (800) 311-1619

MARRIOTT HOTEL AT THE CAPITOL
701 E 11th St (78701)
Rates: $129-$199
(512) 478-1111; (800) 228-9290

MOTEL 6 CENTRAL NORTH
8010 I-35 N (78753)
Rates: $37-$51
(512) 837-9890; (800) 466-8356

MOTEL 6 CENTRAL SOUTH
5330 I-35 N(78751)
Rates: $37-$55
(512) 467-9111; (800) 466-8356

MOTEL 6-NORTH
9420 I-35 N (78753)
Rates: $35-$56
(512) 339-6161; (800) 466-8356

MOTEL 6 SOUTH AIRPORT
2707 Interregional Hwy S (78741)
Rates: $42-$58
(512) 444-5882; (800) 466-8356

NORTHPARK EXECUTIVE SUITE HOTEL
7685 Northcross Dr (78757)
Rates: $75-$129
(512) 452-9391

OMNI AUSTIN HOTEL & SUITES
700 San Jacinto Blvd (78701)
Rates: $139-$379
(512) 476-3700; (800) 843-6664

OMNI AUSTIN HOTEL SOUTHPARK
4140 Governor's Row (78744)
Rates: $179
(512) 448-2222; (800) 843-6664

RAMADA INN SOUTH
1212 W Ben White Blvd (78704)
Rates: $75-$95
(512) 447-0151; (800) 272-6232

RAMADA LIMITED NORTH
9121 N I-35 (78753)
Rates: $45-$99
(512) 836-0079; (800) 272-6232

RED LION HOTEL AIRPORT
6121 I-35 N (78752)
Rates: $69-$99
(512) 323-5466; (800) 733-5466

RED ROOF INN NORTH
8210 N I-35 (78753)
Rates: $34-$54
(512) 835-2200; (800) 843-7663

RED ROOF INN SOUTH
4701 S I-35 (78744)
Rates: $39-$59
(512) 448-0091; (800) 843-7663

Locate Other Dog-Friendly Activities...Check Nearby Cities

RENAISSANCE AUSTIN HOTEL
9721 Arboretum Blvd (78759)
Rates: $179-$199
(512) 343-2626; (800) 468-3571

RESIDENCE INN BY MARRIOTT-ARBORETUM
3713 Tudor Blvd (78759)
Rates: $89-$199
(512) 502-8200; (800) 331-3131

RESIDENCE INN BY MARRIOTT NORTH
12401 N Lamar Blvd (78753)
Rates: $119-$169
(512) 977-0544; (800) 331-3131

RESIDENCE INN BY MARRIOTT SOUTH
4537 S I-35 (78744)
Rates: $119-$159
(512) 912-1100; (800) 331-3131

STAYBRIDGE SUITES HOTEL
10201 Stonelake Blvd (78759)
Rates: $69-$161
(512) 349-0888; (800) 238-8000

STUDIO 6-MIDTOWN
937 Camino La Costa (78752)
Rates: $43-$61
(512) 458-5453; (888) 897-0202

STUDIO 6 NORTHWEST
11901 Pavillion Blvd (78759)
Rates: $43-$60
(888) 897-0202

SUPER 8 MOTEL
6000 Middle Fiskville Rd (78752)
Rates: $40-$74
(512) 467-8163; (800) 800-8000

SUPER 8 MOTEL CENTRAL
1201 N I-35 (78702)
Rates: $55-$89
(512) 472-8331; (800) 800-8000

SUPER 8 MOTEL NORTH
8128 N I-35 (78753)
Rates: $45-$77
(512) 339-1300; (800) 800-8000

TRAVELODGE
8300 N I-35 (78753)
Rates: $39-$89
(512) 835-5050; (800) 578-7878

WALNUT FOREST MOTEL
11506 I-35 N (78753)
Rates: $26-$35
(512) 835-0864

WELLESLEY INN & SUITES-MOPAC
2700 Gracy Farms Ln (78758
Rates: $65-$75
(512) 833-0898; (800) 444-8888

WELLESLEY INN & SUITES-NORTH
8221 N I-35 (78753)
Rates: $62
(512) 339-6005; (800) 444-8888

WELLESLEY INN & SUITES-NW
12424 Research Blvd (78759)
Rates: $63-$72
(512) 219-6500; (800) 444-8888

WELLESLEY INN & SUITES-TOWN LAKE
1001 S I-35 (78744)
Rates: $75-$115
(512) 326-0100; (800) 444-8888

RECREATION

ARKANSAS BEND PARK - Leashes

Info: When you and the dawgus are craving serenity, plan an afternoon in this tranquil 323-acre park. Located on the north shore of Lake Travis, this region is a striking mix of bluffs and a gently sloping, rocky waterfront. Make tracks with your happy

trail sniffer, enjoy a shaded blufftop picnic or try your fly at fishing. For more information: (512) 854-9020 or (512) 854-7275.

Directions: From Austin, take Highway 183 north to FM 1431 and turn left (west). Take FM 1431 to Lohman's Ford Road and bear left at fork to the park entrance.

BALCONES DISTRICT PARK - Leashes

Info: Spend a pleasant afternoon with your pooch in this pretty park where you can get your daily dose on over 3 miles of paw-friendly pathways. For more information: (512) 974-6700.

Directions: Located at 12017 Amherst Drive.

BARTON CREEK GREENBELT HIKE - Leashes

Beginner/1.0 - 15.0 miles

Info: Ever wonder what your dog is dreaming about when his paws start twitching and his legs start kicking? Maybe he's thinking about frolicking through a forest of lush, leafy trees full of songbirds and shade. That's what you'll find when you venture out to Barton Creek. Make your doggie's dream come true with a day of play and exercise in this pretty green oasis. This is a popular trail - be prepared to meet and greet. For more information: (512) 472-4914 or (512) 472-1267.

Directions: From Loop 360, head west on Scottish Woods Trail to the north trailhead of Barton Creek Greenbelt.

BATTY BRIDGE (AKA CONGRESS AVENUE BRIDGE) - Leashes

Info: Put aside the misconceived notion that bats are ominous critters, pack the pooch, point your snout toward Batty Bridge and get set for an unforgettable experience. From mid-March through early November, nearly 1.5 million Mexican free-tail bats stake claim to the underside of the bridge, creating a home for the largest urban bat colony in North America. Come sunset, these hungry little mammals blanket the sky in search of dinner (in bat circles, it's called insecticide). Join the

other onlookers for an incredible, must-see sight. For more information: (512) 478-0098.

Directions: Located at the Congress Avenue Bridge which spans Town Lake.

BLUNN CREEK GREENBELT HIKE - Leashes

Beginner/1.4 miles

Info: Set tails a-wagging with a visit to this beautiful parkland. Pack a biscuit basket and spend the day in Little Stacy Park, or meander along the grounds until you reach Big Stacy Park. If you're in the mood to walk further, lengthen your hike by crossing Riverside Drive and heading toward Town Lake. For more information: (512) 974-6700; www.ci.austin.tx.us.

Directions: From the intersection of Live Oak Street and East Side Drive, head east on Live Oak. Parking for Stacy Park and the trail is located on the north side of Live Oak Street.

BOGGY CREEK GREENBELT HIKE - Leashes

Beginner/2.4 miles

Info: This is a perfect hike for the padded of paw. The concrete and gravel trail leads through a stunning riparian area dotted with trees and shrubbery, the ideal locale to wet those tootsies while enjoying the soothing serenade of songbirds. For more information: (512) 974-6700; www.ci.austin.tx.us.

Directions: From the intersection of East 12th Street and Pleasant Valley Road, head east on East 12th for about .25 miles until you reach the parking area on the north side of the road.

BREMOND BLOCK HISTORIC WALKING TOUR - Leashes

Beginner/0.5 miles

Info: While this walking tour may be short on distance, it's long on history. You and the city licker will stroll from the Governor's Mansion to the Tribune Building, Travis County

Courthouse to Woolridge Park and the Moonlight Tower to the Austin Public Library before reaching your destination - the Bremond Block Historic District. This district provides the opportunity of touring a block of homes that were once occupied by members of a single family, the Bremonds. Talk about close knit. Stop by the Visitor Information Center for a trail guide/map, complete with site descriptions and trail directions. For more information: (512) 478-0098.

Directions: The tour begins in front of the Governor's Mansion at 1010 Colorado Street.

BULL CREEK DISTRICT PARK AND GREENBELT - Leashes

Info: Amidst greenery and woodlands, you and the pupster can get your Texercise on over 3 miles of trails. For more information: (512) 974-6700.

Directions: Located at 6701 Lakewood Drive.

BULL CREEK PARKWAY - Leashes

Info: Get the kinks out on the one-mile trail in this greenbelt.

Directions: Located at Bull Creek and Old Spicewood Springs Road.

BUTTERMILK BRANCH GREENBELT - Leashes

Info: Chill out with your four-footed friend in this lovely stretch of greenery or follow Ol' Four Paws along the .5-mile pathway. For more information: (512) 974-6700.

Directions: Located at 7500 Meador Avenue.

COMMONS FORD METROPOLITAN PARK - Leashes

Info: Pack your tackle and try your fly on the fish or romp through 215 acres of open space in this urban park.

Directions: Located at 614 Commons Ford Road North.

Locate Other Dog-Friendly Activities...Check Nearby Cities

CONGRESS AVENUE & E. 6TH STREET
HISTORIC WALKING TOUR - Leashes

Beginner/2.5 miles

Info: Lace up your tennies, grab Fido's leash and head out on this walking tour through the heart (Congress Avenue) and soul (6th Street) of Austin. While the yesteryear aura surrounding Congress Avenue lures history buffs, 6th Street's international reputation as the Live Music Capital of the World attracts music mutts by the score. But no matter what course you travel, the historic sites are worthy of two paws up. Stop by the Visitor Information Center for a trail guide/map, complete with site descriptions and trail directions. For more information: (512) 478-0098.

Directions: The tour begins at the south entrance of the State Capitol.

CYPRESS CREEK PARK - Leashes

Info: Popular with boaters, anglers and picnickers, this small is located on a slightly sloping waterfront and offers access to the favored basin area of Lake Travis. For more information: (512) 854-9020 or (512) 854-7275.

Directions: From Austin, take Highway 183 to FM 620 and turn left. Follow to FM 2769 and make a right into the park's entrance.

Note: Entrance fees vary.

DICK NICHOLS DISTRICT PARK - Leashes

Info: Social breeds will wag about this action-packed park. Ball fields, BBQ pits and a one-mile walkway offer plenty of inviting pupportunities.

Directions: Located at 5011 Beckett Road.

Hotel Pet Policies May Be Subject To Change

DOVE SPRINGS PARK - Leashes

Info: Plan a day of fun in the sun and make tracks along the .5-mile walkway. Tote a brown bagger and do lunch with your pup.

Directions: Located at 5801 Ainez Drive.

DUNCAN PARK - Leashes

Info: This park is just the place to kick back and catch some rays.

Directions: Located at 900 West 9th Street.

EMMA LONG METROPOLITAN PARK - Leashes

Info: Over 1,100 acres of land and lake await eager paws and poles. Whether you hit the trails or simply laze lakeside on the rolling banks of Lake Austin, you're sure to find some fun in the sun at this popular park more commonly known as "City Park." For more information: (512) 974-6700 or visit their website at www.ci.austin.tx.us.

Directions: Located at 200 S. Lamar Boulevard.

HYDE PARK HISTORIC DRIVING TOUR

Info: Buckle up and take a drive back in time to the days of Queen Anne and bungalow-style homes. Hyde Park is a century-old neighborhood that was a vision and reality of Monroe Martin Shipe, an entrepreneur who relocated to Austin from Abilene, Kansas. In addition to the homes, the landscape is reminiscent of Hyde Park's floral heyday - cottage gardens ablaze with morning glories, daisies, zinnias and lamb's ears, while towering oaks shade the streets. Stop by the Visitor Information Center for a trail guide/map, complete with site descriptions and trail directions. For more information: (512) 478-0098.

Directions: The tour begins at the northeast corner of Avenue F and East 39th Street, just north of downtown and the University of Texas.

J.J. SEABROOK GREENBELT - Leashes

Info: Pamper your pooch with a promenade through greenery and scenery in this pretty area. For more information: (512) 974-6700.

Directions: Located at 2000 Pershing.

JOHNSON CREEK GREENBELT HIKE - Leashes

Beginner/2.2 miles

Info: Even sofa loafers will love this concrete pathway which leads through a gorgeous green scene ending at Town Lake. For more information: (512) 974-6700.

Directions: Located at the intersection of Enfield Road and Winstead.

KENDRA PAGE PARK - Leashes

Info: For your daily dose, do a couple of turns on the .25-mile trail in this small park.

Directions: Located at 2203 Blue Meadow Drive.

LAKE WALTER E. LONG METROPOLITAN PARK - Leashes

Info: Every dog should have his day - make yours great with an afternoon at the lake. This 3,800-acre park offers boat ramps and shoreline fishing for water-loving pups. Landlubbers can lollygag through vast open and shaded areas or birdwatch from a secluded blanket spot. You're sure to find plenty of pleasure-filled opportunities in this beautiful parkland. For more information: (512) 974-6700.

Directions: Located at 6614 Blue Bluff Road.

Hotel Pet Policies May Be Subject To Change

LONGVIEW PARK - Leashes

Info: Perk up the pup with a quick jaunt to this city park. If yours is a ballmeister, stash a tennie in your backpack and surprise the mutt.

Directions: Located at 7609 Longview Road.

MANSFIELD DAM PARK - Leashes

Info: Popular with waterdogs, this 71-acre park is one of the main boat ramp access points on Lake Travis. Snout out Mansfield Dam or picnic with the pooch and soak up some scenery and sun. For more information: (512) 854-9020 or (512) 854-7275.

Directions: From Austin, head west on Highway 290 to FM 71 and turn right. Follow to FM 620 and turn right to the park.

Note: Entrance fees vary.

MARY MOORE SEARIGHT METRO PARK HIKE - Leashes
Beginner/2.0 miles

Info: Tails will be wagging as you and furface traipse over two miles of lush landscape on a trail that circles the Metro Park. For more information: (512) 971-6700.

Directions: Located on David Moore Road approximately 10 miles south of Highway 290.

MARY QUINLAN PARK - Leashes

Info: Repose riverside in this pretty 5.8-acre park. For more information: (512) 854-9020 or (512) 854-7275.

Directions: From Austin, head west on Highway 290 to FM 2222 and follow to FM 620. Turn left to Quinlan Park Road and veer right at the fork to the park entrance.

MCKINNEY FALLS STATE PARK - Leashes

Info: This park offers city weary souls a chance to enjoy some peace and quiet. Several trails honeycomb the area, each leading to a different sight. Tracker can sniff out two waterfalls, an Indian rock shelter or the ruins of an old homestead. In springtime, you'll be dazzled by the wildflowers that line the pathways and brighten the landscape. For more information: (512) 243-1643 or (800) 792-1112; www.tpwd.state.tx.us.

Directions: From the intersection of Highways 71 & 183 in southeast Austin, head south on Highway 183. Make a right on Burleson Road (the second light) to McKinney Falls Parkway and turn left to the park entrance on the right.

Note: $2 entrance fee/person.

The numbered hikes that follow are within McKinney Falls State Park:

1) HOMESTEAD TRAIL HIKE - Leashes

Intermediate/3.7 miles

Info: Your wet and slippery adventure to reach the trailhead begins by crossing Onion Creek. The remaining portion of the unpaved trail will also test your endurance. History buffs and mutts will find this trek interesting - it leads to the "McKinney Homestead." The house was constructed in the 1840s by Thomas F. McKinney, one of the first 300 colonists to settle in Austin, Texas. Although not a part of the Homestead Trail, a well-worn side path leads to Lower McKinney Falls and the creek, a nice spot for some R&R. For more information: (512) 243-1643.

Directions: From Austin, head south on Highway 183 past Highway 290 and Highway 71. Watch for a brown state park sign on the right for McKinney Falls Parkway. McKinney Falls is approximately 3.0 miles from the turn. Park at the waypoint marked "Trailhead."

2) MCKINNEY FALLS HIKE AND BIKE TRAIL - Leashes

Beginner/3.0 miles

Info: A five-star nature excursion awaits you and furface on this paved, looping trail. As you hike through dense woodlands, you'll play hide and seek with Onion Creek. If yours is a hot diggety dog, take a dip in one of the creek's refreshing pools. But if he's a sniffmeister, plan a spring hike when the wildflowers are in full bloom. Don't forget your camera, there are two cascading waterfalls that are pawsitively photo worthy. For more information: (512) 243-1643.

Directions: From the intersection of Highways 71 & 183 in southeast Austin, head south on Highway 183. Make a right on Burleson Road (the second light) to McKinney Falls Parkway and turn left to the park entrance on the right.

3) SMITH ROCKSHELTER TRAIL HIKE - Leashes

Beginner/0.75 miles

Info: If your pooch is a history hound at heart, he'll flip over this cinchy hike to an Indian rock shelter. Along the way, you'll pass limestone overhangs that provide a cool respite from the sun, especially during the dog days of summer. For a quickie education on the area's flora, pick up the guide that corresponds with the trail's interpretive posts. For more information: (512) 243-1643.

Directions: From the intersection of Highways 71 & 183 in southeast Austin, head south on Highway 183. Make a right on Burleson Road (the second light) to McKinney Falls Parkway and turn left to the park entrance on the right.

MOUNT BONNELL TRAIL HIKE - Leashes

Info: For a bird's-eye view of Lake Austin and the surrounding Hill Country, head for Austin's oldest tourist attraction - Mount Bonnell. Be prepared for a bit of a workout. The 106-step climb to the top is challenging, but the views from your lofty perch are simply incredible and definitely worth the effort. For more information: (512) 478-0098.

Locate Other Dog-Friendly Activities...Check Nearby Cities

Directions: Located at 3800 Mount Bonnell Road, approximately one mile past West 35th Street.

PACE BEND PARK

Info: This lovely, 1,300-acre expanse is an excellent choice for boaters, hikers, anglers and nature lovers. Frisky can frolic with leashless abandon through rugged, wild terrain or you can fulfill your exercise quotient as you explore over nine miles of shoreline scenery. Hiking trails lead uphill to fabulous viewing vistas, so pack some snacks and plan to stay awhile. For more information: (512) 854-9020 or (512) 854-7275.

Directions: From Austin, take Ben White Boulevard (Highway 290) to Highway 71 and head northeast to FM 2322. Turn right to the park entrance. The park is about 45 minutes from downtown Austin.

Note: Voice control obedience mandatory. Entrance fees vary.

RICHARD MOYA PARK - Leashes

Info: An even 100 acres of fun and romping room can belong to you and the lickmeister in this large park. Take to the trail or chill out and partake of a brown bag lunch. For more information: (512) 854-9020 or (512) 854-7275.

Directions: Located off Burleson Road about two miles west of Highway 183.

SANDY CREEK PARK - Leashes

Info: Quieter breeds will love this 25-acre picturesque parkland. Meander along wooded bluff and shoreline pathways and scope out the locally rare bird and plant species. Stunning views of Lake Travis and tons of tranquility are yours for the taking. For more information: (512) 854-9020 or (512) 854-7275.

Directions: From Austin, take Highway 183 north to FM 1431 and turn left. Follow to Lime Creek Road and turn left to reach the park entrance.

Hotel Pet Policies May Be Subject To Change

SCHROEDER PARK - Leashes

Info: Sunday strollers can do a turn or two along the one-mile pathway in this city park.

Directions: Located at 11701 Big Trail.

SHOAL CREEK GREENBELT HIKE - Leashes

Beginner/6.0 miles

Info: You and your pal can spend a day traipsing along this trail through a lush landscape, complete with several scenic picnic spots. Start your trek from Town Lake or make your way to the water from the trailhead on 31st Street. For more information: (512) 974-6700; www.ci.austin.tx.us.

Directions: From Town Lake, travel north on North Lamar Boulevard to 31st Street. Take a left on 31st Street and drive to the access point for the trailhead.

SLAUGHTER CREEK METROPOLITAN PARK - Leashes

Info: Home to the Southwest Soccer Complex and the Veloway Bicycle Course, this 546-acre expanse is a perfect place for active breeds seeking open space for their daily dose of Texercise. For more information: (512) 974-6700.

Directions: Located at 507 West Slaughter Lane.

SPRINGFIELD PARK - Leashes

Info: Mosey with Rosie over the one-mile trail that skirts this refreshing green scene. Tote a fishing rod and give it a go.

Directions: Located at 6300 East William Cannon.

TOWN LAKE TRAIL HIKE - Leashes

Beginner/0.8 miles-10.1 miles

Info: Narcissistic pooches can admire their handsome snouts as they gaze into the reflection pond located at the trailhead of

Town Lake and South First Street. But then give that leash a little tug and get going, the trail is brimming with fascinating sights and lovely scenery. Take some time to smell the flowers - over 3,000 blossoming shrubs and trees define the lakeside pathway.

Cross the bridge and investigate the red brick Buford Fire Tower. Dalmatians will perk up those ears when they hear the Memorial Chimes ring. Walk to the west for a Kodak moment from the observation platform in the Jamie Odom Pavilion. Or continue on to Cactus Patch on the north side of Town Lake. You and the pupster can chill at the namesake's bench and study the interesting rock and cactus garden.

Once you reach Lou Neff Point (located where Barton Creek joins Town Lake), unpack the trail treats, kick back and enjoy lunch in the shade of the vine-laden gazebo. Whatever loop you choose, you won't be disappointed. There are points of interest all along this beautiful, shrubbery-studded trail. For more information: (512) 974-6700.

Directions: There are numerous access points and parking lots along the trail. The access point on South 1st Street is located just north of Riverside Drive and the Palmer Auditorium. You can also find the trail and parking from Lamar Boulevard and Mopac Boulevard. On the north bank, park on East Cesar Chavez Street, west of Congress Avenue.

Note: For a free hiking and biking guide of the Town Lake Greenbelt Area, contact: Parks and Recreation Department, 200 South Lamar Boulevard, Austin, TX 78704. Or call: (512) 974-6700.

WALLER CREEK GREENBELT TO TOWN LAKE TRAIL HIKE - Leashes

Beginner/6.0 miles

Info: Amble along a verdant pathway that winds its way along Waller Creek. Pick a creekside spot and enjoy a bit of splish-splashing fun with the dawgus or hightail it all the way to popular Town Lake, where recreation opportunities abound for you and the hound. For more information: (512) 974-6700; www.ci.austin.tx.us.

Hotel Pet Policies May Be Subject To Change

Directions: Trailhead is in Waller Creek Greenbelt, located on Waller Creek at 15th Street.

WALLER CREEK WALKWAY HIKE - Leashes

Beginner/3.2 miles

Info: Make the most of a cool morning and follow Waller Creek as it trickles toward Town Lake. For more information: (512) 974-6700.

Directions: Trailhead is located at 15th and Red River Streets.

WALNUT CREEK METROPOLITAN PARK - Leashes

Info: An active breed's delight, Walnut Creek is teeming with activity. Hike and bike trails skirt the shimmering creek while several grassy softball fields offer lots of romping room for puppy playtime.

Directions: Located at 12138 North Lamar.

WATERLOO PARK - Leashes

Info: Have a lark with your bark in this sun-splashed park. Leave some pawprints behind on the .75-mile trail.

Directions: Located at 403 East 15th Street.

WEBBERVILLE PARK

Info: Hound heaven, this 135-acre park allows leash-free canines to explore wooded hillsides and shoreline scenery. Perfect for exercise and puppy prancing, you'll want to include a fuzzy tennie or a chewed-up frisbee. This park is also home to a fishing hole that's a favorite with families. For a great outdoor experience, you won't regret a moment spent in this fun region. For more information: (512) 854-9020 or (512) 854-7275.

Directions: Located off FM 969 on the banks of the Colorado River at the Bastrop County Line.

Note: Dogs may be off-leash, but voice control obedience is mandatory.

Locate Other Dog-Friendly Activities...Check Nearby Cities

WINDMILL RUN PARK - Leashes

Info: Change your morning routine and treat the tailwagger to some romping fun or shake a leg along one of the trails in this 16-acre park. If your outing is in the summer, tote plenty of Perrier, this scenic area can be sizzling. For more information: (512) 854-9020 or (512) 854-7275.

Directions: Located at the intersection of Highway 290 and FM 71.

ZILKER PARK/BARTON SPRINGS - Leashes

Info: One visit to this 351-acre urban oasis and you'll under-stand why it's considered "Austin's most loved park." Hike and bike along a myriad of trails that honeycomb the park grounds. From rugby fields to botanical gardens, the greenery goes on forever. Keep a snout out for the open-air choo choo that chugs over the land. For leashless abandon, head to the soccer field area between Barton Springs Road, Stratford and Lou Neff Drives and do the fetch thing. Carpe diem Duke. For more information: (512) 476-9044.

Directions: Located at 2100 Barton Springs Road.

Note: Parking fee charged on weekends.

Several leash-free areas within Austin city limits are listed below:

• Auditorium Shores, from South First to Bouldin Avenue

• Bull Creek District Park, behind restrooms, extending 100 yards to the creek

• Emma Long Metro Park between City Park Drive, the west park boundary fence, Turkey Creek and the top ridge of the bluffline overlooking Lake Austin

• Far West Boulevard right of way between Great Northern and Shoal Creek Boulevards

• Northeast District Park between Crystal Brook Drive, the railroad right of way and Decker Lake Road

Hotel Pet Policies May Be Subject To Change

- Norwood Estate, IH-35 at Riverside Drive

- Onion Creek District Park, 6900 Onion Creek Drive

- Red Bud Isle, 3401 Red Bud Trail

- Shoal Creek Greenbelt between 24th and 29th Streets

- Surplus Airport Property between Old Manor Road, Manor Road, Lovell Drive and the airport fence

- Walnut Creek District Park between Cedar Bend Drive, Walnut Creek and the east and west park fences

- Zilker Park soccer field area, between Barton Springs Road, Stratford and Lou Neff Drives

AUSTWELL

RECREATION

ARANSAS NATIONAL WILDLIFE REFUGE - Leashes

Info: If wildlife viewing is your passion, this is your place. A 55,000-acre refuge, it's filled with birds, reptiles and mammals including 12 endangered species, 397 species of birds and more than 80 mammalian species. From saltwater marshes to freshwater ponds, sand dunes to prairie grasslands, oak-wooded mottes to marine bays, the diversity of habitats supports a plentitude of wildlife. But perhaps the refuge's most famous resident is the endangered whooping crane, the largest North American bird. For a glimpse of this rare creature, visit the refuge between late October and mid-April before these elegant birds begin their migration to their summer home in Alberta, Canada. If you're short on time but long on desire, see the refuge by car - a 16-mile paved road runs throughout the region. For a more adventurous experience, you and the dawgus can explore on foot via one of the walking trails that lace the refuge. Stop by the visitor's center for a trail map. Remember, keep Fido on a short leash - over 250 American alligators reside in the lakes, rivers, marshes and sloughs of the area. For more information: (361) 286-3559.

Locate Other Dog-Friendly Activities...Check Nearby Cities

Directions: From Austwell, head east on Highway 239 to FM 774. Follow FM 774 to FM 2040. Follow FM 2040 southeast to the refuge entrance.

Note: Entrance fee schedule: $3 for individuals or $5 for two or more people per vehicle.

The numbered hikes that follow are within Aransas National Wildlife Refuge:

1) BAY OVERLOOK TRAIL HIKE - Leashes

Beginner/0.2 miles

Info: Incredible bay views greet you on this short trail. Break some bread and biscuits with Bowser at the overlook's picnic nook while you ogle pretty San Antonio Bay. For more information: (361) 286-3559.

Directions: From the entrance, follow the 16-mile paved tour road a couple miles to the signed trailhead.

2) HERON FLATS TRAIL HIKE - Leashes

Beginner/1.4 miles

Info: This simple looping trail is the refuge's most pupular. Bird lovers, don't forget your binocs. The Heron Flats Trail offers some of the area's best birding opportunities. For more information: (361) 286-3559.

Directions: From the entrance, follow the 16-mile paved tour road for a couple miles to the signed trailhead.

Hotel Pet Policies May Be Subject To Change

BAIRD

Lodging

BAIRD MOTOR INN
500 I-20 E (79504
Rates: $40-$55
(325) 854-2527

BALLINGER

Lodging

BALLINGER CLASSIC MOTEL
1005 Hutchins (76821)
Rates: $34-$40
(325) 365-5717

DESERT INN MOTEL
Hwy 67 W (76821)
Rates: $28-$40
(325) 365-2518

STONEWALL MOTEL
201 N Broadway (76821)
Rates: $26-$36
(325) 365-3524

BALMORHEA

Recreation

BALMORHEA STATE PARK - Leashes

Info: Promenade to the pond or try to catch some wildlife on film when you visit this pleasant 45.9-acre park. Picnic with your pal and just enjoy the outdoors together. Don't be tempted by the spring-fed pool, pooches aren't allowed. For more information: (432) 375-2370; (800) 792-1112; or visit their website at www.tpwd.state.tx.us.

Directions: The park is 4 miles west of Balmorhea on Highway 290, just 200 yards east of State Highway 17 and Highway 290 intersection.

Note: $3 entrance fee/person.

Locate Other Dog-Friendly Activities...Check Nearby Cities

BANDERA

LODGING

BACKROADS RESERVATIONS
1107 Cedar St (78003)
Rates: $85-$175
(866) 796-0660

BANDERA LODGE MOTEL
700 Hwy 16S (78003)
Rates: $55-$90
(830) 796-3093; (800) 796-3514

COOL WATER ACRES B&B
3301 FM 470 (78003)
Rates: $70-$90
(830) 796-4866

MANSION AT BANDERA B&B
1007 Hackberry St (78003)
Rates: $60-$155
(830) 796-4590

RIVER FRONT MOTEL
1004 Maple (78003)
Rates: $59-$74
(830) 460-3690; (800) 870-5671

RIVER OAK INN & RESTAURANT
1203 Main St (78003)
Rates: $39-$109
(830) 796-7751

RECREATION

BANDERA PARK - Leashes

Info: Jumpstart your day with a riverside romp at this 77-acre parkland. Try your fly in the river or simply vege out in the shade of cypress trees as you listen to the river rolling and tumbling toward the Gulf of Mexico. Songbirds will be singing and the mutt's tail will be wagging as you loll the day away in this unique urban area.

Directions: Located one block south of the intersection of Highway 173 and Highway 16.

HILL COUNTRY STATE NATURAL AREA - Leashes

Info: Renown for rolling countrysides and colorful grasslands, Hill Country is a scenery sniffer's dream come true. This 5,400-acre expanse exemplifies the beauty of the region. Rocky hills, cold springs, oak groves and canyons combine to create a spectacular backdrop for hiking hounds. Over 34 miles of trails honeycomb the park and provide amazing opportunities for solitude and serenity. The park is primitive, so plan accordingly and be sure to tote enough water for you and the pooch. Leave only footprints and take only memories. For more information: (830) 796-4413; (800) 792-1112; www.tpwd. state.tx.us.

Hotel Pet Policies May Be Subject To Change

Directions: From Bandera, head south on Highway 173 for 1.0 mile to Ranch Road 1077 and turn right for 10 miles to park entrance.

Note: $3 entrance fee/person.

MEDINA LAKE PARK - Leashes

Info: You won't find a lot of shade here, but the lake beckons sun-drenched dogs to jump in and cool off. You and furface can relax lakeside and nibble on some kibble after a bit of splish-splashing fun. For more information: (830) 796-3045.

Directions: From Bandera, drive south on Highway 16 for 9 miles to Pipe Creek. When you reach Pipe Creek, turn onto 1283 and drive to PR37. Turn right on PR37 and follow signs for Medina Lake.

ROADSIDE PARK # 1

Info: Located on the banks of a rolling river, this park offers water dogs a chance to dogpaddle the day away. Picnic tables with grills are provided - so don't forget to pack a snack.

Directions: Located 6 miles north of Bandera on Highway 16.

Note: Be aware of water levels. Plan a safe entry and exit path into the river before swimming.

ROADSIDE PARK # 2

Info: Retrievers will love the chance to chill out in the river as they playfully chase a stick or ball. A great place to stop for some leg-stretching and paw-dipping.

Directions: From Bandera, head north on Highway 16 for 5 miles until you reach Highway 470. Head west on 470 for .25 miles to the park.

Note: Be aware of water levels. Plan a safe entry and exit path into the river before swimming.

Locate Other Dog-Friendly Activities...Check Nearby Cities

BANQUETE

RECREATION

SABLATURA PARK - Leashes

Info: Popular with picnicking pooches, this 20-acre park offers BBQ spots and plenty of open space. Dogs are not permitted in the small domestic zoo area.

Directions: Located one mile west of Banquete off Highway 44.

BASTROP

LODGING

DAYS INN
4102 Hwy 71 E (78602)
Rates: $50-$95
(512) 321-1157; (800) 329-7466

PECAN STREET INN B&B
1010 Pecan St (78602)
Rates: $75-$135
(512) 321-3315

HOLIDAY INN EXPRESS HOTEL & SUITES
491 Agnes St (78602)
Rates: $71-$80
(512) 321-1900; (800) 465-4329

SCHAEFFER HOUSE B&B
608 Pecan St (78602)
Rates: $65-$100
(512) 303-2734

RECREATION

BASTROP STATE PARK - Leashes

Info: Savor the shade and find splendor in the grass in this lovely 3,500-acre park. You and the pupster can birdwatch from the banks of the 10-acre lake or drop in on the fish for dinner. Active breeds can make tracks on pine-scented trails and maybe catch a glimpse of some wildlife. For more information: (512) 321-2101; (800) 792-1112; www.tpwd.state.tx.us.

Directions: From Bastrop, take Highway 21 east for one mile to the park entrance.

Note: Dogs are prohibited in cabin area.

The numbered hike that follows is within Bastrop State Park:

1) LOST PINES TRAIL HIKE - Leashes

Intermediate/8.5 miles

Info: Come and explore the beautiful Lost Pines of Texas while you get an aerobic workout on this lengthy looping trail. As you and the dogster trek through Texas' most westerly pine and oak woodland, you'll happen upon a pond, definitely a refreshing treat, especially during those dog days of summer. Go ahead, dip a paw or two and enjoy some splish-splashing antics. The trail is marked with aluminum rectangles that are nailed to the trees to keep you on track. Pack plenty of trail treats, Scooby snacks and agua fria - you'll need them. For more information: (512) 321-2101.

Directions: From Bastrop, take Highway 21 east for one mile to the park entrance. Once in the park, take Park Road 1A to the marked trailhead.

BAY CITY

LODGING

BAY CITY INN & SUITES
101 W 7th St (77414)
Rates: $32-$79
(979) 245-0985

ECONO LODGE
3712 7th St (77414)
Rates: $49-$99
(979) 245-5115; (800) 553-2666

BAYTOWN

LODGING

BAYMONT INN & SUITES
5215 I-10 E (77521)
Rates: $54-$74
(281) 421-7300; (877) 229-6668

HOLIDAY INN EXPRESS
5222 I-10 E (77521)
Rates: $79-$89
(281) 421-7200; (800) 465-4329

LA QUINTA INN
4911 I-10 E (77521)
Rates: $60-$82
(281) 421-5566; (800) 687-6667

MOTEL 6
8911 Hwy 146 (77520)
Rates: $37-$55
(281) 576-5777; (800) 466-8356

QUALITY INN
300 S Hwy 146 (77520)
Rates: $49-$104
(281) 427-7481; (800) 228-5151

BEAUMONT

LODGING

BEST WESTERN BEAUMONT INN
2155 N 11th St (77703)
Rates: $53-$59
(409) 898-8150; (800) 528-1234

BEST WESTERN JEFFERSON INN
1610 I-10 S (77707)
Rates: $50-$62
(409) 842-0037; (800) 528-1234

GRAND DUERR MANOR B&B
2298 McFaddin at 7th (77701)
Rates: $99-$159
(409) 833-9600

HILTON HOTEL
2355 I-10 S (77705)
Rates: $79-$109
(409) 842-3600; (800) 445-8667

HOLIDAY INN ATRIUM PLAZA
3950 I-10 S (77705)
Rates: $89-$99
(409) 842-5995; (800) 465-4329

HOLIDAY INN MIDTOWN
2095 N 11th St (77703)
Rates: $100-$109
(409) 892-2222; (800) 465-4329

J & J MOTEL
6675 Eastex Frwy (77705)
Rates: $24+
(409) 892-4241

LA QUINTA INN
220 I-10 N (77702)
Rates: $63-$82
(409) 838-9991; (800) 687-6667

RAMADA LIMITED
4085 I-10 South (77705)
Rates: $49-$67
(409) 842-1111; (800) 272-6232

SUPER 8 MOTEL
2850 I-10 E (77703)
Rates: $41-$48
(409) 899-3040; (800) 800-8000

Hotel Pet Policies May Be Subject To Change

RECREATION

RIVERFRONT PARK - Leashes

Info: Pamper your pooch with a riverside picnic. Or take a stroll and be serenaded by songbirds and the sound of rushing water.

Directions: Located at 800 Main Street.

SPINDLETOP/GLADYS CITY BOOMTOWN - Leashes

Info: History hounds, this place has your name on it. Complete with clapboard buildings and wooden oil derricks, Spindletop/Gladys City is a boomtown replica reminiscent of petroleum's heyday and is dedicated to the world's first oil boomtown. Check out the monument to the gusher that literally blew the town's hidden oil treasure sky high - Lucas Gusher. For more information: (409) 835-0823.

Directions: From Beaumont, take I-10 west for 2 miles to US 69/96/287. Head south for 3 miles to University Drive. Boomtown is located at the intersection of US 69/96/287 and University Drive.

Note: $2.50/adult & $1.25/child entrance fee. Hours: Tuesday through Sunday from 1 pm to 5 pm.

TIMBER RIDGE TOURS

Info: Puppy paradise could be another name for this wet and wild canoeing adventure through the waterways of the Big Thicket. Make a weekend of it by calling ahead and reserving Timber Ridge's dog-friendly country cottage. Happy wet tails and paws to you. For canoe/cottage reservations and price information call: (409) 246-3107 or (800) 814-7390; www.texas-canoetrips.com.

Directions: From Beaumont, exit Highway 69 north to Lufkin. Travel 10 miles to Highway 96 north exit to Lumberton. Continue 5 miles to Business Highway 96 north to Silsbee, then 2 miles to Eastex Canoe Trails on the left at Turtle Creek

Locate Other Dog-Friendly Activities...Check Nearby Cities

Road, 1/2 mile south of Silsbee. Eastex Canoe Trail address is 1698 Hwy 96 South, Silsbee, TX 77656.

VILLAGE CREEK STATE PARK - Leashes

Info: This delightful park offers a little something for everyone. Paddle your pedigree along the tranquil waters of Village Creek and plan a stop at a sandbar for a leg-stretching jaunt or a brown bag lunch. If you'd rather be a landlubber, you can wander through the dense bottom forest of river birch, sweet gum, pine and sycamore. Birders will undoubtedly see some unusual species. Wildlife watchers might catch sight of a white-tailed deer, mink or even a gator. Anglers could get lucky and bring home catfish, large-mouth bass, perch or crappie. Happy tails to you and the dogster no matter which adventure you choose. For more information: (409) 755-7322; (800) 792-1112; www.tpwd.state.tx.us.

Directions: From Beaumont, take Highway 69 north to the Mitchell Road exit. Turn right on Mitchell Road, then an immediate left onto Village Creek Parkway/FM3573. Follow Village Creek Parkway/FM3573 approximately 2 miles to Alma Drive. Turn right on Alma Drive, cross over the railroad tracks, veer left, go .2 miles and veer left again to the park gate.

Note: Entrance fee charged.

The numbered hikes that follow are within Village Creek State Park:

1) TUPELO TRAIL HIKE - Leashes

Beginner/0.6 miles

Info: Where scenery's concerned, this short, looping trail gets two paws up. So pack your camera and plenty of Fuji. This trail is only accessible via the Village Creek Trail. For more information: (409) 755-7322.

Directions: From Beaumont, take Highway 69 north to the Mitchell Road exit. Turn right on Mitchell Road, then an immediate left onto Village Creek Parkway/FM3573. Follow Village

Hotel Pet Policies May Be Subject To Change

Creek Parkway/FM3573 approximately 2 miles to Alma Drive. Turn right on Alma Drive, cross over the railroad tracks, veer left, go .2 miles and veer left again to the park gate.

2) VILLAGE CREEK TRAIL HIKE - Leashes

Intermediate/2.0 miles

Info: Kiss your cares goodbye and say hello to Mother Nature on this pupular trail. You'll have it made in the shade as you hike along the park's namesake Village Creek where paw dipping opportunities greet you at every turn. The trail deadends at a snow white sandbar that doubles as a designated swimming area. Sorry Snoopy, no doggie paddling allowed here. For more information: (409) 755-7322.

Directions: From Beaumont, take Highway 69 north to the Mitchell Road exit. Turn right on Mitchell Road, then an immediate left onto Village Creek Parkway/FM3573. Follow Village Creek Parkway/FM3573 approximately 2 miles to Alma Drive. Turn right on Alma Drive, cross over the railroad tracks, veer left, go .2 miles and veer left again to the park gate.

3) VILLAGE SLOUGH TRAIL HIKE - Leashes

Beginner/1.2 miles

Info: This trail spells easy from the get-go. You and the mutt will strut through a spectacular ecosystem grabbag of hardwood bottomlands and sandhill forests before looping back to your starting point. As an educational bonus, the trail encompasses a self-guided interpretive section. Pick up a trail guide and learn as you sojourn. For more information: (409) 755-7322.

Directions: From Beaumont, take Highway 69 north to the Mitchell Road exit. Turn right on Mitchell Road, then an immediate left onto Village Creek Parkway/FM3573. Follow Village Creek Parkway/FM3573 approximately 2 miles to Alma Drive. Turn right on Alma Drive, cross over the railroad tracks, veer left, go .2 miles and veer left again to the park gate.

4) WATER OAK TRAIL HIKE - Leashes

Beginner/4.6 miles

Info: Dense hardwood bottomlands and beautiful spreading cypress swamps combine to make this a hike you and Old Brown Eyes won't soon forget. Shutterbugs, keep your camera handy. The scenery along the old logging road provides photo ops aplenty. Wildlife enthusiasts - binocs will come in handy for critter sightings. For more information: (409) 755-7322.

Directions: From Beaumont, take Highway 69 north to the Mitchell Road exit. Turn right on Mitchell Road, then an immediate left onto Village Creek Parkway/FM3573. Follow Village Creek Parkway/FM3573 approximately 2 miles to Alma Drive. Turn right on Alma Drive, cross over the railroad tracks, veer left, go .2 miles and veer left again to the park gate.

BEDFORD

LODGING

COMFORT INN & SUITES
2904 Crystal Spgs St (76095)
Rates: $69-$120
(817) 545-2555; (800) 228-5150

LA QUINTA INN
1450 W Airport Frwy (76022)
Rates: $60-$82
(817) 267-5200; (800) 687-6667

HOLIDAY INN AIRPORT WEST
3005 W Airport Frwy (76021)
Rates: $59-$69
(817) 267-3181; (800) 465-4329

SUPER 8 MOTEL
1800 Airport Frwy (76022)
Rates: $50-$55
(817) 545-8108; (800) 800-8000

BEEVILLE

LODGING

BEST WESTERN TEXAN INN
2001 Hwy 59 (78102)
Rates: $65-$95
(361) 358-9999; (800) 528-1234

DAYS INN
400 SE Bypass 181 (78102)
Rates: $49-$54
(361) 358-4000; (800) 329-7466

EL CAMINO MOTEL
1500 N Washington (78102)
Rates: $32-$39
(361) 358-2141

BELLAIRE

RECREATION

PASEO PARK - Leashes

Info: A restored trolley car is the main attraction for anyone with a passion for the olden days. Get a smidgen of knowledge on the half-mile interpretive trail.

Directions: Located in the middle of Bellaire Boulevard.

BELLMEAD

LODGING

MOTEL 6
1509 Hogan Ln (76705)
Rates: $35-$50
(254) 799-4957
(800) 466-8356

BELLVILLE

LODGING

TEXAS RANCH LIFE (DUDE RANCH)
Tottenham Road at Cactus (77418)
Rates: $135-$160
(866) TEXASRL

BELTON

LODGING

BUDGET HOST INN
1520 I-35 S (76513)
Rates: $35-$52
(254) 939-0744; (800) 283-4678

RAMADA LIMITED
1102 E 2nd Ave (76513)
Rates: $51-$72
(254) 939-3745; (800) 272-6232

RIVER FOREST INN
1414 E 6th Ave (76513)
Rates: $40-$75
(254) 939-5711

BENBROOK

LODGING

MOTEL 6
8601 Benbrook Blvd (76126)
Rates: $44-$75
(817) 249-8885; (800) 466-8356

BIG BEND NATIONAL PARK

LODGING

CHISOS MOUNTAINS LODGE
Basin Rural Station (79834)
Rates: $76-$92
(432) 477-2291

Hotel Pet Policies May Be Subject To Change

RECREATION

BIG BEND NATIONAL PARK - Leashes

If you plan on visiting the Big Bend National Park with your pet, please read the following important information which is provided as a service to our readers:

Info: Dogs are not permitted on any trail within the Big Bend National Park and are not allowed outside developed areas. It is recommended you leave pets at home due to the wild animal population and extreme heat. However, if you do travel with your pet, the Chisos Mountains Lodge offers pet-friendly accommodations and reservations should be made well in advance. Do not leave pets locked in parked cars, travel trailers or RV's. For more information, please contact the Big Bend National Park at (432) 477-2251 or visit their website at www.nps.gov.

Directions: Big Bend National Park is accessible from the following cities:
1) From Marathon via US Highway 385 (70 miles).
2) From Alpine via State Highway 118 (108 miles).
3) From Marfa/Presidio via US Highway 67 and FM 170 (156 miles).

Note: Entrance fees required. Dogs must be on leash at all times. Please obey all posted signs and park regulations.

BIG SPRING

LODGING

DAYS INN
2701 S Gregg St (79720)
Rates: $45-$60
(432) 267-5237; (800) 329-7466

ECONO LODGE
804 I-20 W (79720)
Rates: $49-$79
(432) 263-5200; (800) 553-2666

MOTEL 6
600 I-20 W (79720)
Rates: $30-$51
(432) 267-1695; (800) 466-8356

SUPER 8 MOTEL
700 W I-20 (79720)
Rates: $40-$108
(432) 267-1601; (800) 800-8000

BLANCO

<u>RECREATION</u>

BLANCO STATE PARK - Leashes

Info: You'll be serenaded by the river's gentle cascades as you cloudgaze on the soft grass. Make tracks along the trails or keep a keen snout out for wildlife that might be scurrying about. Anglers, drop in on seasonal trout, perch, catfish or bass. For more information: (830) 833-4333; (800) 792-1112; www.tpwd.state.tx.us.

Directions: Located in Blanco at the intersection of Highway 281 & FM 1623.

Note: Dogs are not allowed in water. River subject to flash flooding. Entrance fees.

The numbered hike that follows is within Blanco State Park:

1) NATURE TRAIL HIKE - Leashes

Beginner / 1.0 miles

Info: Outdoorsy breeds will love this looping trail amid dense uplands and riparian woodlands. Groves of live oak, cedar elm, ashe juniper, cactus, elbowbush, yucca and sumac dominate the first half of the trail, while black willow, sycamore, box elder, hackberry, elderberry, buttonbush and red mulberry vie for your attention on the second leg of the hike. As you and furface hightail it through this lush, shaded area, take some time to read the interpretive signs. Thesy highlight the native plants, their historic significance, wildlife usage and landscaping potential. Other signs explain local ecology. Birders, don't forget your binocs. Typical Texas Hill Country birds as well as wetland tweeters claim this area as home. If yours is an aquapup at heart, keep him on a taut leash, dogs are not permitted in the water. For more information: (830) 833-4333.

Directions: Located in Blanco 5 blocks south of the intersection of Highway 281 & FM 1623.

Hotel Pet Policies May Be Subject To Change

BLUFF DALE

LODGING

**THE HIDEAWAY COUNTRY
LOG CABINS B&B**
1022 Private Rd 1250 (76433)
Rates: $94-$105
(254) 823-6606

TRICKLE CREEK CABINS
3501 CR 196
(76433)
Rates: $115-$135
(254) 396-0000

BOERNE

LODGING

BEST WESTERN TEXAS COUNTRY INN
35150 I-10 W (78006)
Rates: $63-$90
(830) 249-9791; (800) 528-1234
(800) 299-9791

BOERNE B&B RESERVATION SERVICE
132 S Main St (78066)
Rates: $85-$160
(866) 336-3809

BOERNE LAKE LODGE B&B RESORT
310 Lakeview Dr (78006)
Rates: $150-$250
(830) 816-6060; (800) 809-5050

KEY TO THE HILLS MOTEL
1228 S Main St (78006)
Rates: $52-$65
(830) 249-3562; (800) 690-5763

RECREATION

BOERNE LAKE - Leashes

Info: Leashed Laddies will love frolicking along the shores of this petite lake. Pack some biscuits and relax lakeside or drop a line in on the fish. Whatever your waterful pleasure, you might find it here. For more information: (830) 249-9511 or (830) 249-8000.

Directions: Located northwest of Boerne, just outside the city limits off Highway 87.

CIBOLO WILDERNESS TRAIL HIKE - Leashes

Beginner/3.0 miles

Info: Nature lovers, paradise awaits. From marshlands to prairies, woodlands to river bottom, nature surrounds and plants/wildlife abound. The Cibolo Wilderness Trail is actually a network of trails that lace the 80-acre Cibolo Wilderness. Even during the dog days of summer, you'll find a cool spot to call your own. The creek's water is refreshingly delightful, just perfect for some paw-dipping shenanigans. Whether you do the hiking thing or simply chill out creekside, a visit to this riparian oasis is one you won't soon forget. A definite two paws up! For more information: (830) 249-4616 or visit their website at www.cibolo.org.

Directions: From Boerne, take Highway 46 east to the Burney City Park sign. Turn right at the sign, following the road to the Nature Center. Parking and a trail system map are available at the pavilion just before the Nature Center.

BONHAM

LODGING

STAR INN
1515 Old Ector Rd (75418)
Rates: $46-$51
(903) 583-3121

RECREATION

BONHAM STATE PARK - Leashes

Info: Watch that tail wag as you and the mutt strut your stuff in this pleasant natural setting or float with Fido along the waters of the lovely little lake. Cast a line and snatch a catch or tote your own treats and do lunch alfresco. For more information: (903) 583-5022; (800) 792-1112; www.tpwd.state.tx.us.

Hotel Pet Policies May Be Subject To Change

Directions: From Bonham, take Highway 78 south for 1.5 miles to FM 271. Head east on FM 271 for 2 miles to Park Road 24. Follow Park Road 24 to the park entrance.

Note: $2 entrance fee/person.

The numbered hike that follows is within Bonham State Park:

1) BONHAM HIKING TRAIL SYSTEM - Leashes
Beginner/Intermediate/12.0 miles

Info: You and your hiking hound can do your own thing on this interconnecting trail system that honeycombs the thick woodlands of cedar and hardwoods. If your pup is fair of paw, he'll love the flat, easy sections of the trail, while athletic breeds will welcome the challenge of the hilly, steep terrain. Pack some trail mix and agua fria and hike for an hour or all day long. The choice is yours and you can't go wrong. This trail system is popular with the mountain biking set, so be alert. For more information: (903) 583-5022.

Directions: From Bonham, take Highway 78 south for 1.5 miles to FM 271. Head east on FM 271 for 2 miles to Park Road 24. Follow Park Road 24 to the park entrance.

BORGER

LODGING

BEST WESTERN BORGER INN
206 S Cedar (79007)
Rates: $73-$120
(806) 274-7050; (800) 528-1234

HERITAGE INN
100 Bulldog Blvd (79007)
Rates: $35-$59
(806) 273-9556

BOWIE

LODGING

DAYS INN
2436 S Hwy 287 (76230)
Rates: $45-$65
(940) 872-5426; (800) 329-7466

PARK'S INN
708 W Wise St (76230)
Rates: $37-$60
(940) 872-1111

BRACKETTVILLE

RECREATION

ALAMO VILLAGE - Leashes

Info: Break out your spurs and ten-gallon hat, tie a bandana around your hound's neck and kick up some good old fashioned fun at Alamo Village. Complete with jails, saloons, general stores, stagecoaches, wagons, surreys, quarterhorses and Texas Longhorns, the village is a throw back to the days of the wild, wild west. Built in the late 1950's for John Wayne's epic movie "The Alamo", the Village has remained a popular setting for movies, commercials, TV shows and travelogues. Visit in the summer and witness bonafido shoot-outs. For more information: (830) 563-2580.

Directions: From Brackettville, take FM 674 north for 7 miles to the village.

Note: $6/adult & $3/child. Hours: Open daily at 9 am.

Hotel Pet Policies May Be Subject To Change

BRADY

LODGING

BEST WESTERN BRADY INN
2200 S Bridge St (76825)
Rates: $45-$75
(325) 597-3997; (800) 528-1234

GOLD KEY INN
2023 S Bridge St (76825)
Rates: $30-$41
(325) 597-2185

DAYS INN
2108 S Bridge St (76825)
Rates: $39-$79
(325) 597-0789; (800) 329-7466

RECREATION

BRADY LAKE - Leashes

Info: You and Bowser will have tons of fun at Brady Lake where you can fish for crappie, bass and catfish or get wet and wild with your pup as you dip those tootsies in the lake. The picnic area is well shaded, so lucky dogs can stay cool when dinner calls and day is done. For more information: (325) 597-1823.

Directions: From Brady, head west on 2028 for five miles until you reach Brady Lake.

RICHARDS PARK - Leashes

Info: Watch tails wag in the breeze when you and the pupster head out for a day of riverside fun. Get your daily dose of Texercise in the pretty open areas. Hey, don't forget a ball or frisbee.

Directions: Located on the west side of town on Memory Lane. Memory Lane is accessed by heading north on US 87.

BRECKENRIDGE

LODGING

RIDGE MOTEL
Hwy 180 (76424)
Rates: $30-$44
(817) 559-2244; (800) 462-5308

BRENHAM

LODGING

BEST WESTERN INN
1503 Hwy 290 E (77833)
Rates: $65-$109
(979) 251-7791; (800) 528-1234

BRENHAM HOUSE BED & BREAKFST
705 Clinton St (77833)
Rates: $75
(979) 830-0477; (800) 259-8367

COMFORT SUITES
2350 S Day St (77833)
Rates: $62-$107
(979) 421-8100; (800) 228-5150

DAYS INN
201 Hwy 290
Loop East (77833)
Rates: $45-$80
(979) 830-1110; (800) 329-7466

RAMADA LIMITED
2217 S Market St (77833)
Rates: $45-$69
(979) 836-1300; (800) 272-6232

RECREATION

BIG CREEK PARK - Leashes

Info: Canines and company can frolic through the forest or hang out by the lakeshore and listen to the serenading songbirds.

Directions: Located on the north side of Lake Somerville on Park Road 4.

FIREMAN'S PARK - Leashes

Info: Social pups will love a visit to this neighborhood park - maybe you'll meet up with a local mutt or two.

Hotel Pet Policies May Be Subject To Change

Directions: Take Main Street to Highway 36 north. The park will be on the west side off Highway 36.

HENDERSON PARK - Leashes

Info: This park is a great place to bring a biscuit basket, fuzzy tennie and a happy attitude. Spend some quality time with the pupster as you enjoy the serenity of your surroundings.

Directions: From Main Street head north on Highway 36. The park will be on the east side off Highway 36.

JACKSON STATE PARK - Leashes

Info: Let your pooch set the pace as you take advantage of the half mile walking track that winds its way through this park. For more information: (800) 792-1112 or visit their website at www.tpwd.state.tx.us.

Directions: Located at the intersection of Tom Green and Jackson Streets.

LAKE SOMERVILLE STATE PARK/BIRCH CREEK UNIT - Leashes

Info: You and your hot diggety dog can do the lazy lakeside thing in this 640-acre parkland. Or work up a sweat on one of the hiking trails that honeycomb the area and offer nature lovers a chance to wander amidst cool woodlands. Pack plenty of Kodak, you might catch a glimpse of white-tailed deer. For more information: (979) 535-7763; (800) 792-1112; www.tpwd.state.tx.us.

Directions: From Brenham, take Highway 36 north to FM 60. Head west on FM 60 for 8 miles to Park Road 57. Follow Park Road 57 south for 4.3 miles to the park entrance.

Note: Entrance fees required.

*The numbered hikes that follow are within
Lake Somerville State Park/Birch Creek Unit:*

Locate Other Dog-Friendly Activities...Check Nearby Cities

1) BIRCH CREEK HIKING TRAIL - Leashes

Beginner/Intermediate/11.0 miles

Info: A sampling of doggie nirvana can be yours along this diverse trail. Treat your hiking buddy to an afternoon of fresh air, dense forests, rolling hills, crystal clear water and lots of exercise on this trek from one end of the park to the other. Sofa loafers, don't be put off by the mileage. On this trail, you're the maker of your own hiking destiny. No matter how much you do, you're in for one doggone great hiking experience. For more information: (979) 535-7763.

Directions: From Brenham, take Highway 36 north to FM 60. Head west on FM 60 for 8 miles to Park Road 57. Follow Park Road 57 south for 4.3 miles to the park entrance.

2) BIRCH CREEK NATURE TRAIL HIKE - Leashes

Beginner/0.5 miles

Info: Get going with your gadabout and do a roundabout on this coolly shaded nature trail. Towering groves of post oak, yaupon, hickory and blackjack oak canopy your journey, making for a pleasant hike even on those hot diggety dog days of summer. Stop at park headquarters for an interpretive trail guide that corresponds with the numbered posts along the way. For more information: (979) 535-7763.

Directions: From Brenham, take Highway 36 north to FM 60. Head west on FM 60 for 8 miles to Park Road 57. Follow Park Road 57 south for 4.3 miles to the park entrance.

LAKE SOMERVILLE STATE PARK/NAILS CREEK UNIT - Leashes

Info: Nails Creek is smaller than its sister park, but just as pretty. The thick undergrowth of native yaupon creates a unique beauty in the Lake Somerville area, while the lake lends itself to many recreational opportunities. Hike with Spike along the trails or just laze away an afternoon with your four-pawed pal. For more information: (979) 289-2392; (800) 792-1112; www.tpwd.state.tx.us.

Hotel Pet Policies May Be Subject To Change

Directions: From Brenham, take Highway 290 east to FM 1697. Head north on FM 1697 to FM 180. Turn right on FM 180 to the park entrance.

Note: Entrance fee charged.

The numbered hike that follows is within
Lake Somerville State Park/Nails Creek Unit:

1) NAILS CREEK HIKING TRAIL - Leashes

Beginner/2.5 miles

Info: If you and the dawgus are in the mood for an easy, very pretty woodsy hike, then this trail is the one for you. The combination of oak and yaupon woodlands, lush wetlands and hardwood bottomlands guarantees a diversity of flora and fauna you won't soon forget. For more information: (979) 289-2392.

Directions: From Brenham, take Highway 290 east to FM 1697. Head north on FM 1697 to FM 180. Turn right on FM 180 to the park entrance.

LAKE SOMERVILLE TRAILWAY - Leashes

Beginner/Intermediate/13.0 miles

Info: Get the juices flowing on a daylong hike with your furface. The trail connects 2 units of Lake Somerville State Park-Birch Creek Unit and Nails Creek Unit. Dense forests of oak and hickory, open prairies, lush rolling hills, spectacular wildflower displays, sun-drenched lakes and refreshing ponds are just a sampling of the delights to be found on this interesting hike. Nature lovers will go gaga over the variety of flora, fauna and scenery that surrounds you. Rest stops, shade shelters and trail maps keep you perky, cool and on track, while picturesque overlooks provide shutterbugs with mucho Kodak moments. Pack plenty of trail treats, Scooby snacks and water - you'll need them. A shuttle system is the best bet for gungho hikers and hounds who want to see it all, do it all. For more information: (979) 535-7763; (979) 289-2392; (800) 792-1112; www.tpwd.state.tx.us.

Locate Other Dog-Friendly Activities...Check Nearby Cities

Directions: <u>Birch Creek Entrance:</u> Take Highway 36 north to FM 60. Head west on FM 60 for 8 miles to Park Road 57. Follow Park Road 57 south for 4.3 miles to the Birch Creek Unit entrance.

<u>Nails Creek Entrance:</u> Take Highway 290 east to FM 1697. Head north on FM 1697 to FM 180. Turn right on FM 180 to the Nails Creek Unit entrance.

OVERLOOK PARK - Leashes

Info: Water pooches will certainly have something to wag about in this charming park. Find a shady spot lakeside and cloudgaze to your heart's content or explore the woodlands with a stroll amidst a forest of towering trees. No matter how you choose to spend your day, this park spells fun for you and your canine companion.

Directions: Located on Somerville Lake off Highway 36.

ROCKY CREEK PARK - Leashes

Info: The largest park on Somerville Lake, Rocky Creek's landscape is filled with colorful, towering live oak trees. Scenery sniffers will want to spend the day investigating the vast woodlands and uncovering secluded viewing vistas. Pack your digital and take home some memories. Happy wags to you.

Directions: From Brenham, follow FM 1948 to Somerville Lake and continue to the exit for Rocky Creek Park.

WASHINGTON-ON-THE-BRAZOS STATE HISTORICAL PARK - Leashes

Info: Noted as the site of the signing of the Texas Declaration of Independence, this park is a history buff's haven. Modern day visitors can learn about the past while relishing in the peaceful surroundings of the present. If you're the athletic type, check out the designated hiking trail or create your own path along the river banks. Birdwatching, sightseeing and picnicking are popular activities, so don't forget to pack your

binocs and a hearty biscuit basket. For more information: (936) 878-2214; (800) 792-1112; www.tpwd.state.tx.us.

Directions: Head northeast on Highway 105 approximately 21 miles to FM 912. Exit on FM 912 and follow to park.

Note: Dogs are not allowed in the lodge.

The numbered hike that follows is within Washington-On-The-Brazos State Historical Park:

1) BEAVER & BLUEBONNET TRAIL HIKE - Leashes

Beginner / 1.0 miles

Info: If woods, ponds and wildflowers send the dogster's tail into overdrive, then this hike shouldn't be missed. The trail begins with a jaunt through a dense forest of sycamore and oak before reaching the first of the trail's two namesakes. Beaver Pond is where patient pooches and their people might get to observe busy beavers in their natural habitat. When you leave the beavers behind, you'll loop past the second name-sake, a field of bluebonnets, which only bloom in spring, so plan accordingly. For more information: (936) 878-2214.

Directions: Head northeast on Highway 105 approximately 21 miles to FM 912. Exit on FM 912 and follow to park.

YEGUA CREEK PARK - Leashes

Info: An ideal location for a little paw dipping, you and your canine cohort can chill out in the shade of enormous oaks in this calming lakeside park.

Directions: Take FM 1948 to Somerville Lake and exit at Yegua Creek Park.

BRIDGE CITY

RECREATION

VETERANS MEMORIAL PARK - Leashes

Info: This may not be the kind of park that you and the pooch are accustomed to visiting, but it's definitely worth a look-see. Stop and read the names of fallen Texas heroes that are honored on commemorative walls. And then stroll to Rainbow and Veterans Memorial Bridges, highlights of the park. Situated 173' above the Neches River, Rainbow Bridge is the town's tallest bridge, while Veterans Memorial Bridge is noted as the first cable-stayed bridge in Texas. For more information: (409) 735-5671.

Directions: Located approximately one mile south of Veterans Bridge on Highway 87.

BROADDUS

LODGING

COUNTRY INN MOTEL
Hwy 147 N (75929)
Rates: $35-$70
(936) 872-3691

HARVEY'S CABINS
Rt 1, Box 255, Hwy 147 (75929)
Rates: n/a
(936) 872-3644

BRONTE

LODGING

TERLINGUA HOUSE
P. O. Box 657 (76933)
Rates: $200-$225
(325) 473-4400

BROOKSHIRE

LODGING

EXPRESS INN
217 Waller Ave (77423)
Rates: $36-$49
(281) 934-3122

TRAVELERS INN & SUITES
542 FM 1489 Rd (77423)
Rates: n/a
(281) 934-4477

RECREATION

LILYPONS WATER GARDENS - Leashes

Info: For a serene scene, plan an outing to this unusual garden where twenty ponds contribute to the tranquil setting. Fishgaze the colorful koi and exotic goldfish. Admire the elegant water lilies and extraordinary plants. Witness the best of the best at the Lotus Bloom Festival in June or the Koi Festival in September. For more information contact the Brookshire Chamber of Commerce at (281) 375-8100.

Directions: From Brookshire, head west on Interstate 10 to FM 1489. Take FM 1489 south to the gardens.

BROWNFIELD

LODGING

BEST WESTERN CAPROCK INN
321 Lubbock Rd (79316)
Rates: $50-$65
(806) 637-9471; (800) 528-1234

BROWNSVILLE

LODGING

COMFORT INN
825 N Expwy (78520)
Rates: $69-$250
(956) 504-3331; (800) 228-5150

MOTEL 6
2255 N Expwy (78521)
Rates: $34-$48
(956) 546-4699; (800) 466-8356

FOUR POINTS BY SHERATON
3777 N Expwy (78520)
Rates: $99-$129
(956) 547-1500; (800) 325-7385

PLAZA SQUARE MOTOR LODGE
2255 Central Blvd (78520)
Rates: $29-$35
(956) 546-5104

LA QUINTA INN & SUITES
1225 N Expwy (78520)
Rates: $69-$119
(800) 687-6667

RED ROOF INN
2377 N Expwy 83 (78520)
Rates: $49-$113
(956) 504-2300; (800) 843-7663

MOTEL CITRUS
2054 Central Blvd (78520)
Rates: $35-$80
(956) 550-9077

RESIDENCE INN BY MARRIOTT
3975 N Expwy (78520)
Rates: $105-$169
(956) 350-8100; (800) 331-3131

BROWNWOOD

LODGING

BEST WESTERN BROWNWOOD
410 E Commerce (76801)
Rates: $44-$69
(325) 646-3511; (800) 528-1234
(877) 646-3513

LAKE BROWNWOOD BED & BREAKFST
9321 CR 558 (76801)
Rates: $75-$95
(325) 784-7729

DAYS INN
515 E Commerce (76801)
Rates: $44-$74
(325) 646-2551; (800) 329-7466
(877) 500-2600

STAR OF TEXAS BED & BREAKFAST
650 Morelock Ln (76801)
Rates: $95-$115
(325) 646-4128; (800) 850-2003

GATE I MOTOR INN
4410 Hwy 377 S (76801)
Rates: $40-$65
(325) 643-5463; (800) 400-8300

TIN TOP RANCH
1400 FM 586 E (76801)
Rates: $80-$100
(325) 646-4156

Hotel Pet Policies May Be Subject To Change

<u>Recreation</u>
COGGIN PARK - Leashes

Info: Get out early with Curly for your daily dose on the 1.5-mile trail. Or just plan a break in your busy schedule with a visit to this urban parkland.

Directions: Located at the 2000 block on Austin Avenue.

LAKE BROWNWOOD STATE PARK - Leashes

Info: Enjoy the day lounging by the lake in this 538-acre state park. Active breeds will want to wander along the hiking trails that honeycomb the peaceful wooded areas. Birdwatching, picnicking, and fishing are just some of the goodies you can enjoy with your special sidekick. For more information: (325) 784-5223; (800) 792-1112 or visit their website at www.tpwd.state.tx.us.

Directions: From Brownwood, take Highway 279 north for 15 miles to Park Road 15. Head east on Park Road 15 for 6 miles to the park entrance.

Note: $3 entrance fee/person. Dogs are not allowed in the day-use swim area or in the cabin area.

The numbered hikes that follow are within Lake Brownwood State Park:

1) LAKE BROWNWOOD HIKING TRAIL - Leashes
Beginner/1.5 miles

Info: Say goodbye to the summertime blues on this delightful looping trail through lush woodlands and verdant savannahs. Your sniffmeister will flip over the designated wildflower observation area. For a get-the-juices-flowing workout, continue your outing with a sidetrip on the connecting Texas Oak Trail. In addition to the physical benefits, you'll come away with a quickie education on the regional flora. For more information: (325) 784-5223; (800) 792-1112.

Directions: From Brownwood, take Highway 279 north for 15 miles to Park Road 15. Head east on Park Road 15 for 6 miles to the park entrance.

2) LAKE BROWNWOOD SHORELINE TRAIL HIKE - Leashes

Beginner/1.2 miles

Info: Woods, savannahs and Lake Brownwood combine to make this a "don't miss" hiking excursion. After you've burned off some kibble, treat your aquapup to some splish splashing fun in the sun. For more information: (325) 784-5223; (800) 792-1112.

Directions: From Brownwood, take Highway 279 north for 15 miles to Park Road 15. Head east on Park Road 15 for 6 miles to the park entrance.

3) TEXAS OAK TRAIL HIKE - Leashes

Beginner/0.75 miles

Info: Mother Nature has put together quite a sampling of her handiwork on this diverse trail. From prickly pear cactus, mesquite, cedar elm and live oak, to Mexican buckeye, Texas oak, gum elastic and white honeysuckle, this path spells paradise for all flora fiends. If flowers power your pupster's tail, you'll experience a sniff-fest in spring when the wild ones strut their colorful stuff. Pick up a trail guide before you begin and make the most of your outing. For more information: (325) 784-5223; (800) 792-1112.

Directions: From Brownwood, take Highway 279 north for 15 miles to Park Road 15. Head east on Park Road 15 for 6 miles to the park entrance.

Hotel Pet Policies May Be Subject To Change

BRYAN

LODGING

PREFERENCE INN & SUITES
1601 S Texas Ave (77802)
Rates: $40-$99
(979) 822-6196

RECREATION

ASTIN RECREATION AREA - Leashes

Info: Energize your daily regiment with a morning jaunt on the half mile trail and then spend some lakeside quietude with your mellow dude.

Directions: Located at 129 Roundtree Drive.

BRYAN REGIONAL ATHLETIC COMPLEX - Leashes

Info: Sports fans will be enthusiastic about the .75-mile trail that skirts this action-packed athletic complex.

Directions: Located at 5440 North Texas Avenue.

LAKE BRYAN - Leashes

Info: This well kept park hosts the Bryan Balloon Classic and offers a slew of exciting outdoor activities for you and your perky pooch. Take part in the Family Fishing Classic or stomp over several acres of scenery. For more information: (979) 361-0861.

Directions: Located at 7848 Sandy Point Road in Bryan.

TEXAS A&M UNIVERSITY PARK - Leashes

Info: Savor your surroundings as you and the wagalong take to the walking trail that winds its way amidst a tranquil wetland area. End your excursion with a picnic while you soak up some sunshine and enjoy the scenery.

Directions: Located on FM 60 west of Texas A&M main campus.

Locate Other Dog-Friendly Activities...Check Nearby Cities

BUFFALO

Lodging

BEST WESTERN CRAIG'S INN
I-45 & US 79 (75831)
Rates: $59-$85
(903) 322-5831
(800) 528-1234

BURLESON

Lodging

COMFORT SUITES
321 S Burleson Blvd (76028)
Rates: $69-$89
(817) 426-6666; (800) 228-5150

DAYS INN
329 S Burleson Blvd (76028)
Rates: $55-$75
(817) 447-1111; (800) 329-7466

SUPER 8 MOTEL
151 E Alsbury St (76028)
Rates: $55-$120
(817) 447-0011; (800) 800-8000

Recreation

CHISENHALL PARK - Leashes

Info: Your soon-to-be-dirty dog will love you forever if you treat him to an outing on the 2-mile pathway that honeycombs this riparian oasis. The parkland is dotted with BBQ grills and picnic tables where dinner alfresco can top off a fun day. A favorite spot with birdwatchers, you might want to tote your binocs.

Directions: Located at 500 Chisenhall Park Lane.

Hotel Pet Policies May Be Subject To Change

BURNET

LODGING

BEST WESTERN POST OAK INN
908 Buchanan Dr (78611)
Rates: $45-$95
(512) 756-4747; (800) 528-1234

CANYON OF THE EAGLES LODGE
16942 Ranch Rd 2341 (78611)
Rates: $99-$179
(512) 756-8787; (800) 977-0081

ROCKY REST COUNTRY INN
404 S Water St (78611)
Rates: $55-$60
(512) 756-2600

RECREATION

BACKBONE RIDGE NATURE TRAIL HIKE - Leashes

Beginner/3.0 miles

Info: Cooped up canines won't mind the "No dogs in the caverns" rule since there's still plenty to do and explore. In addition to the exercise benefit and the outdoor experience, this hike has an educational twist- a half-mile of the trail is interpretive and identifies native plants. After you've had your hiking fill, break out the biscuit basket and dine alfresco with your best buddy. For more information: (830) 598-CAVE; (877) 441-CAVE.

Directions: From Burnet, head south on Highway 281 to Park Road 4. Follow Park Road 4 west to Longhorn Caverns State Park. The trailhead is located in the park.

Note: Dogs are not permitted in the caverns or the Visitor Center.

INKS LAKE STATE PARK - Leashes

Info: Talk about picturesque! This 1,200-acre park is filled with cedar and oak woodlands, dizzying wildflower displays and pink granite outcroppings, assuring a splendid nature experience. Hike on one of the many trails or do some tootsie dipping in the refreshing water. If you tote a boat, float laketop and drop in on the bass, crappie and catfish. Who knows, you might be a lucky dog and go home with dinner. For more information: (512) 793-2223; (800) 792-1112; www.tpwd.state.tx.us.

Locate Other Dog-Friendly Activities...Check Nearby Cities

Directions: From Burnet, take Highway 29 west approximately 9 miles to Park Road 4. Turn left on Park Road 4 for 3 miles to the park entrance.

Note: $4 entrance fee/person.

The numbered hikes that follow are within Inks Lake State Park:

1) DEVIL'S WATERHOLE TRAIL HIKE - Leashes

Beginner/0.5 miles

Info: Aquatic pups will long remember a visit to this water paradise which is only a hop, skip and jump away. All that separates you and the wagger from an afternoon of waterful fun is a short jaunt through a forest of live oak, cedar elm, mesquite and cedar. Once you arrive at the popular swimming hole, water sports and the doggie paddle will fill the day's agenda. For more information: (512) 793-2223.

Directions: From Burnet, take Highway 29 west approximately 9 miles to Park Road 4. Turn left on Park Road 4 for 3 miles to the park entrance. The trailhead is located in the camping area at the northernmost end of the park.

2) INKS LAKE HIKING TRAIL SYSTEM - Leashes

Beginner/Intermediate/7.5 miles

Info: Get a healthy workout and an eyeful of nature on this excursion. The interconnecting trail system has something for every breed. From lakeside jaunts, rocky ups and downs, dense oak and cedar woodlands to a postcardian pecan forest, beautiful spring wildflowers and abundant year-round wildlife, you'll find the best of Mother Nature backdropped by spectacular pink granite outcroppings. So pick your pleasure and spend an hour or a day exploring all that this park has to offer. Stop at the park headquarters and pick up a map. For more information: (512) 793-2223.

Directions: From Burnet, take Highway 29 west approximately 9 miles to Park Road 4. Turn left on Park Road 4 for 3 miles to the park entrance.

Hotel Pet Policies May Be Subject To Change

CADDO

<u>RECREATION</u>

POSSUM KINGDOM STATE PARK - Leashes

Info: Possum Lake, 20,000 acres of the "clearest, bluest water in the southwest," shimmers like an incredible jewel in this beautiful park. If you're feeling like lazy bones, set yourself up lakeside and be hypnotized by the glistening water and gentle waves. If you're up to a bit of Texercise, boogie with Bowser through rugged canyon country in the Palo Pinto Mountains. Pack some snacks, plenty of film and plan to spend the afternoon. The park has a bounty of wildlife, good fishing and incredible scenery. You won't regret a moment spent in this idyllic setting. For more information: (940) 549-1803; (800) 792-1112; www.tpwd.state.tx.us.

Directions: From Caddo, take Park Road 33 north for 17 miles to the park entrance.

Note: $3 entrance fee/person. Dogs are not allowed in cabin area or cabins.

The numbered hike that follows is within Possum Kingdom State Park:

1) LONGHORN TRAIL HIKE - Leashes

Beginner/1.5 miles

Info: Happy days start with this easy-does-it, woodsy stroll to a scenic lake overlook with wonderful panoramas. Capture some Kodak moments, breathe deeply of the pine-scented air and then loop back to the trailhead. If furface is a cattle chaser at heart, keep him on a tight leash, longhorn cattle freely roam the park grounds. For more information: (940) 549-1803.

Directions: From Caddo, take Park Road 33 north for 17 miles to the park entrance.

Locate Other Dog-Friendly Activities...Check Nearby Cities

CALDWELL

LODGING

CALDWELL MOTEL
1819 W Hwy 21 (77836)
Rates: n/a
(979) 567-4000

THE SURREY INN
403 E Hwy 21 (77836)
Rates: $37-$40
(979) 567-3221

SUNSET INN MOTEL
705 Hwy 36 N (77836)
Rates: $33-$49
(979) 567-4661

CALLIHAM

RECREATION

CHOKE CANYON STATE PARKS (Calliham Unit) - Leashes

Info: Put a twinkle in the pup's eye with an excursion to this region. Partake of some relaxing shoreline serenity or make tracks along the trails through the delightfully shaded woodlands. Ground dwellers and sky soarers are abundant, so pack the binoculars and get ready for some interesting sightings. For more information: (361) 786-3868; (800) 792-1112; www.tpwd.state.tx.us.

Directions: From Calliham, head west on Highway 72 for 12 miles.

Note: Entrance fee charged.

CAMDEN

RECREATION

LONGLEAF PINE TRAIL HIKE - Leashes

Beginner/2.0 miles

Info: Feel the soft pine-cushioned floor beneath your feet. Get a whiff of the pine-scented air. And then lace up your hiking boots and set your pooch's tail in the wagging position as you head out on this delightful forest jaunt. The trail loops through virgin stands of majestic longleaf pine that are over 100 years old. For more information: (936) 632-TREE.

Directions: From Camden, head east on FM 62 for 3 miles to the trailhead.

CAMERON

LODGING

VARSITY MOTEL
1004 E 1st St (76520)
Rates: $34-$40
(254) 697-6446

CANTON

LODGING

BEST WESTERN CANTON INN
2251 N Trade Days Blvd (75103)
Rates: $49-$169
(903) 567-6591; (800) 528-1234

DAYS INN
17299 S I-20 (75103)
Rates: $48-$140
(800) 329-7466

HOLIDAY INN EXPRESS
2406 N Trade Days Blvd (75103)
Rates: $55-$165
(903) 567-0909; (800) 465-4329

SUPER 8 MOTEL
110 N I-20 (75103)
Rates: $45-$63
(903) 567-6567; (800) 800-8000

Locate Other Dog-Friendly Activities...Check Nearby Cities

CANYON

LODGING

COUNTRY HOME BED & BREAKFST
Rt 1, Box 447 (79015)
Rates: $55-$85
(806) 655-7636; (800) 664-7636

HOLIDAY INN EXPRESS HOTEL & SUITES
2901 4th Ave (79015)
Rates: $72-$130
(806) 655-4445; (800) 465-4329

RECREATION

BUFFALO LAKE NATIONAL WILDLIFE REFUGE - Leashes

Info: Over 7,600 acres await your exploration at this waterfowl refuge. You and your tagalong have a choice of hiking one of the interpretive trails or cruising along the 4.5-mile refuge drive. Either way, wildlife sightings are guaranteed. End the afternoon by breaking bread and biscuits with your pooch at the picnic area. Bird lovers, come wintertime, cameras and binoculars are a must. The refuge harbors over a million ducks and nearly 80,000 geese. For more information: (806) 499-3382; www.recreation.gov.

Directions: From Canyon, take US 60 southwest for 12 miles to FM 168. Head south on FM 168 to the refuge.

CANYON LAKE

LODGING

MARICOPA RANCH RESORT
12915 FM 306 (78130)
Rates: $45-$105
(830) 964-3731; (800) 460-8891

CARRIZO SPRINGS

LODGING

BALIA INN
S Hwy 83 (78834)
Rates: $40-$70
(830) 876-3583

Hotel Pet Policies May Be Subject To Change

CARROLLTON

LODGING

RED ROOF INN
1720 S Broadway (75006)
Rates: $33-$61
(972) 245-1700; (800) 843-7663

RECREATION

CARROLLTON GREENBELT - Leashes

Info: If you and the dawgus are fixin' to spend the afternoon in an urban oasis, then this greenbelt is the place to go. Several trails honeycomb the vast area, including a pleasant 2.4-mile pathway along Furneaux Creek, an idyllic spot for some tootsie dipping. For more information: (972) 466-3080.

Directions: Access is off Josie Lane just north of Southern Oaks.

GRAVLEY PARK - Leashes

Info: The sun shimmers and glistens on the rolling grasslands in this lovely green scene. There's also a half-mile path where you and the dogster can get a quickie workout.

Directions: Located at 1508 North Perry.

CARTHAGE

LODGING

CARTHAGE MOTEL
321 S Shelby (75633)
Rates: $28-$35
(903) 693-3814

CEDAR PARK

LODGING

COMFORT INN
300 E Whitestone Blvd (78613)
Rates: $65-$100
(512) 259-1810; (800) 228-5150

CENTER

LODGING

BEST WESTERN CENTER INN
1005 Hurst St (75935)
Rates: $52-$75
(936) 598-3384; (800) 528-1234

RECREATION

SABINE NATIONAL FOREST

Sabine Ranger District
201 South Palm, Hemphill, TX 75948,
(409) 787-3870; (409) 787-2791; (866) 235-1750

Info: With over 160,000 acres of dense woodlands blanketing the terrain, the Sabine National Forest is a slice of heaven for hiking hounds and outdoor enthusiasts. Add to that the 65-mile-long Toledo Bend Reservoir and you'll understand why Fido's tail is in overdrive. Encompassing over 137,000 acres, and marking the Texas/Louisiana state line, the adjacent reservoir guarantees aquapups hours of wet and wild fun. If you've got an electric motorboat, a flat-bottom boat or a canoe, you can float the day away. Sorry, no gasoline powered boats allowed. So, pick your pleasure from one of the numerous recreation areas and happy wet wagging to you. For more information: (409) 787-3870 or visit their website at www.southernregion.fs.fed.us/texas.

Directions: The forest lies within the boundaries of Jasper, Sabine, San Augustine, Newton and Shelby counties and is

easily accessible via Highways 21, 103 and 87. Refer to specific directions following each recreation area and hiking trail.

For more information on recreation in the Sabine National Forest, see listings under Hemphill.

The numbered hikes/recreation areas that follow are within the Sabine National Forest:

1) MOTHER NATURE'S TRAIL HIKE - Leashes

Beginner/2.0 miles

Info: This woodsy trail is perfect for outdoorsy types who simply can't get enough of the crisp, forest-scented air. Lush woodlands of oak and beech canopy the trail, while needles from the groves of southern pine provide a cushiony path. As you loop around, keep watch for some of the trail regulars, like white-tailed deer, fox squirrels, raccoons, frogs, turtles, snakes and opossums. Good news for all hot diggety dogs, the trail's close proximity to the reservoir affords plenty of paw chilling opportunities. You won't regret a moment spent on this woodsy trail. For more information: (409) 787-3870; www.southernregion.fs.fed.us/texas.

Directions: From Center, take Highway 87 south for 13 miles to FM 139. Head east on FM 139 for 6.5 miles to FM 3184. Continue east on FM 3184 for 4 miles to FSR 132 and follow FSR 132 approximately 1.5 miles to the Ragtown Recreation Area. The trailhead is located next to the restroom in the middle of the campground.

2) RAGTOWN RECREATION AREA - Leashes

Info: Pack your sack and your pooch and leave your worries in the city when you set off on a journey to a wonderland of natural beauty. This 56-acre recreation area is the ideal place to commune with nature. Kick back under a shade tree and do a little wildlife watching. Or break out the binocs and see what's a-fly. Bald eagles, geese, ospreys and non-migratory native birds are just some of Ragtown's winged residents. Tote your

boat and take to the water or pack a picnic basket and chow down with your pal on terra firma. If you decide to do some exploring on the nature trail, take your camera with you. Ragtown Campground is situated on a high bluff where the views of Toledo Bend Reservoir are spectacular, especially at sunrise and sunset. For more information: (409) 787-3870; www.southernregion.fs.fed.us/texas.

Directions: From Center, take Highway 87 south for 13 miles to FM 139. Head east on FM 139 for 6.5 miles to FM 3184. Continue east on FM 3184 for 4 miles to FSR 132 and follow FSR 132 approximately 1.5 miles to the recreation area.

CENTER POINT

LODGING

MARIANNE'S COUNTRY B&B
Rt 1, Box 527 (78010)
Rates: $75-$110
(830) 634-7489; (800) 634-7489

CHANNELVIEW

LODGING

BEST WESTERN HOUSTON EAST
15919 I-10 E (77530)
Rates: $46-$80
(281) 452-1000; (800) 528-1234

BUDGET LODGE
17011 I-10 E (77530)
Rates: $44-$165
(281) 457-2966

TRAVELODGE SUITES
15831 2nd St (77520)
Rates: $60-$65
(281) 862-0222; (800) 578-7878

Hotel Pet Policies May Be Subject To Change

CHILDRESS

Lodging

BEST WESTERN CLASSIC INN
1805 Ave "F" NW (79201)
Rates: $60-$80
(940) 937-6353; (800) 528-1234
(800) 346-1576

COMFORT INN
1804 Ave "F" NW (79201)
Rates: $69-$94
(940) 937-6363; (800) 228-5150

ECONO LODGE
1612 Ave "F" NW (79201)
Rates: $38-$70
(940) 937-3695; (800) 553-2666

HOLIDAY INN EXPRESS
2008 Ave "F" NW (79201)
Rates: $59-$99
(940) 937-3434; (800) 465-4329

SUPER 8 MOTEL
411 Ave "F" NE (79201)
Rates: $60-$100
(940) 937-8825; (800) 800-8000

CISCO

Lodging

BEST WESTERN INN CISCO
1898 Hwy 206 W (76437)
Rates: $59-$64
(254) 442-3735
(800) 528-1234; (800) 621-2457

CISCO MOTOR INN
204 I-20 W (76437)
Rates: $30-$50
(254) 442-3040

OAK MOTEL
300 I-20 E (76437)
Rates: $25-$32
(254) 442-2100

CLARENDON

LODGING

BAR H WORKING DUDE RANCH
P O Box 1191 (79226)
Rates: n/a
(806) 874-2634; (800) 627-9871

WESTERN SKIES MOTEL
800 W 2nd St (79226)
Rates: $35-$50
(806) 874-3501

IT'LL DO MOTEL
403 W 2nd St (79226)
Rates: n/a
(806) 874-3471

CLAUDE

LODGING

L A MOTEL
200 E 1st St (79019)
Rates: $35-$50
(806) 226-4981

CLEAR LAKE

RECREATION

BAY AREA PARK - Leashes

Info: Enjoy the views of the Armand Bayou as you and the hound pound the walking trails in this scenic park. Pack a good read, a rawhide and have it made in the waterside shade.

Directions: Located at 7500 Bay Area Boulevard.

CHALLENGER SEVEN MEMORIAL PARK - Leashes

Info: Treat your cityslicker to an afternoon of relaxation and outdoor fun. Find a comfy spot and spread a blanket on the lush dewy grass. Social breeds might prefer a stroll to the pavilion, while bird enthusiasts will find music for their ears

Hotel Pet Policies May Be Subject To Change

in the bird sanctuary. For more information: (281) 488-7676 or (800) 844-5253.

Directions: From the Gulf Freeway (45), exit on NASA Road 1. Head west and turn onto West NASA Road. The park is at 2301 W. NASA.

CLEAR LAKE PARK - Leashes

Info: Located on the north shore of Clear Lake, this scenic region offers mellow fellows a chance to vege out waterside and catch some rays. Or don't be a lazy bones and step lively on one of the jogging trails. You can't go wrong with a journey to this park. For more information: (281) 326-6539.

Directions: From the Gulf Freeway (45) exit on NASA Road 1 and head east. After you cross over Clear Lake, you'll see the park on the south side of the road.

SPACE CENTER HOUSTON - Leashes

Info: Gear up to visit Clear Lake's star attraction. Pooches can't enter the buildings, but air-conditioned kennels are available free of charge for canine companions. While Fido takes a snooze, you can take a tour of this extraordinary facility.

Experience the miraculous exploration of space as you wander through educational exhibits of the NASA space program. You'll be starstruck by the portrait gallery of the astronauts who have traveled in space. Check out the five-story movie theater and experience an amazing up-close journey through the sky. A visit to the space center is definitely worth a slot in your vacation plans. For more information: (281) 244-2100; www.nasa.gov.

Directions: Located at 1601 NASA Road 1, midway between Houston and Galveston off I-45.

Notes: Bring your dog's own water dish. Call for summer or winter hours. Entrance fee subject to change without prior notice. Adults $19.95, children: $13.95, seniors $16.95.

Locate Other Dog-Friendly Activities...Check Nearby Cities

WALTER HALL PARK - Leashes

Info: You and the pooch will find plenty of shade under the oaks in this lovely park. Saunter along a myriad of pathways or paddle around the pond with your pal. Tote your own boat and drop in on the fish. Open and canopied areas make perfect BBQ spots for able fishermen and picnickers alike. Bone appetite!

Directions: Take Highway 45 to 518. Take 518 east for .5 mile to Highway 3. Go left on Highway 3 and drive about 300 yards to park entrance on left-hand side of the road.

CLEBURNE

LODGING

ANGLIN ROSE B&B
808 S Anglin (76031)
Rates: $90-$100
(817) 641-7433

COMFORT INN
2117 N Main St (76031)
Rates: $79-$89
(817) 641-4702; (800) 228-5150

DAYS INN
101 N Ridgeway Dr (76031)
Rates: $50-$80
(817) 645-8836; (800) 329-7466

SAGAMAR INN
2107 N Main (76031)
Rates: $56-$60
(817) 556-3631

RECREATION

CLEBURNE STATE PARK - Leashes

Info: Forests of oak, elm, mesquite and cedar offer plenty of cooling shade. In springtime, bluebonnets carpet and color the hilly terrain. Afishionados, the bass, crappie, catfish and perch beckon your bait in the beautiful, spring-fed, 116-acre lake. Outdoor fun and picturesque surroundings team up to make for a pleasant interlude. For more information: (817) 645-4215; (800) 792-1112; www.tpwd.state.tx.us/park.

Directions: From Cleburne, take Highway 67 west about 4 miles. turn on Park Road 21 for 6 miles to the park entrance.

The numbered hikes that follow are within Cleburne State Park:

Hotel Pet Policies May Be Subject To Change

1) COYOTE RUN NATURE TRAIL HIKE - Leashes

Beginner/2.4 miles

Info: Lose yourself in the beauty of nature on this shade-dappled trail through a woodsy setting of cedar, oak, redwood, pecan and redbud. Pick up a trail guide and expand your knowledge of the area flora. For more information: (817) 645-4215.

Directions: From Cleburne, take Highway 67 west approximately 4 miles to Park Road 21. Turn left on Park Road 21 for 6 miles to the park entrance.

2) SPILLWAY HIKING TRAIL - Leashes

Beginner/1.0 miles

Info: If riparian woodlands and picture-pretty lake overlooks equate to a bonafido hiking excursion for you and your wagalong, you're gonna love this hike. Good news for muscled mutts, trail's end doesn't mean the good times are over. Hook up with the Coyote Run Nature Trail and clock off some more miles. Carpe diem Duke. For more information: (817) 645-4215.

Directions: From Cleburne, take Highway 67 west approximately 4 miles to Park Road 21. Turn left on Park Road 21 for 6 miles to the park entrance.

CLIFTON

LODGING

CLIFFVIEW RESORT CABINS
180 CR 1802 (76634)
Rates: $71-$120
(866) 821-6040

RIVER'S BEND BED & BREAKFAST
P. O. Box 228 (76634)
Rates: $95-$150
(254) 675-4936

CLUTE

LODGING

LA QUINTA INN
1126 Hwy 332 W (77531)
Rates: $65-$87
(979) 265-7461; (800) 687-6667

MOTEL 6
1000 Hwy 332 W (77531)
Rates: $34-$39
(979) 265-4764; (800) 466-8356

MAINSTAY SUITES
1003 Hwy 332 W (77531)
Rates: $99-$139
(979) 388-9300; (800) 660-6246

COLDSPRING

LODGING

SAN JACINTO INN
13815 Hwy 150 W (77331)
Rates: $40-$43
(936) 653-3008

RECREATION

SAM HOUSTON NATIONAL FOREST

Sam Houston Ranger District
394 FM 1375 West, New Waverly, TX 77358,
(936) 344-6205; (888) 361-6908

Info: Over 163,000 acres of alluring serenity are yours for the taking at this national forest named for the father of Texas-Sam Houston. No tour of Texas would be complete without a visit to this delightful woodland. So leave your cares and woes in the city and let the good times roll. It doesn't matter what tickles your fancy, it's all here. Play tagalong with your wagalong as you journey on the picturesque Lone Star Hiking Trail. Be a lazy bones and vege out under a shade tree in a hidden copse where the air is deliciously pine-scented. Or if water sports are more your speed, tote your boat, pack your gear and set your sights on 21,000-acre Lake Conroe and 82,600-acre Lake Livingston. (Gasoline-powered boats are not

Hotel Pet Policies May Be Subject To Change

permitted). Pick your pleasure and then go for it. There's nothing to stop you and furface from having one helluva a good day. Carpe diem Duke. For more information: (936) 344-6205.

Directions: The forest lies within the boundaries of Montgomery, San Jacinto and Walker Counties and is easily accessed via Interstate 45 and Highways 150, 190 and 156. Refer to specific directions following each recreation area and hiking trail.

For more information on recreation in the Sam Houston National Forest, see listings under the following cities: Conroe, Houston, Huntsville, New Waverly and Shepherd.

The numbered recreation area that follows is within the Sam Houston National Forest:

1) DOUBLE LAKE RECREATION AREA - Leashes

Info: Hot diggety dog, you and Boomer are in for an afternoon of fun, fun, fun at this recreation site which revolves around 24-acre Double Lake. AKA puppy paradise, this slice of water heaven is perfect for a day of doggie paddling and tootsie dipping. You might want to tote your pole and try your luck. Maybe you'll end up with bass, bream or catfish for dinner. Or get the lead out and get your daily dose on the 5-mile trail to Big Creek Scenic Area. The name says it all, so pack your digital and take home a slew of memories. Sorry Snoopy - the beach and designated swimming area are off limits. For more information: (936) 344-6205.

Directions: From Coldspring, take Highway 150 west for 2 miles to FM 2025. Turn left on FM 2025 for .25 miles to FSR 210. Make a left on FSR 210 for 1.5 miles to the recreation area.

COLEMAN

LODGING

BEST WESTERN COLEMAN INN
1401 Hwy 84 Bypass (76834)
Rates: $55-$75
(325) 625-4176; (800) 528-1234

COLLEGE STATION

LODGING

HILTON HOTEL & CONFERENCE CENTER
801 E University Dr (77840)
Rates: $69-$125
(979) 693-7500; (800) 445-8667

HOLIDAY INN
1503 Texas Ave S (77840)
Rates: $79
(979) 693-1736; (800) 465-4329

HOWARD JOHNSON EXPRESS
3702 Hwy 6 S (77845)
Rates: $40-$125
(800) 446-4656

LA QUINTA INN
607 Texas Ave S (77840)
Rates: $70-$96
(979) 696-7777; (800) 687-6667

MANOR HOUSE INN
2504 Texas Ave S (77840)
Rates: $60-$99
(979) 764-9540; (800) 231-4100

MOTEL 6
2327 Texas Ave S (77840)
Rates: $37-$57
(979) 696-3379; (800) 466-8356

RAMADA INN
1502 Texas Ave S (77840)
Rates: $65-$150
(979) 693-9891; (800) 272-6232

SUPER 8 MOTEL
301 Texas Ave (77840)
Rates: $65-$109
(979) 846-8800; (800) 800-8000

TOWNEPLACE SUITES BY MARRIOTT
1300 E University Dr (77840)
Rates: n/a
(979) 260-8500; (800) 257-3000

RECREATION

ANDY ANDERSON ARBORETUM - Leashes

Info: If Skip flips over plants and trees, don't miss this 17-acre arboretum. There's no doubt that your tree hound will give this interpretive trail two paws up. After you've had your

woodsy fill, check out the other dog-friendly areas of Bee Creek Park. For more information: (979) 764-3773.

Directions: Located in Bee Creek Park at 1900 Anderson.

BEE CREEK PARK - Leashes

Info: Bursting with activity, this park encompasses over 40 acres of playtime fun for you and the wagger. Take to the open fields or strut with the mutt in the Andy Anderson Arboretum. For a quickie education, hop on one of the interpretive trails and learn about the landscape or just kick back under a shade tree and be serenaded by songbirds.

Directions: Located at 1900 Anderson.

BROTHERS POND PARK - Leashes

Info: This pretty 16-acre park offers rolling hills and plenty of waterful fun. Be a lazy bones pondside or enjoy some splish-splashing hijinks in the intermittent stream. This park fills the bill for some good time fun in the sun with your #1 furface.

Directions: Located at 3100 Rio Grande.

CENTRAL PARK - Leashes

Info: Hot diggety dog! You and your sidekick can chill out on a blanket by the pond or do a bit of exploring through the dense woodlands of this 47-acre community park.

Directions: Located at 1000 Krenek Tap Road.

GABBARD PARK - Leashes

Info: Take your pal for a day of play down by the pond in this 10-acre park.

Directions: Located at 1201 Dexter Drive.

Locate Other Dog-Friendly Activities...Check Nearby Cities

GEORGE K. FITCH PARK - Leashes

Info: Lounge with your hound in the grassy areas or hop on one of the nature trails for your daily quotient of exercise in this 11.3-acre park.

Directions: Located at 1100 Balcones, between Rio Grande and Welsh.

HENSEL PARK - Leashes

Info: Visit this 29-acre green scene and amble with the Aggies through the lush landscape. Jogging trails and open grassy areas make this park a delightful place for you and your pooch to sample a taste of the great outdoors.

Directions: Located on South College just past Texas A&M University.

LEMONTREE PARK - Leashes

Info: Scenery sniffers will love this 15-acre neighborhood park complete with a .75-mile concrete jogging path and a pedestrian bridge. Shady woodlands and grassy areas provide plenty of blanket spreading space for mellow fellows.

Directions: Located at 1300 Lemontree.

LICK CREEK PARK - Leashes

Info: Tote your own supplies and head out to the Lick. You and the pupster will have one howl of a good time frolicking through 500 acres of unspoiled, undeveloped terrain.

Directions: From Highway 6 south, take the Greens Prairie Road exit and go left. Follow Greens Prairie until it dead ends and take a right. Lick Creek Park will be on the right-hand side about one mile down the road.

Hotel Pet Policies May Be Subject To Change

OAKS PARK - Leashes

Info: Get lost in your thoughts and watch tails wag on the jogging trails of this small sunny park.

Directions: Located at 1601 Stallings, off Harvey Road.

RAINTREE PARK - Leashes

Info: Grab your gadabout and do a roundabout on the pathways that crisscross the park's 13 bird-filled, tree-lined acres.

Directions: Located at 2505 Raintree Drive off Highway 6 Bypass.

RICHARD CARTER PARK - Leashes

Info: Curious Georges will want to snout out the statue and reconstructed water well. Or explore the discovery garden area which features decks, benches and plenty of plants to admire.

Directions: Located at 1800 Brazoswood off Highway 6 Bypass.

WOLF PEN CREEK PARK & AMPHITHEATER - Leashes

Info: Hightail it around the soothing creek on one of the many jogging trails. Take a moment to appreciate the detailed landscaping that is meticulously maintained for your pleasure.

Directions: Located at 1015 Colgate Circle.

OTHER PARKS IN COLLEGE STATION - Leashes

For more information, contact the College Station Parks & Recreation Department at (979) 764-3773.

- ANDERSON PARK, Anderson and Holleman
- BRISON PARK, 400 Dexter off George Bush Drive
- CY MILLER PARK, 2615 Texas Avenue

Locate Other Dog-Friendly Activities...Check Nearby Cities

- EASTGATE PARK, Foster Street & Walton Drive
- EDELWEISS PARK, Victoria Avenue
- EMERALD FOREST PARK, 8400 Appomattox
- LINCOLN CENTER PARK, 1000 Eleanor off Holleman
- LIONS PARK, 501 Chappel, off University Drive and Peyton
- LONGMIRE PARK, 2600 Longmire, between FM 2818 and Deacon
- LUTHER JONES PARK, 501 Park Place
- MERRY OAKS PARK, 1401 Merry Oaks, off University Oaks
- PARKWAY PARK, Munson and Woodland Parkway
- PEBBLE CREEK PARK, 401 Parkview Street
- SANDSTONE PARK, 1700 Sebesta
- SOUTHWOOD ATHLETIC PARK, 1600 Rock Prairie Road, off Highway 6 Bypass
- TEXAS A&M RESEARCH PARK, FM 2818 and University Drive, between Wellborn and 2818
- THOMAS PARK, 1300 James Parkway, off Francis and Puryear
- WAYNE SMITH PARK, 401 Luther, off Montclair
- WINDWOOD PARK, 2650 Broadway Court
- WOODCREEK PARK, 9100 Shadowcrest Drive
- WOODWAY PARK, off Holleman at Jones-Butler Road

COLORADO CITY

LODGING

RELAX INN
1041 Westpoint Ave (79512)
Rates: n/a
(325) 728-5742

VILLA INN MOTEL
2310 Hickory St (79512)
Rates: $32-$44
(325) 728-5217

RECREATION

LAKE COLORADO CITY STATE PARK - Leashes

Info: Pack a biscuit basket and a fun attitude and plan an afternoon delight on the rocky banks of lovely Lake Colorado. Tranquility reigns supreme in this 500-acre region where naturalists, anglers and their canine cronies are guaranteed a

bonafido good time. For more information: (325) 728-3931; (800) 792-1112; www.tpwd.state.tx.us.

Directions: From Colorado City, take Highway 20 west for 5 miles to FM 2836. Head south on FM 2836 for 6 miles to the park entrance.

Note: Entrance fee charged.

The numbered hike that follows is within Lake Colorado City State Park:

1) LAKE COLORADO CITY HIKING TRAIL - Leashes

Beginner/3.0 miles

Info: You and your sofa surfer will have a paw-stomping, wet wagging kind of a day on this easy-does-it trail. Say adios to boring afternoons on this sun-speckled hike through cedar and mesquite woodlands. For some pooch shenanigans with a wet slant, find yourself a cozy spot lakeside and go for it. For more information: (325) 728-3931.

Directions: From Colorado City, take Highway 20 west for 5 miles to FM 2836. Head south on FM 2836 for 6 miles to the park entrance.

COLUMBUS

LODGING

COLUMBUS INN
2208 Hwy 71 S (78934)
Rates: $50-$65
(979) 732-5723

COUNTRY HEARTH INN
2436 Hwy 71 S (78934)
Rates: $62-$80
(979) 732-6293; (888) 325-7817

HOLIDAY INN EXPRESS HOTEL & SUITES
4321 I-10 (78934)
Rates: $69-$89
(979) 733-9300; (800) 465-4329

COMANCHE

LODGING

GUEST HOUSE-HERITAGE HILL BED & BREAKFAST
Hwy 36 E, Rt 3
Box 221 (76442)
Rates: $70-$100
(915) 356-3397

RECREATION

PROCTOR LAKE - Leashes

Info: Float your boat over 14,000 acres of refreshing water and enjoy an afternoon of sun-filled, fun-filled adventure. Zip, skim or sail across the surface of the shimmering lake until you and your wet wagger find the ideal fishing hole. Four developed parks offer picnic spots and access to the water. They are as follows:

- COPPERAS CREEK PARK, located at the end of FM 2861
- HIGH POINT PARK, located at the end of FM 1496
- PROMONTORY PARK, located at the end of FM 2318
- SOWELL CREEK PARK, located at the intersection of FM 1476 and Park Road 6R

For more information: (254) 879-2424.

Directions: Head east on Highway 67 about 8 miles to FM 2861 and turn left (north) to the park entrance.

COMFORT

LODGING

IDLEWILDE BED & BREAKFAST
115 Hwy 473 (78013)
Rates: $63-$93
(830) 995-3844

MOTOR INN AT COMFORT
32 N Hwy 87 (78013)
Rates: $60-$140
(830) 995-3822

KLEINA HIMMUL BED & BREAKFAST
Rt 1, Box 127-B (78013)
Rates: $75-$85
(830) 995-2003

Hotel Pet Policies May Be Subject To Change

<u>RECREATION</u>

COMFORT PARK AND GAZEBO - Leashes

Info: Years ago, Comfort founder, Ernest Altgelt, dedicated this small park as a town square for the residents. Today, it remains a lovely spot to spend some quiet moments with your sidekick.

Directions: Located at Highway 27 and Broadway.

COMSTOCK

<u>RECREATION</u>

SEMINOLE CANYON STATE PARK & HISTORIC SITE - Leashes

Info: Kick up some dust on over 8 miles of trails in this striking 2,100-acre park. Rich in history and blessed with gorgeous scenery, Seminole Canyon is an astounding place to visit. The Canyon eats Kodak so take plenty with you. Who knows, you might get lucky and spot some white-tailed deer or an armadillo. Binoculars will come in handy too. Many species of birds inhabit the park. Pack lots of water and an adventurous spirit and let the fun begin. For more information: (432) 292-4464; (800) 792-1112; www.tpwd.state.tx.us.

Directions: From Comstock, take Highway 90 west for nine miles to the entrance. The park is just east of the Pecos River High Bridge.

Note: $2 entrance fee/person.

The numbered hikes that follow are within
Seminole Canyon State Park & Historic Site:

1) RIO GRANDE TRAIL HIKE - Leashes

Intermediate/6.0 miles

Info: This trail follows the rim of the park's cliffs via an old ranch road to a picturesque overlook. From your lofty perch,

you and the dawgus will have to-die-for vistas of Seminole Canyon, the Rio Grande and the age-old pictographs of Panther Cave. As you hightail it along this rather simple trail, keep a snout out for resident wildlife - deer, javelina, badger, coyote and fox are trail regulars. These critters are especially active at night. The "birds" that flutter through the sky at dusk are actually bats, doing their share at keeping the insect populations in check. They're beautiful to watch as they swoop and dive through the air. Several shade shelters make this hike feasible even in the summer, but pack lots of water for you and your hiking hound, this is desert country. For more information: (432) 292-4464.

Directions: From Comstock, take Highway 90 west approximately 9 miles to the park entrance just east of the Pecos River High Bridge.

2) WINDMILL NATURE TRAIL HIKE - Leashes

Beginner/0.6 miles

Info: A desert experience awaits you and your canine companion on this easy nature trail. Ocotillo and cholla, plains prickly pear and blackbrush acacia represent some of the area's vegetation and close proximity to the Chihuahuan Desert. Pack plenty of Perrier - you'll need it. The trail is short, but it's also unshaded, so dress accordingly. For a quickie education on the surrounding flora and geology, pick up an interpretive guide before setting out. For more information: (432) 292-4464.

Directions: From Comstock, take Highway 90 west approximately 9 miles to the park entrance just east of the Pecos River High Bridge.

CONCAN

LODGING

B.E.N.T. RIVER RETREAT CABINS
1000 CR 350 (78838)
Rates: $100-$180
(888) 388-3707

SEVEN BLUFF CABINS
3rd Crossing - River Rd (78838)
Rates: $90-$400
(800) 360-5260

FRIO ACRES
CABINS
1047 CR 350 (78838)
Rates: $90-$145
(877) 635-4848

RECREATION

GARNER STATE PARK - Leashes

Info: A slice of doggie heaven can be yours in this hilly, picturesque region. Whether you want to get the juices flowing along the hiking trail or just put some pleasure in your day, you can't go wrong at this postcardian pretty place. Head for the hills or the fabulous Frio River and give Fido something to bark home about. This parkland is a water wonderland of fun in the sun for you and the furball. For more information: (830) 232-6132; (800) 792-1112; www.tpwd.state.tx.us.

Directions: From Concan, take Highway 83 north for 7 miles to Park Road 29. Make a right on Park Road 29 to the park entrance.

Note: $5 entrance fee/person. Dogs are not allowed in cabin area.

The numbered hike that follows is within Garner State Park:

1) GARNER STATE PARK HIKING TRAIL - Leashes

Beginner/2.0 miles

Info: If your woofer's a hoofer, you can get your daily dose on this undemanding trail through lush forests of cedar, elm and Spanish oak. And then get psyched for some dirty dog antics at the Frio River before calling it a day. For more information: (830) 232-6132.

Locate Other Dog-Friendly Activities...Check Nearby Cities

Directions: From Concan, take Highway 83 north for 7 miles to Park Road 29. Make a right on Park Road 29 to the park entrance.

CONROE

LODGING

BAYMONT INN & SUITES
1506 I-45 S (77301)
Rates: $69-$84
(936) 539-5100; (877) 229-6668

MOTEL 6
820 I-45 S (77304)
Rates: $36-$45
(926) 760-4003; (800) 466-8356

LA QUINTA INN & SUITES
4006 Sprayberry Ln (77303)
Rates: $69-$109
(800) 687-6667

RAMADA LIMITED
1520 S Frazier (77301)
Rates: $49-$79
(936) 756-8939; (800) 272-6232

RECREATION

KASMIERSKY PARK - Leashes

Info: Do some Texas dreaming as you cruise over 9 acres of woodlands in this sun-dappled green scene. Get the kinks out on the half-mile trail or do nothing in a shady alcove.

Directions: Located at Old Magnolia and Kirk Roads.

SAM HOUSTON NATIONAL FOREST

Sam Houston Ranger District
394 FM 1375 West, New Waverly, TX 77358,
(936) 344-6205; (888) 361-6908

Info: Over 160,000 acres of alluring serenity are yours for the taking at this national forest named for the father of Texas- Sam Houston. No tour of Texas would be complete without a visit to this delightful woodland. So leave your cares and woes in the city and let the good times roll. It doesn't matter what tickles your fancy, it's all here. Play tagalong with your wagalong as you journey on the picturesque Lone Star Hiking

Trail. Be a lazy bones and vege out under a shade tree in a hidden copse where the air is deliciously pine-scented. Or if water sports are more your speed, tote your boat, pack your gear, and set your sights on 21,000-acre Lake Conroe and 82,600-acre Lake Livingston. (Gasoline-powered boats are not permitted). Pick your pleasure and then go for it. There's nothing to stop you and furface from having one helluva a good day. Carpe diem Duke. For more information: (936) 344-6205.

Directions: The forest lies within the boundaries of Montgomery, San Jacinto and Walker Counties and is easily accessed via Interstate 45 and Highways 150, 190 and 156. Refer to specific directions following each recreation area and hiking trail. For more information on recreation in the Sam Houston National Forest, see listings under the following cities: Coldspring, Houston, Huntsville, New Waverly and Shepherd.

The numbered hike that follows is within the Sam Houston National Forest:

1) LONE STAR HIKING TRAIL - Leashes

Intermediate/1.0-140.0 miles

Info: Holding the distinction as the longest public hiking trail in Texas, the 140-mile Lone Star Trail is considered a state landmark. Spanning the entire width of the Sam Houston National Forest, hikers can experience a cornucopia of nature running the gamut from hardwood bottomlands, forested uplands, designated scenic areas to protected wilderness areas, deep ravines and postcardian bluffs. A definitive slice of doggie heaven, you won't regret a moment spent at this woodsy and water wonderland. All along the trail, you and the dirty dog will have the opportunity to paw and tootsie dip your way in streams, creeks, lakes, ponds and rivers. Put a visit to this forestland at the top of your day's itinerary and get set for tons of fun.

The Lone Star Hiking Trail is divided into three major sections- Lake Conroe Area, Central Area and Winters Bayou/Tarkington Creek Area. The first portion of the trail is the Lake Conroe Area, which is located near the intersection of FS 219 and FM 149. This area is situated west of Lake Conroe, has 4 connecting loops and encompasses the Little Lake Creek Wilderness Area and Stubblefield Recreation Area. The second section, Central Area, runs east from Stubblefield, through the Four Notch Area to Evergreen, and then south on FM 945 to the trailhead parking area. The third and final portion of the trail, Winters Bayou/Tarkington Creek Area has received National Recreation Trail status. This section runs east from FM 945 to Double Lake Recreation Area, then south through Big Creek Scenic Area and finally southwest through Winters Bayou. In addition to the National Recreation status, Winters Bayou has been given Special Management Designation as a Biological Area because of its uniquely diverse vegetation.

Some sections of the trail are developed with raised walkways and footbridges making it suitable for most hikers. The majority of the trail, however, is somewhat rugged and requires hiking know-how. You might, for example, have to overcome obstacles such as crossing creeks via fallen trees. Before you set out, contact the Sam Houston Ranger District in New Waverly for a trail guide and map at (936) 344-6205, and decide on a hiking route. Along with the rectangular aluminum markers nailed to trees, the map will help keep you on course. Don't be put off by the length of the trail. Scattered trailheads and parking areas make car shuttles possible, so the distance you cover is up to you. For more information: (936) 344-6205.

Directions: The trail begins just west of Lake Conroe off FM 149 and ends at FM 1725 in Cleveland.

CONWAY

LODGING

BUDGET HOST INN S&S MOTEL
I-40 & Hwy 207 (79068)
Rates: $35-$47
(806) 537-5111; (800) 283-4678

COOPER

RECREATION

COOPER LAKE STATE PARKS (Doctors Creek Unit) - Leashes

Info: Sniff the cedars, enjoy the elms and ogle the oaks in this beautiful, 2,500-acre expanse. Make your fishy dreams come true with a cruise atop the reservoir and a fish fry for dinner. If hiking's to your liking strap on the pedometer and skedaddle along one of the nature trails for your daily dose of Texercise. Or be a lazy bones and merely chill out lakeside with your hot diggety doggie. For more information: (903) 395-3100; (800) 792-1112; www.tpwd.state.tx.us.

Directions: From Cooper, go east on Highway 154 for 1 mile, turning south on FM 1529 and drive 2 miles to park entrance.

Note: Entrance fee charged.

COPPERAS COVE

LODGING

HOWARD JOHNSON EXPRESS INN
302 W Hwy 190 (76522)
Rates: $54-$69
(254) 547-2345; (800) 446-4656

CORPUS CHRISTI

<u>LODGING</u>

ANCHOR RESORT CONDOMINIUMS
14300 S Padre Island Dr (78418)
Rates: $69-$129
(800) 460-8770

BAYFRONT INN
601 N Shoreline Blvd (78401)
Rates: $49-$125
(361) 883-7271; (800) 456-2293

BEST VALUE INN & SUITES
6255 Corn Products Rd (78409)
Rates: $29-$159
(361) 289-0991

BEST WESTERN GARDEN INN
11217 I-37 (78410)
Rates: $59-$139
(361) 241-6675; (800) 528-1234

BEST WESTERN MARINA GRAND HOTEL
300 N Shoreline Dr (78401)
Rates: $69-$195
(361) 883-5111; (800) 528-1234
(800) 883-5119

BEST WESTERN ON THE ISLAND
14050 S Padre Island Dr (78418)
Rates: $59-$150
(361) 949-2300; (800) 528-1234

BEST WESTERN PARADISE INN
6301 S Padre Island Dr (78412)
Rates: $74-$145
(361) 992-3100; (800) 528-1234

CHRISTY ESTATE SUITES/CONDOS
3942 Holly Rd (78415)
Rates: $109-$189
(361) 854-1091; (800) 6-SUITE

CLARION HOTEL
5224 I-37 (78407)
Rates: $69-$84
(361) 883-6161; (800) 252-7466

COMFORT INN & SUITES
3838 Hwy 77 (78410)
Rates: $69-$120
(361) 241-6363; (800) 228-5150

DAYS INN
901 Navigation Blvd (78408)
Rates: $40-$130
(361) 888-8599; (800) 329-7466

DAYS INN-SOUTH
2838 S Padre Island Dr (78415)
Rates: $59-$169
(361) 854-0005; (800) 329-7466

DRURY INN
2021 N Padre Island Dr (78408)
Rates: $62-$92
(361) 289-8200; (800) 378-7946

GULF BEACH-II LUXURY MOTOR INN
3500 Surfside Blvd (78402)
Rates: $40-$90
(361) 882-3500

HOLIDAY INN EMERALD BEACH
1102 S Shoreline Blvd (78401)
Rates: $115-$179
(361) 883-5731; (800) 465-4329

HOLIDAY INN-PADRE IS. DRIVE
5549 Leopard St (78408)
Rates: $79-$129
(361) 289-5100; (800) 465-4329

HOWARD JOHNSON EXPRESS INN
722 N Port Ave (78408)
Rates: $50-$149
(800) 446-4656

LA QUINTA INN-NORTH
5155 I-37 N (78408)
Rates: $63-$129
(361) 888-5721; (800) 687-6667

Hotel Pet Policies May Be Subject To Change

LA QUINTA INN-SOUTH
6225 S Padre Island Dr (78412)
Rates: $69-$129
(361) 991-5730; (800) 687-6667

MOTEL 6-LANTANA
845 Lantana St (78408)
Rates: $29-$53
(361) 289-9397; (800) 466-8356

MOTEL 6-SPI DRIVE
8202 S Padre Island Dr (78412)
Rates: $33-$55
(361) 991-8858; (800) 466-8356

OMNI HOTEL
900 N Shoreline Blvd (78401)
Rates: $99-$185
(800) THE-OMNI

QUALITY INN & SUITES
1901 N Padre Island Dr (78408)
Rates: $79-$150
(361) 289-2500; (800) 228-5151

RAMADA LIMITED
5501 I-37 at McBride (78408)
Rates: $39-$149
(361) 289-5861; (800) 272-6232
(800) 894-5821

RED ROOF INN AIRPORT
6301 I-37 (78409)
Rates: $37-$175
(361) 289-6925; (800) 843-7663

RESIDENCE INN BY MARRIOTT
5229 Blanche Moore Dr (78411)
Rates: $89-$159
(361) 985-1113; (800) 331-3131

SURFSIDE CONDOMINIUM APARTMENTS
15005 Windward Dr (78418)
Rates: $120-$155
(361) 949-8128; (800) 548-4585

RECREATION

CORPUS CHRISTI BOTANICAL GARDENS & NATURE CENTER -
Leashes

Info: Visit this Edenesque spot and you and your flower sniffer will be treated to a cornucopia of nature. Interpretive trails, scenic overlooks, lush gardens (which include a hibiscus garden, orchid house, plumeria collection, rose garden and hummingbird garden), sun-splashed lakes, and the chance of wildlife sightings at every turn. For more information: (361) 852-2100.

Directions: Located at 8545 South Staples.

Note: $4/adult, $3.75/seniors & $1.50/child entrance fee.

Locate Other Dog-Friendly Activities...Check Nearby Cities

The numbered hikes that follow are within the
Corpus Christi Botanical Gardens & Nature Center:

1) BIRD AND BUTTERFLY TRAIL HIKE - Leashes

Beginner/0.50 miles

Info: If you're a bird lover at heart, this hike's for you. Bring your binoculars and aim for the skies as you and the dawgus dawdle amidst a mini-forest brimming with native habitat. This interpretive trail begins at the visitor's center, meanders to Palapa Grande on Gator Lake, loops around to the children's garden and passes an observation tower before looping back to the visitor's center. FYI, the observation tower is perfect for birdwatching and the views of Gator Lake are certainly worth a gander. For more information: (361) 852-2100.

Directions: Located at 8545 South Staples.

2) OSO CREEK TRAIL HIKE - Leashes

Beginner/3.0 miles

Info: Leave the hustle and bustle of city life behind as you and your pooch hike through a green oasis of nature. From mesquite brush and tall yuccas to retama scrub, verdant meadows and natural wetlands, this is a definite mellow out destination. Follow the Bird and Butterfly Trail from the Visitor's Center for a half-mile to Palapa Grande. The Oso Creek Trail branches off from the Wetlands Awareness Boardwalk. For more information: (361) 852-2100.

Directions: Located at 8545 South Staples.

HILLTOP NATURE AREA - Leashes

Info: Put a visit to this slice of nature at the top of your day's agenda and be greeted by a wooded wonderland filled with shade trees and sweet songbirds. Two miles of pathways crisscross the landscape, providing plenty of opportunity for solitude and reflection. For more information: (361) 241-3754.

Directions: Located at 11425 Leopard.

PADRE BALLI PARK

Info: Saunter over 374 acres of waterside landscape or pack a good read and find a spot where you can spend a day just relaxing outdoors. For more information: (361) 949-8122.

Directions: On the north end of Padre Island on Park Road 22.

PADRE ISLAND NATIONAL SEASHORE - Leashes

Info: Beachcomb, hike, lollygag or four-wheel drive over 80 miles of sandy seashore when you visit this vast stretch of natural beauty with your beach bum Bowser. Pack plenty of sunscreen, water and a beach umbrella for shade and get psyched for a great day of waterside fun. Savor the serenity of the Gulf or treat the pup to a tranquil sunset walk. For more information: (361) 949-8068; (800) 766-BEACH; www.nps.gov.

Directions: From Corpus Christi, take Padre Island Drive over JFK Causeway and follow to the end, turning right to reach the Padre Island National Seashore.

Note: Driving on the dunes is prohibited. Collection of live shells or animals is prohibited. Fill up your gas tank before setting out and tote your own water. Entrance fees vary.

CORRIGAN

RECREATION

BULL CREEK TRAIL HIKE - Leashes

Beginner/1.5 miles

Info: Hot diggety dogs give this looping, creekside trail two paws up, while tree hounds flip over the dense woodlands. As you mosey along spring-fed Bull Creek, interpretive signs will highlight the grabbag forest of magnolia, oak, maple, dogwood, pine, sweet and black gum trees. For more information: (936) 632-TREE.

Directions: From Corrigan, take Highway 287 west for 8.5 miles to the trailhead.

Locate Other Dog-Friendly Activities...Check Nearby Cities

CORSICANA

LODGING

DAYS INN
2018 Hwy 287 S (75110)
Rates: $37-$90
(903) 872-0659; (800) 329-7466

RAMADA INN
2000 S Hwy 287 (75110)
Rates: $49-$69
(903) 874-7413; (800) 272-6232

CROCKETT

LODGING

CROCKETT FAMILY RESORT & MARINA
Rt 3, Box 460 (75835)
Rates: $40-$60
(877) 544-8466

EMBERS MOTOR INN
1401 Loop 304 E (75835)
Rates: $25-$36
(936) 544-5681

CROCKETT INN
1600 Loop 304 E (75835)
Rates: $35+
(936) 544-5611; (800) 633-9518

RECREATION

DAVY CROCKETT NATIONAL FOREST

Davy Crockett Ranger District
Rt 1, Box 55-FS, Kennard, TX 75847,
(936) 655-2299; (936) 639-8501

Info: Play tagalong with your wagalong in the dense woodlands of this peaceful region. Comprised of nearly 162,000 acres, Davy Crockett National Forest is the reigning champ of Texas' national forests. Remote sloughs offer one-of-a-kind canoeing adventures, pine woodlands provide bonafido hiking excursions, while the Neches River gives you a chance to hone your fishing skills. This forest rates two paws up as a nature excursion extraordinare. Pack plenty of snacks and Perrier. For more information: (936) 655-2299; (936) 639-8501.

Directions: The forest lies within the boundaries of Houston and Trinity counties and is easily accessed via Highways 21, 7 and 94. Refer to specific directions following each recreation area and hiking trail. For more information on recreation in the Davy Crockett National Forest, see listings in Lufkin.

The numbered hikes/recreation areas that follow are within the Davy Crockett National Forest:

1) FOUR C NATIONAL RECREATION TRAIL HIKE - Leashes

Intermediate/1.0-40.0 miles

Info: Whether you backpack or daytrip it, you're in for some terrific Texas touring along this pine-scented trail. Your sniffmeister won't know where to turn his nose first in this big slice of doggie heaven. Shaded woodlands, boggy sloughs, upland forests and hardwood bottomlands are just the beginning. Your journey will also take you past sun-drenched lakes, panoramic overlooks, stocked ponds and even endangered species colonies. This trail has it all. Designated as a National Recreation Trail, the 20-mile long (40 miles roundtrip) 4-C is a picturesque route connecting Ratcliff Lake to the Neches Overlook. A cornucopia of nature, you and your lucky dog will follow a simple course beside abandoned tramways, through second and third growth forests, over sloughs and across streams. Along the way, white rectangular markers nailed to the trees keep you on the right track.

If splish-splashing antics equate to joyfulness for your wet wagger, this locale will be like paradise found. The forest is dotted with streams, ponds and lakes. Adventurous hounds will positively flip over the 300-foot pedestrian bridge that circles an old millpond and a 480-foot long raised walkway that crosses a boggy slough. Birders might get a chance to see the endangered red-cockaded woodpeckers, while fishing fiends can possibly score a catch in the man-made ponds. A car shuttle is recommended for those determined to hike the trail from beginning to end - you'll cut your mileage in half. For more information: (936) 655-2299; (936) 639-8501.

Locate Other Dog-Friendly Activities...Check Nearby Cities

Directions: From Crockett, take Highway 7 east for 20 miles to the Ratcliff Lake Recreation Area. The trailhead is located at the parking lot near the concession stand.

2) NECHES BLUFF RECREATION AREA - Leashes

Info: The combination of dense woodlands and Texas-style recreation is a must-see, must-do experience. Lush pine and hardwood forests atop skyhigh Neches Bluff form a perfect backdrop for a brown bagger with the wagger. Don't forget your camera and plenty of film. This place eats Kodak. For more information: (936) 655-2299; (936) 639-8501.

Directions: From Crockett, take Highway 21 northeast for 25 miles to FSR 511-3. Turn right on FSR 511-3 for one mile then turn left (north) and follow entrance road for one mile.

3) RATCLIFF LAKE RECREATION AREA - Leashes

Info: A water woofer's dream come true, 45-acre Ratcliff Lake is the main attraction of the area. From swimming, floating, fishing and boating, hours of wet and wild fun await you and your dirty dog. Landlubbers won't be disappointed either. Take your pick from several hiking trails where you'll have it made in the shade as you explore thick woodlands. Afishionados, dangle your line, the fishing's just fine. The lake is stocked with bass, bream and catfish. Sorry Charlie, doggie paddling is not permitted at the beach or the designated swimming area. For more information: (936) 655-2299; (936) 639-8501.

Directions: From Crockett, take Highway 7 east for 20 miles to the recreation area.

4) TALL PINE TRAIL HIKE - Leashes

Beginner/2.5 miles

Info: No bones about it, you and furface will get your share of pine-scented air and Texercise on this trail through lush woodlands. Après hiking, cool those tootsies in the refreshing lake. For more information: (936) 655-2299; (936) 639-8501.

Hotel Pet Policies May Be Subject To Change

Directions: From Crockett, take Highway 7 east for 20 miles to the Ratcliff Lake Recreation Area and the trailhead.

CROWELL

LODGING
CYNTHIA ANN PARKER COUNTRY INN
915 N 2nd St (79227)
Rates: $55-$65
(940) 684-1915

CRYSTAL CITY

LODGING
RIATA INN
1531 N Hwy 83 (78839)
Rates: $40-$70
(830) 374-5665

CUERO

LODGING
SANDS MOTEL & RV PARK
2117 N Esplanade (77954)
Rates: $32-$38
(512) 275-3437

DALHART

LODGING
BEST WESTERN NURSANICKEL MOTEL
102 Scott Ave (79022)
Rates: $48-$78
(806) 249-5637; (800) 528-1234
(800) 309-2399

BUDGET INN
415 Liberal St (79022)
Rates: $36-$69
(806) 244-4557

COMFORT INN
1110 Hwy 54 E (79022)
Rates: $65-$90
(806) 249-8585; (800) 228-5150

DAYS INN
701 Liberal St (79022)
Rates: $75-$109
(806) 244-5246; (800) 329-7466

HOLIDAY INN EXPRESS
801 Liberal St (79022)
Rates: $79-$99
(806) 249-1145; (800) 465-4329

SANDS MOTEL
301 Liberal St (79022)
Rates: $25-$70
(806) 244-4568

SUPER 8 MOTEL
403 Tanglewood Rd (79022)
Rates: $49-$65
(806) 249-8526; (800) 800-8000

DALLAS

LODGING

ADOLPHUS, THE
1321 Commerce St (75202)
Rates: $130-$415
(214) 742-8200

AMERISUITES GALLERIA
5229 Spring Valley Rd (75240)
Rates: $99-$109
(972) 716-2001; (800) 833-1516

AMERISUITES PARK CENTRAL
12411 N Central Expy (75243)
Rates: $99-$119
(972) 456-1224; (800) 833-1516

AMERISUITES WEST END
1907 N Lamar St (75202)
Rates: $149-$159
(214) 999-0500; (800) 833-1516

BEST WESTERN TELECOM AREA SUITES
13636 Goldmark Dr (75240)
Rates: $79-$89
(972) 669-0478; (800) 528-1234

BRISTOL HOUSE SUITES-PARK CENTRAL
7880 Alpha Rd (75240)
Rates: $114-$129
(972) 391-0000

BUDGET SUITES-MARKET CENTER
8150 Stemmons Frwy (75247)
Rates: $59-$79
(877) 822 -5272

CANDLEWOOD SUITES-MARKET CENTER
7930 N Stemmons (75247)
Rates: $74-$144
(214) 631-3333; (800) 465-4329

CANDLEWOOD SUITES-GALLERIA
13939 Noel Rd (75240)
Rates: $49-$119
(972) 233-6888; (800) 465-4329

CANDLEWOOD SUITES-NORTH
12525 Greenville Ave (75243)
Rates: $69-$99
(972) 669-9606; (800) 465-4329

Hotel Pet Policies May Be Subject To Change

COMFORT INN GALLERIA
14975 Landmark Blvd (75240)
Rates: $69-$125
(972) 701-0881; (800) 228-5150

COMFORT INN SOUTH
8541 S Hampton Rd (75232)
Rates: $69-$120
(972) 572-1020; (800) 228-5150

CROWNE PLAZA HOTEL/RESORT-MARKET CENTER
7050 Stemmons Frwy (75247)
Rates: $119-$179
(214) 630-8500; (800) 227-6963

CROWNE PLAZA SUITES/RESORT-DALLAS PARK
7800 Alpha Rd (75240)
Rates: $79-$139
(972) 233-7600; (800) 227-6963

DOUBLETREE CLUB HOTEL
8102 LBJ Frwy (75251)
Rates: $59-$89
(972) 960-6555; (800) 222-8733

DRURY INN & SUITES-DALLAS NORTH
2421 Walnut Hill Ln (75229)
Rates: $63-$97
(972) 484-3330; (800) 378-7946

ECONO LODGE
2275 Valley View Lane (75234)
Rates: $45-$65
(972) 243-5500; (800) 553-2666

EMBASSY SUITES HOTEL-DALLAS/ PARK CENTRAL
13131 N Central Expwy (75243)
Rates: $89-$143
(972) 234-3300; (800) 362-2779

EMBASSY SUITES MARKET CENTER
2727 Stemmons Frwy (75207)
Rates: $99-$219
(214) 630-5332; (800) 362-2779

FAIRMONT HOTEL
1717 N Akard St (75201)
Rates: $129-$309
(214) 720-2020; (800) 527-4727

HAWTHORN SUITES-MARKET CENTER
7900 Brookriver Dr (75247)
Rates: $79-$159
(214) 688-1010; (800) 527-1133

HEARTHSIDE SUITES BY VILLAGER
12301 N Central Expwy (75243)
Rates: $59-$99
(972) 716-0600

HEARTHSIDE SUITES BY VILLAGER
10326 Finnell St (75220)
Rates: $59-$99
(214) 904-9666

HOLIDAY INN EXPRESS
13185 N Central Expwy (75243)
Rates: $59-$75
(972) 907-9500; (800) 465-4329

HOLIDAY INN EXPRESS-LOVE FIELD
2370 W Northwest Hwy (75220)
Rates: $69-$79
(214) 350-5577; (800) 465-4329

HOLIDAY INN SELECT DALLAS CENTRAL
10650 N Central Expwy (75231)
Rates: $129-$350
(214) 373-6000; (800) 465-4329

HOMESTEAD STUDIO SUITES
17425 N Dallas Pkwy (75287)
Rates: $39-$54
(972) 447-1800; (888) 782-9473

HOMESTEAD STUDIO SUITES
12121 Coit Rd (75251)
Rates: $49-$64
(972) 663-1800; (888) 782-9473

HOMESTEAD STUDIO SUITES/PLANO
18470 N Dallas Pkwy (75287)
Rates: $64-$79
(972) 248-2233; (888) 782-9473

Locate Other Dog-Friendly Activities...Check Nearby Cities

HOMEWOOD SUITES BY HILTON
2747 N Stemmons Frwy (75207)
Rates: $86
(214) 819-9700; (800) 225-5466

HOMEWOOD SUITES BY HILTON
9169 Markville Dr (75243)
Rates: $109
(972) 437-6966; (800) 225-5466

HOTEL CRESCENT COURT
400 Crescent Court (75201)
Rates: $365-$2500
(214) 871-3200; (800) 654-6541

HOTEL DALLAS MOCKINGBIRD
1893 W Mockingbird Ln (75235)
Rates: $49-$109
(214) 634-8850

HOTEL ST. GERMAIN
2516 Maple Ave (75201)
Rates: $290-$650
(214) 871-2516

HOTEL ZAZA
2332 Leonard St (75201)
Rates: $275-$2000
(214) 468-8399

LA QUINTA INN-DALLAS CITY PLACE
4440 N Central Expwy (75206)
Rates: $80-$100
(214) 821-4220; (800) 687-6667

LA QUINTA INN- DALLAS EAST
8303 E R L Thornton Frwy (75228)
Rates: $60-$81
(214) 324-3731; (800) 687-6667

LA QUINTA INN LOVE FIELD
1625 Regal Row (75247)
Rates: $50-$80
(214) 630-5701; (800) 687-6667

LA QUINTA INN RICHARDSON
13685 N Central Expwy (75243)
Rates: $50-$70
(972) 234-1016; (800) 687-6667

LA QUINTA INN & SUITES NORTHPARK
10001 N Central Expwy (75231)
Rates: $80-$121
(214) 361-8200; (800) 687-6667

LA QUINTA INN & SUITES NORTHWEST
2380 W Northwest Hwy (75220)
Rates: $59-$79
(214) 904-9955; (800) 687-6667

MAGNOLIA HOTEL DALLAS
1401 Commerce St (75201)
Rates: $159-$230
(214) 915-6500

THE MANSION ON TURTLE CREEK
2821 Turtle Creek Blvd (75219)
Rates: $400-$2400
(214) 559-2100; (800) 527-5432

MARRIOTT SUITES MARKET CENTER
2493 N Stemmons Frwy (75207)
Rates: $79-$199
(214) 905-0050; (800) 228-9290

THE MELROSE HOTEL
3015 Oak Lawn Ave (75219)
Rates: $249-$1500
(214) 521-5151

MOTEL 6
8108 E R L Thornton Frwy (75228)
Rates: $41-$65
(214) 388-8741; (800) 466-8356

MOTEL 6
10335 Gardner Rd (75220)
Rates: $36-$54; (972) 506-8100
(800) 466-8356

MOTEL 6 NORTH
2753 Forest Ln (75234)
Rates: $35-$51
(972) 620-2828; (800) 466-8356

MOTEL 6 SOUTH
2660 Forest Ln (75234)
Rates: $33-$56
(972) 484-9111; (800) 466-8356

Hotel Pet Policies May Be Subject To Change

MOTEL 6-SOUTHEAST
4220 Independence Dr (75237)
Rates: $35-$42
(972) 296-3331; (800) 466-8356

RADISSON HOTEL CENTRAL/DALLAS
6060 N Central Expwy (75206)
Rates: $139-$159
(214) 750-6060; (800) 333-3333

RED ROOF INN MARKET CENTER
1550 Empire Central Dr (75235)
Rates: $39-$59
(214) 638-5151; (800) 843-7663

RED ROOF INN-NORTHWEST
10335 Gardner Rd (75220)
Rates: $45-$60
(972) 506-8100; (800) 843-7663

RENAISSANCE HOTEL MARKET CENTER
2222 Stemmons Frwy (75207)
Rates: $89-$199
(972) 631-2222; (800) 228-9898

**RESIDENCE INN BY MARRIOTT/
CENTRAL-N.PARK**
10333 N Central Expwy (75231)
Rates: $126-$165
(214) 750-8220; (800) 331-3131

**RESIDENCE INN BY MARRIOTT-
MARKET CENTER**
6950 N Stemmons Frwy (75247)
Rates: $79-$119
(214) 631-2472; (800) 331-3131

**RESIDENCE INN BY MARRIOTT-
PARK CENTRAL**
7642 LBJ Frwy (75251)
Rates: $69-$159
(972) 503-1333; (800) 331-3131

SHERATON BROOKHOLLOW HOTEL
1241 W Mockingbird Ln (75247)
Rates: $59-$119
(214) 630-7000; (800) 325-3535

SHERATON SUITES MARKET CENTER
2101 Stemmons Frwy (75207)
Rates: $219-$229
(214) 747-3000; (800) 325-3535

STERLING HOTEL DALLAS
1055 Regal Row (75247)
Rates: $69-$79
(214) 634-8550

STONELEIGH HOTEL
2927 Maple Ave (75201)
Rates: $119-$199
(800) 255-9299

STUDIO 6
2395 Stemmons Tr (75220)
Rates: $199-$269
(214) 904-1400; (888) 892-0202

**WELLESLEY INN & SUITES
PARK CENTRAL**
9019 Vantage Point Rd (75243)
Rates: $69-$79
(972) 671-7722; (800) 444-8888

WESTIN-CITY CENTER DALLAS
650 N Pearl St (75201)
Rates: $109-$149
(214) 979-9000; (800) 228-3000

WESTIN HOTEL GALLERIA DALLAS
13340 Dallas Pkwy (75240)
Rates: $199-$359
(972) 934-9494; (800) 228-3000

WESTIN HOTEL PARK CENTRAL
12720 Merit Dr (75251)
Rates: $239-$259
(972) 385-3000; (800) 228-3000

WINGATE INN
8650 N Stemmons Frwy (75247)
Rates: $89-$109
(214) 267-8400

Locate Other Dog-Friendly Activities...Check Nearby Cities

RECREATION

ALLEN PARK - Leashes

Info: When play's the thing, this park's the stage with 27 acres of open space for you and the dogster to explore.

Directions: Located in Simpson Stuart at 7071 Bonnie View Rd.

ALTA MESA PARK - Leashes

Info: Pack a fun attitude and a couple of snacks and then set out for this 22-acre park.

Directions: Located in Simpson Stuart at 2905 Alta Mesa.

ANDERSON-BONNER PARK - Leashes

Info: Do a little Texas touring on the 1.3-mile walking trail or kick back and catch a local ball game.

Directions: Located in Hillcrest at 12000 Park Central Drive.

ASH CREEK GREENBELT - Leashes

Info: Play tagalong with your wagalong on over 30 acres of grounds.

Directions: Located in Lakeland at the 7026, 7027 & 7031 blocks of Ferguson.

BACHMAN CREEK GREENBELT - Leashes

Info: Take your bark for a lark in the park and set tails a-wagging with a walk through this pleasant 58-acre region.

Directions: Located in Love Field at the 3900 Block of Shorecrest Drive.

BACHMAN LAKE PARK - Leashes

Info: Grab your gadabout and do a roundabout along the 3-mile trail in this local green scene.

Directions: Located in Love Field at 3500 Northwest Highway.

BARK PARK CENTRAL (OFF-LEASH FACILITY)

Info: The City of Dallas Parks & Recreation Department dedicated this "bark park" for the enjoyment of all pooches and their people. Bark Park Central is the place for the dogster to socialize with other canines in leashless abandon. For more information: (214) 670-4100.

Directions: Located at the southwest corner of Good-Latimer and Commerce Street.

Note: Dogs should always be leashed outside of the Off-Leash area.

BOREN PARK - Leashes

Info: Every dog should have his day. Make this one special for yours with some pooch shenanigans on 30 acres of open fields.

Directions: Located in Cedar Crest at 2700-2900 Van Cleave.

BOULDER PARK - Leashes

Info: Say goodbye to the summer doldrums and spend an afternoon cloudgazing with your best pal in this 100-acre expanse.

Directions: Located in Red Bird at 3200 Red Bird Lane.

BROOKS PARK - Leashes

Info: Perk up your day with a turn around the 1.2-mile walkway or find a shady spot for a brown bagger with your tailwagger in this 28-acre neighborhood parkland.

Directions: Located in Hillcrest at 6800-7100 Merriman Parkway.

CALIFORNIA CROSSING PARK - Leashes

Info: If you're in the neighborhood, pop into to this parkland for some puppy playtime.

Directions: Located in Stemmons North at 1400 California Crossing Road.

CAMPBELL GREEN PARK - Leashes

Info: Take a turn or two on the quarter-mile pathway for your morning constitutional or search out a shady spot and munch on lunch with the dawgus.

Directions: Located in Prestonwood at 16600 Hillcrest.

CEDAR HILL STATE PARK - Leashes

Info: Find a secluded spot within this 1800-acre park and let your leashed aquapup cool off in the refreshing water. Pack a fishing pole - catfish, crappie and bass are abundant. Lucky dogs might snag a catch and then eat a batch at one of the picnic tables overlooking the lake. For more information: (972) 291-3900; (800) 792-1112; www.tpwd.state.tx.us.

Directions: From Dallas, head west on Interstate 20, exiting FM 1382. Go south (left) on FM 1382 for 3 miles to the park

Note: $3 entrance fee/person.

CEDAR RIDGE PRESERVE - Leashes

Info: Treat your cityslicker to an afternoon of peace and solitude in a paradise of nature. You and the dawgus can chart your own course through this 630-acre preserve or hop on one of the paw-friendly hiking trails (including a shorter trail for the handicapped). Whether your explorations lead to the preserve's top land (Austin Chalk) or bottomland (Eagleford Shale), keep an eye out for the resident birds, mammals and reptiles. At day's end, break bread and biscuits with Bowser before heading home. Bone appetite! For more information: (972) 293-5150; www.audubondallas.org.

Directions: Take I-20 to Mountain Creek Parkway exit and go south 2.5 miles to 7171 Mountain Creek Parkway.

Note: $3/car donation is requested. Hours: 7 am to dusk, closed Mondays.

The numbered hikes that follow are within the Cedar Ridge Preserve:

1) CATTAIL POND TRAIL HIKE - Leashes

Intermediate/2.2 miles

Info: Make tracks to the most pupular trail in the preserve and you won't be disappointed. About halfway into your hike, you'll reach an observation deck with terrific views of Joe Pool Lake, the Mesquite Prairie and the Fort Worth skyline. When you've had your scenic fill, continue on to Cattail Pond where you can relax with Max pondside before retracing your paw prints to the trailhead. For more information: (972) 293-5150; www.audubondallas.org.

Directions: Take I-20 to Mountain Creek Parkway exit and go south 2.5 miles to 7171 Mountain Creek Parkway.

2) CEDAR BRAKE TRAIL HIKE - Leashes

Intermediate/Expert/2.5 miles

Info: This trail is definitely not for the fair of paw or the out of shape. Before reaching the trail's namesake, you and your hardy hound are in for a calorie burning workout on the preserve's steepest slopes. Take a trail mix/biscuit break under one of the towering cedars before doing the descent thing. For more information: (972) 293-5150; www.audubondallas.org.

Directions: Take I-20 to Mountain Creek Parkway exit and go south 2.5 miles to 7171 Mountain Creek Parkway.

3) ESCARPMENT ROAD TRAIL HIKE - Leashes

Beginner/2.25 miles

Info: Scenic and cinchy, this trail from the visitor's center to Cattail Pond is perfect for sofa loafers. At the pond, kick back and contemplate the tranquility of your surroundings before heading home. For more information: (972) 293-5150; www.audubondallas.org.

Directions: Take I-20 to Mountain Creek Parkway exit and go south 2.5 miles to 7171 Mountain Creek Parkway.

Locate Other Dog-Friendly Activities...Check Nearby Cities

4) FOSSIL VALLEY TRAIL HIKE - Leashes

Intermediate/Expert/2.8 miles

Info: No bones about it, this trail is a butt-kicker from the get-go. Consisting of a series of steep ascents and descents, you and your Herculean hound will definitely fulfill your exercise quotient on this hike. Take a break at Cattail Pond - your turn-around point -before retracing your steps. For more information: (972) 293-5150; www.audubondallas.org.

Directions: Take I-20 to Mountain Creek Parkway exit and go south 2.5 miles to 7171 Mountain Creek Parkway.

5) LITTLE BLUESTEM TRAIL HIKE - Leashes

Beginner/0.25 miles

Info: The city tempo will seem worlds away on this easy trail through a wildflower prairie. To witness the best of what this trail has to offer, plan a spring or fall hike when the prairieland explodes in a kaleidoscope of color. For more information: (972) 293-5150; www.audubondallas.org.

Directions: Take I-20 to Mountain Creek Parkway exit and go south 2.5 miles to 7171 Mountain Creek Parkway.

6) POSSUM HAW TRAIL HIKE - Leashes

Beginner/0.75 miles

Info: Sunday strollers, this trail's for you. Take the time to smell the flowers and admire the various ecosystems which comprise the Cedar Ridge Preserve. For more information: (972) 293-5150; www.audubondallas.org.

Directions: Take I-20 to Mountain Creek Parkway exit and go south 2.5 miles to 7171 Mountain Creek Parkway.

CRAFT PARK - Leashes

Info: The sun shimmers and glistens on the soft dewy grass in this pretty park. Nab a bit of Texercise on the 1.4-mile path-

way that skirts this 21-acre community-minded green scene.

Directions: Located in Fair Park at 4500 Spring Avenue.

CRAWFORD PARK - Leashes

Info: Get lost in your thoughts as you stroll on either the one-mile paved pathway or the .75-mile unpaved trail. If picnicking tickles your fancy, you'll find over 50 sites to choose from. Or make your own cozy nest on a grassy knoll and dine with your canine.

Directions: Located in Elam at 8700 Elam Road.

DALLAS DOG PARK OFF-LEASH AREA

Info: Located at the north end of White Rock Lake, the one with the waggily tail will give you puppy kisses for taking him to this 1-acre off-leash play area. For more information: (214) 670-4100.

Directions: 8000 East Mockingbird Lane.

Note: Dogs should always be leashed outside of the Off-Leash area.

DEVON-ANDERSON PARK - Leashes

Info: Furface will love jumpstarting the day in the open fields of this friendly neighborhood parkland.

Directions: Located in Jim Miller at 1525 Devon.

DIXON'S BRANCH GREENBELT - Leashes

Info: Puppy paradise could be another name for this lush 70-acre, riparian region. Fun and games can be yours as you carouse creekside with your canine companion and kiss your cares goodbye. Or pack a brown bagger and munch on lunch.

Directions: Located in White Rock on Peavy Road North. The greenbelt runs alongside Dixon Branch Creek.

EMERALD LAKE PARK - Leashes

Info: Do some Texas dreaming as you do the stroll along the grounds of this 62-acre jewel. Pack some snacks and Perrier and have a laid-back kind of day.

Directions: Located in Mountain Creek on Vista Hill.

ESCARPMENT GREENBELT - Leashes

Info: Put this plush park at the top of your itinerary and you'll experience a memorable outing on over 600 acres of greenery. Pack a biscuit basket and end the day on a special note.

Directions: Located in Mountain Creek on Florina-Danieldale Road.

ESCARPMENT GREENBELT (KEENLAND) - Leashes

Info: Make the most of a cool morning with a saunter through more than 30 acres of undeveloped land in this urban greenbelt.

Directions: Located in Cliff Hill at 5500 Block Keenland Parkway.

FAIR OAKS PARK - Leashes

Info: Sports fans can root for the home team at this popular 233-acre park. Or work off some calories with a brisk walk on the one-mile pathway. Happy tails to you.

Directions: Located in Vickery at 7600 Fair Oaks.

FISH TRAP LAKE - Leashes

Info: Amble along the shoreline on the .6-mile trail or find a shade tree and break some bread and biscuits with Bowser. Whatever your pleasure, 46 acres of lakeside tranquility await your exploration.

Directions: Located in West Dallas at 2400 Toronto.

FLAGPOLE HILL PARK - Leashes

Info: Destination Greenland, Texas style. A sun-streaked landscape and over 90 acres of thick grass will definitely shift the wagger's tail into overdrive. Pack a good read, a favorite chew and find yourself a shady knoll. This park is one great way to spend the day.

Directions: Located in Lake Highlands on Doran Circle.

FOX HOLLOW PARK - Leashes

Info: Happy days begin with a walk on the .3-mile trail and end with a game of catch and fetch in this park's 36 acres. Go ahead, put a smile on the ballmeister's mug.

Directions: Located in Mountain Creek on Eagle Ford Drive.

FRETZ PARK - Leashes

Info: Do something different for a change and start your day with some sunshine and playtime at this 31-acre grassy expanse.

Directions: Located in Prestonwood at 6950 Belt Line Road.

GATEWAY PARK - Leashes

Info: For a doggone great park experience, don't miss this place. 110 acres means lots of room for a lucky dog to run and play. Bring a biscuit or two, there are cozy spots all about.

Directions: Located in Jim Miller at 6900 Bruton Road.

GLENDALE PARK - Leashes

Info: The local bark park, you're sure to meet and greet lots of neighborhood pooches. Drop in before or after the work day and do a bit of socializing. There's also a 1.7-mile trail that lets you unwind as you hightail it through this attractive green scene.

Directions: Located in Singing Hills at 1300 East Ledbetter Drive.

Locate Other Dog-Friendly Activities...Check Nearby Cities

GRAUWYLER PARK - Leashes

Info: Plan a kibble cookout for you and Fido in this friendly, 27-acre community park equipped with ball fields and basketball courts for sports enthusiasts.

Directions: Located in Love Field at 7500 Harry Hines Boulevard.

JACKSON PARK - Leashes

Info: When walk time calls, answer it with a visit to this 45-acre open expanse and make yours feel like a lucky dog. Don't forget a fuzzy tennie and a fun attitude.

Directions: Located in Renner at 4900 Haverwood.

KIDD SPRINGS PARK - Leashes

Info: Lots of room and more than 100 picnic tables can be yours at this park. Go ahead, make your dog's day.

Directions: Located in Kessler-Stevens at 700 West Cantry Street.

KIEST PARK - Leashes

Info: Leave the crowds behind and find a special place to call your own in this huge urban oasis. Watch tails swing in the breeze as you hustle along the 2.4-mile trail that laces this splendid 258-acre park.

Directions: Located in Kiest at 3080 South Hampton Road.

KINGSBRIDGE PARK - Leashes

Info: End a warm summer afternoon with an interlude in this 36-acre park. There's bound to be a softball game in progress; pick a team and simply spectate.

Directions: Located in West Dallas at 3400 Kingsbridge.

KLEBERG PARK - Leashes

Info: Join the doggie social set at this friendly neighborhood meeting spot where 26 acres spell fun times for canines.

Directions: Located in Kleberg at 1515 Edd Road.

LAKE CLIFF PARK - Leashes

Info: Wander through this lovely setting with your sidekick or find a shaded nook where you can kick back and nibble on some kibble.

Directions: Located in Kessler-Stevens at 300 East Colorado.

LAKE HIGHLANDS PARK - Leashes

Info: When push comes to shove and play time wins out, set your sights on this parkland's 25 scenic acres.

Directions: Located in Lakeland at 1000 Buckner at Lake Highlands.

LAKE HIGHLANDS NORTH PARK - Leashes

Info: Put a little zip in your morning schedule with a jaunt on the one-mile trail. And if you've got the time, this park's got the place for a quiet brown bagger with the wagger.

Directions: Located in Lake Highlands at 9344 Church Road.

LAWNVIEW PARK - Leashes

Info: Sports fans will love this active park. Catch a local soccer game or just vege out on the cool grass.

Directions: Located in Urbandale at 5500 Seyene Road.

LEMMON PARK - Leashes

Info: When you're looking for fun, you might just find it in this 27-acre neighborhood park.

Directions: Located in Simpson Stuart at 6100 J.J. Lemmon.

Locate Other Dog-Friendly Activities...Check Nearby Cities

MARCUS PARK - Leashes

Info: Sunday strollers, take a leisurely turn or two on the .3-mile trail that skirts this 15-acre park.

Directions: Located in Letot at 3003 Northhaven Road.

MARSHALL PARK - Leashes

Info: When the dog days of summer seem endless, get out early and start the day off right with a visit to this 24-acre community parkland.

Directions: Located in Red Bird at 5150 Mark Trail Way.

MCCOMMAS BLUFF PARK - Leashes

Info: If your woofer's a hoofer, you'll want to make tracks to this 110-acre preserve. A 2-mile, soft-surface trail will definitely get the lead out and let the dawgus feel like a champ.

Directions: Located in Dowdy Ferry at Fairport Road.

MOORE PARK - Leashes

Info: Telly bellies, give the pooch an afternoon outing in this oh so active 24-acre community park.

Directions: Located in Cedar Crest at 1900 East Eighth Street.

MOSS PARK - Leashes

Info: Wiggle your way along the 1.25-mile trail that laces this 280-acre regional expanse. You'll find plenty of pupportunities for relaxation and fun in the sun.

Directions: Located in Lake Highlands at 8000 Greenville.

MOUNTAIN CREEK LAKE PARK - Leashes

Info: Give the dawgus something to bark home about with a sojourn to this 4,500-acre regional expanse. Pack a biscuit basket and do lunch à la blanket with the pet. Birdwatchers, point those binocs skyward and see what's a-fly or kick back on a

Hotel Pet Policies May Be Subject To Change

grassy knoll and cloudgaze the day away. For more information: (214) 670-4100.

Directions: Located in Mountain Creek at 3436 Florina.

NETHERLAND PARK - Leashes

Info: Get your daily dose of Texercise as you do a few laps around the .25-mile trail in this pretty peanut of a park.

Directions: Located in Walnut Hill at 5600 Dittmar.

NICK TRACT - Leashes

Info: For a doggone great outing, shake a leg in this expansive region. More than 75 acres let you and the dogster do your own thing in your own time.

Directions: Located in South Dallas at Claypool Road, south of Seyene.

NORBUCK PARK - Leashes

Info: Bowwow! This community preserve encompasses 100 acres for you and furface to explore. The pretty landscape is a lovely backdrop for a day in nature. If you're in the mood to spectate, you're likely to encounter a ballgame or two. Happy tails to you.

Directions: Located in White Rock at 200 North Buckner Boulevard.

NORTHAVEN PARK & GREENBELT - Leashes

Info: Soak up some scenery and greenery in this 21-acre park or play a game of tagalong with your wagalong.

Directions: Located in Park Forest at 3800 Northaven.

NORTHWOOD PARK - Leashes

Info: The .4-mile track in this park is a perfect place to take your pup for his daily constitutional.

Directions: Located in Prestonwood at 8500 Royal Lane and Ashcroft.

OAK CLIFF FOUNDERS PARK - Leashes

Info: Do a few turns on the quarter-mile walkway in this 15-acre park and you'll get your day off to a fresh start.

Directions: Located in Kessler-Stevens at 300 East Colorado Boulevard.

ORBITER PARK - Leashes

Info: You and Astropup can run circles around Orbiter Park on the .5-mile pathway or just be lazy bones and do nothing but relax.

Directions: Located in Lake Highlands at 9100 Orbiter Drive.

OWEN PARK - Leashes

Info: There's lots of roaming room for you and the pupster to peruse in this 26-acre community park.

Directions: Located in Lake Highlands at 10700 Kingsley Road.

PARK IN THE WOODS - Leashes

Info: A sun-dappled landscape presents a pretty picture in this woodsy community parkland. You'll have over 25 acres to explore, so pack plenty of Perrier and a brown bagger for you and the pooch to enjoy.

Directions: Located in Mountain Creek at Florina-Danieldale Road.

PHELPS PARK - Leashes

Info: Do some puppy prancing on the .8-mile trail or plan lunch alfresco with your furry friend.

Directions: Located in Cedar Crest at 3000 Tips Boulevard.

Hotel Pet Policies May Be Subject To Change

PLEASANT OAKS PARK - Leashes

Info: Put a little zip in your day with an outing to this 21-acre community park.

Directions: Located in Bruton at 8700 Greenmound.

REVERCHON PARK - Leashes

Info: Make some new friends, both the human and canine kind at this bustling-with-activity community park.

Directions: Located in Oak Lawn at 3505 Maple.

ROBERTSON PARK - Leashes

Info: Grab your pooch, pack your sack and leave your troubles in the city with a visit to this regional green scene. More than 250 acres of paw-stomping terrain will make your dog's day. Carpe diem Duke.

Directions: Located in Ray Hubbard at Interstate 30 and Dalrock Road.

ROCHESTER PARK - Leashes

Info: For a bonafido adventure in the midst of Mother Nature, you can't go wrong at this 1000-acre expanse. Tails will be wagging in the breeze as you hightail it through the tree-strewn, sunny landscape.

Directions: Located in South Dallas at 3000 Rochester.

ROSEMEADE PARK - Leashes

Info: Left in an undeveloped state, this community park offers mucho acres where you and your hot diggety dog can make your own fun. Pack plenty of Perrier, a fuzzy tennie and a playful attitude.

Directions: Located in Renner at Marsh Lane and Rosemeade.

Locate Other Dog-Friendly Activities...Check Nearby Cities

SHAPIRO PARK - Leashes

Info: Put some pleasure in your pup's day with a stop at this park. You can even get an aerobic workout along the one-mile trail.

Directions: Located in Vickery at Skillman to West Lawther.

SIMONDS PARK - Leashes

Info: Let the good times roll in the 200 acres of open space you'll find at this undeveloped region. Pack a biscuit basket and end your day with an outdoor repast.

Directions: Located in Kleberg at Bowers Road.

SINGING HILLS PARK - Leashes

Info: You and your mutt can strut your stuff on the quarter-mile pathway in this 17-acre community parkland.

Directions: Located in Singing Hills at 1919 Crouch.

ST. AUGUSTINE PARK - Leashes

Info: Savor the sun-streaked landscape in this 22-acre neighborhood setting.

Directions: Located in Bruton at 1500 North St. Augustine.

TENISON PARK - Leashes

Info: A picnicker's paradise, this regional oasis offers 54 picnic perfect tables and 32 acres of paw-stomping space.

Directions: Located in East Dallas at 3500 Samuell Boulevard.

TIPTON PARK - Leashes

Info: You and lazy bones can take a leisurely stroll or merely soak up some afternoon sun in this 23-acre park.

Directions: Located in Trinity at 3607 Magdeline.

Hotel Pet Policies May Be Subject To Change

TRINITY RIVER PARK - Leashes

Info: Say ta ta to the summertime doldrums with an excursion to this 3,000-acre undeveloped parkland. There might even be some splish-splashing shenanigans in your soon-to-be-dirty dog's future.

Directions: Located in Stemmons North from Spur 482 to Corinth Street.

VALLEY VIEW PARK - Leashes

Info: Make tracks on the .7-mile trail or munch on lunch with your best buddy in this 27-acre community playland.

Directions: Located in Prestonwood at 7000 Valley View Road.

WHEATLAND PARK - Leashes

Info: You'll find splendor in the grass and coolness in the shaded landscape of this pleasant urban green scene.

Directions: Located in Red Bird at 700 Wheatland Road.

WHITE ROCK LAKE PARK - Leashes

Info: Get along with your little doggie to this amazing urban oasis. Birdwatching, fishing and hiking are popular activities, so pack accordingly. More than 11 miles of trails honeycomb the 1800-acre region. Pick a pathway and see what's in store for you and the dogster. When you've had your fill of energized activity, kick back and cool off lakeside. For more information: (214) 670-4100 or (214) 670-8958.

Directions: Located in Skillman at 8300 Garland Road.

WONDERVIEW PARK - Leashes

Info: Take to the half-mile trail for a smidgen of Texercise in this 6-acre neighborhood park.

Directions: Located in Cedar Crest at 2704 Wonderview Way.

Locate Other Dog-Friendly Activities...Check Nearby Cities

WOODLAND SPRINGS PARK - Leashes

Info: Sports enthusiasts can pick their pleasure in this action-packed park equipped with basketball and volleyball courts. Quieter breeds can stroll the area's 35 acres to find that perfect, get-away-from-it-all place.

Directions: Located in Dowdy Ferry at 7321 Fairport.

OTHER PARKS IN DALLAS - Leashes

For more information on the following parks, contact the Dallas Parks & Recreation Department at (214) 670-4100.

PARKS IN DALLAS - Leashes

- ASTON PARK, 1919 Pacific
- BROWDER STREET MALL PARK, at 200 Block of Browder
- CENTRAL SQUARE, 3000 Swiss Avenue
- DEALEY PLAZA, 400 Main Street
- ELM AT PEARL PARK, at 2100 Elm
- ENERGY PLAZA, 1600 Bryan
- EXALL PARK, 3500 Live Oak
- EXPOSITION PLAZA PARK, at Exposition & Canton Streets
- FEDERAL PLAZA PARK, 1900 Federal Street
- FERRIS PLAZA PARK, 400 South Houston
- FOUNDERS SQUARE, 1000 Jackson
- FOUR-WAY PLACE MALL, 140 Elm Street
- GRIGGS PARK, 2200 Hugo
- HERITAGE WAY, 600 Pearl Street
- LINCOLN PARK, Akard & Bullington Streets
- LUBBEN PLAZA, 701 Young Street
- MARCUS PARK, at Flora & Pearl
- MARTYR'S PARK, 265 Commerce Street
- PACIFIC PLAZA, 2000 Pacific Avenue
- PEGASUS PLAZA, Akard & Main Streets
- PHELPS PARK, Cedar Springs at Pearl Street
- PIKE PARK, 2800 Harry Hines
- RAY PARK, 2010 North Washington Street
- REUNION PARK, Reunion Boulevard & Sports Street
- SAN JACINTO PLAZA, St. Paul at San Jacinto

Hotel Pet Policies May Be Subject To Change

- STONE PLACE MALL, 100 Stone Place
- ZONTA PARK, 1300 Young

PARKS IN EAST DALLAS - Leashes

- BUCKNER PARK, 4550 Worth Street
- COCHRAN PARK, 2600 North Henderson
- CROCKETT PARK, at Carroll & Victor
- GARRETT PARK, 5100 Bryan Street
- HARRELL PARK, 6401 Gaston
- LINDSLEY PARK, 7100 Lindsley Avenue

DAVY CROCKETT NATIONAL FOREST

Davy Crockett Ranger District
Rt 1, Box 55-FS, Kennard, TX 75847,
(936) 897-1068; (936) 655-2299

Info: Play tagalong with your wagalong in the dense woodlands of this peaceful region. Comprised of nearly 162,000 acres, Davy Crockett National Forest is the reigning champ of Texas' national forests. Remote sloughs offer one-of-a-kind canoeing adventures, pine woodlands provide bonafido hiking excursions, while the Neches River gives you a chance to hone your fishing skills. This forest rates two paws up as a nature excursion extraordinare. Pack plenty of snacks and Perrier. For more information: (936) 655-2299.

Directions: The forest lies within the boundaries of Houston and Trinity counties and is easily accessible via Highways 21, 7 and 94. Contact the Davy Crockett Ranger District in Kennard at (936) 897-1068 for specific directions following each recreation area and hiking trail.

For more information on recreation in the Davy Crockett National Forest, see listings under the following cities: Crockett and Lufkin.

DE SOTO

LODGING

RED ROOF INN
1401 N Beckley Dr (75115)
Rates: $36-$54
(972) 224-7100
(800) 843-7663

DECATUR

LODGING

BEST WESTERN INN
1801 Hwy 287 S (76234)
Rates: $55-$85
(940) 627-5982
(800) 528-1234; (800) 399-1553

COMFORT INN
1709 Hwy 287 S (76234)
Rates: $54-$110
(940) 627-6919; (800) 228-5150

DAYS INN & SUITES
1900 S Trinity St (76234)
Rates: $60-$105
(940) 627-2463; (800) 329-7466

DECATUR MANOR GUEST HOUSE
500 W Walnut St (76234)
Rates: $59-$99
(940) 627-3079

PAINTED VALLEY RANCH B&B
1724 W Preskitt Rd (76234)
Rates: $89-$129
(940) 627-8056; (888) 817-6377

DEL RIO

LODGING

AMISTAD LODGE MOTEL
Hwy 90 W (78840)
Rates: $31+
(830) 775-8591

ANGLER'S LODGE MOTEL
Hwy 90 W (78840)
Rates: $27+
(830) 775-1586

BEST WESTERN INN OF DEL RIO
810 Veterans Blvd (78840)
Rates: $59-$135
(830) 775-7511; (800) 528-1234
(800) 336-3537

DAYS INN & SUITES
3808 Veterans Blvd (78840)
Rates: $49-$79
(830) 775-0585; (800) 329-7466

Hotel Pet Policies May Be Subject To Change

HOLIDAY INN EXPRESS
3616 Veterans Blvd (78840)
Rates: $59-$69
(830) 775-2933; (800) 465-4329

LA QUINTA INN
2005 Veterans Blvd (78840)
Rates: $63-$83
(830) 775-7591; (800) 687-6667

LAKEVIEW INN DIABLO EAST
Hwy 90 W, HCR 3, Box 38 (78840)
Rates: $29-$48
(830) 775-9521

MOTEL 6
2115 Ave F (78840)
Rates: $31-$49
(830) 774-2115; (800) 466-8356

RAMADA INN
2101 Veterans Blvd (78840)
Rates: $79-$105
(830) 775-1511; (800) 272-6232

ROUGH CANYON INN MOTEL
Hwy 277 N, RR 2 (78840)
Rates: $27+
(830) 774-6266

WESTERN MOTEL
1203 Ave F (78840)
Rates: $24-$56
(830) 774-4661

<u>RECREATION</u>

AMISTAD NATIONAL RECREATION AREA - Leashes

Info: Talk about crystal clear waters - you'll be utterly dazzled by the beautiful waterways in this natural playland. The lack of loose soil and a preponderance of limestone combine to create water of an extraordinary blue color. Afishionados can try to snatch a catch of bass or catfish for a hearty BBQ feast. Landlubbers can explore the world-class rock art in some of the region's caves. Or treat your dirty dog to a trek along the shoreline where a wet and wild adventure awaits. If you're towing a boat, you won't want to miss the steep-walled limestone canyons and inspiring scenery that only boaters can peruse.

The name "Amistad" means friendship and reflects the cooperation of the United States and Mexico in creating an oasis for locals and travelers alike. Desert is the primary environment here, so come prepared. Always carry plenty of agua fria. The park encompasses over 57,000 acres including 540 miles of U S shoreline and 67,000 acres of water. It extends 74 miles up the Rio Grande, 24 miles up the Devils River and 14 miles up the Pecos River. Bowwow! For more information: (830) 775-7491; www.nps.gov.

Locate Other Dog-Friendly Activities...Check Nearby Cities

Directions: From Del Rio, take Highway 90 west approximately 3 miles to park headquarters.

The numbered hikes that follow are within
Amistad National Recreation Area:

1) DIABLO EAST NATURE TRAIL HIKE - Leashes

Beginner/0.25 miles

Info: This recently opened trail will take you and furface through fascinating flora. For more information: (830) 775-7491; www.nps.gov.

Directions: From Del Rio, take Highway 90 west approximately 3 miles to park entrance. The trailhead is located at the back of the parking area.

2) MOUTH OF THE PECOS NATURE TRAIL HIKE - Leashes

Beginner/0.25 miles

Info: This trail may be short on mileage, but it's chock-full of desert flora including century plants, catsclaw acacias, crustose lichens, evergreen sumacs, narrow leafed yuccas and tasajillo cactus. Pick up a trail guide to help you and the tail-wagger identify the plants. Between posts 11 & 12, take the spur trail to the Pecos River overlook - the view is worth the effort. Before setting out, stop by park headquarters for current trail conditions. For more information: (830) 775-7491; www.nps.gov.

Directions: From Del Rio, take Highway 90 west approximately 3 miles to park entrance. The trailhead is located 44 miles west of headquarters on Highway 90.

Hotel Pet Policies May Be Subject To Change

DENISON

LODGING

MOTEL 6
615 N Hwy 75 (75020)
Rates: $37-$44
(903) 465-4446; (800) 466-8356

TEXOMA INN
1600 S Austin Ave (75021)
Rates: $39-$66
(903) 465-6800

RECREATION

EISENHOWER BIRTHPLACE STATE HISTORICAL PARK - Leashes

Info: History buffs and Republican Rovers can check out the birthplace of the nation's 34th president. Located atop a bluff overlooking Lake Texoma, the park is a beautiful place to spend the day. A 6-mile nature trail laces the area, while historic sites and picnic spots dot the landscape. Fishing is excellent and anglers might get a tug from striped, white, smallmouth and large-mouth bass, black and white crappie, catfish or alligator gar. For more information: (903) 465-8908; (800) 792-1112; www.eisenhowerbirthplace.org.

Directions: Located at 208 East Day.

EISENHOWER STATE PARK HIKING TRAIL - Leashes

Intermediate/8.4 miles

Info: Strap on the pedometer and get a jumpstart on your day with an excursion along this somewhat lengthy hike. If your woofer's a hoofer, he's gonna love this adventure. The trail winds its way amid dense forests of ash, oak and elm, passing interesting limestone fossils along the way. Keep a snout out for animal tracks - wildlife abounds. About halfway through the hike, you'll reach a picnic area, the ideal place to break some bread and biscuits. When you arrive at Lake Texoma, let tails wag and paws dunk before heading home. For more information: (903) 465-1956.

Directions: From Denison, take Highway 75A north for 5 miles to FM 1310 (on the south side of Denison Dam). Turn

west on FM 1310 and follow for just under 2 miles to the park. Once past park headquarters, take the right fork to the marked trailhead.

WATERLOO PARK - Leashes

Info: About one-third of this beautiful 148-acre park is for anglers and boaters to enjoy. For those on terra firma, hiking trails honeycomb the land and picnic areas offer pretty places to nibble on kibble. Whether you're seeking an easy-does-it Sunday stroll or an afternoon of fresh air and shimmering lake waters, this park is a definite paw pleaser. For more information: (903) 463-5116 or (803) 463-7166.

Directions: Located at 1101 Waterloo Lake Drive.

DENTON

LODGING

DESERT SANDS MOTOR INN
611 S I-35 E (76205)
Rates: $28-$50
(940) 387-6181

EXEL INN
4211 N I-35 E (76201)
Rates: $38-$65
(940) 383 1471; (800) 367-3935

THE HERITAGE INNS B&B
815 N Locust (76201)
Rates: $65-$135
(940) 565-6414; (888) 565-6414

HOLIDAY LODGE
1112 E University (76205)
Rates: $25-$31
(940) 382-9688

HOWARD JOHNSON EXPRESS
3116 Bandera Dr (76207)
Rates: $35-$54
(800) 446-4656

LA QUINTA INN
700 Fort Worth Dr (76201)
Rates: $66-$95
(940) 387-5840 (800) 687-6667

MOTEL 6
4125 N I-35 (76207)
Rates: $37-$56
(940) 566-4798; (800) 466-8356

**RADISSON HOTEL
& EAGLE POINT GOLF CLUB**
2211 I-35E N (76205)
Rates: $129-$169
(940) 565-8499; (800) 333-3333

<u>RECREATION</u>

AVONDALE PARK - Leashes

Info: Get the lead out with a morning jaunt in this 16-acre neighborhood park. Popular with other canines, be prepared to meet and greet.

Directions: Located on Nottingham at Devonshire.

BOWLING GREEN PARK - Leashes

Info: This peanut park offers 5 acres of stomping ground and fills the bill for a morning or evening constitutional.

Directions: Located at Bowling Green and Auburn.

CIVIC CENTER PARK - Leashes

Info: Tails will be going a mile a minute as you traverse the acres of open space that await your romping pleasure in this well-groomed and beautifully maintained park. Stroll through a lush green garden punctuated with colorful plants. Take the time to smell the flowers or vege out under the shade of a towering oak tree. For more information: (940) 349-7275.

Directions: Located on Bell Avenue at Withers.

DENIA PARK - Leashes

Info: You'll have a tailwagging good time roaming and playing with your pup on the 25 acres of this spacious park.

Directions: Located on Parvin at Bernard.

EVERS PARK - Leashes

Info: You and your mutt can strut your stuff on the grounds of this 25-acre park.

Directions: Located on North Locust at Windsor.

Locate Other Dog-Friendly Activities...Check Nearby Cities

FRED MOORE PARK - Leashes

Info: Happy days begin with a visit to this 10-acre neighborhood park.

Directions: Located on Bradshaw at East Prairie.

JOE SKILES PARK - Leashes

Info: Spectate at a softball match or have your own game of catch in this 6-acre neighborhood park.

Directions: Located on Stemmons at Stonegate.

MACK PARK - Leashes

Info: Every dog must have his day. Make yours a gleeful one at this lovely 20-acre parkland.

Directions: Located on East McKinney at Mack Place.

MARTIN LUTHER KING JR. PARK - Leashes

Info: When Tex is tugging at the leash, set your sights on this pleasant park and have yourself some outdoor fun.

Directions: Located on Morse at Newton.

MCKENNA PARK - Leashes

Info: Happy tails will wag in the breeze as you and your pup frolic in the natural open space of this 18-acre park. Pack a snack and repast with Rover at one of the picnic sites.

Directions: Located on Scripture at Bonnie Brae.

NETTE SCHULTZ PARK - Leashes

Info: Lounge with your hound on the grounds of this 10-acre neighborhood park.

Directions: Located on Rockwood at Woodhaven.

NORTH LAKES PARK - Leashes

Info: Wow! Two paws up for this expansive park. Spend a day fishing with Fido on the lakeshore, or set out for a day of exploration in this vast region. Plenty of open space and lush grass are bound to please those restless paws. Pack some kibble and stay awhile, this park is a wonderful way to make your dog's day. For more information: (940) 349-7275.

Directions: Located on Windsor at Bonnie Brae.

PHOENIX PARK - Leashes

Info: Make it a habit for you and the hound to get a daily dose of exercise in this 7-acre park.

Directions: Located on Wood Street.

OTHER PARKS IN DENTON - Leashes

For more information, contact the Denton Parks & Recreation Department at (940) 349-7275.

•BRIERCLIFF PARK, State School Road
•MILAM PARK, Mockingbird at Bob-o-Link

DIBOLL

<u>LODGING</u>
BEST WESTERN INN
910 N Temple Dr (75941)
Rates: $56-$89
(936) 829-2055; (800) 528-1234

DONNA

<u>LODGING</u>
HOWARD JOHNSON EXPRESS INN
602 N Victoria Rd (78537)
Rates: $72-$109
(956) 464-7801; (800) 446-4656

Locate Other Dog-Friendly Activities...Check Nearby Cities

DUMAS

LODGING

BEST WESTERN WINDSOR INN
1701 S Dumas Ave (79029)
Rates: n/a
(806) 935-9644; (800) 528-1234
(800) 661-7626

ECONO LODGE OLD TOWN INN
1719 S Dumas Ave (79029)
Rates: $49-$96
(806) 935-9098; (800) 553-2666

HOLIDAY INN EXPRESS
1525 S Dumas Ave (79029)
Rates: $69-$99
(806) 935-4000; (800) 465-4329

KONA KAI DUMAS INN MOTEL
1712 S Dumas Ave (79029)
Rates: $52-$80
(806) 935-6441; (800) 396-8831

PHILLIPS MANOR MOTEL
1821 S Dumas Ave (79029)
Rates: $28-$44
(806) 935-9281

SUPER 8 MOTEL
119 W 17th (79029)
Rates: $59-$89
(806) 935-6222; (800) 800-8000

SUPER INN
1820 S Dumas Ave (79029)
Rates: n/a
(806) 935-9281

DUNCANVILLE

LODGING

MOTEL 6
202 Jellison Rd (75116)
Rates: $35-$55
(972) 296-0345; (800) 466-8356

RAMADA INN-DALLAS SW
711 E Camp Wisdom Rd (75116)
Rates: $59-$69
(972) 298-8911; (800) 272-6232

RECREATION

HARRINGTON PARK - Leashes

Info: A shady oasis beckons you and the tailwagger in this pleasant park. Make tracks along the one-mile trail or take in a local ball game.

Directions: Located at 1815 South Cockrell Hill.

Hotel Pet Policies May Be Subject To Change

EAGLE LAKE

LODGING

THE FARRIS 1912 INN
201 N McCarty St (77434)
Rates: $40-$95;
(409) 234-2546

RECREATION

ATTWATER PRAIRIE CHICKEN NATIONAL WILDLIFE REFUGE - Leashes

Info: The original purpose of this 3,400-acre refuge was the preservation of the endangered Attwater's prairie chicken. Today the goal of preservation has remained the same, but the diversity of wildlife to be safeguarded has increased. While the Attwater's prairie chicken is still the #1 priority, an assortment of wildlife inhabits the refuge. As you and the mutt motor along the touring road or hike the trails, you might see Ross's geese, Sandhill cranes, white-tailed hawks, prairie falcons, tricolored herons, Harris' sparrows, armadillos, white-tailed deer, American buffalo, alligators, red-eared slider turtles or water moccasins, among others. If you're a wildflower fancier, visit in the spring when over 250 flowering plants bedeck the landscape in a profusion of color. FYI, the population of the refuge's namesake is declining at such an alarming rate that their habitat is presently closed to the public. For more information: (979) 234-3021.

Directions: From Eagle Lake, head northeast on FM 3013 for 7 miles to the main entrance of the refuge. Refuge headquarters is located 2 miles west of the main entrance on FM 3013.

Note: Entrance fee charged. Insect repellent is highly recommended.

The numbered hikes that follow are within the
Attwater Prairie Chicken National Wildlife Refuge:

1) ATTWATER REFUGE AUTO TOUR

Info: If you're short on time but still want a quickie look-see at the refuge, take a drive on the five-mile auto tour. You and the

pooch will pass by prairies and man-made marshlands affording plenty of bird and wildlife sightings. One of the drive's newest attractions is the half-dozen American buffalo who can often be glimpsed from the road. The road is unpaved and impassable after heavy rains, so call ahead. For more information and road conditions: (979) 234-3021.

Directions: From Eagle Lake, head northeast on FM 3013 for 7 miles to the main entrance of the refuge. Refuge headquarters is located 2 miles west of the main entrance on FM 3013.

Note: The road is only open from sunrise to sunset.

2) PIPIT TRAIL HIKE - Leashes
Beginner/1.5 miles

Info: Let the good times roll as you and the dogster skedaddle on this easy looping trail. Keep your eyes peeled for wildlife in both the prairie and riparian habitats. Spring and fall offer the best wildlife viewing opportunities. The trailhead is located on the way to refuge headquarters. For more information: (979) 234-3021.

Directions: From Eagle Lake, head northeast on FM 3013 for 7 miles to the main entrance of the refuge. Refuge headquarters is located 2 miles west of the main entrance on FM 3013.

3) SYCAMORE TRAIL HIKE - Leashes
Beginner/2.0 miles

Info: Hike with Spike on this simple trail and find yourselves immersed and surrounded by prairie and riparian habitats. You'll encounter plenty of wildlife viewing opportunities, especially in the spring and fall. The trailhead is located at refuge headquarters. For more information: (979) 234-3021.

Directions: From Eagle Lake, head northeast on FM 3013 for 7 miles to the main entrance of the refuge. Refuge headquarters is located 2 miles west of the main entrance on FM 3013.

Hotel Pet Policies May Be Subject To Change

EAGLE PASS

LODGING

BEST WESTERN EAGLE PASS
1923 Loop 431 (78852)
Rates: $84-$90
(830) 758-1234; (800) 528-1234
(800) 992-3245

HOLIDAY INN EXPRESS HOTEL & SUITES
2007 Loop 431 (78852)
Rates: $85-$99
(830) 757-3050; (800) 465-4329

HOLLY INN
2421 E Main St (78852)
Rates: $39-$44
(830) 773-9261; (800) 424-8125

LA QUINTA INN
2525 E Main St (78852)
Rates: $65-$86
(830) 773-7000; (800) 687-6667

SUPER 8 MOTEL
2150 N Hwy 277
(78852)
Rates: $50-$65
(830) 773-9531; (800) 272-9786

EARLY

LODGING

POST OAK INN
606 Early Blvd (76802
Rates: $55-$75
(325) 643-5621

EASTLAND

LODGING

BUDGET HOST INN
2001 I-20 W (76448)
Rates: $38-$50
(254) 629-3324

THE EASTLAND B&B
112 N Lamar St (76448)
Rates: $70-$135
(254) 629-8397

RAMADA INN
2501 I-20 East (76448)
Rates: $45-$65
(254) 629-2655; (800) 272-6232

SUPER 8 MOTEL & RV PARK
3900 I-20 E (76448)
Rates: $49-$79
(254) 629-3336; (800) 800-8000

Locate Other Dog-Friendly Activities...Check Nearby Cities

EDINBURG

LODGING

ECHO HOTEL & CONF CENTER
1903 S Closner Blvd (78539)
Rates: $47-$91
(800) 422-0336

SUPER 8 MOTEL
202 N Hwy 81 (78541)
Rates: $49-$79
(956) 381-1688; (800) 800-8000

EDNA

RECREATION

LAKE TEXANA STATE PARK - Leashes

Info: Relax lakeside and keep your cool beneath the shade of oak and pecan trees. Dangle your line, the fishing's just fine. Crappie, perch, catfish and bass are abundant. You and the dawgus will find plenty of peace and quiet in this park's 575 acres. For more information: (361) 782-5718; (800) 792-1112; www.tpwd.state.tx.us.

Directions: Located off Highway 111, 6.5 miles east of Edna.

Note: Entrance fee charged.

The numbered hike that follows is within Lake Texana State Park:

1) LAKE TEXANA HIKING TRAIL - Leashes

Beginner/3.5 miles

Info: Grab your gadabout and do a hike about on this pleasant nature excursion. Breathe deeply of the woodsy fragrances as you journey through a lush, mixed oak and pecan forest. At the end of the trail, turn your hound around and head for the lake where you can cool your tootsies before calling it a day. For more information: (361) 782-5718.

Directions: The park is located off Highway 111, 6.5 miles east of Edna.

Hotel Pet Policies May Be Subject To Change

EL CAMPO

LODGING

BEST WESTERN EXECUTIVE INN
1022 Hwy 59 W (77437)
Rates: $55-$120
(979) 543-7033; (800) 528-1234

EL CAMPO INN
210 W Hwy 59 (77437)
Rates: $37-$52
(979) 543-1110

EL PASO

LODGING

AMERICANA INN
14387 Gateway Blvd W (79927)
Rates: $38-$52
(915) 852-3025

AMERISUITES-EL PASO AIRPORT
6030 Gateway Blvd E (79905)
Rates: $79-$115
(915) 771-0022; (800) 833-1516

BAYMONT INN & SUITES
7520 N Mesa St (79912)
Rates: $54-$79
(915) 585-2999; (877) 229-6668
(800) 789-4103

BAYMONT INN & SUITES
7944 Gateway Blvd E (79915)
Rates: $54-$79
(915) 591-3300; (877) 229-6668
(800) 789-4103

BEST WESTERN AIRPORT INN
7144 Gateway Blvd E (79915)
Rates: $59-$68
(915) 779-7700 (800) 528-1234
(800) 295-7276

BEST WESTERN SUNLAND PARK INN
1045 Sunland Park Dr (79922)
Rates: $54-$69
(915) 587-4900; (800) 528-1234

BUDGET LODGE MOTEL
1301 N Mesa St (79902)
Rates: $28-$38
(915) 533-6821

CAMINO REAL HOTEL
101 S El Paso St (79901)
Rates: $99-$170
(915) 534-3099; (800) 722-6466

CHASE SUITES BY WOODFIN
6791 Montana Ave (79925)
Rates: $95-$170
(915) 772-8000; (800) 237-8811

COMFORT INN AIRPORT EAST
900 N Yarborough St (79915)
Rates: $45-$95
(915) 594-9111; (800) 228-5150
(800) 497-1347

COMFORT SUITES
949 Sunland Park Dr (79922)
Rates: $69-$85
(915) 587-5300; (800) 228-5150

DAYS INN
5035 S Desert Blvd (79932)
Rates: $48-$79
(915) 845-3500; (800) 329-7466

Locate Other Dog-Friendly Activities...Check Nearby Cities

ECONO LODGE
6363 Montana St (79925)
Rates: $50-$60
(915) 778-3311; (800) 553-2666

EL PASO RESIDENT INN
6355 Gateway Blvd W (79925)
Rates: $119-$129
(915) 771-0504

HAWTHORN INN & SUITES
6789 Boeing St (79925)
Rates: $120-$140
(915) 778-6789; (800) 527-1133

HILTON-EL PASO AIRPORT
2027 Airway Blvd (79925)
Rates: $114-$147
(915) 778-4241; (800) 445-8667
(800) 742-7248

HOLIDAY INN SUNLAND PARK
900 Sunland Park Dr (79922)
Rates: $92-$104
(915) 833-2900; (800) 465-4329
(800) 658-2744

HOWARD JOHNSON EXPRESS
500 Executive Center Blvd (79902)
Rates: $55-$86
(915) 532-8981; (800) 446-4656

HOWARD JOHNSON INN
8887 Gateway Blvd W (79925)
Rates: $60-$80
(915) 591-9471; (800) 446-4656

LA QUINTA INN-AIRPORT
6140 Gateway Blvd E (79905)
Rates: $63-$84
(915) 778-9321; (800) 687-6667

LA QUINTA INN- CIELO VISTA
9125 Gateway Blvd W (79925)
Rates: $60-$89
(915) 593-8400; (800) 687-6667

LA QUINTA INN-LOMALAND
11033 Gateway Blvd W (79935)
Rates: $46-$75
(915) 591-2244; (800) 687-6667

LA QUINTA INN-EL PASO WEST
7550 Remcon Cir (79912)
Rates: $63-$85
(915) 833-2522; (800) 687-6667

MICROTEL INN & SUITES AIRPORT
2001 Airway Blvd (79925)
Rates: $49-$93
(915) 772-3650; (888) 771-7171

MOTEL 6
1330 Lomaland Dr (79935)
Rates: $34-$44
(915) 592-6386; (800) 466-8356

MOTEL 6-CENTRAL
4800 Gateway Blvd E (79905)
Rates: $34-$39
(915) 533-7521; (800) 466-8356

PEAR TREE CORPORATE APARTMENTS
222 Bartlett (79912)
Rates: $50-$85
(915) 833-7327

QUALITY INN & SUITES
6099 Montana Ave (79925)
Rates: $64-$89
(915) 772-3300; (800) 228-5151

RED ROOF INN EAST
11400 Chito Samaniego (79936)
Rates: $35-$45
(915) 599-8877; (800) 843-7663

RED ROOF INN WEST
7530 Remcon Cir (79912)
Rates: $36-$61
(915) 587-9977; (800) 843-7663

SLEEP INN
953 Sunland Park Dr (79922)
Rates: $49-$94
(915) 585-7577; (800) 753-3746

Hotel Pet Policies May Be Subject To Change

STUDIO 6
11049 Gateway Blvd W (79935)
Rates: $39-$56
(915) 594-8533; (888) 897-0202

TRAVELODGE HOTEL CITY CENTER
409 E Missouri St (79901)
Rates: $45-$90
(915) 544-3333; (800) 578-7878

TRAVELODGE
7815 N Mesa St (79932)
Rates: $45-$70
(915) 833-2613; (800) 578-7878

TRAVELODGE LA HACIENDA AIRPORT
6400 Montana Ave (79925)
Rates: $37-$77
(915) 772-4231; (800) 578-7878

RECREATION

ARLINGTON PARK - Leashes

Info: Surprise your canine crony with a quick Texas two-step to this neighborhood park.

Directions: Located at 18350 Pasadena.

ASCARATE PARK - Leashes

Info: When play's the thing, this park's the place. You'll find 440 acres of open space, ideal for some romping fun. Fishing fiends, see if you can outwit the bass, catfish and trout in the 44-acre stocked lake. For more information: (915) 772-5605.

Directions: Located at 6900 Delta Drive.

Note: $1 entrance fee on weekends.

BLACKIE CHESHER PARK - Leashes

Info: Plan a kibble cookout with furface in this 33-acre regional park.

Directions: Located at 9144 Escobar.

CAPISTRANO PARK - Leashes

Info: Cap off a busy indoor day with a brief outdoor interlude in 15-acre Capistrano Park.

Directions: Located at 8700 Padilla.

Locate Other Dog-Friendly Activities...Check Nearby Cities

CRESTMONT PARK - Leashes

Info: Tie those tennies and hightail it with your tailwagger to this 7-acre neighborhood green scene. Who knows, you might meet up with some local canines and company.

Directions: Located at 515 Chermont.

DELTA PARK - Leashes

Info: In honor of WWII Veterans, Delta Park has 9 acres of open space for you and pooch-face.

Directions: Located at 4321 Delta.

EASTWOOD PARK - Leashes

Info: Go ahead, make your dog's daydreams come true and take him for a play period in this park. Over 40 acres constitute this urban escape, so pack some snacks and plan to spend the afternoon. For more information: (915) 541-4331.

Directions: Located at 3110 Parkwood.

FRANKLIN MOUNTAINS STATE PARK - Leashes

Info: Venture into an unspoiled wilderness and be dazzled by the beauty of the desert. The 24,000-acre park encompasses an entire Chihuahuan Desert mountain range and houses many species of animals and plants including the rare Southwestern barrel cactus. You're sure to sight any number of birds, reptiles and small mammals. Turbulent geology and fascinating archeology also add to the allure of the region. Lace up your hiking boots, fill up your water bottles, pack the pooch's pouch and head out for a great day of desert hiking. For more information: (915) 566-6441; (800) 792-1112 or visit their website at www.tpwd.state.tx.us.

Directions: Follow Interstate 10 around El Paso and exit right (east) on Loop 375/Transmountain Road for four miles to the park entrance.

Note: Entrance fee charged.

FRANKLIN PARK - Leashes

Info: Gadabout with your furry snout in this 9-acre park.

Directions: Located at 6050 Quail.

HACIENDA HEIGHTS PARK - Leashes

Info: Set on nearly 21 acres of turf, this park offers neighborhood pooch walkers plenty of strolling space.

Directions: Located at 7735 Phoenix.

HUECO TANKS STATE HISTORICAL PARK - Leashes

Info: Trail sniffers can scout out some 3,000 Indian pictographs in this unique park. Pack your Kodak and lots of film and take home some memories. Fascinating rock formations, several species of desert flora and fauna and plenty of serenity are yours for the taking in this distinctly beautiful area. For more information: (915) 857-1135; (800) 792-1112; www.tpwd.state.tx.us.

Directions: The park is located 32 miles east of El Paso on Ranch Road 2775, just north of Highway 62/180.

Note: Entrance fee charged.

IRWIN J. LAMBKA PARK - Leashes

Info: Lollygag around the landscape in this 12-acre community park.

Directions: Located at 6600 Cloudview.

J.P. SHAUVER PARK - Leashes

Info: Explore over 37 acres in this regional green scene. Sniff out a secluded spot in the shade and do a brown bagger with your four-pawed pal... he'll love the adventure.

Directions: Located at 652 Riverside.

Locate Other Dog-Friendly Activities...Check Nearby Cities

LINCOLN PARK - Leashes

Info: For an honest-to-goodness fun time, take the dawgus for a leg-stretcher in this 10-acre community park.

Directions: Located at 4001 Durazino.

LOMALAND PARK - Leashes

Info: If you're in the neighborhood, treat your faithful furball to a walk in the park.

Directions: Located at 715 Lomita.

MARTY ROBBINS PARK - Leashes

Info: Named for the late country singer, you and your sidekick will be crooning "Out in the west Texas town of El Paso..." as you enjoy this 30-acre community park. For more information: (915) 541-4331.

Directions: Located at 11600 Vista Del Sol.

MARWOOD PARK - Leashes

Info: You and the dogster can spend some quality time together exploring 12 acres of greenery.

Directions: Located at 4325 Riverbend.

MCARTHUR PARK - Leashes

Info: Wag your dog's tail with a walk in this 6-acre neighborhood park where you just might meet some other four-pawed pals.

Directions: Located at 738 Gerald.

MCKELLIGON CANYON PARK - Leashes

Info: Escape the city doldrums and set your sights on this beautiful canyon where 17 acres of rugged terrain have been set aside as a wilderness preserve. Roam the landscape until you find that perfect vista spot. Or do the lazy bones thing

and relax with Max in the 30 developed acres. Home to the Viva El Paso! production, the canyon is an interesting contrast of modern architecture and ancient geology. For more information: (915) 565-6900.

Directions: From El Paso, head northeast on Alabama Street about 10 miles. The canyon is located across from William Beaumont Hospital.

MEMORIAL PARK - Leashes

Info: Play tagalong with your wagalong on an outing to this 32-acre park. Happy tails to you.

Directions: Located at 1701 Copia.

MIDDLE DRAIN PARK - Leashes

Info: Don't pass up the old El Paso, stop in this 17-acre park for a bit of puppy playtime.

Directions: Located at Rosemay East to Presa.

MISSION HILLS PARK - Leashes

Info: Make it your mission to make your dog's day in this 10-acre neighborhood park.

Directions: Located at 3800 O'Keefe.

MODESTO GOMEZ PARK - Leashes

Info: Savor the sun-dappled terrain and seek out some serenity in this pleasant 31-acre park.

Directions: Located at 4600 Edna.

NATIONS TOBIN PARK - Leashes

Info: Do a little Texas dreaming with your best buddy beside you in this 42-acre parkland.

Directions: Located at 8831 Railroad Drive.

NORTH HILLS PARK - Leashes

Info: You and Will can chill in the 17 acres of North Hills.

Directions: Located at 11055 Loma Del Norte.

PAVO REAL PARK - Leashes

Info: Couch pups, listen up. Pavo Real offers 17 acres of recreational pupportunities, so stop surfing and start stretching in the sunshine.

Directions: Located at 9301 Almeda.

POWDER PARK - Leashes

Info: When walktime calls and tails are wagging, spend some time in the great outdoors with a journey to this 21-acre park.

Directions: Located at 7500 Burgess.

SUE YOUNG PARK - Leashes

Info: Bring the fuzzy tennie or the chewed up frisbee and enjoy some canine playtime in this 24-acre community park. The ballmeister will love you forever.

Directions: Located at 9730 Diana.

VETERANS PARK - Leashes

Info: Your pooch will love starting the day with a stroll over this park's 41 acres.

Directions: Located at 5301 Salem.

VISTA DEL SOL PARK - Leashes

Info: Don't forget to pack a fun attitude when you visit this park. Plan ahead and tote a brown bagger to share with your wagger. You'll have 15 acres of blanket spreading spots to choose from.

Directions: Located at 1900 Trawood.

Hotel Pet Policies May Be Subject To Change

VISTA DEL VALLE PARK - Leashes

Info: This quiet park is perfect for your daily dose of fresh air.

Directions: Located at 1288 Hawkins.

WALTER CLARKE PARK - Leashes

Info: If it's a lovely day in your neighborhood, lace up your tennies and leash up your furball - a 16-acre green scene awaits.

Directions: Located at 1519 Bob Hope.

WASHINGTON PARK - Leashes

Info: Even telly bellies will love a morning stroll in this 15-acre park.

Directions: Located at 4201 Paisano.

WILDERNESS PARK - Leashes

Info: Get an eyeful of interesting outdoor exhibits and absorb a bit of knowledge about the past with a visit to this parkland. Make the most of your outing by hopping on the one-mile trail through a pretty desert landscape. Pack plenty of water in the summer, we're talking hot. For more information: (915) 541-4331; (915) 755-4332.

Directions: Located at 4301 Woodrow Bean.

YUCCA PARK - Leashes

Info: Your yippy Skippy will love a jaunt at 15-acre Yucca Park.

Directions: Located at 7975 Williamette.

ZARAGOZA PARK - Leashes

Info: When walktime calls, answer it with a sojourn to this 17-acre community setting.

Directions: Located at 1100 North Zaragoza.

Locate Other Dog-Friendly Activities...Check Nearby Cities

ELGIN

LODGING
RAGTIME RANCH BED & BREAKFAST
P. O. Box 575 (78621)
Rates: $95-$125
(800) 800-9743

ELMENDORF

LODGING
SAN ANTONIO INN & SUITES
13800 I-37 S (78112)
Rates: $49-$63
(210) 633-1833

ENNIS

LODGING
DAYS INN
600 N I-45 (75119)
Rates: $49-$99
(972) 875-6990; (800) 329-7466

EULESS

LODGING
LA QUINTA INN-DFW AIRPORT WEST
1001 W Airport Frwy (76040)
Rates: $60-$85
(817) 540-0233; (800) 687-6667

MICROTEL INN & SUITES
901 W Airport Frwy (76040)
Rates: $47-$70
(817) 545-1111; (888) 771-7171
(888) 545-1112

MOTEL 6
110 W Airport Frwy (76039)
Rates: $35-$50
(817) 545-0141; (800) 466-8356

Hotel Pet Policies May Be Subject To Change

EUSTACE

PURTIS CREEK STATE PARK - Leashes

Info: Make your fishiest dreams reality at Purtis Creek where perch or crappie could end up as dinner. Pooches are allowed to join in the expedition but the pier and swimming area are off limits. That still leaves 1,500 acres for your playtime pleasure, including a nice hike on the nature trail through the primitive camping area. Or be a lazy bones and do some lakeside lolling and tootsie dipping. For more information: (800) 792-1112; www.tpwd.state.tx.us.

Directions: From Eustace, head north on FM 316 for 2.5 miles to park entrance.

Note: Bass fishing is catch and release only. Entrance fee charged.

The numbered hike that follows is within Purtis Creek State Park:

1) PURTIS CREEK'S HIKING TRAIL - Leashes

Beginner/1.25 miles

Info: Get the lead out on this easy looping trail through lush hardwood forests. Tree hounds will flip over the variety of pecan, oak, cedar, elm and walnut trees that shade the pathway. When hike time is over, kick back lakeside before calling it a day. For more information: (903) 425-2332.

Directions: From Eustace, head north on FM 316 for 2.5 miles to park entrance.

FAIRFIELD

REGENCY INN
903 W Hwy 84 (75840)
Rates: $38-$51
(903) 389-4440

Recreation

FAIRFIELD LAKE STATE PARK - Leashes

Info: Anglers and wildlife watchers will adore this park. Renowned for its trophy large-mouth bass and blue tilipia, this lake region also attracts bald eagles and white-tailed deer. Seasonal wildflowers splatter color along nine miles of trails that lace the park's 1,400 acres, while sunshine streaks the laketop with shimmering hues of gold the year round. For more information: (903) 389-4514; (800) 792-1112; www.tpwd.state.tx.us.

Directions: From Fairfield, take Highway 84 east to FM 488. Head north on FM 488 approximately 2 miles to FM 2570. Turn east on FM 2570 for just over a mile to Park Road 64. Follow Park Road 64 to the park entrance.

Note: Entrance fees charged.

The numbered hikes that follow are within Fairfield Lake State Park:

1) BIG BROWN CREEK TRAIL HIKE - Leashes

Intermediate/5.0 miles

Info: City weary pooches can join their country cousins and get away from it on this cooling trail. Sun-dappled forests of hickory, elm, white ash, post oak and eastern red cedar will soothe you with a sense of tranquility. The first 1.5 miles is an interpretive trail so you'll get an education along with a serene experience. Wet waggers will love you for the water wonderful adventure that awaits at the pond. No bones about it, you and the dogster are sure to end your day feeling delightfully refreshed. For more information: (903) 389-4514.

Directions: From Fairfield, take Highway 84 east to FM 488. Head north on FM 488 approximately 2 miles to FM 2570. Turn east on FM 2570 for just over a mile to Park Road 64. Follow Park Road 64 to the park entrance.

2) BIRDWATCHING TRAIL HIKE - Leashes

Beginner/2.0 miles

Info: Break out your binoculars and aim for the sky, birding is the name of the game on this hike. This easy trail is filled with bird feeders. Sit a spell on one of the benches and test your avian acumen. For more information: (903) 389-4514.

Directions: From Fairfield, take Highway 84 east to FM 488. Head north on FM 488 approximately 2 miles to FM 2570. Turn east on FM 2570 for just over a mile to Park Road 64. Follow Park Road 64 to the park entrance. The trailhead is north of the entrance.

3) PERIMETER TRAIL HIKE - Leashes

Beginner/6.0 miles

Info: This multi-use trail will give you and your hiking guru an experience you won't soon forget. But watch out for the horsey set -- this trail was also designed for equestrian lovers. For more information: (903) 389-4514.

Directions: From Fairfield, take Highway 84 east to FM 488. Head north on FM 488 approximately 2 miles to FM 2570. Turn east on FM 2570 for just over a mile to Park Road 64. Follow Park Road 64 to the park entrance. The trailhead is adjacent to the Post Oak camping area.

4) POST OAK TRAIL HIKE - Leashes

Beginner/2.0 miles

Info: Spend some quality time with your pooch on this cinchy nature trail. The fresh air of the woodlands and the peaceful surroundings combine for a great outdoor sojourn. For more information: (903) 389-4514.

Directions: From Fairfield, take Highway 84 east to FM 488. Head north on FM 488 approximately 2 miles to FM 2570. Turn east on FM 2570 for just over a mile to Park Road 64.

Follow Park Road 64 to the park entrance. The trailhead is adjacent to the Post Oak camping area.

FARMERS BRANCH

LODGING

BEST WESTERN DALLAS NORTH
13333 N Stemmons Frwy (75234)
Rates: $59-$104
(972) 241-8521
(800) 528-1234; (800) 308-4593

DAYS INN DALLAS NORTH
13313 N Stemmons Frwy (75234)
Rates: $39-$69
(972) 488-0800; (800) 329-7466

DOUBLETREE CLUB HOTEL
11611 Luna Rd (75234)
Rates: $59-$149
(972) 506-0066; (800) 222-8733

LA QUINTA INN NORTHWEST
13235 N Stemmons Frwy (75234)
Rates: $50-$79
(972) 620-7333; (800) 687-6667

OMNI DALLAS PARK WEST
1590 LBJ Frwy (75234)
Rates: $68-$99
(972) 869-4300; (800) 843-6664

RECREATION

FARMERS BRANCH HISTORICAL PARK - Leashes

Info: This 22-acre park spells fun for both antiquarians and hounds alike. As you travel from one historic site to another, the tree-shaded path makes for a cool outing. The park includes a depot, school, church, log house, Queen Anne Victorian Cottage and the Gilbert House - the oldest rock structure in Northeast Texas that is still on its original foundation. For more information: (972) 406-0184.

Directions: Located on Farmers Branch Lane, just east of Denton Drive.

Note: Hours vary according to season, call beforehand. Dogs are not allowed in the buildings.

FLORESVILLE

LODGING

BEST WESTERN FLORESVILLE INN
1720 S 10th St (78114)
Rates: $59-$79
(830) 393-0443; (800) 528-1234
(800) 847-4364

FORNEY

LODGING

FORNEY INN
103 W Hwy 80 (75126)
Rates: $50-$65
(972) 552-3888

FORT DAVIS

LODGING

FORT DAVIS MOTOR INN
Hwy 17 N (79734)
Rates: $55-$65
(800) 80-DAVIS

HISTORIC LIMPIA HOTEL
100 Main St,
On the Town Square (79734)
Rates: $79-$175
(432) 426-3237; (800) 662-5517

**WILDFLOWER VACATION HOMES
& COTTAGES**
210 Webster Ave (79734)
Rates: $75-$125
(800) 752-4145

RECREATION

CHIHUAHUAN DESERT RESEARCH INSTITUTE - Leashes

Info: Nestled in the Davis Mountains, you can enjoy this 500-acre desert museum from a shaded ramada or lace up your hiking boots, fill your canteens and hop on one of the trails that lead to a journey through picturesque desert flora and Chihuahuan oaks. In the summer months, plan your excur-

sion for early morning or late afternoon and listen for the eerie howling of coyotes mixed with the soothing serenade of songbirds. For more information: (432) 364-2499.

Directions: From Fort Davis, take Highway 118 south for 4 miles to the visitor center.

Note: Open April through August from 1 pm - 5 pm weekdays, 9 am - 6 pm weekends. $2.00 entrance fee.

The numbered hikes that follow are within the
Chihuahuan Desert Research Institute:

1) MODESTA CANYON TRAIL HIKE - Leashes

Beginner/1.0 miles

Info: Simple and scenic best describe this canyon hike. As you Texas two-step to beautiful Modesta Canyon Springs, the sweet tweets of songbirds fill the air, while colorful wildflowers paint the landscape. For more information: (432) 364-2499.

Directions: From Fort Davis, take Texas Highway 118 south for 4 miles to the visitor center.

2) MODESTA CANYON TRAIL TO CLAYTON OVERLOOK HIKE - Leashes

Intermediate/1.5 miles

Info: If you and furface aren't ready to call it quits once you reach the springs, take the quarter-mile hike to the overlook. Prepare yourself for a workout though - the climb to the desert's highest point is somewhat challenging, but the views are worth the sweat. Pack plenty of Perrier, you'll need it. For more information: (432) 364-2499.

Directions: From Fort Davis, take Highway 118 south for 4 miles to the visitor center.

DAVIS MOUNTAINS STATE PARK - Leashes

Info: This park encompasses over 2,700 acres of stunning, dramatic scenery. When you're seeking a remarkable desert experience, take Old Brown Eyes and kick up some dust on one of

the trails in this park. You and your canine crony will be treated to an amazing variety of flora and fauna. Pack your camera and plenty of film - Kodak moments abound in this scenic region of towering mountains and cactus-strewn landscape. Birders, don't forget your binocs - if it's your lucky day you might catch a glimpse of a golden eagle. This park gets two paws up for scenery and serenity. For more information: (432) 426-3337; (800) 792-1112; www.tpwd.state.tx.us.

Directions: From Fort Davis, take Highway 118 northwest for 4 miles to the park entrance.

Note: $2 entrance fee/person. Very hot in summer, pack plenty of water.

The numbered hike that follows is within Davis Mountain State Park:

1) DAVIS MOUNTAINS STATE PARK HIKING TRAIL - Leashes

Intermediate/9.0 miles

Info: If you and your hiking hound love to hit the trails and can take the heat, strap on the pedometer, and make tracks on this interesting desert trail. You'll travel through the beautiful Davis Mountains along the park's highest ridge on this connecting trail from the park to Fort Davis National Historic Site. En route, you'll pass unique geologic formations, native flora and fauna and several scenic overlooks that offer spectacular panoramas of the region. Be prepared for this lengthy arid hike, pack plenty of agua fria and high energy snacks. For more information: (432) 426-3337.

Directions: From Fort Davis, take Highway 118 northwest for 4 miles to the park entrance.

FORT DAVIS NATIONAL HISTORIC SITE - Leashes

Info: An excellent example of a 19th century frontier fort and one-time home of the renowned Buffalo Soldiers of the Indian Wars, Fort Davis is the focal point in a desert environment recreation area. Journey along one of four trails that explore various points of interest or just kick back and enjoy the desert scene. For more information: (432) 426-3224.

Locate Other Dog-Friendly Activities...Check Nearby Cities

Directions: Located in Fort Davis at the intersection of Highways 17 & 118.

Note: Entrance fee. Hot in summer, chilly in winter - plan accordingly.

The numbered hikes that follow are within Fort Davis National Historic Site:

1) CEMETERY TRAIL HIKE - Leashes

Intermediate/1.0 miles

Info: This unshaded trail escorts you to the historic Post Cemetery. Although the remains that were buried here were moved to the National Cemetery in San Antonio in 1892, the arid terrain still makes for a hot diggety dog hike in the summer. For more information: (432) 426-3224.

Directions: Located in Fort Davis at the intersection of Highways 17 & 118.

2) HOSPITAL CANYON TRAIL HIKE - Leashes

Intermediate/2.0 miles

Info: Get your daily dose of Texercise on this rather steep trail that climbs from the canyon's bottom to the North Ridge Trail. Along the way, you'll pass interpretive markers that identify the area's vegetation and explain the intriguing geologic formations. Once at the North Ridge Trail intersection, turn the hound around, you're homeward bound. For more information: (432) 426-3224.

Directions: Located in Fort Davis at the intersection of Highways 17 & 118. The trailhead is at the Post Hospital, a quarter-mile hike from the visitor's center.

3) NORTH RIDGE TRAIL HIKE - Leashes

Intermediate/4.0 miles

Info: For a bird's-eye view of historic Fort Davis, don't miss this ridgetop voyage, but be prepared for a workout. As you boogie with Bowser on this trail, check out the unique rock

formations and scenic overlooks. Once you reach Davis Mountains State Park, chill out at the green scene or retrace your pawprints to the fort. For more information: (432) 426-3224.

Directions: Located in Fort Davis at the intersection of Highways 17 & 118.

4) TALL GRASS NATURE TRAIL HIKE - Leashes

Intermediate/1.0 miles

Info: Exercise and education go hand-in-hand on this looping interpretive trail. You'll have to step lively on this steep and rocky trail to the overlook with its pretty views of the surrounding desertscape. Pack some trail mix and lots of Perrier, you're sure to burn a few calories on this challenging trek. Take some time to read the posted signs, they provide educational tidbits on the local vegetation and geologic formations. For more information: (432) 426-3224.

Directions: Located in Fort Davis at the intersection of Highways 17 & 118.

FORT HANCOCK

<u>**LODGING**</u>
FORT HANCOCK MOTEL
I-20, Exit 72 (79839)
Rates: $38-$52
(915) 769-3981

FORT STOCKTON

LODGING

ATRIUM WEST INN
1305 N Hwy 285 (79735)
Rates: $59-$129
(432) 336-6666

HOLIDAY INN EXPRESS
1308 N Hwy 285 (79735)
Rates: $58-$95
(432) 336-5955; (800) 465-4329

BEST WESTERN SWISS CLOCK INN
3201 W Dickinson Blvd (79735)
Rates: $58-$99
(432) 336-8521; (800) 528-1234

LA QUINTA INN
1537 N Hwy 285 (79735)
Rates: $53-$68
(432) 336-9781; (800) 687-6667

BUDGET INN
801 E Dickinson Blvd (79735)
Rates: $59-$99
(432) 336-3311

MOTEL 6
3001 W Dickinson Blvd (79735)
Rates: $31-$34
(432) 336-9737; (800) 466-8356

COMFORT INN
3200 W Dickinson Blvd (79735)
Rates: $56-$85
(432) 336-8531; (800) 228-5150

SANDS MOTEL
1801 W Dickinson Blvd (79735)
Rates: $26-$30
(432) 336-2274

DAYS INN
1408 N Hwy 285 (79735)
Rates: $46-$76
(432) 336-7500; (800) 329-7466

TOWN & COUNTRY MOTEL
1505 W Dickinson Blvd (97935)
Rates: $21-$30
(432) 336-2651

ECONO LODGE
800 E Dickinson Blvd (79735)
Rates: $39-$79
(432) 336-9711; (800) 553-2666

RECREATION

HISTORIC FORT STOCKTON - Leashes

Info: Journey back to the late 1880's when you visit this historic frontier military post. You and Bowser can browser the fort grounds which include three of the original eight Officers' Quarters and the Guard House. Dogs are not permitted in the museum. For more information: (432) 336-2400 or (800) 336-2166; www.ci.fort-stockton.tx.us.

Directions: Located at 300 E. 3rd Street.

Note: Entrance fee charged. Open Monday through Saturday. Call for summer hours.

Hotel Pet Policies May Be Subject To Change

FORT WORTH

LODGING

AMERISUITES CITY VIEW
5900 City View Blvd (76132)
Rates: $105-$115
(817) 361-9797; (800) 833-1516

THE ASHTON HOTEL
610 Main St (76102)
Rates: $250-$770
(817) 332-0100

BEST WESTERN INN
6700 Fossil Bluff Dr (76137)
Rates: $59-$89
(817) 847-8484; (800) 528-1234

BEST WESTERN INN & SUITES
2000 Beach St (76103)
Rates: $62-$119
(817) 534-4801; (800) 528-1234

CANDLEWOOD SUITES
5201 Endicott Ave (76137)
Rates: $69-$99
(817) 838-8229; (800) 465-4329

CARAVAN MOTOR HOTEL
2601 Jacksboro Hwy (76114)
Rates: $33-$42
(817) 626-1951

COMFORT INN NORTH
4850 North Frwy (76137)
Rates: $49-$99
(817) 834-4001; (800) 228-5150

DAYS INN
4213 S 1-35 W Fwy (76115)
Rates: $40-$65
(817) 923-1987; (800) 329-7466

DAYS INN
1551 University Dr (76107)
Rates: $45-$65
(817) 336-9823; (800) 329-7466

DAYS INN WEST
8500 W I-30 (76108)
Rates: $32-$59
(817) 246-4961; (800) 329-7466

GREEN OAKS INN & CONF CENTER
6901 W Frwy (76116)
Rates: $61-$98
(817) 738-7311; (800) 433-2174
(800) 772-7341

HAMPTON INN
2700 Cherry Ln (76116)
Rates: $72-$77
(817) 560-4180; (800) 426-7866

HAMPTON INN & SUITES
13600 North Frwy (76178)
Rates: n/a
(817) 439-0400; (800) 426-7868

HOLIDAY INN & CONF CENTER
100 Altamesa Blvd E (76134)
Rates: $70-$100
(817) 293-3088; (800) 465-4329

HOLIDAY INN & CONF CENTER-NORTH
2540 Meacham Blvd (76106)
Rates: $69-$199
(817) 625-9911
(800) 465-4329

HOLIDAY INN EXPRESS HOTEL & SUITES
4609 City Lake Blvd W (76109)
Rates: $74-$164
(817) 292-4900
(800) 465-4329

HOLIDAY INN EXPRESS HOTEL & SUITES-WEST
2730 Cherry Ln (76116)
Rates: $89-$129
(817) 560-4200; (800) 465-4329

Locate Other Dog-Friendly Activities...Check Nearby Cities

HOMESTEAD STUDIO SUITES
1601 River Run (76107)
Rates: $59-$74
(817) 338-4808; (888) 782-9473

LA QUINTA INN & SUITES NORTH
4700 North Frwy (76137)
Rates: $80-$106
(817) 222-2888; (800) 687-6667

LA QUINTA INN & SUITES-SOUTHWEST
4900 Bryant Irvin Rd (76132)
Rates: $90-$116
(817) 370-2700; (800) 687-6667

LA QUINTA INN-MEDICAL CENTER
7888 I-30 W (76108)
Rates: $66-$80
(817) 246-5511; (800) 687-6667

MD RESORT BED & BREAKFAST
601 Old Base Rd (76078)
Rates: $79-$350
(817) 489-5150

MOTEL 6-EAST
1236 Oakland Blvd (76103)
Rates: $38-$56
(817) 834-7361; (800) 466-8356

MOTEL 6-NORTH
3271 W I-35 (76106)
Rates: $38-$56
(817) 625-4359; (800) 466-8356

MOTEL 6-SOUTH
6600 S Frwy (76134)
Rates: $38-$56
(817) 293-8595; (800) 466-8356

MOTEL 6-WEST
8701 W I-30 (76116)
Rates: $35-$51
(817) 244-9740; (800) 466-8356

RAMADA INN-MIDTOWN
1401 S University Dr (76107)
Rates: $57-$80
(817) 336-9311; (800) 272-6232

RENAISSANCE WORTHINGTON HOTEL
200 Main St (76102)
Rates: $142-$225
(817) 870-1000; (800) 468-3571
(800) 433-5677

RESIDENCE INN BY MARRIOTT
1701 S University Dr (76107)
Rates: $138-$179
(817) 870-1011; (800) 331-3131

RESIDENCE INN-ALLIANCE AIRPORT
13400 North Frwy (76177)
Rates: $69-$250
(817) 750-7000; (800) 331-3131

RESIDENCE INN-FOSSIL CREEK
5801 Sandshell (76137)
Rates: $69-$114
(817) 439-1300; (800) 331-3131

STOCKYARDS HOTEL
109 E Exchange Ave (76106)
Rates: $89-$360
(817) 625-6427; (800) 423-8471

TOWNEPLACE SUITES BY MARRIOTT
4200 International Plaza Dr (76109)
Rates: $67-$109
(817) 732-2224; (800) 257-3000

RECREATION

ARROW SOUTH PARK - Leashes

Info: Your pooch will love starting his day with a stroll in 37-acre Arrow Park where a bit of fun in the sun awaits.

Directions: Located at 7900 Cahoba Drive.

Hotel Pet Policies May Be Subject To Change

BUCK SANSOM PARK - Leashes

Info: You'll have 131 acres of spacious greenery to trek through with your wagalong in this oasis.

Directions: Located at 3600 Angle Avenue.

CARTER PARK - Leashes

Info: For a hot diggety dog time, take your pup to this enormous urban green scene. More than 147 acres of sun-dappled land is yours for the exploring.

Directions: Located at 1300 East Seminary/Carter Park Drive.

CASINO BEACH - Leashes

Info: Slather on the sun protection, pack a biscuit basket, a good read and get set for a day of R&R.

Directions: Located at 7500 Watercress Drive.

COBB PARK - Leashes

Info: This large recreation-filled park offers plenty of paw pleasing opportunities for you and furface.

Directions: Located at 1600-3000 Cobb Park Drive.

CREEKSIDE PARK - Leashes

Info: Let the brook babble away your city cares while you and the dawgus spend a lazy, hazy day in this 16-acre green scene.

Directions: Located at 3100 Roddy Drive.

ELLIS PARK - Leashes

Info: A perfect place for your AM or PM constitutional.

Directions: Located at 3400 South Riverside Drive.

FORT WOOF DOG PARK

Info: Your woofer will love Fort Woof Dog Park, located in beautiful Gateway Park. This double-gated off-leash fenced area has 5 acres for Frisky to frolic and socialize with other canines, separate areas for small and large dogs, picnic tables, baggies, litter receptacles and a pet washing area. For more information: (817) 871-5700 or (817) 871-7275.

Directions: Gateway Park is located at 750 North Beach Street.

Note: Dogs should always be leashed outside of the Off-Leash area.

FORT WORTH NATURE CENTER & REFUGE - Leashes

Info: Forests, marshes, prairies and a river comprise this 3,500-acre region and afford you and your canine cohort a two paws up nature experience. White-tailed deer, buffalo and armadillos roam the refuge, while wildflowers and native plants bedeck the landscape. Take your pick from over 25 miles of trails and let the trekking begin. Stop by the interpretive center for a trail system map. For more information: (817) 237-1111.

Directions: Located 10 miles northwest of downtown Fort Worth on Texas 199, just past Lake Worth Bridge.

Note: Hours: 9 am to 4:30 pm Tuesdays through Saturdays, 12 pm to 4:30 pm on Sundays, closed Mondays.

The numbered hikes that follow are within the
Fort Worth Nature Center & Refuge:

1) CANYON RIDGE TRAIL HIKE - Leashes

Intermediate/6.0 miles

Info: Exercise and scenery go hand-in-hand on this trail. You and the pupster will find yourselves in shaded canyons as you hightail it to the ridgetop where the views are pawsitively worth the huffing and puffing. For more information: (817) 237-1111.

Directions: Located 10 miles northwest of downtown Fort Worth on Texas 199, just past Lake Worth Bridge.

Hotel Pet Policies May Be Subject To Change

2) GREER ISLAND TRAILS HIKE - Leashes

Beginner/1.5 hours

Info: Trail hop with Old Brown Eyes along the interconnecting trail system on Greer Island. Sun-splashed Lake Worth, lush forests and wildlife sightings make for a great outing. When you've had your hiking fill, chill out lakeside and partake of some wet and wild fun. For more information: (817) 237-1111.

Directions: Located 10 miles northwest of downtown Fort Worth on Texas 199, just past Lake Worth Bridge.

3) LIMESTONE LEDGE TRAIL HIKE - Leashes

Beginner/0.15 miles

Info: If you and your sofa loafer are looking for a minute-size leg-stretcher, this paved interpretive path (handicapped accessible) has your name on it. Pick up a trail guide before setting out - and garner some interesting facts on the area's flora. For more information: (817) 237-1111.

Directions: Located 10 miles northwest of downtown Fort Worth on Texas 199, just past Lake Worth Bridge.

4) MARSH BOARDWALK TRAIL HIKE - Leashes

Beginner/0.2 miles

Info: Birders will love this short trail (handicapped accessible) over a marsh and through a riverbottom forest. Bring your camera - the resident herons are definitely photo worthy. For more information: (817) 237-1111.

Directions: Located 10 miles northwest of downtown Fort Worth on Texas 199, just past Lake Worth Bridge.

5) OAK MOTTE TRAIL HIKE - Leashes

Beginner/3.2 miles

Info: If your woofer's a hoofer, plan a journey along this trail through prairies and groves of red and live oak. Flower hounds will want to plan a springtime visit when the wild ones bloom in crayola colors. For more information: (817) 237-1111.

Directions: Located 10 miles northwest of downtown Fort Worth on Texas 199, just past Lake Worth Bridge.

6) PRAIRIE TRAIL HIKE - Leashes

Beginner/1.0 miles

Info: Buffalo are the main attraction of this cinchy trail which meanders through a prairie. As you pass by the buffalo range, take a moment to admire this icon of the American West, but keep your distance and keep Fido away from the fence. For more information: (817) 237-1111.

Directions: Located 10 miles northwest of downtown Fort Worth on Texas 199, just past Lake Worth Bridge.

FORT WORTH WATER GARDENS - Leashes

Info: If the sight and sound of water sends your pup's tail into a wagging frenzy, then this cool 5.4-acre park is a must-see, must-do experience. Rover will think he's in paradise as he watches the water bubble, cascade, spurt and flow from channels, fountains and pools. For more information: (817) 871-7698.

Directions: Located north of I-30 between Houston & Commerce Streets, adjacent to the Tarrant County Convention Center.

FOSTER PARK - Leashes

Info: Go ahead, make your mutt's day with an afternoon break in this 11-acre parkland.

Directions: Located at 4800 Trail Lake Drive.

Hotel Pet Policies May Be Subject To Change

FREEMONS PARK - Leashes

Info: Happy tails will wag with a trip to 17-acre Freemons Park. Pack a fuzzy tennie for a quickie game of fetch with the ballmeister.

Directions: Located at 9800 Heron Drive.

GEORGE MARKOS PARK - Leashes

Info: Get along with your little doggie to this 29-acre neighborhood green scene where you're sure to meet some local pups and their people.

Directions: Located at 400 Academy Boulevard.

GREENBRIAR PARK - Leashes

Info: Give in to those pleading puppy eyes and get down to Greenbriar for some playtime in the sunshine.

Directions: Located at 5200 Hemphill/5201 James.

GREENWAY PARK - Leashes

Info: This 13-acre community park is a pleasant place for you to take the tailwagger for his daily dose.

Directions: Located at 2013 East Belknap.

HALLMARK PARK - Leashes

Info: You don't need a special occasion to give your furball something to bark about. Take him to pretty Hallmark Park for some outdoor amusement.

Directions: Located at 502 Sycamore School Road.

HANDLEY PARK - Leashes

Info: Avoid the summer doldrums with an uplifting jaunt to this 15-acre park. Pack a brown bagger to share with your wagger.

Directions: Located at 2700 Haynie/6201 Beaty.

HARMON FIELD - Leashes

Info: Lead your mellow fellow through 100 acres of open space or break some bread and biscuits in a secluded spot.

Directions: Located at 1601 Cypress & Poly Freeway.

HIGHLAND HILLS PARK - Leashes

Info: Set your sights on Highland and let your hound bound through the park's 25 acres.

Directions: Located at 1600 Glasgow Road.

HILLSIDE PARK - Leashes

Info: You and your shadow will love a leg-stretcher in this 24-acre park.

Directions: Located at 1200 East Magnolia/1301 East Maddox.

KELLIS PARK - Leashes

Info: Savor the surroundings as you rove over this 16-acre neighborhood park.

Directions: Located at 4651 Southridge Terrace.

KRAUSS BAKER PARK - Leashes

Info: Do the lazy thing or plan a game of catch and fetch in 18-acre Baker Park.

Directions: Located at 6151 Woodway Drive.

Hotel Pet Policies May Be Subject To Change

MARINE CREEK LINEAR PARK - Leashes

Info: Strut with the mutt through the tree-dotted terrain of 48-acre Linear Park.

Directions: Located at 3000-3400 Angle Avenue.

MARION SANSOM PARK - Leashes

Info: Pack some snacks and a fun attitude and hightail it to this vast 264-acre park.

Directions: Located at 2300-2500 Roberts Cutoff.

MCDONALD PARK - Leashes

Info: Shake a tail and let the good times prevail in this 14-acre outdoor setting.

Directions: Located at 5400 Eastland.

MEADOWS WEST PARK - Leashes

Info: This 17-acre green scene is the perfect paw-stomping space for you and the dogster.

Directions: Located at 4600 Mellaire Drive South.

MOSQUE POINT PARK - Leashes

Info: You'll have it made in the shade as you luxuriate in lakeside serenery in this 80-acre urban oasis.

Directions: Located at 8200-8500 Cahoba Drive at Lake Worth.

OAKLAND LAKE - Leashes

Info: Laze lakeside with your lap dog or try your fly along the banks of lovely Oakland Lake. For more information: (817) 871-5700.

Directions: Located at 1645 Lakeshore Drive.

Locate Other Dog-Friendly Activities...Check Nearby Cities

OVERTON PARK - Leashes

Info: When play's the thing, this park's the stage. 48 acres of open space spell fun for your cold nose pal.

Directions: Located at 3200 Overton Park Drive East.

PRAIRIE DOG PARK - Leashes

Info: Furry fellows will have a howl of a good time scampering through this fun-filled 40-acre park.

Directions: Located at 5000 Parker Henderson Road.

RIVERSIDE PARK - Leashes

Info: Hey, a river runs through it - so leash up aquapup and wiggle on down to this pretty 30-acre park.

Directions: Located at 501 Oakhurst Scenic Drive.

ROLLINGS HILLS PARK - Leashes

Info: Head for the hills and spend a day frolicking with Fido through 197 acres of greenery. Perfect for a picnic or an aerobic leg-stretcher, this park is certain to get tails wagging.

Directions: Located at 2525 Joe B. Rushing Road/2600 Coffee.

ROSEMONT PARK - Leashes

Info: Rosemont's 30 acres of paw-stomping terrain can make your dog's day.

Directions: Located at 1600 Seminary Drive.

SANDY LANE PARK - Leashes

Info: Grab your gadabout and do a turnabout through the grounds of this attractive 28-acre parkland.

Directions: Located at 2201 Sandy Lane.

STRATFORD PARK - Leashes

Info: Let your wagalong tagalong to this large, 50-acre neighborhood park. Maybe you'll make some canine friends while you're at it.

Directions: Located at 4050 Meadowbrook Drive.

SUMMERBROOK PARK - Leashes

Info: Boogie with Bowser in Summerbrook's 27 acres of sun-streaked scenery. And happy tails to you.

Directions: Located at 4315 Huckleberry.

SYCAMORE PARK - Leashes

Info: Savor the serenity and cooling shade that this 112-acre region offers. Pack a biscuit basket and make an afternoon of it. Bone appetite!

Directions: Located at 2525 East Rosedale.

SYLVANIA PARK - Leashes

Info: Have a lark in the park with your bark.

Directions: Located at 3700 East Belknap.

TANDY HILLS PARK - Leashes

Info: When you want to be alone with your canine cohort, Tandy Hills could be the place for you. It won't be hard to find that perfect secluded spot among the 105 acres to choose from.

Directions: Located at 3317 View Street and Tandy Street.

TEXAS TRAIL OF FAME - Leashes

Info: This is Fort Worth's version of the famous Hollywood Walk of Fame in California. Located on public walkways throughout the Stockyards National Historic District, your starry-eyed Bowser will be wowed by the 59 inlaid bronze markers honoring men, women and groups who have made

Locate Other Dog-Friendly Activities...Check Nearby Cities

significant contributions to Texas and promoted the western lifestyle. Among the honorees are Will Rogers, Roy Rogers, Dale Evans and Charles Goodnight. For more information: (817) 626-7131; (817) 624-4741; www.fortworthstockyards.com.

Directions: The Stockyards National Historic District is located at 140 E. Exchange Avenue.

Z-BOAZ PARK - Leashes

Info: Pamper your pup by taking him to this 134-acre urban oasis. Explore the landscape or lounge with the hound in the shade of towering trees. Any way you shake it, this park is tons of fun.

Directions: Located at 5250 Old Benbrook Road.

OTHER PARKS IN FORT WORTH - Leashes

For more information, contact the Fort Worth Parks & Recreation Department at (817) 871-5700.

- ARNESON PARK, 1311 Homan Avenue
- ARNOLD PARK, 700 Samuels at Cold Springs Road
- BERNEY PARK, 6301 Curzon
- BONNIE BRAE PARK, 3213 Wesley Street
- CAMELOT PARK, 1500 Andante
- CAMP JOY PARK, 9700 Watercress Drive
- CANDLERIDGE PARK, 4300 French Lake Drive
- CAPPS PARK, 907 West Berry
- CIRCLE PARK, 600 Park Street
- CRESTWOOD PARK, 3750 Rockwood Park Drive
- DAGGETT PARK, 2312 College Avenue
- DELGA PARK, 1400 Nixon Street
- DIAMOND HILL PARK, 1701 NE 36th Street
- DIXIE PARK, Troost & Verbena
- EASTBROOK PARK, 2700 Escalante
- EASTERN HILLS, 5900 Yosemite Drive
- EDERVILLE PARK, 1450 Nottingham
- ENGLEWOOD PARK, 3200 Hanger Avenue
- FAIRFAX PARK, 4000 Fairfax Avenue

FREDERICKSBURG

LODGING

ALFRED HAUS BED & BREAKFAST
231 W Main St (78624)
Rates: $74+
(830) 997-5612; (866) 427-8374

BE MY GUEST LODGING SERVICE
110 N Milam (78624)
Rates: $61-$135
(830) 997-7227; (800) 314-8555

BECKERS BED & BREAKFAST & BICYCLES
404 W Hackberry St (78624)
Rates: $75-$85
(830) 990-9157

BEST WESTERN FREDERICKSBURG
324 E Highway St (78624)
Rates: $79-$135
(830) 992-2929; (800) 528-1234
(888) 908-2929

COMFORT INN
908 S Adams St (78624)
Rates: $75-$90
(830) 997-9811; (800) 228-5150

COUNTRY INN MOTEL
Hwy 290 W (78624)
Rates: $38-$62
(830) 997-2185

DAS KEIDELINN B&B
Main St (78624)
Rates: $98-$195
(830) 997-5612; (866) 427-8374

DELUXE INN
901 E Main St (78624)
Rates: $45-$120
(830) 997-3344

DIETZEL MOTEL
1141 W Hwy 290 (78624)
Rates: $45-$79
(830) 997-3330

FIRST CLASS B&B RESERVATION SERVICE
909 E Main St (78624)
Rates: $75-$195
(888) 991-6749

FRONTIER INN & RV PARK
1704 US Hwy 290 West (78624)
Rates: $46-$150
(830) 997-4389

THE FULL MOON INN B&B
3234 Luckenbach Rd (78624)
Rates: $150-$200
(830) 997-2205; (800) 997-1124

THE GARDEN HOUSE BED & BREAKFAST
104 N Adams St (78624)
Rates: $69
(830) 990-8455; (800) 745-3591

HOFFMAN HAUS GUESTHOUSE
608 E Creek St (78624)
Rates: $120-$190
(830) 997-6739; (800) 899-1672

HOLIDAY INN EXPRESS
1220 N Hwy 87 (78624)
Rates: $84-$109
(830) 990-4200; (800) 465-4329

**HOME ON THE RANGE B&B AT
STONEWALL VALLEY RANCH**
7490 Ranch Rd 2721 (78624)
Rates: $95-$60
(800) 460-2380

MILLERS INN MOTEL
910 E Main St (78624)
Rates: $35-$85
(830) 997-2244

MISS TOODLES INN BED & BREAKFAST
104 N Adams St (78624)
Rates: $115+
(830) 990-8455; (800) 745-3591

Locate Other Dog-Friendly Activities...Check Nearby Cities

PEACH TREE INN & SUITES
401 S Washington (78624)
Rates: $40-$100
(830) 997-2117; (800) 843-4666

**ROCK HOUSE ON ACORN
BED & BREAKFAST**
231 W Main St (78624)
Rates: $85+
(830) 997-5612; (866) 427-8374

ROCKY TOP BED & BREAKFAST
7910 Ranch Rd #965 (78624)
Rates: $85
(830) 997-8145

SCHMIDT BARN BED & BREAKFAST
231 W Main St (78624)
Rates: $65-$140
(830) 997-5612; (866) 427-8374

**SETTLERS CROSSING
HISTORIC GUEST HOUSES**
104 Settlers Crossing Rd (78624)
Rates: $90-$125
(830) 997-2722; (800) 874-1020

STONEWALL VALLEY RANCH HOUSE
104 N Adams St (78624)
Rates: $85
(830) 990-8455; (800) 745-3591

**STRACKBEIN-ROEDER SUNDAY HAUS
BED & BREAKFAST**
231 W Main St (78624)
Rates: $100+
(830) 997-5612; (866) 427-8374

SUNDAY HOUSE INN & SUITES
501 E Main St (78624)
Rates: $69-$150
(830) 997-4484; (800) 274-3762

SUNSET INN
900 S Adams St (78624)
Rates: $54-$69
(830) 997-9581

SUPER 8 MOTEL
514 E Main St (78624)
Rates: $59-$110
(830) 997-6568; (800) 800-8000
(877) 776-7283

WEST MAIN HAUS BED & BREAKFAST
231 W Main St (78624)
Rates: $75+
(830) 997-5612; (866) 427-8374

WOLF CREEK BARN B&B
231 W Main St (78624)
Rates: $98+
(830) 997-5612; (866) 427-8374

RECREATION

ENCHANTED ROCK STATE NATURAL AREA - Leashes

Info: Fairy shrimp, massive chunks of pink granite and rocks dating back 1 billion years make this area a land of enchantment for you and your sidekick. Tote your own water and hike through scenic, dome-shaped hills of rosy colored rock. Wildflowers in springtime bring a cornucopia of color to the landscape and add to your hiking and aesthetic pleasure. The area is primitive, please respect the rules. Picnickers can snout out one of the special, day-use areas and have a kibble cookout. Bone appetite! For more information: (325) 247-3903; (800) 792-1112; www.tpwd.state.tx.us.

Hotel Pet Policies May Be Subject To Change

Directions: From Fredericksburg, head north on RR 965 for 18 miles to park's entrance.

Note: The patches of vegetation on the bare granite are called vernal pools. They are extremely fragile and "severely threatened." You can look, but please do not disturb these areas. $5 entrance fee/person.

The numbered hikes that follow are within
Enchanted Rock State Natural Area:

1) LOOP TRAIL HIKE - Leashes

Beginner/4.0 miles

Info: Couch potato pooches, this flat simple trail around the base of Enchanted Rock is just your speed. As you loop about this billion-year-old granite dome, you'll pass several spur trails that make for great little sidetrips to scenic overlooks and ridgetops. Please remain on the trails, the surrounding soil is prone to erosion. For more information: (325) 247-3903; (800) 792-1112.

Directions: From Fredericksburg, head north on RR 965 for 18 miles to park's entrance.

2) SUMMIT TRAIL HIKE - Leashes

Intermediate/1.2 miles

Info: This trail to the top of Enchanted Rock may be short on distance, but not on effort. Get ready for an aerobic workout as you and the dawgus climb 425 feet in just .6 miles. Your reward, summit vistas. Once at the top, sit a spell and drink in the magnificence of the surrounding hill country or check out the vernal pools. The pools are home to unique flora and fauna that co-exist in dormant conditions from season to season. This fragile ecosystem must be left undisturbed. For more information: (325) 247-3903; (800) 792-1112.

Directions: From Fredericksburg, head north on RR 965 for 18 miles to park's entrance.

Locate Other Dog-Friendly Activities...Check Nearby Cities

LADY BIRD JOHNSON MUNICIPAL PARK - Leashes

Info: Escape the city for awhile and settle in for a comfy afternoon in the shade of an oak tree at this vast park. Cloudgaze to your heart's content or try your luck at trout fishing. For more information: (830) 997-4202.

Directions: Located two miles southwest of the Fredericksburg city limits on Texas Highway 16 (Kerrville Highway).

LBJ STATE PARK AND HISTORIC SITE - Leashes

Info: Give your pooch the VIP treatment by spending the day combing the 717 acres of LBJ State Park and Historic Site. Nestled in a natural setting, this historical park offers lots of eye-pleasing recreation for you and the tailwagger. You can sniff out the past as you lead your history hound past the log cabins that reflect the influence of early German settlers. Or learn about the local flora on the 1.5-mile nature trail that winds its way through lovely fields of dazzling wildflowers as well as several wildlife enclosures and exhibits. Don't forget your binoculars, the bird watching opportunities are excellent. If you're a fishing fiend, try your rod in the river, while the pooch munches on Scooby snacks beside you. For more information: (830) 644-2252; (800) 792-1112; www.tpwd.state.tx.us.

Directions: From Fredericksburg, take Highway 290 east for 16 miles to park entrance.

The numbered hike that follows is within LBJ State Park and Historic Site:

1) PASEO DEL ARROYO NATURE TRAIL HIKE - Leashes

Beginner / 1.25 miles

Info: Leash your hound since wildlife abounds on this interpretive trail that journeys through a landscape filled with white-tailed deer, bison, longhorn cattle and wild turkeys. Glance skywards once in awhile for a sighting of the numerous bird species that call this park home. If your pooch is a sniffmeister at heart, plan a spring hike. The park's spectacular

Hotel Pet Policies May Be Subject To Change

wildflower display will send Bowser's tail and nose into over-drive. For more information: (830) 644-2252.

Directions: From Fredericksburg, take Highway 290 east for 16 miles to park entrance.

FREEPORT

LODGING

ANCHOR MOTEL
1302 Bluewater Hwy (77541)
Rates: $35-$55
(979) 239-3543

COUNTRY HEARTH INN
1015 W 2nd St (77541)
Rates: n/a
(979) 39-1602

BEACH RESORT SERVICES-RENTALS
409 E Hwy 332,
#2 (77541)
Rates: $75-$350
(800) 382-9283

RECREATION

SAN BERNARD NATIONAL WILDLIFE REFUGE - Leashes

Info: Birders have been known to go bonkers at the 27,000-acre San Bernard National Wildlife Refuge. With more than 300 species of birds, sightings are significant, especially during spring and fall migrations. In addition to birds, the refuge is home to a variety of fish, reptiles, amphibians and mammals. Saltwater fishing and crabbing are allowed at Cedar Lakes, Cow Trap Lakes and Cedar Lake Creek. So pack the pooch, the binocs, your rod and reel and head out for an afternoon of wildlife fun along miles of hiking trails or on the 3-mile driving tour. For more information: (979) 849-6062; (979) 964-3639.

Directions: From Freeport, head west on Highway 36 to FM 2611. Turn right on FM 2611 to FM 2918. Make a left on FM 2918 for one mile to County Road 306. Turn right for a half-mile to the refuge.

Note: Insect repellent is highly recommended.

Locate Other Dog-Friendly Activities...Check Nearby Cities

The numbered auto tour that follows is within the
San Bernard National Wildlife Refuge:

1) MOCCASIN POND AUTO TOUR

Info: For those who prefer the comfort of a car to a walking expedition, take a cruise along the 3-mile touring road. You and the dawgus won't know where to look first - at the wildlife on land or the birds soaring overhead. Bone voyage. For more information: (979) 849-6062; (979) 964-3639.

FULTON

LODGING

BAY FRONT COTTAGES
309 S Fulton Beach Rd (78382)
Rates: $45-$54
(361) 729-6693

INN AT FULTON HARBOR
215 N Fulton Beach Rd (78358)
Rates: $94-$119
(866) 301-5111

BEST WESTERN INN BY THE BAY
3902 N Hwy 35 (78358)
Rates: $80-$95
(361) 729-8351; (800) 528-1234
(800) 235-6076

PELICAN BAY RESORT
4206 N Hwy 35 (78358)
Rates: $69-$275
(866) 729-7177

HARBOR LIGHTS COTTAGES
108 Laurel (78358)
Rates: $45+
(361) 729-6770

GAINESVILLE

LODGING

BEST WESTERN SOUTHWINDS
2103 I-35 N (76240)
Rates: $49-$79
(940) 665-7737; (800) 528-1234
(800) 731-1501

RAMADA LIMITED
600 Fair Park Blvd (76240)
Rates: $59-$119
(940) 665-8800; (800) 272-6232

BUDGET HOST INN
1900 N I-35 (76240)
Rates: $40
(940) 665-2856; (800) 283-4678

Hotel Pet Policies May Be Subject To Change

GALVESTON

LODGING

AVENUE O BED & BREAKFAST
2323 Ave O (77550)
Rates: $85-$145
(866) 762-2868

COTTAGE BY THE BEACH RENTAL
810 Ave L (77550)
Rates: $90-$250 per night/
$500+ weekly/$900 monthly
(409) 770-9332

GALVESTONAPTS.COM
1811 Moody (21st), #5 (77550)
Rates: $40-$125
(409) 765-6916

HILLTOP MOTEL
8828 Seawall Blvd (77554)
Rates: $35-$75
(409) 744-4423

LA QUINTA INN
1402 Seawall Blvd (77550)
Rates: $70-$199
(409) 763-1224; (800) 687-6667

THE MAGNOLIA HOUSE-VACATION RENTAL
812 Ave L (77550)
Rates: $120-$195 per night/
$800-$1600 month
(409) 770-9332

MOTEL 6
7404 Ave J - Broadway (77554)
Rates: $33-$69
(409) 740-3794; (800) 466-8356

RECREATION

BAYSHORE PARK - Leashes
Info: Let your cares drift away as you relax with Max in this peaceful park.

Directions: Located at 5437 East FM 646.

CARBIDE PARK - Leashes
Info: Do the lazy thing and just chill out in this pleasant park or bring a tennie along and play a game of catch.

Directions: Located at 4102 FM 519.

ELVA LOBIT PARK - Leashes
Info: Burn some kibble with a leg-stretching jaunt in this neighborhood parkland.

Directions: Located at 1901 East FM 646.

Locate Other Dog-Friendly Activities...Check Nearby Cities

GALVESTON ISLAND STATE PARK - Leashes

Info: A land of diversity and diversions, this 2000-acre park offers bayous, lakes, ponds and miles of beach for you and furface to explore. Dig your toes and paws into the soft sand as you listen to the waves roll onto shore. Drop a line for flounder or spotted sea trout. Or birdwatch along the bayou. Four different ecological zones including a salt marsh, coastal prairie, sand dunes/maritime wetlands and sand beaches are yours to experience. Four miles of trails allow you to journey through this varied terrain. So plan a day with Mother Nature at this delightful water wonderland. Carpe diem Duke. For more information: (409) 737-1222; (800) 792-1112; www.tpwd.state.tx.us.

Directions: From Highway 45 in Galveston, take the 61st Street exit and go right (south) to Seawall Boulevard (FM 3005). Turn right (west) on Seawall Boulevard (FM 3005) and drive 10 miles to park entrance on left-hand side of road.

Note: Entrance fee charged.

The numbered hike that follows is within Galveston Island State Park:

1) CLAPPER RAIL TRAIL HIKE - Leashes

Beginner/4.0 miles

Info: Expect a bonafido interesting excursion on this trail. From marshlands, meadows, saltwater ponds and freshwater lakes to beaches, coastal prairies and bayous, you and the pupster will be escorted through a wonderland of nature. As you hike from one ecological zone to the next, check out the scenic observation overlooks, the bird viewing blinds and the 1,000-foot boardwalk across the marsh. For more information: (409) 737-1222.

Directions: From Highway 45 in Galveston, take the 61st Street exit and go right (south) to Seawall Boulevard (FM 3005). Turn right (west) on Seawall Boulevard (FM 3005) and drive 10 miles to park entrance on left-hand side of road.

JACK BROOKS PARK - Leashes

Info: Get the juices flowing as you and the dawgus investigate this lovely multi-use park. Canines can dip their paws in one of three ponds that dot the landscape. Wet waggers will love you forever after a stroll beside Diversion Creek, which cuts a ribbon through the park and adds a touch of coolness to the scenery. Hop on the half-mile nature trail into a dense forest of cedar and oak where you'll have it made in the shade. The creek that skirts the trail provides a gurgling backdrop to this peaceful woodsy setting.

For more of a workout, don't miss the three-mile pedestrian trail that circles this 600 acre parkland. Take a moment and visit the Veteran's Memorial along the way. If you're a model airplane buff, the Kittyhawk Model Airplane Landing Strip is definitely something to wag about. Spread your wings and fly your plane as you socialize with other grounded pilots. Pack some snacks, you and the dawgus may just want to make a day of it. FYI: The park's new covered arena hosts AKC sanctioned dog shows. For more information: (409) 934-8100.

Directions: From Highway 45 take the Gulf Greyhound Park exit. Head south on FM 2004 about 1.5 miles. The entrance to the park will be on your right-hand side.

PAUL HOPKINS PARK - Leashes

Info: Take a gander at the Gulf as you lead your Laddie through this city park.

Directions: Located at 1000 A FM 517.

RAY HOLBROOK PARK - Leashes

Info: Frolic with furface through this verdant scene.

Directions: Located at 99000 Owens Drive.

RUNGE PARK - Leashes

Info: Hightail it to this hound haven and make tracks over the acreage.

Directions: Located at 4605 Peck.

OTHER PARKS IN GALVESTON - Leashes

For more information, contact the Galveston Parks & Recreation Department at (409) 621-3177.

- •BEACH PARK # 1, 11102 FM 646
- •BEACH PARK # 2, 11743 FM 3005
- •BEACH PARK # 3, 13315 San Luis Pass

GARLAND

Lodging

BEST WESTERN LAKEVIEW INN
1635 E I-30 at Chaha Rd (75043)
Rates: $49-$89
(972) 303-1601; (800) 528-1234
(800) 276-7462

COMFORT INN
12670 E Northwest Hwy (75228)
Rates: $45-$53
(972) 613-5000
(800) 228-5150

DAYS INN
6222 Beltline Rd (75043)
Rates: $40-$49
(972) 226-7621; (800) 329-7466

LA QUINTA INN NORTHEAST
12721 I-635 (75041)
Rates: $60-$86
(972) 271-7581; (800) 687-6667

MICROTEL INN & SUITES
1901 Pendleton Dr (75041)
Rates: $40-$85
(972) 270-7200; (888) 771-7171

MOTEL 6
436 W I-30 & Beltline (75043)
Rates: $33-$53
(972) 226-7140; (800) 466-8356

Hotel Pet Policies May Be Subject To Change

GATESVILLE

LODGING

**BEST WESTERN
CHATEAU VILLE MOTOR INN**
2501 E Main St (76528)
Rates: $49-$69
(254) 865-2281; (800) 528-1234
(888) 451-4521

KEENER HOUSE BED & BREAKFAST
1308 W Main (76528)
Rates: $60-$70
(254) 865-6476

GEORGE WEST

LODGING

BEST WESTERN EXECUTIVE INN
208 N Nueces St (78022)
Rates: $65-$90
(361) 449-3300; (800) 528-1234

GEORGETOWN

LODGING

COMFORT INN
1005 Leander Rd (78628)
Rates: $54-$89
(512) 863-7504; (800) 228-5150

LA QUINTA INN
333 I-35 N (78628)
Rates: $60-$86
(512) 869-2541; (800) 687-6667

RECREATION

CEDAR BREAKS PARK - Leashes

Info: Do some lakeside lolling with your wet wagger or work off some energy on one of the hiking trails. Your eyes will be captivated by the shoreline scenery, while your sniffer's senses will be filled with the crisp fragrance of cedar. For more information: (512) 930-5253.

Directions: From Georgetown, head west on Williams Drive to Cedar Breaks Road. Turn left and travel straight across the dam to the park.

Locate Other Dog-Friendly Activities...Check Nearby Cities

INNER SPACE CAVERN

Info: Geology aficionados, you're gonna love this place. From stalagmites to stalactites, flowstones to prehistoric mastodons, you won't soon forget a visit to the Inner Space Cavern. Spectacular sound and light shows enhance the subterranean atmosphere, while a year round temperature of 72 degrees makes the cavern a cool oasis even during the dog days of summer. Although your canine spelunker can't explore with you, he can chill out (free of charge) at the cavern's pet taxi. If you have the time (75 minutes), the cavern guarantees an unimaginable experience. For more information: (512) 931-CAVE; www.innerspace.com.

Directions: Located off Interstate 35 at the Georgetown offramp (Exit #259).

Note: Entrance fee charged. Open 7 days a week; call for hours.

RUSSEL PARK - Leashes

Info: Float your own boat atop the lake with your best buddy beside you. If you prefer to keep your paws grounded, gear up for a great hike on one of the many trails through thick woodlands in this vast natural region. Bring your binoculars, you might get lucky - several species of ground dwellers and sky soarers inhabit the parkland. For more information: (512) 930-5253.

Directions: From Georgetown, head northwest on 2338 until it intersects with FM 3405. Head west on FM 3405 to CO 262. Drive south on CO 262 to park entrance.

SAN GABRIEL PARK - Leashes

Info: Graced with 200 year-old oak trees, this park beckons you and Rover to sit in shaded splendor and spectate. Or, if your barkmeister needs to b on he go, try the new 1.0 mile wooded trail that meanders along the North Fork of the San Gabriel River. For more information: (512) 930-3595; www.georgetown.org.

Hotel Pet Policies May Be Subject To Change

Directions: San Gabriel Park is centrally located in Georgetown and is bordered by Austin Avenue, River Haven Drive, Stadium Drive and North College Street.

TEJAS CAMP - Leashes

Info: Happy days begin with an excursion to this delightful water oasis. Rove over miles of riverside trails, or just relax by the water's edge with furface. You'll find plenty of shade and lots of scenic picnic areas ideal for a biscuit break with the chompmeister. For more information: (512) 930-5253.

Directions: From Georgetown, head west on Highway 29 to Highway 183. Take Highway 183 north until you reach FM 3405. Head east on FM 3405 to CO 258. Take a right (southeast) on CO 258. The river marks the start of Tejas Camp.

GIDDINGS

LODGING

RAMADA LIMITED
4002 E Austin St (78942)
Rates: $70-$75
(979) 542-9666; (800) 272-6232

SUPER 8 MOTEL
3556 E Austin (78942)
Rates: $44-$61
(979) 542-5791; (800) 800-8000

SANDS MOTEL
1600 E Austin (78942)
Rates: $37-$50
(979) 542-3111

GILMER

LODGING

EXECUTIVE INN
1200 Hwy 271 S (75644)
Rates: $55-$80
(903) 843-6099

Locate Other Dog-Friendly Activities...Check Nearby Cities

GLEN ROSE

LODGING

**BEST WESTERN DINOSAUR VALLEY
INN & SUITES**
1311 NE Big Bend Trail (76043)
Rates: $85-$375
(254) 897-4818; (800) 528-1234

COUNTRY WOODS INN B&B
420 Grand Ave (76043)
Rates: $90-$150
(254) 279-3002; (888) 849-6637

GLEN HOTEL
201 Barnard St (76043)
Rates: $35-$60
(254) 897-2420

GLEN ROSE INN & SUITES
300 SW Big Bend Trail (76043)
Rates: $49-$99
(800) 577-2540

**THE HAYLOFT BED & BATH
AT ROLLING ROCK RANCH**
County Rd 2009 (76043)
Rates: n/a
(254) 897-3094

**HIDEAWAY COUNTRY LOG CABIN
BED & BREAKFAST**
P. O. Box 430 (76043)
Rates: $95-$140
(254) 823-6606

QUAIL RIDGE RANCH B&B
P. O. Box 900 (76043)
Rates: $195-$350
(866) 897-3618

**ROUGH CREEK LODGE
EXECUTIVE RETREAT/RESORT**
P O Box 2400 (76043)
Rates: $199-$1200
(800) 864-4705

TRES RIOS RIVER RESORT/ RV MOTEL
2322 CR 312 (76043)
Rates: $56-$175
(254) 897-4253; (888) 4-CAMPRV

RECREATION

DINOSAUR VALLEY STATE PARK - Leashes

Info: No bones about it, you and your Texasaurus will have a paw-stomping good time in this 1,500-acre expanse. Take the dawgus riverside and see if he sniffs out any prehistoric surprises. Present day flora and fauna also inhabit the area. Tote your binocs and scout out the birds or pack a biscuit basket and dine alfresco in the shade of a sycamore. Whatever your pleasure, you're sure to find it here. For more information: (254) 897-4588; (800) 792-1112; www.tpwd.state.tx.us.

Directions: From Glen Rose, take Highway 67 west approximately one mile to FM 205. Turn north FM 205 and drive 4

miles to Park Road 59. Follow Park Road 59 for one mile to headquarters.

Note: Dinosaur tracks are located in the river. Check with headquarters for river conditions. $5 entrance fee/person.

The numbered hike that follows is within Dinosaur Valley State Park:

1) CEDAR BRAKE TRAIL SYSTEM - Leashes

Beginner/Intermediate/13.0 miles

Info: Located on the left bank of the Paluxy River, a network of hiking and nature trails will send the tails of hiking hounds and aquapups into wagging overdrive. With miles of dinosaur tracks, scenic overlooks, river crossings, dense forests and color-coded trails, this region is so diverse that you won't know where to begin your nature excursion. No matter how many miles you cover, cool off at day's end with some water hijinks in the river.

From the left bank, you have four looping choices. If you and the pooch prefer your hikes woodsy and shaded, point snouts to the Denio Creek Trail where groves of elm, oak and cedar canopy the path. Fishing hounds and Dino wannabes should hightail it to the River Trail where fishing holes and dinosaur tracks are the main attractions. Couch slouches and wet waggers should head towards the Buckeye Creek Trail - it's short and loaded with paw dipping delights. Exercise enthusiasts will want to check out the Outer Ridge Trail, the park's longest. Or get an early start and do it all, see it all. To help chart your course, pick up a trail map at the park entrance. For more information: (254) 897-4588 or (800) 792-1112.

Directions: From Glen Rose, take Highway 67 west approximately one mile to FM 205. Turn north for 4 miles to Park Road 59. Follow Park Road 59 for one mile to headquarters.

Note: Flash floods are common to area. Avoid the trails after a heavy rain.

Locate Other Dog-Friendly Activities...Check Nearby Cities

GOLIAD

RECREATION

GOLIAD STATE HISTORICAL PARK - Leashes

Info: Spend a lazy summer day on the nature trail perusing the serenity of your surroundings. Typical Texas brushland and chaparral contrast with the dense woodlands of the San Antonio River floodplain. Birdwatchers will delight in the diversity of species in this 188-acre park, while aimless amblers can just spend some quality time with their best buddy. Pups are not permitted on the Mission Grounds, but may accompany you anywhere else. For more information: (361) 645-3405; (800) 792-1112; www.tpwd.state.tx.us.

Directions: From Goliad, take Highway 183 and 77A south for a quarter mile to the park entrance.

Note: Entrance fee charged.

The numbered hikes that follow are within Goliad State Historical Park:

1) ANGEL OF GOLIAD HIKE/BIKE/NATURE TRAIL - Leashes

Beginner/4.0 miles

Info: This hike/bike/nature trail follows the banks of the San Antonio River through a riparian habitat and connects downtown Goliad with the Goliad State Historical Park, Presidio La Bahia and Fannin Memorial Monument. You and furface are sure to get your fill of history on this enjoyable trek. Be sure to yield to cyclists. For more information: (361) 645-3405.

Directions: From Goliad, take Highway 183 and 77A south for a quarter mile to the park entrance.

2) ARANAMA NATURE TRAIL HIKE - Leashes

Beginner/0.33 miles

Info: Named for the Aranama Indians, this no-sweat trail is a mini leg-stretcher. Make the most of this interpretive walk by

picking up a trail brochure, which corresponds with the numbered markers. For more information: (361) 645-3405.

Directions: From Goliad, take Highway 183 and 77A south for a quarter mile to the park entrance.

3) SAN ANTONIO RIVER TRAIL HIKE - Leashes
Beginner/3.0 miles

Info: Sunday strollers, a riparian oasis awaits you and the water woofer on this lovely riverside jaunt. Like an outdoor concert, songbirds serenade as you stroll amidst stands of cottonwood, sugarberry, pecan and sycamore beside the banks of the San Antonio River. For more information: (361) 645-3405.

Directions: From Goliad, take Highway 183 and 77A south for a quarter mile to the park entrance.

GONZALES

LODGING

BOOTH HOUSE BED & BREAKFAST
706 St. George St (78629)
Rates: $85-$140
(830) 672-7509

LUXURY INN
1804 Sarah DeWitt Dr (78629)
Rates: $50-$93
(830) 672-9611

RECREATION
INDEPENDENCE PARK - Leashes

Info: Say adieu to the summertime blues with a journey to this charming park. Hit the 2-mile trail in this green scene or find a grassy knoll and cloudgaze to your heart's content in a beautiful, rolling savannah.

Directions: From Gonzales, take 183 south for 2 miles to the park on the right-hand side of the road.

PALMETTO STATE PARK - Leashes

Info: Dotted with dwarf palmettos and filled with songbirds, Palmetto Park has been billed as a tropical wonderland. Boogie with Bowser on one of the trails or laze lakeside with your best pal. There are lots of picnic areas, so you might want to plan a kibble cookout. For more information: (830) 672-3266; (800) 792-1112; www.tpwd.state.tx.us.

Directions: From Gonzales, take Highway 183 north to FM 1586. Head west on FM 1586 to Park Road 11. Follow Park Road 11 south to the park entrance.

Note: $2 entrance fee/person

The numbered hikes that follow are within Palmetto State Park:

1) LAKE TRAIL HIKE - Leashes

Beginner/1.3 miles

Info: Short and sweet best describe this wooded, lakeside trail. As you circle the 4-acre oxbow lake, sniff out a good picnic spot and do lunch alfresco. Finish the afternoon off with some tootsie dipping in the refreshing water. For more information: (830) 672-3266.

Directions: From Gonzales, take Highway 183 north to FM 1586. Head west on FM 1586 to Park Road 11. Follow Park Road 11 south to the park entrance.

2) PALMETTO STATE PARK HIKING TRAIL - Leashes

Intermediate/1.25 miles

Info: Get your daily dose of Texercise on this interesting nature expedition. Experience the best of what the park has to offer scenery wise on this looping trail through swamplands and woodlands. Birders, don't forget the binocs. Over 240 species of birds have been spotted in the park. For more information: (830) 672-3266.

Hotel Pet Policies May Be Subject To Change

Directions: From Gonzales, take Highway 183 north to FM 1586. Head west on FM 1586 to Park Road 11. Follow Park Road 11 south to the park entrance.

3) PALMETTO TRAIL HIKE - Leashes

Beginner/0.3 miles

Info: If you're a lover of forests and swamps this is one peanut-sized nature trail you won't want to miss. As you loop through the heart of the Ottine Swamp, groves of towering willow, sycamore, cedar, ash, palmetto and elder shade the trail, making this a pleasantly cool excursion even during the hot diggety dog days of summer. For an educational perk, pick up an interpretive trail guide. For more information: (830) 672-3266.

Directions: From Gonzales, take Highway 183 north to FM 1586. Head west on FM 1586 to Park Road 11. Follow Park Road 11 south to the park entrance.

4) RIVER TRAIL HIKE - Leashes

Beginner/0.6 miles

Info: This piece-of-cake riverside jaunt is perfect for wet waggers and tree hounds. Not only does the trail skirt the San Marcos River, it also slices through lush forests of cottonwood and cedar elm. Pick up a trail guide before setting out on your amble and learn as you take a turn around this popular interpretive trail. For more information: (830) 672-3266.

Directions: From Gonzales, take Highway 183 north to FM 1586. Head west on FM 1586 to Park Road 11. Follow Park Road 11 south to the park entrance.

WES GROVES PARK - Leashes

Info: Your pooch will love starting his day with a jaunt along the 1.2-mile trail in this park.

Directions: Located at 5601 West Washington.

Locate Other Dog-Friendly Activities...Check Nearby Cities

GRAHAM

LODGING

GATEWAY INN
1401 Hwy 16 S (76450)
Rates: $38-$45
(940) 549-0222

GRANBURY

LODGING

COMFORT INN
1201 Plaza Dr N (76048)
Rates: $70-$190
(817) 573-2611; (800) 228-5150

PLANTATION INN ON THE LAKE
1451 E Pearl St (76048)
Rates: $60-$95
(817) 573-8846; (800) 422-2402

DAYS INN
1339 N Plaza Dr (76048)
Rates: $49-$99
(817) 573-2691; (800) 329-7466
(800) 858-8607 (TX)

**THE BAKER-CARMICHAEL HOUSE
SOUTHERN COUNTRY INN**
226 E Pearl St (76048)
Rates: $89-$149
(866) 476-8631

RECREATION

DAVIS CATFISH PONDS - Leashes

Info: Fishing aficionados, stock up for your next fish fry. A pond chock-full of Arkansas catfish awaits. So, pack your pole (or rent one at the pond), drop a line and try your luck. Or just stow a chew and a good read and treat yourself and the dogster to a lazy day outing. For more information: (817) 573-3738.

Directions: From Granbury, take Highway 377 east to FM 167. Turn left (north) on FM 167 for approximately 1.4 miles to the ponds. The entrance is signed.

Note: Fishing is seasonal, call ahead.

GRANBURY CITY BEACH - Leashes

Info: Although small, this beach will satisfy your furball's need to frolic in the sand and your yen for waterful fun. For more information: (817) 573-9692.

Directions: Located off East Pearl Street.

GRANBURY CITY PARK - Leashes

Info: Pack a fun attitude and a pocketful of treats before you head out to this park. Pace Rover over acres and acres of open space, try the 1 1/2-mile walking path or just chill with Will under the shade of towering tress. For more information: (817) 573-9692.

Directions: Located at 100 Park Drive off West Pearl.

LAMBERT BRANCH PARK - Leashes

Info: For a quickie workout, shake a tail to this pretty little neighborhood park. Who knows, you might just meet up with some local canines. For more information: (817) 573-9692.

Directions: Located on Brazos Street in the city limits of Granbury.

OTHER PARKS IN GRANBURY - Leashes

For more information, contact the City of Granbury at (817) 573-3212.

- •DECORDOVA BEND DAM, HCR 309 off Highway 167 South
- •HUNTER PARK, Highway 51 North
- •LAROE PICNIC GREEN, South Houston
- •ROUGH CREEK PARK, off Highway 144 South

GRAND PRAIRIE

LODGING

AMERISUITES
1542 N Hwy 360 (75050)
Rates: $109-$119
(972) 988-6800; (800) 833-1516

BUDGET SUITES OF AMERICA
2270 N Hwy 360 (75050)
Rates: $59-$99
(877) 822-5272

DAYS INN
2615 Sara Jane Pkwy (75050)
Rates: $54-$145
(972) 623-1998; (800) 329-7466

HOWARD JOHNSON EXPRESS INN
1114 E Main St (75050)
Rates: $45-$65
(800) 446-4656

LA QUINTA INN SIX FLAGS
1410 NW 19th St (75050)
Rates: $60-$95
(972) 641-3021; (800) 687-6667

MOTEL 6
406 E Safari Pkwy (75050)
Rates: $29-$53
(972) 642-9424; (800) 466-8356

RECREATION

LOYD PARK - Leashes

Info: Dollars to dog biscuits, you and the lickmeister are gonna enjoy a stroll around the open space or a lazy bones day in the grass.

Directions: Located at 3401 Ragland Road.

LYNN CREEK PARK - Leashes

Info: Bustling with activity, this park is a great place to carouse with your social sport. For more information: (972) 237-8100.

Directions: Located at 5700 Lakeridge Parkway.

Note: Dogs are prohibited on beaches and in swimming areas.

MIKE LEWIS PARK - Leashes

Info: Burn some kibble on the fitness trail or dangle a line, the fishing is fine. Pack a biscuit basket and a fun attitude and treat the pooch to a bit of playtime.

Directions: Located on the 2600 block of North Carrier Parkway.

Hotel Pet Policies May Be Subject To Change

TURNER PARK - Leashes

Info: Stroll through the scenic open space with the dawgus or do some Texas dreaming from the gazebo.

Directions: Located at 600 Northeast Eighth Street (Beltline Road).

WAGGONER PARK - Leashes

Info: When play's the thing, this park's the place. Frolic through expansive fields while you and Tex enjoy an afternoon of fun in the sun. Or relax in the shade of an oak and root for one of the local teams.

Directions: Located at 2122 North Carrier Parkway.

GRAPEVINE

LODGING

AMERISUITES-DFW AIRPORT N
2220 Grapevine Mills Circle W (76051)
Rates: $89-$119
(972) 691-1199; (800) 833-1516

HOMEWOOD SUITES
2214 Grapevine Mills Circle W (76051)
Rates: $125-$134
(972) 691-2427; (800) 225-5466

EMBASSY SUITES OUTDOOR WORLD
2401 Bass Pro Dr (76051)
Rates: $109-$229
(972) 724-2600; (800) 362-2779

SUPER 8 MOTEL
250 E Hwy 114 (76051)
Rates: $59-$79
(972) 329-7222; (800) 800-8000

GREENVILLE

LODGING

AMERICAN INN
I-30 & US 69 (75401)
Rates: $30-$45
(903) 455-9600

BEST WESTERN INN & SUITES
1216 I-30 W (75402)
Rates: $64-$74
(903) 454-1792; (800) 528-1234
(800) 795-2300

Locate Other Dog-Friendly Activities...Check Nearby Cities

HOLIDAY INN EXPRESS HOTEL & SUITES
2901 Mustang Crossing (75402)
Rates: $89-$125
(903) 454-8680; (800) 465-4329

MOTEL 6
5109 I-30 & US 69 (75402)
Rates: $34-$52
(903) 455-0515; (800) 466-8356

SUPER 8 MOTEL
5010 Hwy 69 S (75402)
Rates: $48-$69
(903) 454-3736; (800) 800-8000

TRAVELERS INN
1215 E I-30 (75402)
Rates: $69
(903) 454-7000

RECREATION

FLETCHER WARREN PARK - Leashes

Info: Make your dog's day with a trip to this pleasant green scene.

Directions: Located at Live Oak and Eastland.

GRAHAM PARK - Leashes

Info: The stately oak trees in this quiet lakeside park provide a delightfully cool retreat for a serene lunch alfresco. The dawgus will love you for the outing.

Directions: Take the 69 business loop to Cross Road. Head southwest on Cross Road to the park.

MIDDLETON PARK - Leashes

Info: When the mutt is tugging at the leash, make tracks to Middleton for an afternoon of R&R.

Directions: Located at Pickett and Sayle Streets.

WIND POINT PARK - Leashes

Info: Play tagalong with your wagalong on over 350 acres at this spacious park. You and the dogster can have your fill of fun and all kinds of adventures. Fish off the pier, picnic in the shade, or hustle your butt through the scenic terrain. For more information: (903) 457-3116.

Directions: Located on FM 1571 southeast of Lone Oak.

Hotel Pet Policies May Be Subject To Change

GROESBECK

RECREATION

OLD FORT PARKER STATE HISTORICAL PARK - Leashes

Info: Rich in history and steeped in folklore, Old Fort Parker is a haven for history buffs. A white settler, Cynthia Ann Parker, was captured by a band of Comanches and later married Chief Peta Nacona. She bore three children before being recaptured and returned to relatives in East Texas. Unable to adjust to the Anglo-American way of life, she died at age 37. Her son, Quanah, adopted his mother's name and led many Comanches in a successful integration with settlers. Pamphlets detailing this interesting story are available at the Fort.

Today the fort offers opportunities for nature study as well as Western lore. You and your gadabout can explore the sites as you travel over a green landscape in this 37-acre expanse. Or pack a snack and find yourself a riverside locale where you'll be entertained by the resident songbirds. For more information: (254) 729-5253; (800) 792-1112; www.tpwd.state.tx.us.

Directions: Head north on Highway 14 to Park Road 35 and exit left for one mile to entrance.

Note: $2 entrance fee/person.

GROVES

LODGING

MOTEL 6
5201 E Pkwy (77619)
Rates: $29-$35
(409) 962-6611; (800) 466-8356

HALE CENTER

<u>RECREATION</u>

BELL PARK CACTI GARDEN - Leashes

Info: Cactus is the name of the game at this petite garden park, home to more than 350 cactus. Mosey with Rosie along the walking path and see how many species you can identify. Afterwards, do a brown bagger with the wagger at the picnic area. For more information: (806) 839-2642.

Directions: Located at the intersection of Avenue K and Cleveland Street (FM 1424 and FM 1914).

HALLETTSVILLE

<u>LODGING</u>

AUNT CAROL'S BED & BREAKFAST
749 CR 244 (77964)
Rates: $65-$75
(361) 798-4674; (888) 556-6582

HAMILTON

<u>LODGING</u>

HAMILTON GUEST HOTEL B&B
109 N Rice (76351)
Rates: $49-$79
(254) 386-8977; (800) 876-2502

WESTERN MOTEL
1208 S Rice St (76351)
Rates: $31-$37
(254) 386-3141

VALUE LODGE INN MOTEL
Rt 3, Box 319 (76351)
Rates: $25-$40
(254) 386-8959

<u>RECREATION</u>

PECAN CREEK COMMUNITY RECREATION PARK - Leashes

Info: A memorable day is in the making for you and the dog-ster at this lovely urban oasis. Running alongside Pecan

Hotel Pet Policies May Be Subject To Change

Creek, the park offers a great getaway opportunity on a sultry summer day. Take to the 1.3-mile trail, rockhop or just sprawl out creekside and soak up some serenery. For more information: (254) 386-3383.

Directions: Located one block east of town. The park runs from Standerfer to East Gentry.

HARLINGEN

LODGING

COMFORT INN
406 N Expwy 77 (78552)
Rates: $69-$120
(956) 412-7771; (800) 228-5150

COUNTRY INN & SUITES
3825 S Expwy 83 (78550)
Rates: $59-$120
(956) 428-0043; (800) 456-4000

HOWARD JOHNSON INN
6779 W Expwy 83 (78552)
Rates: $55-$67
(956) 425-7070; (800) 446-4656

LA QUINTA INN
1002 S Expwy 83 (78552)
Rates: $75-$101
(956) 428-6888; (800) 687-6667

MOTEL 6
224 S Expwy 77 (78550)
Rates: $33-$39
(956) 421-4200; (800) 466-8356

RAMADA LIMITED
4401 S Expwy 83 (78550)
Rates: $67-$110
(956) 425-1333; (800) 272-6232

SUPER 8 MOTEL
1115 S Expwy 83 (78550)
Rates: $45-$59
(956) 412-8873; (800) 800-8000

RECREATION

LAGUNA ATASCOSA NATIONAL WILDLIFE REFUGE - Leashes

Info: Wildlife enthusiasts will have a tailwagging good time at the Laguna Atascosa National Wildlife Refuge. Comprised of more than 45,000 acres of brushlands, grasslands, ponds and resacas, the refuge is home to a unique assortment of wildlife. Some of the animals include the endangered ocelot, aplomado falcon and piping plover. Equipped with a network of trails and drives, this region affords visitors plenty of wildlife viewing opportunities.

If gators are more your style, grab your camera and head down to Alligator Pond. Located just a quarter-mile south of Osprey Overlook, the pond usually has at least one alligator in residence. If it's been a rainy year, you're bound to see alligators in all the ponds. Use caution and common sense near these reptiles. Do not feed them and keep a tight grip on the pooch's leash. For more information: (956) 748-3607.

Directions: From Harlingen, head east on Highway 106 approximately 14 miles past Rio Hondo. At the "T", turn left for 3 miles to the visitor center.

Note: $3 entrance fee (entrance fees are included with Golden Age, Golden Eagle and Golden Access Passports). Insect repellent is highly recommended.

The numbered drives and hikes that follow are within the
Laguna Atascosa National Wildlife Refuge:

1) BAYSIDE DRIVE

Info: Couch slouches, this no-sweat car trip might make you want to get out more often. Buckle up and take a drive around the refuge's 15-mile looping tour road. Your voyage will include passage through thorn forests and coastal prairies before arriving at the Laguna Madre. For terrific bay views and wildlife sightings, plan a stop at the Redhead Ridge Overlook. Don't forget your digital - the loop passes several scenic pullouts where photo opportunities abound. For more information: (956) 748-3607.

Directions: From Harlingen, head east on Highway 106 approximately 14 miles past Rio Hondo. At the "T", turn left for 3 miles to the visitor center.

2) KISKADEE TRAIL HIKE - Leashes

Beginner/0.13 miles

Info: Short and shaded, this looping trail gets the high five from all visitors. Depending upon recent rainfall, the pond may treat you and your wagalong to some interesting bird sightings. For more information: (956) 748-3607.

Hotel Pet Policies May Be Subject To Change

Directions: From Harlingen, head east on Highway 106 approximately 14 miles past Rio Hondo. At the "T", turn left for 3 miles to the visitor center.

3) LAKESIDE DRIVE

Info: This 1.5-mile tour road leads to the refuge's namesake, Laguna Atascosa. The lake is a popular feeding and resting haven for more than 20 species of waterfowl, so keep Fido leashed if you venture out of the car. For up-close encounters of the bird kind, the Osprey Overlook is equipped with two mounted telescopes. For more information: (956) 748-3607.

Directions: From Harlingen, head east on Highway 106 approximately 14 miles past Rio Hondo. At the "T", turn left for 3 miles to the visitor center.

4) LAKESIDE TRAIL HIKE - Leashes

Beginner/3.0 miles

Info: Pretty lake vistas and a lush thorn forest provide the backdrop for a pleasant outing on this cinchy trail. Come March and April, wildflowers paint the landscape in a rainbow of color. For more information: (956) 748-3607.

Directions: From Harlingen, head east on Highway 106 approximately 14 miles past Rio Hondo. At the "T", turn left for 3 miles to the visitor center.

5) MESQUITE TRAIL HIKE - Leashes

Beginner/1.5 miles

Info: Your excursion on this simple trail will include a journey through verdant savannahs where scattered trees provide the only shade. If you're a lucky dog and the refuge has experienced a fair amount of rain, the ponds should be teeming with birdlife. Keep a look out for tracks left by resident deer and coyote as well. The trailhead is located at the visitor center's parking lot. For more information: (956) 748-3607.

Directions: From Harlingen, head east on Highway 106 approximately 14 miles past Rio Hondo. At the "T", turn left for 3 miles to the visitor center.

6) PAISANO TRAIL HIKE - Leashes

Beginner/1.0 miles

Info: Birders will definitely want to pack their binocs and get psyched for some intense sightings. Greater roadrunner, plain chachalaca, verdin and long billed thrasher are just some of the region's inhabitants. In fact, this easy, paved trail is named for the resident roadrunner. For more information: (956) 748-3607.

Directions: From Harlingen, head east on Highway 106 approximately 14 miles past Rio Hondo. At the "T", turn left for 3 miles to the visitor center.

HASKELL

LODGING

BEVERS HOUSE BED & BREAKFAST
311 N Ave F (79521)
Rates: $60-$85
(940) 864-3284; (800) 580-3284

HEARNE

LODGING

EXECUTIVE INN
Hwy 6 at FM 485 (77859)
Rates: $45-$69
(979) 279-5345

OAK TREE INN
1051 N Market St (77859)
Rates: $75-$125
(979) 279-5599

Hotel Pet Policies May Be Subject To Change

HEBBRONVILLE

LODGING
EXECUTIVE INN
1302 N Smith (78361)
Rates: $45-$69
(361) 527-4082; (800) 870-7689

HEMPHILL

RECREATION
SABINE NATIONAL FOREST

Sabine Ranger District
201 South Palm, Hemphill, TX 75948,
(409) 787-3870; (409) 787-2791; (866) 235-1750

Info: With over 160,000 acres of dense woodlands blanketing the terrain, the Sabine National Forest is a slice of heaven for hiking hounds and outdoor enthusiasts. Add to that the water wonderland of the 65-mile-long Toledo Bend Reservoir and you'll understand why Fido's tail is in overdrive. Encompassing over 137,000 acres, and marking the Texas/Louisiana state line, the adjacent reservoir guarantees aquapups hours of wet and wild fun. If you've got an electric motorboat, a flat-bottom boat or a canoe, you can float the day away. Sorry, no gasoline powered boats allowed. So, pick your pleasure from one of the following recreation areas and happy wet wagging to you. For more information: (409) 787-3870; www.southernregion.fs.fed.us/texas.

Directions: The forest lies within the boundaries of Jasper, Sabine, San Augustine, Newton and Shelby counties and is easily accessible via Highways 21, 103 and 87. Refer to specific directions following each recreation area and hiking trail.

For more information on recreation in the Sabine National Forest, see listings under Center.

The numbered recreation areas/hikes that follow are within the
Sabine National Forest:

1) INDIAN MOUNDS RECREATION AREA - Leashes

Info: Pack the pooch, the checkered blanket, picnic goodies and get set for an idyllic afternoon of outdoor fun. Lucky ducks can doggie paddle the day away in refreshing Toledo Bend Reservoir, while landlubbers can stay grounded and explore the 11,000-acre Indian Mounds Wilderness Area. Since there are no designated trails, you and furface are the makers of your own hiking destiny. Perhaps this is also the place to make your fishiest dreams come true. The reservoir is swimming with catfish, large-mouth bass, white perch, white bass, bream and stripers. For more information: (409) 787-3870.

Directions: From Hemphill, take Highway 83 east for 7 miles to Highway 3382. Turn right (south) on 3382 for 3.9 miles to the recreation area.

2) LAKEVIEW RECREATION AREA - Leashes

Info: If wet paws equate to happiness for your dirty dog, this recreation area is a must-see, must-do destination. You and the dawgus can frolic for hours in Toledo Bend Reservoir or hike to your heart's content on pine cushioned trails through lush forests. Ah, smell the fragrant air. And for fishing fiends, there's always a chance to take home dinner. Bone appetite! For more information: (409) 787-3870.

Directions: From Hemphill, take Highway 87 south for 9 miles to FM 2928. Turn left on FM 2928 for approximately 6 miles, following the signs to the recreation area.

3) RED HILLS LAKE RECREATION AREA - Leashes

Info: When you and furface are looking for a place to visit that has a little something for everyone, look no further. Hiking hounds - lace up your boots, you're gonna get some Texas style exercise as you investigate pine and hardwood forests. Boaters - BYOB - (bring your own boat) and check out the 19-

Hotel Pet Policies May Be Subject To Change

acre spring-fed lake. FYI, no gasoline powered boats allowed. Afishianados, pack your rod and try your luck on bream, catfish or bass - the lake is stocked. Or be a lazy bones and just vege out lakeside and soak up some rays. Sorry Charlie, the beach and designated swimming areas are off limits to pooches. For more information: (409) 787-3870.

Directions: From Hemphill, take Highway 87 north for 10.5 miles to the recreation area.

4) TOWER TRAIL HIKE - Leashes

Beginner/0.5 miles

Info: An easy-does-it trail through a lush pine and hardwood forest, you and the dogster will be done lickety split. Once you reach the old lookout tower, it's time to turn the hound around, you're homeward bound. For more information: (409) 787-3870.

Directions: From Hemphill, take Highway 87 north for 10.5 miles to Red Hills Lake Recreation Area. The trailhead is located across from the Arrowwood camping loop.

5) TRAIL-BETWEEN-THE-LAKES HIKE - Leashes

Beginner/Intermediate/1.0-28.0 miles

Info: No bones about it, this is one lengthy trail. Extending from Lakeview Recreation Area to Highway 96 (within sight of the easternmost point of Sam Rayburn Reservoir), this 28-mile trail gives you and the hound a chance to rack up lots of hiking points. So strap on the pedometer and see how much ground you can cover.

The scenic and delightfully fragrant trail follows a rather easy course through dense forests, continues along Toledo Bend Reservoir and travels to streams and into special wildlife areas where excellent critter viewing abounds. Birders can go gaga with a possible sighting of the endangered red-cockaded woodpecker. The boundaries of the woodpecker colonies are clearly marked with aqua green paint and appropriate signs. Please

keep the dogster leashed within these delicate habitats. Don't worry about losing your way in the woods. 2"x4" rectangular shaped directional signs are nailed to the trees to keep you on the straight and narrow. For more information: (409) 787-3870.

Directions: From Hemphill, take Highway 87 south for 9 miles to FM 2928. Turn left on FM 2928 for approximately 6 miles, following the signs to the Lakeview Recreation Area.

6) WILLOW OAK RECREATION AREA - Leashes

Info: Situated on the Toledo Bend Reservoir, Willow Oak is a slice of paradise for water woofers. From boating and swimming to fishing and sun worshipping, you and your canine crony are in for an afternoon of fun in the sun. This recreation area was the first of its kind to open on the reservoir and it continues to be a popular destination spot. For more information: (409) 787-3870.

Directions: From Hemphill, take Highway 87 south for 15 miles to the recreation area.

HENDERSON

LODGING
BEST WESTERN INN
1500 Hwy 259 S (75652)
Rates: $65-$85
(903) 657-9561; (800) 528-1234

RECREATION
LAKE FOREST PARK - Leashes

Info: Highlighted by a one-acre lake that's stocked with catfish and crappie, this beautiful 55-acre park has plenty to offer. Strut with your mutt on the one-mile walking trail or unpack your scooby snacks and picnic along the shoreline. A concession stand can refill empty picnic baskets. For more information: (903) 657-6551 or (866) 650-5529.

Directions: Located on Highway 64 west of the traffic circle.

Hotel Pet Policies May Be Subject To Change

LAKE STRIKER - Leashes

Info: Your wet wagger can cool his tootsies in this delightful lake area before you make tracks for the rolling hills that surround you. The fishing's divine, so drop a line in the warm waters. And there are lots of picnic areas where you can grill the day's catch as you and the pupster savor the breathtaking scenery. For more information: (903) 854-4559.

Directions: Located 18 miles southwest of Henderson.

PIONEER PARK - Leashes

Info: Derrick-covered pavilions create coolly shaded picnic spots for you and the pooch. Munch on lunch and then work off some calories investigating the interesting terrain. In your travels, you're bound to encounter the Joe Roughneck Monument which was erected in 1956 by Lone Star Steel to honor the working men of the oil fields. Petro's tail will be wagging in the breeze as you make your way 1.25 miles north to the Miller Farm. Look for a pink granite marker that indicates the site of the Daisy Bradford #3. When this lucrative oil well spurted liquid gold in 1930, the East Texas Oil Boom was underway. For more information: (903) 657-5528; (903) 657-6551; (866) 650-5529.

Directions: From the traffic circle, head west on Highway 64 for 6 miles until you reach CR 4148. Pioneer Park will be just west of the intersection of Highway 64 and CR 4148. (Highway 64 W at Joinerville).

HEREFORD

<u>LODGING</u>

BEST WESTERN RED CARPET INN
830 W 1st St (79045)
Rates: $60-$75
(806) 364-0540; (800) 528-1234

Locate Other Dog-Friendly Activities...Check Nearby Cities

HILLSBORO

LODGING

BEST WESTERN HILLSBORO INN
307 I-35 (76645)
Rates: $59-$71
(254) 582-8465; (800) 528-1234

MOTEL 6
1506 Hillview Dr (76645)
Rates: $43-$57
(254) 580-9000; (800) 466-8356

DAYS INN
I-35 & Hwy 22 (76645)
Rates: $41-$65
(254) 582-3493; (800) 329-7466

HONDO

LODGING

HONDO EXECUTIVE INN
102 E 19th St (78861)
Rates: $35-$65
(830) 426-2535

WHITETAIL LODGE
401 Hwy 90 E (78861)
Rates: $45-$86
(830) 426-3031; (800) 375-4065

HORSESHOE BAY

LODGING

MARRIOTT HORSESHOE BAY RESORT
200 Hi Circle North (78657)
Rates: $99-$159
(512) 404-6939; (800) 228-9290

Hotel Pet Policies May Be Subject To Change

Basic Dog Rules

THEY CAN'T BE AVOIDED AND THEY'RE REALLY QUITE EASY TO LIVE WITH. BE A RESPONSIBLE DOG OWNER AND OBEY THE RULES.

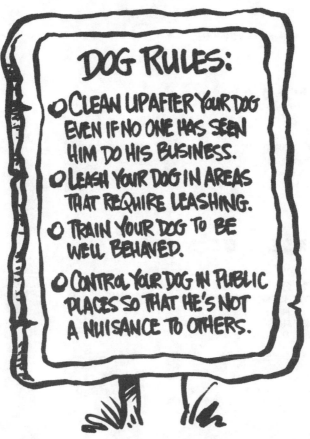

Note: When leashes are required, they must be six feet or less in length. Leashes should be carried at all times. They are prudent safety measures particularly in wilderness areas.

HOUSTON

LODGING

AMERICAS INN
10552 Southwest Frwy (77074)
Rates: $46-$50
(713) 270-9559

AMERISUITES
300 Ronan Park Pl (77060)
Rates: $109-$129
(281) 820-6060; (800) 833-1516

AMERISUITES HOBBY AIRPORT
7922 Mosley Rd (77061)
Rates: $99-$109
(713) 943-1713; (800) 833-1516

BAYMONT INN & SUITES
12701 North Frwy (77060)
Rates: $59-$71
(281) 875-2000; (877) 229-6668

BAYMONT INN & SUITES-NW
11130 NW Frwy (77092)
Rates: $64-$79
(713) 680-8282; (877) 229-6668

BAYMONT INN & SUITES-SW
6790 SW Frwy (77074)
Rates: $59-$84
(713) 784-3838; (877) 229-6668

**BEST WESTERN GREENWAY PLAZA
INN & SUITES**
2929 SW Freeway (77098)
Rates: $59-$89
(713) 528-6161; (800) 528-1234

**BEST WESTERN PARK PLACE SUITES-
HOUSTON MEDICAL**
1400 Old Spanish Trail (77054)
Rates: $89-$189
(713) 796-1000; (800) 528-1234

BEST WESTERN WINDSOR SUITES
13371 FM 1960 W (77065)
Rates: $79-$135
(800) 528-1234

CANDLEWOOD SUITES-GALLERIA
4900 Loop Central Dr (77081)
Rates: $129-$159
(713) 839-9411; (800) 465-4329

CANDLEWOOD SUITES-TOWN & COUNTRY
10503 Town & Country Way (77024)
Rates: $109
(713) 464-2677; (800) 465-4329

CANDLEWOOD SUITES-WESTCHASE
4033 W Sam Houston Pkwy S (77042)
Rates: $49-$109
(713) 780-7881; (800) 465-4329

CHAMPIONS LODGE MOTEL
4726 FM 1960 W (77069)
Rates: $42-$57
(281) 587-9171

CLARION HOTEL
1301 NASA Rd One (77058)
Rates: $59-$99
(281) 488-0220; (800) 4CHOICE

COMFORT SUITES GALLERIA
6221 Richmond Ave (77057
Rates: $99-$206
(713) 787-0004; (800) 228-5150

COMFORT INN GALLERIA-WESTCHASE
9041 Westheimer Rd (77063)
Rates: $69-$89
(713) 783-1400; (800) 228-5150

COMFORT INN WEST/ENERGY CORRIDOR
715 SR 6 S (77079)
Rates: $79-$169
(281) 493-0444; (800) 228-5150

Hotel Pet Policies May Be Subject To Change

CROWNE PLAZA HOTEL/RESORT-BROOKHOLLOW
12801 Northwest Frwy (77040)
Rates: $149
(713 462-9977; (800) 227-6963

DAYS INN
4640 S Main St (77002)
Rates: $59-$99
(713) 523-3777; (800) 329-7466

DAYS INN
9535 Katy Frwy (77024)
Rates: $44-$89
(713) 467-4411; (800) 329-7466

DAYS INN-NORTH
9025 N Frwy (77037)
Rates: $44-$55
(281) 820-1500; (800) 329-7466

DAYS INN & SUITES
1303 NASA Road One (77058)
Rates: $59-$89
(281) 286-0434; (800) 329-7466

DAYS INN-INTERCONTINENTAL AIRPORT
12500 N I-45 (77060)
Rates: $42-$64
(281) 876-3888; (800) 329-7466

DOUBLETREE GUEST SUITES
5353 Westheimer Rd (77056)
Rates: $89-$239
(713) 961-9000; (800) 222-8733
(800) 772-7666

DOUBLETREE HOTEL AT ALLEN CENTER
400 Dallas St (77002)
Rates: $139-$339
(713) 759-0202 ; 800) 222-8733
(800) 772-7666

DRURY INN-GALLERIA
1615 W Loop 610 S (77027)
Rates: $105-$120
(713) 963-0700; (800) 378-7946

DRURY INN HOUSTON HOBBY
7902 Mosley Rd (77017)
Rates: $81-$111
(713) 941-4300; (800) 378-7946

DRURY INN I-10 WEST
1000 N Hwy 6 (77079)
Rates: $72-$106
(281) 558-7007; (800) 378-7946

**EXECUTIVE INN
& SUITES-HOBBY AIRPORT**
6711 Telephone Rd (77061)
Rates: $45-$180
(713) 645-7666; (866) 888-1755

FOUR SEASONS HOTEL
1300 Lamar St (77010)
Rates: $295-$350
(713) 650-1300; (800) 332-3442

GRANTS PALM COURT INN
8200 S Main St (77025)
Rates: $55-$75
(713) 668-8000; (800) 255-8904

GUESTHOUSE INN-ASTRODOME
2364 South Loop W (77054)
Rates: $68-$93
(713) 799-2436

HAMPTON INN I-10 EAST
828 Mercury Dr (77013)
Rates: $69-$92
(713) 673-4200; (800) 426-7866

HEARTHSIDE SUITES BY VILLAGER
12925 Northwest Frwy (77040)
Rates: $59-$99
(713) 895-8888

HEARTHSIDE SUITES BY VILLAGER
15385 Katy Frwy (77094)
Rates: $59-$99
(281) 398-6500

HILTON HOTEL-AMERICAS/DOWNTOWN
1600 Lamar St (77010)
Rates: $159-$404
(800) 236-2905

Locate Other Dog-Friendly Activities...Check Nearby Cities

**HOLIDAY INN EXPRESS HOTEL
& SUITES-INTERCONTINENTAL**
1330 N Sam Houston Pkwy (77032)
Rates: $109
(281) 372-1000; (800) 465-4329

HOLIDAY INN-GALLERIA
7787 Katy Frwy (77024)
Rates: $119-$139
(713) 681-5000; (800) 465-4329

HOLIDAY INN HOUSTON AIRPORT
15222 JFK Blvd (77032)
Rates: $79-$159
(281) 449-2311; (800) 465-4329

HOLIDAY INN-NASA/CLEAR LAKE
1300 NASA Pkwy (77058)
Rates: $69-$159
(800) 682-3193

HOLIDAY INN SELECT GREENWAY PLAZA
2712 Southwest Frwy (77098)
Rates: $65-$160
(713) 523-8448; (800) 465-4329

**HOLIDAY INN EXPRESS HOTEL
& SUITES-WEST**
10137 North Frwy (77037)
Rates: $71-$80
(832) 554-5000; (800) 465-4329

HOLIDAY INN SELECT WEST
14703 Park Row (77079)
Rates: $130-$188
(281) 558-5580; (800) 465-4329

HOMESTEAD STUDIO SUITES-GALLERIA
2300 W Loop S (77092)
Rates: $69-$89
(713) 960-9660; (888) 782-9473

**HOMESTEAD STUDIO SUITES-
MEDICAL CENTER**
7979 Fannin St (77054)
Rates: $53-$78
(713) 797-0000; (888) 782-9473

**HOMESTEAD STUDIO SUITES-
WILLOWBROOK**
13223 Champions Center Dr (77069)
Rates: $45-$64
(281) 397-9922; (888) 782-9473

HOMEWOOD SUITES
401 Bay Area Blvd (77058)
Rates: $139-$189
(281) 486-7677; (800) 225-5466

**HOMEWOOD SUITES HOTEL-
WILLOWBROOK**
7655 W FM 1960 (77070)
Rates: $119-$169
(281) 955-5200; (800) 225-5466

HOTEL DEREK
2525 W Loop S (77027)
Rates: $90+
(713) 961-3000

HOTEL SOFITEL
425 N Sam Houston Pkwy E (77060)
Rates: $89-$209
(281) 445-9000

HOWARD JOHNSON EXPRESS
9604 S Main St (77025)
Rates: $49-$96
(800) 446-4656

INTER-CONTINENTAL HOUSTON
2222 W Loop S (77027)
Rates: $259-$515
(713) 627-7600

INTERSTATE MOTOR LODGE
13213 I-10 E (77015)
Rates: $42-$47
(713) 453-6353

LA QUINTA INN-ASTRODOME
9911 Buffalo Speedway (77054)
Rates: $70-$107
(713) 668-8082; (800) 687-6667

LA QUINTA INN-BROOKHOLLOW
11002 Northwest Frwy (77092)
Rates: $60-$81
(713) 688-2581; (800) 687-6667

LA QUINTA INN-CYFAIR
13290 FM 1960W (77065)
Rates: $70-$93
(281) 469-4018; (800) 687-6667

LA QUINTA INN GREENWAY PLAZA
4015 Southwest Frwy (77027)
Rates: $70-$100
(713) 623-4750; (800) 687-6667

LA QUINTA INN HOBBY AIRPORT
9902 Gulf Frwy (77034)
Rates: $65-$82
(713) 941-0900; (800) 687-6667

LA QUINTA INN-EAST
11999 E Frwy (77029)
Rates: $60-$80
(713) 453-5425; (800) 687-6667

LA QUINTA INN-LOOP 1960
17111 N Frwy (77090)
Rates: $60-$82
(281) 444-7500; (800) 687-6667

LA QUINTA INN & SUITES-BUSH AIRPORT
15510 JFK Blvd (77032)
Rates: $100-$130
(281) 219-2000; (800) 687-6667

LA QUINTA INN & SUITES-GALLERIA
1625 W Loop S (77027)
Rates: $70-$150
(713) 355-3440; (800) 687-6667

LA QUINTA INN & SUITES-NORTH
10137 North Frwy (77037
Rates: $79-$99
(800) 687-6667

LA QUINTA INN & SUITES-PARK 10
15225 Katy Frwy (77094)
Rates: $80-$110
(281) 646-9200; (800) 687-6667

LA QUINTA INN-WILCREST
11113 Katy Frwy (77079)
Rates: $60-$80
(713) 932-0808; (800) 687-6667

LA QUINTA INN-WIRT RD
8017 Katy Frwy (77024)
Rates: $63-$87
(713) 688-8941; (800) 687-6667

LANCASTER HISTORIC HOTEL
701 Texas at Louisiana (77002)
Rates: $200-$350
(713) 228-9500; (800) 231-0336

THE LOVETT INN HISTORIC B&B
501 Lovett Blvd (77006)
Rates: $85-$275
(713) 522-5224; (800) 779-5224

MARRIOTT-BY THE GALLERIA
1750 W Loop S (77027)
Rates: $76-$229
(713) 960-0111; (800) 228-9290

MARRIOTT-HOBBY AIRPORT
9100 Gulf Frwy (77017)
Rates: $179-$199
(713) 943-7979; (800) 228-9290

MARRIOTT-HOUSTON MEDICAL CENTER
6580 Fannin St (77030)
Rates: $89-$199
(713) 796-0080; (800) 228-9290

MOTEL 6
16884 Northwest Frwy (77040)
Rates: $40-$56
(713) 937-7056; (800) 466-8356

MOTEL 6
5555 W 34th St (77092)
Rates: $38-$44
(713) 682-8588; (800) 466-8356

MOTEL 6-ASTRODOME
3223 S Loop W (77025)
Rates: $39-$57
(713) 664-6425; (800) 466-8356

Locate Other Dog-Friendly Activities...Check Nearby Cities

MOTEL 6 HOBBY AIRPORT
8800 Airport Blvd (77061)
Rates: $37-$45
(713) 941-0990; (800) 466-8356

MOTEL 6
9638 Plainfield Rd (77036)
Rates: $38-$54
(713) 778-0008; (800) 466-8356

MOTEL 6 WEST
2900 W Sam Houston Pkwy S (77042)
Rates: $46-$62
(713) 334-9188; (800) 466-8356

PARKVIEW INN & SUITES
9000 S Main (77085)
Rates: $49-$76
(713) 666-4151

OMNI HOUSTON
4 Riverway (77056)
Rates: $315-$399
(713) 871-8181; (800) 843-6664

OMNI HOUSTON WESTISDE
13210 Katy Frwy (77079)
Rates: $71-$184
(281) 558-8338
(800) 843-6664

QUALITY INN-AIRPORT
6115 Will Clayton Pkwy (77205)
Rates: $69-$120
(281) 446-9131 (800) 228-5151
(800) 231-6134

RADISSON HOTEL ASTRODOME
8686 Kirby Dr (77054)
Rates: $129-$279
(713) 795-8477; (800) 333-3333

RAMADA LIMITED S.H. 249
18836 Tomball Pkwy (77070)
Rates: $80-$90
(281) 970-5000; (800) 272-6232

RAMADA PLAZA HOTEL/GALLERIA
7611 Katy Frwy, Hwy 10 W (77024)
Rates: $90-$121
(713) 688-2222; (800) 272-6232

RED ROOF INN HOBBY AIRPORT
9005 Airport Blvd (77061)
Rates: $39-$61
(713) 943-3300; (800) 843-7663

RED ROOF INN NORTHWEST
12929 Northwest Frwy (77040)
Rates: $39-$64
(713) 939-0800; (800) 843-7663

RED ROOF INN WEST
15701 Park Ten Place (77084)
Rates: $39-$62
(281) 579-7200; (800) 843-7663

RED ROOF INNS
2960 W Sam Houston Pkwy S (77042)
Rates: $44-$63
(713) 785-9909; (80) 843-7663

RESIDENCE INN BY MARRIOTT
2500 McCue (77056)
Rates: $99-$299
(713) 840-9757; (800) 331-3131

RESIDENCE INN BY MARRIOTT
9965 Westheimer (77042)
Rates: $132-$180
(713) 974-5454; (800) 331-3131

**RESIDENCE INN BY MARRIOTT
ASTRODOME**
7710 S Main St (77030)
Rates: $139-$179
(713) 660-7993; (800) 331-3131

RESIDENCE INN HOUSTON-CLEAR LAKE
525 Bay Area Blvd (77058)
Rates: $139-$179
(281) 486-2424; (800) 331-3131

RESIDENCE INN BY MARRIOTT-WILLOWBROOK
7311 W Greens Rd (77064)
Rates: $120-$170
(832) 237-2002; (800) 331-3131

ROBIN'S NEST B&B INN
4104 Greeley (77006)
Rates: $89-$150
(713) 528-5821; (800) 622-8343

RODEWAY INN-SW FREEWAY
3135 Southwest Frwy (77098)
Rates: $52-$73
(713) 526-1071; (800) 228-2000

SAM HOUSTON HOTEL
1117 Prairie (77002)
Rates: $159-$299
(832) 200-8800; (877) 348-8800

SHERATON HOUSTON BROOKHOLLOW
3000 N Loop W (77092)
Rates: $229-$259
(713) 688-0100; (800) 325-3535
(888) 627-8196

SHERATON SUITES-HOUSTON GALLERIA
2400 W Loop S (77027)
Rates: $89-$279
(713) 586-2444; (800) 325-3535

THE ST. REGIS HOUSTON
1919 Briar Oaks Ln (77027)
Rates: $430
(713) 840-7600

STAYBRIDGE SUITES-GALLERIA
5190 Hidalgo St (77056)
Rates: $79-$149
(713) 355-8888; (800) 348-8000

STUDIO 6
1255 Hwy 6 N (77084)
Rates: $41-$58
(281) 579-6959; (888) 897-0202

STUDIO 6-CYPRESS STATION
220 Bammel-Westfield Rd (77090)
Rates: $39-$53
(281) 580-2221; (888) 897-0202

STUDIO 6-HOBBY SOUTH
12700 Featherwood (77034)
Rates: $41-$71
(281) 929-5400; (888) 897-0202

STUDIO 6-NORTHWEST
14255 Northwest Frwy (77040)
Rates: $41-$58
(888) 897-0202

STUDIO 6-WESTCHASE
3030 W Sam Houston Pkwy S (77042)
Rates: $46-$63
(888) 897-0202

SUPER 8 MOTEL
609 W FM 1960 (77090)
Rates: $60-$109
(281) 866-8686; (800) 800-8000

SUPER 8 MOTEL GESSNER
8201 Southwest Frwy (77074)
Rates: $45-$59
(713) 772-3626; (800) 800-8000

TOWNEPLACE SUITES BY MARRIOTT
15155 Katy Frwy (77024)
Rates: $60-$120
(281) 646-0058; (800) 257-3000

TOWNEPLACE SUITES BY MARRIOTT-NORTHWEST
12820 Northwest Frwy (77040)
Rates: $60-$90
(713) 690-4035; (800) 257-3000

TRAVELERS INN
17607 Eastex Fwy &
Will Clayton Fwy (77396)
Rates: $49-$69
(281) 446-4611

Locate Other Dog-Friendly Activities...Check Nearby Cities

THE WARWICK
5701 S Main St (77005)
Rates: $129-$350
(713) 526-1991

THE WESTIN GALLERIA
5060 W Alabama St (77056)
Rates: $129-$349
(713) 960-8100; (800) 228-3000

WELLESLEY INN & SUITES-MEDICAL CENTER
1301 S Braeswood (77030)
Rates: $109-$119
(713) 794-0800; (800) 444-8888

THE WESTIN OAKS
5011 Westheimer Rd (77056)
Rates: $129-$349
(713) 960-8100; (800) 228-3000

WELLESLEY INN & SUITES-MEMORIAL
7855 Katy Frwy (77024)
Rates: $55-$159
(713) 263-9770; (800) 444-8888

RECREATION

ADAIR PARK - Leashes

Info: Complete with a pleasant nature trail, this 61-acre park offers plenty of outdoor pupportunities for you and your pal. Sniff out the John Biggers Mural or just make yourself comfy on the soft dewy grass.

Directions: Located at 15107 Cullen Road.

ALMEDA ROAD PARK - Leashes

Info: You'll have 43 acres of undeveloped land for frolicking with Fido in this vast community park. Pack plenty of water, there are no amenities.

Directions: Located on Almeda Road at Clear Creek.

BANE PARK - Leashes

Info: Wag your pooch's tail with a day in the park.

Directions: Located at 9600 West Little York.

BAYLAND PARK - Leashes

Info: Laze the day away with your best buddy beside you.

Directions: Located at 6400 Bissonet.

Hotel Pet Policies May Be Subject To Change

BLACKHAWK PARK SITE - Leashes

Info: You and the dogster will have it made in the shade at this 76-acre region that's shaded by a generous assortment of towering trees.

Directions: Located at 9401 Fuqua.

BLUERIDGE PARK - Leashes

Info: Take Rover for a quickie jaunt along the .6-mile asphalt trail in this 43-acre park.

Directions: Located at 5600 Court Road.

BOONE ROAD PARK - Leashes

Info: Jog with your dog along the half-mile trail or kick up some dust on the multi-purpose field.

Directions: Located at 7700 Boone Road.

BRAESWOOD PARKWAY - Leashes

Info: Set out early with Curly along the 10-mile trail that connects a series of pretty little parks. Equipped with exercise stations and drinking fountains, this is the perfect paw-stomping place for you and the furball to get your daily workout and stay in shape.

Directions: Access points are located on Holcombe & South Gessner.

BROWN PARK - Leashes

Info: If your woofer's a hoofer, there's a 2-mile trail that skirts this bustling park. Lazy dogs can relax riverside or kick back in the natural area.

Directions: Located at 400 Mercury Drive.

BUFFALO BAYOU PARK - Leashes

Info: Rent a canoe and paddle your pup around the bayou. Pack a camera, the view of the Houston skyline is incredible. For more information: (713) 845-1000.

Directions: 3600 Block of Allen Pkwy and Memorial Drive.

BUFFALO BAYOU TRAIL HIKE - Leashes

Beginner/5.5 miles

Info: Dollars to dog biscuits, you and the wagger are gonna like this trail. A popular urban exercise route, you're sure to meet and greet lots of other people and their pooches. This bayouside trail guarantees a bonafido good time. For more information: (713) 845-1000.

Directions: The trail runs the length of Allen Parkway from Sabine Street to Shepherd, crosses right to Memorial Drive and loops back on Memorial to Sabine.

BURNETT-BAYLAND PARK - Leashes

Info: Cloudgaze with your canine or plan a picnic lunch as you spend some quality time with Old Brown Eyes.

Directions: Located at 6000 Chimney Rock.

CAMBRIDGE VILLAGE PARK - Leashes

Info: 80 acres of grassy fields offer plenty of fun and games for you and your hound. Chill out in the gazebo or get your Texercise along the walking trail.

Directions: Located at 13000 Nitida.

CAROL TREE PARK - Leashes

Info: Find a peaceful, shaded spot and do a brown bagger with your wagger.

Directions: Located at 11600 Memorial Drive.

CHOATE ROAD PARK - Leashes

Info: 41 acres of undeveloped space provide lots of romping room for you and furface. Tote your own water, especially in summer, we're talking hot.

Directions: Located on Dixie Farm Road at Clear Creek.

CLINTON PARK - Leashes

Info: Geared mainly for sporting breeds, this park still offers quiet places for you and the dogster. Lounge with your hound on a shaded mound and do the spectator bit.

Directions: Located at 200 Mississippi.

CROWLEY PARK - Leashes

Info: Calling all sports enthusiasts, this 30-acre park offers an open field and an abundance of playtime-perfect terrain. Or pick a courtside seat and root for one of the local teams.

Directions: Located at 5100 Lauder Road.

CULLEN PARK - Leashes

Info: As Houston's largest municipal park, this 10,500-acre expanse has plenty to entice you and the furry one. Shake a leg along the 3.3-mile trail and sniff out several interesting sights including a cemetery, wildflower seeded areas, two wetlands, towering oaks and lots of time-out spots. The spacious picnic grounds are in a pretty setting that beckons you to break out the biscuit basket and do lunch alfresco. Or get the dawgus settled with a favorite chew while you lose yourself in a good read.

Directions: Located at 19008 Saums Road.

CULLINAN PARK/OYSTER CREEK - Leashes

Info: This sprawling 754-acre oasis features plenty of paw-friendly opportunities worthy of exploration. Stroll among the coolly shaded oasis of pecan and oak groves. Or choose

between two lakes and find the perfect spot to count clouds. Active breeds can amble along the boardwalk and pad up to the lookout point. And birders can get an eyeful in the wetlands. No matter how you choose to spend your time in this slice of nature, you won't be disappointed. For more information: (713) 942-8500.

Directions: Located at 12300 Highway 6 South.

DIXIE FARM ROAD PARK - Leashes

Info: When Tex is tugging at the leash, stop procrastinating and get thee to a parkaree. Make your own fun on more than 40 acres of undeveloped land. Pack some snacks and Perrier and do what feels good.

Directions: Located at 2900 Dixie Farm Road.

DODSON LAKE PARK - Leashes

Info: Give your pup something to wag about by taking him to this 22-acre expanse. Pack an old tennie or a chewed up frisbee and get a bit of Texercise in the grassy fields.

Directions: Located at 9010 Dodson.

DOSS PARK - Leashes

Info: Every dog should have his day. Make yours a great one and enjoy some R&R in this community green scene.

Directions: Located at 2500 Frick Road.

DOW PARK # 1 - Leashes

Info: Stroll this park's 9 acres with your sidekick or break out the biscuits and dine à la blanket with your chompmeister.

Directions: Located at 15401 Greendale Drive.

DRIVER PARK - Leashes

Info: A bit of outdoor recreation can be yours at this park.

Directions: Located at 10918 1/2 Bentley.

DUESSEN PARK - Leashes

Info: This 309-acre park has a little something for every breed. Tote a boat and float your way to that perfect fishing spot. Or stay grounded and get the lead out as you bound with your hound through beautiful grounds.

Directions: Located at 12303 Sonnier and Lake Houston Parkway.

EISENHOWER PARK - Leashes

Info: For a doggone terrific adventure, plan a day in the 682 acres of this parkland. Boating Bowsers will have one howl of a time floating atop Lake Houston. Fishing hounds can drop a line anywhere along the river bank. Who knows, you might end up with din din. If you're feeling like lazy bones, simply get lost in your thoughts along the rolling banks of the San Jacinto River. Dry dockers have their pick of natural areas, picnic spots and lots of shaded spaces, so just go for it. For more information: (281) 454-6076.

Directions: Located at 13500 Aqueduct Road.

EL FRANCO LEE PARK - Leashes

Info: An expansive, 309-acre part of the Clear Creek chain of parks, El Franco Lee can be just the break you and the pooch need. Make the most of a beautiful afternoon as you strut with the mutt on the several paths and boardwalks that slice through the natural terrain. Birders will want to tote binocs, feathered friends abound.

Directions: Located at 9400 Hall Road.

ELDRIDGE ROAD PARK SITE - Leashes

Info: Solitude seekers, make your own way through the trees in this delightful, undeveloped park where you just might have the place to yourselves.

Directions: Located at 1700 Eldridge Road.

FARNSWORTH PARK - Leashes

Info: Nurture your pup's desire to frolic outdoors with an excursion in this 22-acre area and then find yourself a grassy knoll to do a little Texas dreaming.

Directions: Located on Basin Street in St. Walden Woods.

FINNIGAN PARK - Leashes

Info: Baseball enthusiasts can share a sporting day with their pooches in this 19-acre park. Take sides in a local game and then do some ball tossing of your own in the open areas.

Directions: Located at 4900 Providence.

FREED PARK - Leashes

Info: When the fields in this action-packed park are empty, you'll have lots of room for a game of catch and fetch with your happy go lucky ballmeister. Less active breeds can doze away the afternoon under a shade tree.

Directions: Located at 7020 Shadyvilla Lane.

GRAGG PARK - Leashes

Info: Although industrial, this 57-acre park harbors a natural area, a small stretch of Brays Bayou and a picnic area for your lunching pleasure.

Directions: Located at 2999 South Wayside.

GUS WORTHAM PARK - Leashes

Info: Get a head start on your day with a daily dose of Texercise on the hike and bike trail. Beware of flying golf balls, an 18-hole course is the main attraction of this 150-acre region.

Directions: Located at 311 South Wayside Drive.

HALL ROAD RESERVE - Leashes

Info: Tails will be twitching in the breeze in this pretty reserve. Pack a biscuit basket and pamper your pooch with lunch alfresco in this undeveloped natural area. Tote plenty of water, there are no amenities in this 325-acre green scene.

Directions: Located at 9500 Hall Road.

HARDY/TIDWELL PARK SITE - Leashes

Info: Among the 21 acres of undeveloped land, you're sure to find the perfect frisbee field for a playful workout or the ideal shaded knoll for lunch à la blanket.

Directions: Located at 1800 Tidwell.

HAVILAND PARK SITE - Leashes

Info: Popular with athletes, this 17-acre park is a nice place to take social waggers. Be prepared to meet and greet the locals.

Directions: Located at 11600 Haviland.

HEIGHTS BOULEVARD PARK - Leashes

Info: Take some time to smell the roses in the manicured garden before chilling out in one of the gazebos. Active breeds will wag about the 1.7-mile trail that winds through this region.

Directions: Located at the 100-1900 block of Heights Boulevard.

HERMANN PARK - Leashes

Info: This popular 407-acre metropolitan park offers lots of outdoor recreation. Music lovers will want to visit when an outdoor concert is planned. Fishermen can visit year round and make tall tales happen at Grand Basin. Sniffmeisters will want to check out the flower exhibits. Or just break some biscuits with Bowser on a Sunday afternoon and do nothing for a change. The covered buildings and zoo are off limits to dogs.

Directions: Located at 6001 Fannin.

The numbered activities that follow are within the
Houston Arboretum and Nature Center:

1) JAPANESE GARDEN - Leashes

Info: Over 6 acres of exotic plants, cascading waterfalls, beautiful flowers and quiet pools await you and furface at this unique garden. Simply stroll the winding walkways and delight in the spectacular designs of Ken Nakajima, world-renowned landscape architect. For more information: (713) 284-1914.

Directions: Located in Hermann Park at the intersection of Fannin and Montrose.

Note: $1.50/adult, $.25/child entrance fee. Open daily from 10 am to 6 pm.

2) MILLER OUTDOOR THEATER - Leashes

Info: Treat your Beethoven to a night he won't soon forget. An eclectic assortment including jazz, country, gospel, classical and more, the Miller Outdoor Theater can satisfy the music mutt in all of us. Tote a blanket, some lawn chairs, even a picnic dinner and head for the free performance of your choice. For more information: (713) 284-8350.

Directions: Located at 100 Concert Drive in Hermann Park.

Note: March through October marks the annual theater season.

HERMANN SQUARE PARK - Leashes

Info: Cityslickers can take a break from window shopping at Hermann Square and give their credit cards a rest. Hosting more than 200 annual events, this user-friendly urban green scene is just the place to spend an afternoon. Pick up a sandwich and tote some biscuits for the dogster. Downtown lunch alfresco is a fun way to people-watch. And you're sure to make some new friends.

Directions: Located in downtown Houston at 900 Smith.

HIDALGO PARK - Leashes

Info: Take a peek at the interesting playground designed by renowned architect Robert S. Leathers before you and your canine do the social thing in the "Parque de la Amistad" (aka "Friendship Park)". The architecture and scenery will delight your senses in this charming park.

Directions: Located at 7000 Avenue Q.

HOGG BIRD SANCTUARY PARK - Leashes

Info: Slip those binocs into your backpack and get set for an afternoon of birding. Be a lazy bones and kick back in the natural area or chill out along the banks of the Buffalo Bayou.

Directions: Located at 100 Westcott.

HOUSTON ARBORETUM AND NATURE CENTER - Leashes

Info: A slice of Mother Nature at its best, adventure-loving canines will jump at the chance to explore 155 acres of sanctuary land dedicated to urban wildlife. Investigate the five miles of shaded nature trails and admire the landscape in one of Houston's oldest environmental successes. Be alert - many species of woodland dwellers happily reside in the surrounding forests, swamps, ponds and prairies. For more information: (713) 681-8433.

Directions: Located at 4501 Woodway Drive.

Note: Hours: 7:30 am to 6 pm.

Locate Other Dog-Friendly Activities...Check Nearby Cities

*The numbered activities that follow are within the
Houston Arboretum and Nature Center:*

1) ALICE BROWN INTERPRETIVE TRAIL HIKE - Leashes

Beginner/0.5 miles

Info: Learn as you turn around this peanut-sized, self-guided trail. Pick up a brochure from the nature center and experience a nifty nature education. Towering post oaks and loblolly pines help you and the pupster keep your cool, even on those dog day afternoons. For more information: (713) 681-8433.

Directions: Located at 1500 Hermann Drive on the north edge of Hermann Park.

2) HOUSTON GARDEN CENTER - Leashes

Info: City weary pooches, listen up. Rose gardens and nature trails are just a hop, skip and jump away. Flower lovers, get ready for a sniff-fest - the rose, bulb, fragrant and perennial gardens are fantastic. For more information: (713) 284-1986 or (713) 284-1989.

Directions: Located at 1500 Hermann Drive on the north edge of Hermann Park.

HUTCHESON PARK - Leashes

Info: Jumpstart your day on the jogging trail in this 8-acre bark park.

Directions: Located at 5400 Lockwood.

INDEPENDENCE PARK - Leashes

Info: Hightail it to this relaxing green scene and give your pooch something to wag about.

Directions: Located at 5515 Clara Road.

JASPER PARK - Leashes

Info: Spend a lazy day spectating at this sports-filled 20-acre park. Or find an open field and make your own fun with an old tennie or frisbee.

Directions: Located at 13400 River Trail Road.

JESTER PARKWAY - Leashes

Info: Take your time as you pound your paws along the one-mile trail that skirts this region. The white oak bayou presents a lovely riparian scene, while towering trees provide abundant shade for an afternoon repast.

Directions: Located at 4201 T.C. Jester West.

JORDAN PARK - Leashes

Info: If you're in the neighborhood, this 6-acre park is just the place for a bit of early morning Texercise.

Directions: Located at 6400 Winfield.

KEITH-WIESS PARK - Leashes

Info: For a day away from it all, set your sights on this parkland. Hoof it along the hiking trail as you explore this 500-acre expanse and then vege out on the banks of the Halls Bayou, the ideal oasis for a take-out lunch.

Directions: Located at 12300 Aldine-Westfield.

MACGREGOR PARK - Leashes

Info: Military mutts will come to attention at the WW II tribute in this 120-acre park. A thousand trees shade the area, so pick a place to chill with Will and cloudgaze the day away.

Directions: Located at 5225 Calhoun.

MACGREGOR PARKWAY - Leashes

Info: Hop on the 3.3-mile trail that skirts the Brays Bayou and you'll find yourself in a cornucopia of nature. Benches are pro-

vided for break time and water is available at any one of the parks along the way.

Directions: Located at 2200 MacGregor.

MARKET SQUARE PARK - Leashes

Info: If you find yourself near the Greater Houston Convention and Visitors Bureau, take a break in Market Square. The park is home to the first Houston City Hall/Market House which was built in 1840.

Directions: Located at the intersection of Travis and Congress Streets (301 Milam).

MASON PARK - Leashes

Info: Packed with pupportunities, this 100-acre region offers a natural area, more than a thousand trees, a hiking trail and a stretch of the Brays Bayou for you and the dawgus to peruse.

Directions: Located at 541 South 75th Street.

MAXEY PARK - Leashes

Info: Savor the open space or make your way down to the small stretch of the Greens Bayou for a pleasant interlude. Sports fans might get lucky and catch a game in progress.

Directions: Located at 601 Maxey Road.

MCKEE STREET PARK - Leashes

Info: Sofa loafers, get the lead out and tickle your toes with a saunter through this pleasant community park.

Directions: Located at the McKee Street Bridge.

MELROSE PARK - Leashes

Info: A great place for your daily dose or a bit of canine communing. The open fields are dog-friendly but avoid the golf course and the driving range.

Directions: Located at 1000 Canino Road.

Hotel Pet Policies May Be Subject To Change

MEMORIAL PARK - Leashes

Info: Put this park at the top of your dog's agenda and you won't regret a moment spent. It's hard to believe that such a beautiful green scene exists so close to a major city. But it does and its popularity attests to its accessibility. Sun-dappled, expansive, picturesque, lushly green and well-shaded are just some of the adjectives that describe this charming 1,500-acre parkland which is bedecked with more than 1,500 flowering trees. Sunday strollers can make a day of simply wandering about admiring nature's handiwork. Birders can take their bird dogs and venture to the arboretum where sightings are a shoo-in. Those seeking a great place to jog with the dog can join the locals on the crushed granite pathway or wiggle with the wagger along the nature trail. Social breeds give this park the high five for the friendly amenities including abundant picnic areas and playing fields. So pick your pleasure, pack your biscuit basket and delight your pooch with a day of outdoor funnery and sunnery at this pretty park. Carpe diem Duke. For more information: (713) 845-1000.

Directions: Located on Loop 610 at 6501 Memorial Park Drive.

MILBY PARK - Leashes

Info: The Sims Bayou is an ideal setting for a quiet lunch alfresco. Or just enjoy some laid-back relaxation while you spectate at a tennis match or softball game.

Directions: Located at 2001 Central.

MOFFITT/SPRINGWOOD PARK - Leashes

Info: If you're cruising by, stop at this 40-acre urban scene with your canine cohort and catch a ball game.

Directions: Located at 10645 Hammerly.

MUELLER PARK - Leashes

Info: Get your daily dose with a brisk walk around the 13 acres in this park.

Directions: Located at 14750 Henry Road.

NORTH YORK PARK SITE - Leashes

Info: Boogie with Bowser along the Buffalo Bayou or romp through the grassy field in this pretty 20-acre area.

Directions: Located at 808 North York.

NORTHSHORE PARK - Leashes

Info: Take the dawgus for his daily dose in this agreeable urban expanse.

Directions: Located on Wallisville at Uvalde.

OXNARD PARK - Leashes

Info: Play tagalong with your wagalong on the nature trail in this 13-acre parkland.

Directions: Located at 16702 Oxnard.

RANDOLPH PARK - Leashes

Info: Tone up along the exercise course or simply enjoy an outing on the nature trail in this 93-acre region. And then make your own tracks through the open space, find a shady spot and break some bread with the biscuitmeister.

Directions: Located at 5150 FM 2351 at Clear Creek.

REVEILLE PARK - Leashes

Info: Stretch out alongside the Sims Bayou or kick up some dust through the wooded area in this friendly 18-acre park-where making the most of your afternoon is a done deal.

Directions: Located at 7700 Oak Vista.

Hotel Pet Policies May Be Subject To Change

SAM HOUSTON NATIONAL FOREST

Sam Houston Ranger Disrict
394 FM 1375 West, New Waverly, TX 77358,
(936) 344-6205; (888) 361-6908

Info: Over 160,000 acres of alluring serenity are yours for the taking at this national forest named for the father of Texas-Sam Houston. No tour of Texas would be complete without a visit to this delightful woodland. So leave your cares and woes in the city and let the good times roll. It doesn't matter what tickles your fancy, it's all here. Play tagalong with your wagalong as you journey on the picturesque Lone Star Hiking Trail. Be a lazy bones and vege out under a shade tree in a hidden copse where the air is deliciously pine-scented. Or if water sports are more your speed, tote your boat, pack your gear, and set your sights on 21,000-acre Lake Conroe and 82,600-acre Lake Livingston (gasoline-powered boats are not permitted). Pick your pleasure and then go for it. There's nothing to stop you and furface from having one helluva a good day. For more information: (936) 344-6205.

Directions: The forest lies within the boundaries of Montgomery, San Jacinto and Walker Counties and is easily accessed via Interstate 45 and Highways 150, 190 and 156. Refer to specific directions following each recreation area and hiking trail. For more information on recreation in the Sam Houston National Forest, see listings under the following cities: Coldspring, Conroe, Huntsville, New Waverly and Shepherd.

SAM HOUSTON PARK - Leashes

Info: Take your little sniffmeister out to smell the roses in this 19-acre parkland. If you've got the time, set yourself up beside the petite pond and munch on lunch.

Directions: Located at 1000 Bagby.

Locate Other Dog-Friendly Activities...Check Nearby Cities

SAN JACINTO BATTLEGROUND STATE HISTORICAL COMPLEX - Leashes

Info: Learn as you sojourn with your military mutt through this park's rolling acres, where historical markers dot the landscape and depict highlights of the famous battle. Marvel at the towering, 570′ San Jacinto Monument,. Or take a gander at the Battleship Texas, the only surviving warship that served in both world wars.

Lounge hounds will love the stands of live oak that shade much of the landscape. Pack a basket and dine à la blanket, enjoying the bay and bayou breezes. Plan a kibble cookout - there are a number of grills for your BBQing pleasure. If you're into birding, wiggle over to the marshlands and scout out the varied species. Whatever you do, you're sure to set tails into high gear at this 1,000-acre region. For more information: (281) 479-2431; (800) 792-1112; www.tpwd.state.tx.us.

Directions: From Houston, take Highway 225 east for 22 miles, exiting on Highway 134 north (Battleground Road). Follow for a few miles to park's entrance.

SAND CANYON PARK - Leashes

Info: If you're seeking a smidgen of solitude, this 23-acre expanse could fill the bill.

Directions: Located at 13900 Sand Canyon Drive.

SCHNUR PARK - Leashes

Info: You and your best buddy will have it made in the shade as you compete for the "most lazy bones" award.

Directions: Located at 12227 Cullen Boulevard.

SCOTTCREST PARK - Leashes

Info: Saunter along the Sims Bayou or pick a spot to break some biscuits with your bowwow.

Directions: Located at 10700 Rosehaven.

Hotel Pet Policies May Be Subject To Change

SESQUICENTENNIAL PARK - Leashes

Info: Born on the bayou in celebration of Houston's 150th year, this park offers a unique and scenic blend of urban and natural surroundings.

Directions: Located at 400 Texas Avenue.

SHELDON LAKE STATE PARK - Leashes

Info: For a taste of nature extraordinaire, plan an outing to this diverse region. Distinguished as the last freshwater marsh habitat and refuge for many species of wildlife within the greater Houston area, Sheldon Lake is a birdwatcher's paradise and a nature lover's dream. The reservoir is a haven for nesting waterfowl and fish. Anglers can drop in anytime from the bank, but boats are prohibited from November 1st through March 1st to prevent any disturbance to the waterfowl area. In all, the park encompasses 2,500 acres of scenery and serenity. And if you're interested in learning how to attract wildlife to your own property with the use of plants and wildflowers, visit the Wildscape Demonstration Garden where these techniques are taught. For more information: (281) 456-9350; (800) 792-1112; www.tpwd.state.tx.us.

Directions: Turn east off Beltway 8 onto Garrett Road and the park's entrance (13240 Garrett Road).

Note: Fees vary. Alligators are common to the area, do not allow your dog to swim or roam free.

SHELDON PARK - Leashes

Info: Baseball fans will go batty as they saunter through the ball fields in this 15-acre park.

Directions: Located at 8815 Pineland.

SIMS BAYOU HIKE AND BIKE TRAIL #1 - Leashes

Beginner/4.0 miles

Info: If hiking's to your liking, kick up some dust on this bayou trail and fill your exercise quota for the day. This is a

popular trail, so get ready to meet a new canine pal or two. For more information: (713) 845-1000.

Directions: The trail runs from Scott to M.L. King Blvd.

SIMS BAYOU HIKE AND BIKE TRAIL #2 - Leashes

Beginner/6.0 miles

Info: Hopscotch among several green scenes on this hike and bike trail where you can take five, play a game of frisbee fetching or do a brown bagger with the tailwagger. For more information: (713) 845-1000.

Directions: The trail runs from Croquet to South Post Oak.

STEIN FAMILY PARK - Leashes

Info: Change your morning routine and perk up the pooch's spirits with a sojourn to this neighborhood park.

Directions: Located at 7800 Braeswood Drive.

STUDE REGIONAL PARK - Leashes

Info: Take your bark to this park for a lark and stroll riverside along the banks of the White Oak Bayou.

Directions: Located at 1030 Stude.

TAYLOR PARK - Leashes

Info: Bring along a chew for the dawgus, a good book for yourself and uncover a cozy nook in this 15-acre parkland.

Directions: Located at 8100 Kenton.

TIDWELL REGIONAL PARK - Leashes

Info: Sunshine and good times are the one-two punch at this sporty 84-acre park. You'll have plenty of romping room and chill out space if you set your directionals for the trees in this area.

Directions: Located at 9720 Spaulding.

Hotel Pet Policies May Be Subject To Change

TOM BASS PARK SECTION I - Leashes

Info: This neighborhood park is popular with families and their furfaces. Go ahead, make some new friends.

Directions: Located at 3452 Fellows Road.

TOM BASS PARK SECTION III - Leashes

Info: Satisfy your fishy dreams at the 20-acre spring-fed lake encircled by this parkland. After you snatch a catch, strut your mutt along one of the nature or jogging trails that lace this tree-lined landscape.

Directions: Located at 5050 Cullen Boulevard.

TOWNWOOD PARK - Leashes

Info: Stroll the half-mile stretch of the Sims Bayou or treat the pooch to a favorite rawhide while you get a kick watching the local soccer game.

Directions: Located at 3403 Simsbrook.

TRANQUILITY PARK - Leashes

Info: You'll have a howl of a good time ambling amidst this grassy region which commemorates man's landing on the moon. Check out the replica of the first lunar footprint.

Directions: From the Gulf Freeway (45) exit on Bagby in downtown Houston and head east. The park will be on the right-hand side just past City Hall (400 Rusk).

TROTTER PARK - Leashes

Info: Do something different for a change with a visit to this tree-strewn urban green scene. Canine capers can be yours on over 26 acres of flat open fields.

Directions: Located at 7809 East Little York.

Locate Other Dog-Friendly Activities...Check Nearby Cities

WATONGA PARKWAY - Leashes

Info: 30 acres await you and furface at this green expanse. Find a secluded spot along the White Oak Bayou and while away the hours with your faithful furball.

Directions: Located at 4100 Watonga Boulevard.

WAY PARK - Leashes

Info: Seven acres of undeveloped land in this park provide the ideal locale for some frisbee fetching.

Directions: Located on Mount Houston at Homestead.

WEST LITTLE YORK PARK - Leashes

Info: Pack plenty of Perrier, the region is undeveloped with only 10 trees providing shade. If you want to be alone this could be the place.

Directions: Located at 2800 West Little York.

WHITE OAK BAYOU HIKE & BIKE TRAIL- Leashes

Beginner/5.0 miles

Info: Exercise is the name of the game on this popular hike and bike trail. Make the most of a cool morning with an outing to this charming green oasis. Your journey parallels White Oak Bayou and includes the White Oak Parkway. For more information: (713) 845-1000.

Directions: The trail runs from Studemont to Houston Avenue.

WHITE OAK PARKWAY - Leashes

Info: Grab your gadabout and do a roundabout on the easy 2.25-mile trail or do what feels good in this 23-acre oasis. If yours is an aquapup, find an out-of-the-way bend along the one-mile riverside stretch of the White Oak Bayou and have some wet and wild fun. If you're into birding, bring your

binoculars and check out the pedestrian bridge for some great avian opportunities.

Directions: Located at 1513 White Oak Boulevard.

WILSON MEMORIAL PARK - Leashes

Info: When not in play, the two soccer fields in this 29-acre park provide some splendor in the grass romping areas for you and the dogster.

Directions: Located at 100 Gilpin.

WOODLAND PARK - Leashes

Info: Savor some serenery in the natural area or get social at the sports fields. When you've had your fill of fun, be a lazy dog and kick back on the banks of the White Oak Bayou and do some Texas dreaming.

Directions: Located at 212 Parkview.

OTHER PARKS IN HOUSTON - Leashes

For more information, contact the Houston Parks & Recreation Department at (713) 845-1000.

- ALLEN'S LANDING, 1001 Commerce
- AMERICAN LEGION PARK, 3621 Golf Drive
- ANDERSON PARK, 5701 Beverly Hills
- ANDOVER PARK, 6301 Nunn
- ANTIOCH PARK, 1400 Smith-Clay
- AUTRY PARK, 911 Shepherd-Allen Parkway
- BALDWIN PARK, 1701 Elgin
- BEECH-WHITE PARK, 7551 Scott
- BELL PARK, 4800 Montrose
- BENDWOOD PARK, 12700 Kimberly
- BENNETT PARK, 3000 Ennis
- BEVERLY HILLS PARK, 10201 Kingspoint
- BONHAM PARK, 8401 Braes Acres
- BOYCE-DORIAN PARK, 2000 Erastus
- BRAESWOOD PARK, 2345 Maroneal

Locate Other Dog-Friendly Activities...Check Nearby Cities

HUBBARD

RECREATION

OAK PARK - Leashes

Info: Get lost in your thoughts as you do a lap or two on the half-mile creekside nature trail.

Directions: From Hubbard, head northeast on Highway 31 to Farm Road 667. Turn left and continue about 2 miles. The park will be on your left.

HUNTSVILLE

LODGING

GATEWAY INN & SUITES
606 I-45 S (77340)
Rates: $35-$80
(936) 295-7595

MOTEL 6
122 I-45 N (77340)
Rates: $33-$39
(936) 291-6927; (800) 466-8356

HOLIDAY INN EXPRESS
201 W Hill Park Circle (77340)
Rates: $62-$99
(936) 293-8800; (800) 465-4329

SAM HOUSTON PLACE
3296 I-45 S, Exit 114 (77340)
Rates: $48-$59
(936) 295-9151; (800) 395-9151

LA QUINTA INN
124 I-45 N (77340)
Rates: $62-$79
(936) 295-6454; (800) 687-6667

RECREATION

HUNTSVILLE STATE PARK - Leashes

Info: Leave the hustle bustle of city life behind and get a taste of Mother Nature in this 2,000-acre sun-dappled region. Promenade through the piney woods and enjoy a day's outing or pull up a lakeside seat and picnic with the pooch-face in a pine-scented wonderland. Sorry, no paw dipping for the pup. For more information: (936) 295-5644; (800) 792-1112; www.tpwd.state.tx.us.

Hotel Pet Policies May Be Subject To Change

Directions: From Huntsville, take Interstate 45 south approximately 6 miles to Exit 109/Park Road 40. Follow the signs to the park.

Note: $3 entrance fee/person.

The numbered hikes that follow are within Huntsville State Park:

1) HUNTSVILLE STATE PARK HIKING TRAIL - Leashes

Intermediate/7.7 miles

Info: When push comes to shove and hiking wins out, this is the trail for you. Sun-splashed Lake Raven is the backdrop for a lengthy journey through dense woodlands of loblolly pine, red maple, oak, sweetgum, beech, dogwood and sassafras. Your path branches off from the nature trail located behind the interpretive center. Sections of this trek are popular with cyclists, so keep your leashed pooch to your right to prevent accidents. For more information: (936) 295-5644.

Directions: From Huntsville, take Interstate 45 south approximately 6 miles to Exit 109/Park Road 40. Follow signs to the park. The trailhead is located at the park's interpretive center.

2) NATURE TRAIL HIKE - Leashes

Beginner/0.5 miles

Info: Even telly bellies give this easy, self-guided nature stroll the high-five. As you meander along the trail, interpretive posts provide interesting tidbits on the area flora. For more information: (936) 295-5644.

Directions: From Huntsville, take Interstate 45 south approximately 6 miles to Exit 109/Park Road 40. Follow signs to the park. The trailhead is located at the park's interpretive center.

SAM HOUSTON NATIONAL FOREST

Sam Houston Ranger District
394 FM 1375 West, New Waverly, TX 77358,
(936) 344-6205; (888) 361-6908

Info: Over 160,000 acres of alluring serenity are yours for the taking at this national forest named for the father of Texas-Sam Houston. No tour of Texas would be complete without a visit to this woodsy oasis. So leave your cares and woes in the city and let the good times roll. It doesn't matter what tickles your fancy, it's all here. Play tagalong with your wagalong as you journey on the Lone Star Hiking Trail. Be a lazy bones and vege out under a shade tree in a hidden copse where the air is deliciously pine-scented. Or if water sports are more your speed, tote your boat, pack your gear, and set your sights on 21,000-acre Lake Conroe and 82,600-acre Lake Livingston (gasoline-powered boats are not permitted). There's nothing to stop you and furface from having one helluva a good day. For more information: (936) 344-6205.

Directions: The forest lies within the boundaries of Montgomery, San Jacinto and Walker Counties and is accessed via Interstate 45 and Highways 150, 190 and 156. Refer to specific directions following each area and hiking trail.

For more information on recreation in the Sam Houston National Forest, see listings under the following cities: Coldspring, Conroe, Houston, New Waverly and Shepherd.

HURST

<u>LODGING</u>

AMERISUITES
1601 Hurst Town Center Dr (76054)
Rates: $89-$99
(817) 577-3003; (800) 833-1516

Hotel Pet Policies May Be Subject To Change

HYE

LODGING
HERITAGE FARMS B&B
P. O. Box 232 (78635)
Rates: $80-$105
(830) 868-4204

INGLESIDE

LODGING
BEST WESTERN-NAVAL STATION INN
2025 State Hwy 361 (78362)
Rates: $65-$150
(361) 776-2767; (800) 528-1234

INGRAM

LODGING
HUNTER HOUSE MOTOR INN
310 Hwy 39 W (78025)
Rates: $44-$99
(830) 367-2377; (800) 655-2377

IRVING

LODGING
AMERISUITES LAS COLINAS-HIDDEN RIDGE
333 W John Carpenter Frwy (75039)
Rates: $89-$119
(972) 910-0302; (800) 833-1516

AMERISUITES LAS COLINAS-WALNUT HILL
5455 Green Park Dr (75038)
Rates: $69-$109
(972) 550-7400; (800) 833-1516

CANDLEWOOD LAS COLINAS
5300 Green Park Dr (75038)
Rates: $95-$114
(972) 714-9990; (800) 465-4329

DRURY INN-DFW AIRPORT
4210 W Airport Frwy (75062)
Rates: $65-$104
(972) 986-1200; (800) 378-7946

Locate Other Dog-Friendly Activities...Check Nearby Cities

FOUR SEASONS RESORT & CLUB
4150 N Mac-Arthur Blvd (75038)
Rates: $315-$460
(972) 717-0700; (800) 332-3442

HAMPTON INN-DFW AIRPORT
4340 W Airport Frwy (75061)
Rates: $92-$112
(972) 986-3606; (800) 426-7866

HARVEY HOTEL-DFW AIRPORT
4545 W John Carpenter Frwy (75063)
Rates: $119-$149
(972) 929-4500; (800) 922-9222

HARVEY SUITES- DFW AIRPORT
4550 W John Carpenter Frwy (75063)
Rates: $110-$152
(972) 929-4499; (800) 922-9222

HOLIDAY INN SELECT-DFW AIRPORT
4440 W Airport Frwy (75062)
Rates: $69-$99
(972) 399-1010; (800) 465-4329

HOMESTEAD STUDIO SUITES-LAS COLINAS
5315 Camaby St (75038)
Rates: $49-$64
(972) 756-0458; (800) 225-5466

HOMEWOOD SUITES-LAS COLINAS
4300 Wingren Rd (75039)
Rates: $139-$199
(972) 556-0665; (800) 225-5466

KNIGHTS INN
120 W Airport Frwy (75062)
Rates: $35-$45
(800) 843-5644

LA QUINTA INN DFW AIRPORT-N
4850 W John Carpenter Frwy (75063)
Rates: $70-$106
(972) 915-4022; (800) 687-6667

LA QUINTA INN DFW AIRPORT-S
4105 W Airport Frwy (75062)
Rates: $70-$106
(972) 252-6546; (800) 687-6667

MAINSTAY SUITES DFW AIRPORT-S
2323 Imperial Dr (75062)
Rates: $69-$99
(972) 257-5400; (800) 660-6246

MOTEL 6
510 S Loop 12 (75060)
Rates: $33-$49
(972) 438-4227; (800) 466-8356

MOTEL 6-DFW N
7800 Heathrow Dr (75063)
Rates: $37-$58
(972) 915-3993; (800) 466-8356

MOTEL 6-DFW S
2611 W Airport Frwy (75062)
Rates: $29-$55
(972) 570-7500; (800) 466-8356

OMNI MANDALAY LAS COLINAS
221 E Las Colinas Blvd (75039)
Rates: $109-$249
(972) 556-0800; (800) 843-6664

PARK INN & SUITES-DFW N
4100 W John Carpenter Frwy (75063)
Rates: $49-$119
(972) 929-4008

RADISSON HOTEL DFW AIRPORT-N
4600 W Airport Frwy (75062)
Rates: $99-$139
(972) 513-0800; (800) 333-3333

RED ROOF INN-DFW AIRPORT
8150 Esters Blvd (75063)
Rates: $39-$92
(972) 929-0020; (800) 843-7663

**RESIDENCE INN BY MARRIOTT
LAS COLINAS**
950 Walnut Hill Ln (75038)
Rates: $132-$149
(972) 580-7773; (800) 331-3131

Hotel Pet Policies May Be Subject To Change

RESIDENCE INN BY MARRIOTT-DFW IRVING
8600 Esters Blvd (75063)
Rates: $94-$159
(972) 871-1331; (800) 331-3131

SHERATON GRAND HOTEL
4440 W Carpenter Frwy (75261)
Rates: $75-$170
(972) 929-8400; (800) 325-3535
(800) 345-5251 (TX)

STAYBRIDGE SUITES-LAS COLINAS
1201 Executive Circle (75038)
Rates: $120-$150
(972) 465-9400; (800) 465-4329
(800) 238-8000

SUMMERFIELD SUITES-LAS COLINAS
5901 N MacArthur Blvd (75039)
Rates: $65-$148
(972) 831-0909; (800) 833-4353

SUPER 8 MOTEL DFW NORTH
4770 W John Carpenter Frwy (75063)
Rates: $49-$65
(214) 441-9000; (800) 800-8000

TOWNEPLACE SUITES LAS COLINAS
900 W Walnut Hill Ln (75038)
Rates: $80
(972) 550-7796; (800) 257-3000

WELLESLEY INN & SUITES
5401 Green Park Dr (75038)
Rates: $79-$149
(972) 751-0808; (800) 444-8888

JACKSBORO

LODGING

JACKSBORO INN
704 S Main St (76458)
Rates: $34-$43
(940) 567-3751

RECREATION

FORT RICHARDSON STATE HISTORIC PARK - Leashes

Info: Four-pawed friends will find splendor in the grass throughout this peaceful 350-acre park. Hit the 1.7-mile trail that laces the prairie, make tracks along the 0.5-mile trail beside Lost Creek or trek the 9.50-mile hike/bike/equestrian trailway adjacent to Fort Richardson and Lost Creek. Chill out by the pond and tootsie dip awhile. The fishing's good too if you're in the mood. For more information: (940) 567-3506; (800) 792-1112; www.tpwd.state.tx.us.

Locate Other Dog-Friendly Activities...Check Nearby Cities

Directions: From Jacksboro, take Highway 281 south for 1/2-mile to reach the park.

Note: $2 entrance fee/person.

The numbered hikes that follow are within
Fort Richardson State Historic Park:

1) LOST CREEK NATURE TRAIL HIKE - Leashes

Beginner/1.0 miles

Info: Even futon-loving Fidos will give this short, creekside jaunt two paws up. During the dog days of summer, the creek is a refreshing treat and a great spot for some splish-splashing fun. For more information: (940) 567-3506.

Directions: From Jacksboro, take Highway 281 south for 1/2-mile to reach the park.

2) LOST CREEK RESERVOIR STATE TRAILWAY - Leashes

Beginner/Intermediate/19.0 miles

Info: Are you ready for some serious trekking? Then put on your pawdometer and traverse this hike/bike/equestrian trail that runs adjacent to Fort Richardson and meanders along Lost Creek. Stately pecan and oak trees help shade your way along the trail. The scenic beauty of the trailway is highlighted by an abundance of wildflowers. Wildlife sightings are an added plus, so don't forget your binocs and camera. Yield to the horsey set and cyclists. For more information: (940) 567-3506.

Directions: From Jacksboro, take Highway 281 south for 1/2-mile to reach the park. Trailheads are located at Fort Richardson State Historical Park and on Lost Creek Reservoir.

3) PRICKLY PEAR TRAIL HIKE - Leashes

Beginner/1.7 miles

Info: Enjoy the beauty of the open prairie on this looping trail. Come summertime though, this is one hot hike. So pack some Perrier and when the heat gets you down, perk up the pooch

with a sidetrip to Lost Creek where lunch alfresco can be a nice way to top off your morning. For more information: (940) 567-3506.

Directions: From Jacksboro, take Highway 281 south for 1/2-mile to reach the park.

JACKSONVILLE

LODGING

HOLIDAY INN EXPRESS
1848 S Jackson St (75766)
Rates: $80-$110
(903) 589-8400; (800) 465-4329

JASPER

LODGING

BEST WESTERN INN
205 W Gibson (75951)
Rates: $53-$59
(409) 384-7767; (800) 528-1234

SWAN HOTEL BED & BREAKFAST
250 N Main St (75951)
Rates: $59-$99
(409) 489-9010

RAMADA INN
239 E Gibson (75951)
Rates: $55-$79
(409) 384-9021; (800) 272-6232

RECREATION

MARTIN DIES JR. STATE PARK - Leashes

Info: Retreat into 705 acres of luxuriant woodlands along the eastern shore of the B.A. Steinhagen Reservoir. Ponder the piney woods with the pupster and keep your eyes peeled for woodland warblers, woodpeckers, heron, crane but watch out - alligators are here as well. In autumn, the brilliant yellow hues of beech trees contrast the deep red of blackgum and oak, creating an eye-pleasing array of color among the evergreens. Hightail it through bottomland forests on shaded

pathways or make your fishy dreams come true. There are plenty of crappie, bass and catfish inhabiting the sun-dappled reservoir. For more information: (409) 384-5231; (800) 792-1112; www.tpwd.state.tx.us.

Directions: From Jasper, take Highway 190 west for 12 miles to the park entrance.

Note: $2 entrance fee/person.

The numbered hikes that follow are within Martin Dies Jr. State Park:

1) HEN HOUSE RIDGE TRAIL HIKE - Leashes

Beginner/0.75 miles

Info: Boogie with Bowser along Gum Slough and do a bit of birding in this bottomland forest. You just might catch sight of a resident woodpecker, heron, crane, bluebird or wood duck. Alligators live here too, so be alert. For more information: (409) 384-5231.

Directions: From Jasper, take Highway 190 west for 12 miles to the park entrance.

2) WALNUT RIDGE TRAIL HIKE - Leashes

Beginner/0.75 miles

Info: An island oasis awaits you and furface at the Walnut Ridge unit of the park. Simply cross over the wooden bridge and get ready for a pleasant hike through a dense grabbag forest - oak, pine, willow, sweet bay and beech comprise the woodsy landscape. As you loop around the trail, listen for the trill of songbirds. For more information: (409) 384-5231.

Directions: From Jasper, take Highway 190 west for 12 miles to the park entrance.

Hotel Pet Policies May Be Subject To Change

JEFFERSON

LODGING

INN OF JEFFERSON
400 S Walcott (75657)
Rates: $42-$68
(903) 665-3983

BUDGET INN
Hwy 59 S (75657)
Rates: $30-$54
(903) 665-2581

RECREATION

OTSTOTT PARK - Leashes

Info: Lucky dogs can catch a free concert in this beautiful park. The bandstand is one of the largest public performance structures of its kind in the United States and can accommodate a forty-member seated band.

Directions: Located at the corner of Vale and Lafayette Streets.

YELLOW POPLAR TRAIL HIKE - Leashes

Beginner/1.0 miles

Info: You and your hounddog will loop around Texas' only stand of yellow poplar trees on this easy hike. Check out the 99-foot state champion yellow poplar - you'll know it when you see it.

Directions: From Jefferson, head north on Highway 59 about 8.5 miles. The trailhead is across from the highway roadside park.

JOHNSON CITY

LODGING

CAROLYNE'S COTTAGE B&B
103 Live Oak (78636)
Rates: $90+
(830) 868-4548

SAVE INN MOTEL
107 Hwy 281 & 290 S (78636)
Rates: $40-$60
(830) 868-4044

EXOTIC RESORT ZOO & LODGING
235 Zoo Trail (78636)
Rates: $100-$120
(830) 868-4357

RECREATION

PEDERNALES FALLS STATE PARK - Leashes

Info: A water lover's paradise, you'll be treated to the sight of spectacular cascades that careen down a rugged, boulder-strewn gorge before spilling into wide pools of clear, cool water. Luxuriant woodlands of oak, elm and hackberry offer welcome shade on hot summer days. Varied species of wildlife, including osprey, bald eagle and golden-cheeked warblers beckon birders to point their binocs skyward. This extraordinary 4,800-acre park represents all the beauty of hill country. And beautiful it is. For a memorable outing, you won't want to miss this place. For more information: (830) 868-7304; (800) 792-1112; www.tpwd.state.tx.us.

Directions: From Johnson City, head east on FM 2766 for 9 miles to the park entrance.

The numbered hikes that follow are within Pedernales Falls State Park:

1) FALLS OVERLOOK TRAIL HIKE - Leashes

Beginner/0.5 miles

Info: An easy woodsy hike leads you and the dawgus to the park's cascading falls. Don't forget your camera - the falls are pawsitively worthy of a few snapshots. For more information: (830) 838-7304.

Directions: From Johnson City, head east on FM 2766 for 9 miles to the park entrance.

2) LOOP TRAIL HIKE - Leashes

Expert/6.5 miles

Info: Only hardy hikers and conditioned canines should attempt this butt-kicker of a hike. Located east of the river, this primitive trail system is steep and unmarked, challenging both your physical endurance and your navigational skills. From the moment you and your Herculean hound ford the river at Trammels Crossing, the workout begins. If you're up

Hotel Pet Policies May Be Subject To Change

for a hiking adventure like no other, pack your topo map, high energy trail mix, plenty of water and an adventurous spirit. When day is done, cool off riverside and enjoy some splish-splashing shenanigans with the dogster. You'll have earned it. For more information: (830) 868-7304.

Directions: From Johnson City, head east on FM 2766 for 9 miles to the park entrance.

3) PEDERNALES HILL COUNTRY NATURE TRAIL HIKE - Leashes

Beginner/0.25 miles

Info: This looping jaunt through lush cedar and oak woodlands gives you a teeny sampling of the park's beauty. Worthwhile and pretty on its own, it can also be the limber-up prelude to one of the longer, more difficult trails. For more information: (830) 868-7304.

Directions: From Johnson City, head east on FM 2766 for 9 miles to the park entrance.

4) WOLF MOUNTAIN TRAIL HIKE - Leashes

Intermediate/8.0 miles

Info: If hiking's to your liking, strap on the pedometer and rack up some miles on this developed trail through ruggedly beautiful terrain. You and Curious George will wander riverside and discover interesting historical sites all along the way. Anglers, pack a pole - there are several noteworthy fishing holes trailside. Once you reach the primitive camping area, turn the hound around, you're homeward bound. For more information: (830) 868-7304.

Directions: From Johnson City, head east on FM 2766 for 9 miles to the park entrance. Trailhead is located in the parking lot just east of the park headquarters building.

Note: If flood warning siren is heard, leave river area immediately. Entrance fee charged.

Locate Other Dog-Friendly Activities...Check Nearby Cities

JUNCTION

LODGING

DAYS INN
111 S Martinez St (76849)
Rates: $62-$70
(325) 446-3730; (800) 329-7466

THE HILLS MOTEL
1520 N Main St (76849)
Rates: $34-$42
(325) 446-2567

RECREATION

SOUTH LLANO STATE PARK - Leashes

Info: Get along little doggie to this beautiful park. The 507-acre wooded area is home to one of the most substantial and oldest winter turkey roosts in the central part of Texas. There's also something fishy going on in the river and the oxbow lakes, so pack your rod and reel. Dense shade trees and crisp, cool water make this place an idyllic spot for you and the dawgus. For more information: (915) 446-3994; (800) 792-1112; www.tpwd.state.tx.us.

Directions: From Junction, head south on Highway 377 for 5 miles to park's entrance.

Note: The turkey roosting area is closed from October through March. Entrance fee charged. Hiking trails are closed from October 1st through March 31st.

The numbered hike that follows is within South Llano State Park:

1) SOUTH LLANO RIVER HIKING TRAIL SYSTEM - Leashes

Beginner/4.0 miles

Info: If water and trees are your thing, you and the wagger will want to set your sails for this interconnecting trail system. Dense pecan forests shade the path, while the South Llano River and oxbow lakes provide some wet and wild fun. Try your luck in the stocked lake. Perhaps you'll catch some sup for you and the pup. If you'd rather be a lazy bones, kick back and chill your tootsies in the river. For more information: (915) 446-3994.

Directions: From Junction, head south on Highway 377 for 5 miles to park's entrance.

Hotel Pet Policies May Be Subject To Change

KATY

LODGING

BEST WESTERN HOUSTON WEST
22455 I-10 W (77450)
Rates: $59-$78
(281) 392-9800; (800) 528-1234

HOLIDAY INN EXPRESS
22105 Katy Fwy (77450)
Rates: $62-$67
(281) 395-4800; (800) 465-4329

SUPER 8 MOTEL
22157 Katy Frwy (77450)
Rates: $45-$55
(281) 395-5757; (800) 800-8000

KAUFMAN

LODGING

BEST WESTERN-LA HACIENDA INN
200 E Hwy 175 (75142)
Rates: $45-$65
(972) 962-6272; (800) 528-1234

KEMAH

LODGING

THE SCULPTURED GARDEN B&B
710 Bradford (77565)
Rates: $75-$300
(281) 334-2517

KENEDY

LODGING

DAYS INN
453 N Sunset Strip (78119)
Rates: $45-$85
(830) 583-2521; (800) 329-7466

KERRVILLE

LODGING

BEST WESTERN SUNDAY HOUSE INN
2124 Sidney Baker St (78028)
Rates: $60-$109
(830) 896-1313; (800) 528-1234
(800) 677-9477

BUDGET INN
1804 Sidney Baker St (78028)
Rates: $40-$65
(830) 896-8200; (800) 219-8158

DAYS INN
2000 Sidney Baker St (78028)
Rates: $59-$94
(830) 896-1000; (800) 329-7466

ECONO LODGE
2145 Sidney Baker St (78028)
Rates: $39-$129
(830) 896-1711; (800) 553-2666

FLAGSTAFF INN
906 Junction Hwy (78028)
Rates: $40+
(830) 792-4449

HILLCREST INN
1508 Sidney Baker St (78028)
Rates: $36-$80
(830) 896-7400; (800) 221-0251

LA REATA RANCH BED & BREAKFAST
2555 Sheppard Rees Rd (78028)
Rates: $75+
(830) 896-5503

TURTLE CREEK LODGE
689 Upper Turtle Creek (78028)
Rates: $150-$250
(210) 828-0377

**Y.O. RANCH RESORT HOTEL
& CONF CENTER**
2033 Sidney Baker St (78028)
Rates: $98-$119
(830) 257-4440; (800) 531-2800
(877) YO-RESORT

RECREATION

KERRVILLE-SCHREINER STATE PARK - Leashes

Info: For a doggone great adventure, you'll have it made in the shade of cypress, oak and juniper when you visit this stunning park situated on the banks of the Guadalupe River. Redbud, sumac and wildflowers brighten the landscape with seasonal color. Shutterbugs and nature lovers will be astounded by the opportunities for close encounters of the wildlife kind. Don't miss the .25-mile nature trail for a photo-filled finish.

A birder's bonanza, the region teems with songbirds and other feathered friends. Over 7.5 miles of hiking trails provide you

Hotel Pet Policies May Be Subject To Change

and the bird dog with some excellent exercise options as well as several viewing areas. Fishing fiends can throw in a line from the lighted fishing pier. Crappie, perch, catfish and bass are plentiful. Wherever your paws lead you in this 500-acre region, happy tails to you. For more information: (830) 257-5392; (800) 792-1112; www.tpwd.state.tx.us.

Directions: From Kerrville, take Highway 173 southeast approximately 3 miles to the park entrance.

Note: $3 entrance fee/person.

The numbered hikes that follow are within Kerrville-Schreiner State Park:

1) BLUE TRAIL HIKE - Leashes

Intermediate/3.2 miles

Info: When you and the tailwagger want to burn off the kibble, set your sights on this trail where rolling hills and lush woodlands comprise the pretty landscape. Remember to pack plenty of water - you and the pooch are likely to work up a thirst on this excursion. For more information: (830) 257-5392.

Directions: From Kerrville, take Highway 173 southeast approximately 3 miles to the park entrance.

2) ORANGE TRAIL HIKE - Leashes

Beginner/2.0 miles

Info: Scenic, shaded and easy, this trail is perfect for both nature hounds and couch potatoes. Come springtime, an abundance of wildflowers paint the hillsides in a kaleidoscope of color. For more information: (830) 257-5392.

Directions: From Kerrville, take Highway 173 southeast approximately 3 miles to the park entrance.

Locate Other Dog-Friendly Activities...Check Nearby Cities

3) YELLOW TRAIL HIKE - Leashes

Beginner/0.9 miles

Info: Running short on time? Then shake a leg on this trail and treat the pupster to a quickie jaunt through pretty hill country. You'll have a bonafido good time traipsing through oak and cedar woodlands. For more information: (830) 257-5392.

Directions: From Kerrville, take Highway 173 southeast approximately 3 miles to the park entrance.

LOUISE HAYS PARK - Leashes

Info: Sprawling cypress line the banks of the Guadalupe River and create a shady water wonderland for you and your side-kick to explore. Traverse Tranquility Bridge and find a quiet corner just perfect for a lazy afternoon. Daydream away the hours on rolling hills of dewy grass as you listen to the sooth-ing sounds of the stream. Or lounge with your hound in the cooling shade of a cypress. Ah, what a way to spend the day! For more information: (830) 896-1155.

Directions: Located in the heart of Kerrville, the park is accessed from Thompson Drive west of Sidney Baker South.

KILGORE

LODGING

DAYS INN
3505 N Hwy 259 (75662)
Rates: $35-$52
(903) 983-2975; (800) 329-7466

RAMADA INN
3501 N Hwy 259 (75662)
Rates: $48-$66
(903) 983-3456; (800) 272-6232

Hotel Pet Policies May Be Subject To Change

KILLEEN

LODGING

HOLIDAY INN EXPRESS
1602 E Center Expwy (76541)
Rates: $59-$95
(254) 554-2727; (800) 465-4328

LA QUINTA INN
1112 S Ft Hood St (76541)
Rates: $70-$86
(254) 526-8331; (800) 687-6667

KINGSVILLE

LODGING

BUDGET INN
716 S 14th St (78363)
Rates: $27-$50
(361) 592-4322

MOTEL 6
101 Hwy 77 N (78363)
Rates: $34-$37
(361) 592-5106; (800) 466-8356

ECONOMY INN
1415 S 14th St (78363)
Rates: $28-$55
(361) 592-5214

QUALITY INN
221 S Hwy 77 (78363)
Rates: $59-$99
(361) 592-5251; (800) 228-5151

HOLIDAY INN
3430 Hwy 77 S (78363)
Rates: $52-$65
(361) 595-5753; (800) 465-4329

SUPER 8 MOTEL
105 S 77 Bypass (78363)
Rates: $49-$79
(361) 592-6471; (800) 800-8000

KINGWOOD

LODGING

LA QUINTA INN & SUITES
22790 Hwy 59 N (77339)
Rates: $69-$119
(800) 687-6667

Locate Other Dog-Friendly Activities...Check Nearby Cities

KOUNTZE

LODGING

LITTLE HOUSE ON TIMBER RIDGE
Hwy 92 & 1943 (77625)
Rates: $75+
(409) 246-3107

LA GRANGE

LODGING

BED & BREAKFAST ON MAIN
512 S Main St (78945)
Rates: $70-$75
(979) 968-9535

RECREATION

MONUMENT HILL & KREISCHE BREWERY STATE HISTORICAL PARKS - Leashes

Info: No bones about it, this is one pretty locale. Browse blufftop with Bowser and witness some views of the Colorado River and surrounding region. Shaded areas and grassy open spaces offer ample à la blanket dining spots for you and your furry friend. For more information: (979) 968-5658; (800) 792-1112; www.tpwd.state.tx.us.

Directions: From La Grange, head south on Highway 77 one mile to Spur 92. Turn right on Spur 92 to the park entrance.

Note: $2 entrance fee/person.

The numbered hikes that follow are within
Monument Hill & Kreische Brewery State Historical Parks:

1) MONUMENT HILL INTERPRETIVE TRAIL HIKE - Leashes

Beginner/0.5 miles

Info: Scenery and education combine to make this a must-see, must-do hike. As you and the pupster saunter along, interpre-

Hotel Pet Policies May Be Subject To Change

tive signs provide interesting tidbits about the Brewery, the Kreische House and other historic sites. But the highlight of the trail is definitely the scenic overlook. From your blufftop perch, you'll be rewarded with incredible views of the Colorado River and beautiful hill country. Talk about Kodak moments. As a bonus, the trail is equipped with benches and water. For more information: (979) 968-5658.

Directions: From LaGrange, take Highway 77 south for 1 mile to Spur 92. Turn right on Spur 92 to the park entrance.

2) MONUMENT HILL NATURE TRAIL HIKE - Leashes

Beginner/0.5 miles

Info: If woods and songbirds send Fido's tail into the wagging mode, you won't want to miss this mini-jaunt through thick woodlands and prairie grasslands. A unique combination of habitats provides the chance to walk among groves of oak and cedar one minute and little blue stem grass the next. The local mockingbirds, cardinals and bluejays provide the musical entertainment. Wildlife enthusiasts, keep an eye out for white-tailed deer. For the best of what this self-guided trail has to offer, pick up a trail guide at park headquarters and get a quickie education on the area's flora. For more information: (979) 968-5658.

Directions: From LaGrange, take Highway 77 south for 1 mile to Spur 92. Turn right on Spur 92 to the park entrance.

LA PORTE

LODGING

LA QUINTA INN
1105 Hwy 146 S (77571)
Rates: $65-$87
(281) 470-0760; (800) 687-6667

RECREATION

SYLVAN BEACH PARK - Leashes

Info: Tote a bunch of doggie treats and a good read to this lovely park and spend the afternoon enjoying some quiet time with the dogster.

Directions: Located at the end of Fairmont and Bayshore Drive.

LAGUNA VISTA

LODGING

EXECUTIVE INN
1411 E Hwy 100 (78578)
Rates: $43-$62
(956) 943-7866

LAKE JACKSON

LODGING

CHERTEL BRAZOSPORT HOTEL & CONF CENTER
925 Hwy 332 (77566)
Rates: $132-$161
(979) 297-1161; (800) 544-2119

SUPER 8 MOTEL
915 Hwy 332 W (77566)
Rates: $55-$65
(979) 297-3031; (800) 800-8000

LAKE LBJ

LODGING

TROPICAL HIDEAWAY BEACH RESORT
604 Highcrest Dr (78654)
Rates: $85-$250
(210) 598-9896; (800) 662-4431

VALENTINE LAKESIDE RESORT
814 Euel Moore Dr (Kingsland 78639)
Rates: $60-$250
(915) 388-4418

Hotel Pet Policies May Be Subject To Change

LAKEWAY

LODGING

LAKEWAY INN CONFERENCE RESORT
101 Lakeway Dr (78734)
Rates: $109-$29
(512) 261-6600; (800) 525-3929

LAMESA

LODGING

BUDGET HOST INN
901 S Dallas Ave (79331)
Rates: $32-$46
(806) 872-2118; (800) 283-4678

SHILOH INN
1707 Lubbock Hwy (79331)
Rates: $35-$53
(806) 872-6721; (800) 222-2244

LAMPASAS

LODGING

COUNTRY INN
1502 S Key Ave (76550)
Rates: $40-$52
(512) 556-6201; (800) 556-2322

SARATOGA MOTEL
1408 S Key Ave (76550)
Rates: $30-$60
(512) 556-6244

RECREATION

COLORADO BEND STATE PARK - Leashes

Info: Say ta ta to the humdrum days and hello to Mother Nature with a journey to this parkland. You'll make your own way and find your own fun in the 53,000 acres of primitive landscape. Hiking gurus, there are lots of trails to choose from. Fishing fiends, snag a bagful in the lake. Naturalists, you'll find grassy fields, plenty of trees and lots of wildlife. So get along with your little doggie and just do it in this verdant scene. For more information: (325) 628-3240; (800) 792-1112; www.tpwd.state.tx.us.

Directions: From Lampasas, take FM 580 west to the town of Bend. Once in Bend, follow the signed gravel road for 10 miles to the park entrance.

Note: Entrance fee charged.

The numbered hikes that follow are within Colorado Bend State Park:

1) RIVER TRAIL HIKE - Leashes

Intermediate/8.0 miles

Info: You'll feel like a champ at the end of this challenging hike. Not to mention the possibilities for fun that can be had at the Colorado River. Wet waggers and conditioned canines will definitely bark home about this destination. Après hiking, break some bread and biscuits with Bowser before calling it a day. Bone appetite! For more information: (325) 628-3240.

Directions: From Lampasas, take FM 580 west to the town of Bend. Once in Bend, follow the signed gravel road for 10 miles to the park entrance.

2) SPICEWOOD SPRINGS TRAIL HIKE - Leashes

Intermediate/6.0 miles

Info: You're sure to rave about this voyage to anyone who'll listen. Your extraordinary adventure will include floodplains, uplands, travertine pools, cascading waterfalls, dense forests, scrub woodlands, riparian vegetation, prickly pear cactus, delicate stream environments and age-old limestone bluffs. You and the dogster can do it all and see it all on this looping trail. By hike's end, you'll have wet your tootsies in the Colorado River, ogled scenic Spicewood Springs and trekked through lush and beautiful Hill Country. Ah, what a day. For more information: (325) 628-3240.

Directions: From Lampasas, take FM 580 west to the town of Bend. Once in Bend, follow the signed gravel road for 10 miles to the park entrance.

Note: Dogs are not permitted in the swimming hole.

Hotel Pet Policies May Be Subject To Change

3) UPPER GORMAN CREEK TRAIL HIKE - Leashes
Intermediate/6.0 miles

Info: If hiking's to your liking, lace up your boots, and get psyched for a picturesque journey through pretty Hill Country, the scenic backdrop on this double-loop trail. You'll traverse lush grasslands and stands of juniper and scrub oak via old jeep roads. Follow the blue and yellow trail markers to stay on track. For more information: (325) 628-3240.

Directions: From Lampasas, take FM 580 west to the town of Bend. Once in Bend, follow the signed gravel road for 10 miles to the park entrance.

LAREDO

LODGING

FAMILY GARDEN INN & SUITES
5830 San Bernardo Ave (78041)
Rates: $49-$79
(956) 723-5300; (800) 292-4053

FIESTA INN
5240 San Bernardo Ave (78040)
Rates: $69-$74
(956) 723-3603; (800) 460-1176

LA QUINTA INN
3610 Santa Ursula Ave (78041)
Rates: $83-$106
(956) 722-0511; (800) 687-6667

MOTEL 6-NORTH
5920 San Bernardo Ave (78041)
Rates: $46-$64
(956) 722-8133; (800) 466-8356

MOTEL 6-SOUTH
5310 San Bernardo Ave (78041)
Rates: $46-$63
(956) 725-8187; (800) 466-8356

RED ROOF INN
1006 W Calton Rd (78041)
Rates: $49-$74
(956) 712-0733; (800) 843-7663

RIO GRANDE PLAZA HOTEL BY HOWARD JOHNSON
1 S Main Ave (78040)
Rates: $79-$125
(956) 722-2411; (800) 446-4656

LEAKEY

LODGING

LEAKEY SPRINGS CABINS
P. O. Box 610 (78873)
Rates: $75-$125
(830) 232-6351

WHISKEY MOUNTAIN INN B & B
HCR 1, Box 555 (78873)
Rates: $60-$125
(830) 232-6797; (800) 370-6797

LEWISVILLE

LODGING

COMFORT SUITES
755A Vista Ridge Mall Dr (75067)
Rates: $59-$75
(972) 315-6464; (800) 228-5150

MOTEL 6
1705 Lakepointe Dr (75057)
Rates: $34-$52
(972) 436-5008; (800) 466-8356

COUNTRY INN & SUITES
755B Vista Ridge Mall Dr (75067)
Rates: $59-$79
(972) 315-6565; (800) 456-4000

RAMADA LIMITED AIRPORT
1102 Texas St (75057)
Rates: $48-$80
(972) 221-2121; (800) 272-6232

HEARTHSIDE SUITES BY VILLAGER
1920 Lakepointe Dr (75057)
Rates: $59-$99
(972) 459-7777

RESIDENCE INN BY MARRIOTT
755C Vista Ridge Mall Dr (75067)
Rates: $125-$130
(972) 315-3777; (800) 331-3131

LA QUINTA INN
1657 N Stemmons Frwy (75067)
Rates: $55-$86
(972) 221-7525; (800) 687-6667

SUPER 8-DALLAS NORTH AIRPORT
1305 S Stemmons Frwy (75067)
Rates: $45-$50
(972) 221-7511; (800) 800-8000

MICROTEL INN & SUITES
881 S Stemmons Frwy (75067)
Rates: $42-$83
(972) 434-0447; (888) 642-7685

RECREATION

AUSTIN KENT ELLIS PARK - LEASHES

Info: Enjoy a romp with your sidekick in this pipsqueak park. Pack a Penn and give the ballmeister a run for the money.

Directions: Located at 1730 South Old Orchard and Fox.

Hotel Pet Policies May Be Subject To Change

CENTRAL PARK - Leashes

Info: Wag Fido's tail with a few laps along the .25 mile jogging path that winds through this 5-acre park.

Directions: Located at 1829 South Edmonds and Willow Oak.

CREEKVIEW PARK AND GREENBELT - Leashes

Info: Treat the dawgus to a game of catch and fetch in this 5.7-acre green scene.

Directions: Located at 1806 South Old Orchard.

EAST HILL PARK - Leashes

Info: Lounge by the lake with your best buddy beside you in this serene setting.

Directions: From Highway 121 exit at East Hill Road and continue to the park at road's end.

HIDDEN COVE PARK - Leashes

Info: A perfect place for a brown bagger with your wagger, this 720-acre park is situated along the shore of Lake Lewisville. Pack a rawhide, plenty of sunscreen and your fishing pole to set the stage for a relaxing day of fun in the sun. Hop on the 3-mile trail for some Texercise or skedaddle over acres of soft grass backdropped by shoreline scenery. For more information: (972) 294-1155.

Directions: From Lewisville, head east on Highway 121 to Highway 423 and turn left (north). Proceed to Hackeberry Road, make a left and continue three miles to the park.

Note: Entrance fee charged.

HIGHLAND PARK - Leashes

Info: Perk up a humdrum day with a romp along the path in this 6.8-acre park.

Directions: Located at 1936 Big Sky and Electric.

Locate Other Dog-Friendly Activities...Check Nearby Cities

LAKELAND ROTARY PARK - Leashes

Info: Pack a basket and picnic with the pooch in this 5-acre park.

Directions: Located at 800 Fox and Edmonds.

LEONARD L. WOODS PARK - Leashes

Info: When walktime calls, answer with an excursion to this green scene where you can kick up some dust on the .75-mile jogging trail, or just stroll and enjoy your surroundings. You can also test your skills at the disc course or, for a day devoted to relaxation, pack a good read, a favorite chew and do the lazy bones thing.

Directions: Located at 1000 Arbour Way and Century Oaks.

LEWISVILLE LAKE PARK - Leashes

Info: Imagine a lovely lakeside park and then put yourself there. This is the perfect place to spend some quality time with the dawgus.
Directions: From Highway 35E exit on Lake Park Road at park headquarters and continue to park.
Note: Fees may be required. Call for info: (972) 219-3550.

PILOT KNOLL PARK - Leashes

Info: The day-use area offers several picnic sites where you and the pooch can do lunch alfresco. Laze the day away lakeside or tote and float your own boat.

Directions: From Highway 35E, exit FM 407 and head west to Chapel Road. Turn right on Chapel Road to park's entrance.

POINT VISTA TOWER BAY PARK - Leashes

Info: A boat ramp lets you and the dogster get those grounded paws off the shore and atop the agua fria.

Directions: Follow Highway 35E to Hickory and turn left. Make another left on Vista to reach the access point.

Hotel Pet Policies May Be Subject To Change

RALDON-LAKE CITIES PARK - Leashes

Info: After a few laps around the .25-mile jogging path, toss the tennie to Tex or simply chill out in this 12-acre park.

Directions: Located at 800 Foxwood Place and Foxcreek.

SUN VALLEY PARK - Leashes

Info: Get thee to this parkaree and drench yourself with sunshine as you dine with your canine in this 6-acre green scene.

Directions: Located at 800 South Valley Parkway and Idlewood.

SYCAMORE BEND - Leashes

Info: Treat your tailwagger to an afternoon delight in this quiet area. Pull up a grassy spot lakeside and listen to the waves lapping the shoreline or find a secluded knoll beneath the shade of a sycamore.

Directions: Follow Highway 35E to FM 2181 and turn left. Head left on Sycamore Bend to the park.

SYCAMORE PARK - Leashes

Info: This petite neighborhood park is a pleasant, pet-friendly place to visit.

Directions: Located at 700 Hembry & Birch

VALLEY RIDGE GREENBELT PARK - Leashes

Info: You can't beat this 19-acre verdant setting for your morning or evening constitutional.

Directions: Located at 1400 North Valley Parkway.

VISTA RIDGE PARK - Leashes

Info: The smellmeister is sure to enjoy an outing in this park where 19 acres await your exploration, including a .25-mile jogging trail.

Directions: Located at 2950 Lake Vista Drive.

Locate Other Dog-Friendly Activities...Check Nearby Cities

WESTLAKE PARK - Leashes

Info: Wag away the afternoon hours frolicking lakeside with the pupster. Pack a biscuit basket and do lunch along the shore in the shade of a towering oak.

Directions: Take Highway 35E to Carlisle and turn right. Make another right on Main Street to the entrance on the left-hand side of road.

LINDALE

LODGING

DAYS INN
13307 CR 472 E (75771)
Rates: $40-$70
(903) 882-7800; (800) 329-7466

LITTLEFIELD

LODGING

CRESCENT PARK MOTEL
2000 Hall Ave (79339)
Rates: $36-$65
(806) 385-4464; (800) 658-9960

LIVE OAK

LODGING

LA QUINTA INN TOPPERWEIN
12822 I-35 N (78233)
Rates: $69-$109
(210) 657-5500; (800) 687-6667

Hotel Pet Policies May Be Subject To Change

LIVINGSTON

LODGING

LAKE LIVINGSTON INN
2500 Hwy 59 S (77351)
Rates: $37-$45
(936) 327-2525

RECREATION

LAKE LIVINGSTON STATE PARK - Leashes

Info: Do the boating thing in this 84,000-surface-acre reservoir and make your own water fun. If you're landlocked, take advantage of the 2.5-mile shoreline and traipse through forests of loblolly pine and water oak. Fish for crappie, perch, catfish and bass. Who knows, you might bring home dinner. And wherever you are, watch for white-tailed deer, mallards and armadillos. For more information: (936) 365-2201; (800) 792-1112; www.tpwd.state.tx.us.

Directions: From Livingston, take FM 1988 south to FM 3126. Follow FM 3126 northwest to the park entrance.

Note: Entrance fee charged.

The numbered hikes that follow are within Lake Livingston State Park:

1) DUCK POND TRAIL HIKE - Leashes

Beginner/2.8 miles

Info: Two words best describe this hike to Duck Pond - easy and shaded. Contrary to the pond's name, there's not a duck to be found, but fish do abound. So pack your rod and try to catch some din din for you and your canine crony. For more information: (936) 365-2201.

Directions: From Livingston, take FM 1988 south to FM 3126. Follow FM 3126 northwest to the park entrance.

2) LAKE LIVINGSTON HIKING TRAIL - Leashes

Intermediate/5.4 miles

Info: Pack a fun attitude along with some high energy snacks and make your dog's day on this woodsy trail. Plenty of fresh air and wildlife sightings are guaranteed as you and furface step lively through a dense woodland of pine and oak. A memorable day is in the making amidst the serenery and greenery of this parkland hike. For more information: (936) 365-2201.

Directions: From Livingston, take FM 1988 south to FM 3126. Follow FM 3126 northwest to the park entrance.

3) OAK FLAT NATURE TRAIL HIKE - Leashes

Beginner/0.3 miles

Info: Even sofa loafers will take to this peanut-size and gentle hike. Your nature loving hound is bound to enjoy a jaunt through a lush hardwood bottomland on this interesting, interpretive trail. For more information: (936) 365-2201.

Directions: From Livingston, take FM 1988 south to FM 3126. Follow FM 3126 northwest to the park entrance.

LLANO

LODGING

THE BADU HOUSE HISTORIC B&B
601 Bessemer St (78643)
Rates: $60-$70
(325) 247-1207

CHAPARRAL MOTOR INN
700 W Young (78643)
Rates: $38-$65
(325) 247-4111

BEST WESTERN LLANO INN
901 W Young St (78643)
Rates: $51-$79
(325) 247-4101; (800) 528-1234
(800) 346-1578

Hotel Pet Policies May Be Subject To Change

<u>RECREATION</u>

ROBINSON CITY PARK - Leashes

Info: Acres of roving opportunities await you and your faithful friend in this pleasant, breezy riverside park. Anglers, come prepared. There are mucho fishing holes along the way For more information: (325) 247-4158.

Directions: Located on RR 152, 2 miles west of the courthouse.

LOCKHART

<u>LODGING</u>

BEST WESTERN PLUM CREEK INN
2001 Hwy 183 S (78644)
Rates: $75-$95
(512) 398-4911; (800) 528-1234

LOCKHART INN
1207 Hwy 183 S (78644)
Rates: $29-$39
(512) 398-5201

<u>RECREATION</u>

LOCKHART STATE PARK - Leashes

Info: The 263 acres of this park offer a little something for everyone, including a par 35 nine-hole golf course. Wet waggers and fishing fiends will love Plum Creek, a waterway that is chockablock with bass, catfish and sunfish. Nature lovers will want to check out the forested terrain where sightings of deer, fox and armadillo are common. For more information: (512) 398-3479; (800) 792-1112; www.tpwd.state.tx.us.

Directions: From Lockhart, head south one mile on Highway 183 to FM 20, then southwest on FM 20 for 2 miles to Park Road 10. Continue one mile south on Park Road 10 to the entrance.

Note: $3 entrance fee/person. Flash floods may occur at creek crossings on Park Road.

LONGVIEW

LODGING

DAYS INN
3103 Estes Pkwy (75602)
Rates: $46-$62
(903) 758-1113; (800) 329-7466

HAMPTON INN
112 S Access Rd (75603)
Rates: $68-$80
(903) 758-0959; (800) 426-7866

LA QUINTA INN
502 S Access Rd (75602)
Rates: $63-$79
(903) 757-3663; (800) 687-6667

LONGVIEW INN
605 Access Rd (75602)
Rates: $40-$80
(903) 753-0350; (800) 933-1139

MOTEL 6
110 S Access Rd (75603)
Rates: $33-$38
(903) 758-5256; (800) 466-8356

RECREATION

CARGILL LONG PARK TRAIL HIKE - Leashes

Beginner/2.5 miles

Info: Just say yes to Tex and hustle your butt on this pretty trail shaded by towering pines and bedecked with colorful native flora. Popular with joggers and bikers, you'll want to keep your furball close by your side. For more information: (903) 753-3281.

Directions: Located on Hollybrook Street, one block west of US 259.

GUTHRIE PARK - Leashes

Info: The sounds of rushing water and serenading songbirds combine to make a visit to this park a soothing one. Grab your gadabout and do a turnabout on the 1.25-mile walking trail for a quickie workout.

Directions: Located at 301 Tupelo.

MARTIN CREEK LAKE STATE PARK - Leashes

Info: A gamut of activities beckons eager tailwaggers and their human counterparts at Martin Lake. Tote a boat and set sail on the warm waters of the lake. Or fish from the shoreline and hope for dinner of large-mouth bass, crappie, channel catfish, perch and sunfish. A 1.5-mile hiking trail provides the means to meet your exercise quotient for the day. The pathway leads through pristine pine and hardwood forests. Watch for white-tailed deer, rabbits, squirrels, raccoons, and armadillos as you make your way on the one-mile hiking trail around the island, a favorite with birders. Tweet tweet heaven, you might catch sight of mallard ducks, great blue herons, green-backed herons, great egrets, red-headed woodpeckers, and bobwhites. Whatever your pleasure, you and the hound are bound for fun in this parkland. For more information: (903) 836-4336; (800) 792-1112; www.tpwd.state.tx.us.

Directions: From I-20 in Longview, take the Estes Parkway exit and head south on Highway 149 to Tatum. Once in Tatum, head southwest on Highway 43 approximately 3.5 miles to FM 2183. Turn south on FM 2183 to the park entrance.

Note: $3 entrance fee/per person.

The numbered hikes that follow are within Martin Creek Lake State Park:

1) AMPHITHEATER TRAIL HIKE - Leashes

Beginner/1.5 miles

Info: A bonafido leg-stretcher, you and your roustabout will have it made in the shade on this trail through pine and hardwood forests. And when the hike is over, vege out in the serene greenery of this charming park. For more information: (903) 836-4336.

Directions: From I-20 in Longview, take the Estes Parkway exit and head south on Highway 149 to Tatum. Once in Tatum, head southwest on Highway 43 approximately 3.5 miles to FM 2183. Turn south on FM 2183 to the park entrance.

2) ISLAND TRAIL HIKE - Leashes

Beginner/1.0 miles

Info: Get ready for a snoutful of fresh air as you and the dawgus travel lickety-split on this scenic, wooded trail. For a show of autumnal colors, visit between late October and mid-November and witness the park's spectacular display. For more information: (903) 836-4336.

Directions: From I-20 in Longview, take the Estes Parkway exit and head south on Highway 149 to Tatum. Once in Tatum, head southwest on Highway 43 approximately 3.5 miles to FM 2183. Turn south on FM 2183 to the park entrance.

MCWHORTER PARK - Leashes

Info: Do something different and start your day with a stroll beside the small creek in this woodland park.

Directions: Located at 1000 Toler Road.

TEAGUE PARK - Leashes

Info: Lounge lakeside with your hound or get your daily dose on the .25-mile trail. Birdwatchers, point those binocs skyward and see what's a-fly in this bird-filled region.

Directions: Located at Teague Lake on American Legion Boulevard.

LUBBOCK

LODGING

BARCELONA COURT HOTEL
5215 S Loop 289 (79424)
Rates: $65-$85
(800) 222-1122

BEST WESTERN WINDSOR INN
5410 I-27 (79412)
Rates: $69-$109
(806) 762-8400; (800) 528-1234

CIRCUS INN MOTEL
150 Slaton Hwy, I-27 (79404)
Rates: $35-$65
(888) 745-5677

DAYS INN-TEXAS TECH
2401 4th St (79415)
Rates: $49-$89
(806) 747-7111; (800) 329-7466

Hotel Pet Policies May Be Subject To Change

ECONO LODGE
5401 Ave Q (79412)
Rates: $45-$99
(806) 747-3525; (800) 553-2666

FOUR POINTS SHERATON HOTEL
505 Ave Q (79401)
Rates: $99-$200
(806) 747-0171; (800) 325-3535

HOLIDAY INN EXPRESS HOTEL & SUITES
5806 I-27 (79404)
Rates: $74-$95
(806) 687-2500; (800) 465-4329

HOLIDAY INN-PARK PLAZA
3201 Loop 289 S (79423)
Rates: $72-$82
(806) 797-3241; (800) 465-4329

KOKO INN
5201 Ave Q (79412)
Rates: $45-$85
(800) 782-3254

LA QUINTA INN-CIVIC CENTER
601 Ave Q (79412)
Rates: $65-$83
(806) 763-9441; (800) 687-6667

LA QUINTA INN-MEDICAL CENTER
4115 Brownfield Hwy (79407)
Rates: $69-$96
(806) 792-0065; (800) 687-6667

MOTEL 6
909 66th St (79412)
Rates: $35-$55
(806) 745-5541; (800) 466-8356

RAMADA INN & CONF CENTER
6624 I-27 (79404)
Rates: $54-$95
(806) 745-2208; (800) 272-6232

RESIDENCE INN BY MARRIOTT
2551 S Loop 289 (79423)
Rates: $81-$140
(806) 745-1963; (800) 331-3131

SUPER 8 MOTEL
501 Ave Q (79401)
Rates: $44-$67
(806) 762-8726; (800) 800-8000

TOWNEPLACE SUITES
5310 W Loop 289 (79424)
Rates: $99-$139
(806) 799-6226; (800) 257-3000

RECREATION

BUDDY HOLLY STATUE AND WALK OF FAME - Leashes

Info: Calling all rock and roll mutts. Strut your stuff down the walk of fame and see how many names you recognize. The bronze plaques honor West Texans who have contributed significantly to the entertainment industry. But the main attraction is the towering bronze statue of Lubbock's favorite son - Buddy Holly.

Directions: Located at 8th Street and Avenue Q.

LLANO ESTACADO AUDUBON SOCIETY NATURE TRAIL HIKE - Leashes

Beginner/1.7 miles

Info: You and Fido will learn as you sojourn around this popular nature hike. The trail escorts you on a pleasant journey from the plains of the Llano Estacado down into Yellowhouse Canyon. As you hike, numbered posts and a corresponding trail guide educate you on the canyon's plants, animals and geologic features. After your no-sweat excursion, catch some R&R at Buffalo Springs Lake and enjoy some water shenanigans with the woofer. For more information: (806) 747-3353 or (806) 797-9562.

Directions: Buffalo Springs Lake is located 5 miles southeast of Lubbock on FM 835.

LUBBOCK MEMORIAL ARBORETUM - Leashes

Info: When you're longing for an afternoon of quietude, make this sweet spot your destination. Spend hours admiring the lovely trees, shrubs, vines, ornamental plants and garden sculptures as you and the pupster stroll amidst a flora museum. For more information: (806) 797-4520 or visit their website at: www.lubbockarboretum.org.

Directions: Located at 4111 University Avenue.

LUFKIN

LODGING

DAYS INN
2130 S 1st St (75901)
Rates: $67-$87
(936) 639-3301; (800) 329-7466

LA QUINTA INN
2119 S 1st St (75901)
Rates: $66-$86
(936) 634-3351 (800) 687-6667

EXPO INN
4200 N Medford Dr (75901)
Rates: $47-$66
(936) 632-7300

MOTEL 6
1110 S Timberland Dr (75901)
Rates: $32-$55
(936) 637-7850; (800) 466-8356

HOLIDAY INN
4306 S 1st St (75901)
Rates: $60-$85
(936) 639-3333; (800) 465-4329

Hotel Pet Policies May Be Subject To Change

ANGELINA NATIONAL FOREST

Angelina Ranger District
111 Walnut Ridge Rd, Zavalla, TX 75980,
(936) 897-1068

Info: The Angelina may be the smallest national forest in Texas, but it packs a large recreational punch. Named for the legendary Indian woman who befriended early Spanish and French missionaries, this forest encompasses over 154,000 acres with 10 developed recreation areas and 560 miles of shoreline, making it a naturalist's dream come true. Lace up for an invigorating hike through thick pine forests or set sail for a waterful adventure on Texas' largest lake - 114,000-acre Sam Rayburn Reservoir. When play's the thing, this forest is the stage. For more information: (936) 897-1068 or visit their website at www.southernregion.fs.fed.us.

Directions: The forest lies within the boundaries of Angelina, San Augustine, Jasper and Nacogdoches counties and is accessible from a handful of secondary highways in Zavalla. Refer to specific directions following each recreation area and hiking trail.

For more information on recreation in the Angelina National Forest, see listings under Zavalla.

The numbered hikes/recreation areas that follow are within the Angelina National Forest:

1) BOUTON LAKE RECREATION AREA - Leashes

Info: A favorite with the wet set, 12-acre Bouton Lake is the main attraction of this recreation area. Watch the sunlight dance across the water from a pretty lakeside setting or break out the checkered blanket and chow down under a shady river-bottom hardwood. If you're fixin' to burn some kibble, hustle your butt to the Sawmill Hiking Trail. Anglers can fish to their heart's content and snag a bag of bream, bass, catfish and crappie. Remember, no gasoline powered motors allowed.

Or play Sherlock and do your own investigation of this diverse landscape. For more information: (936) 897-1068 or visit their website at www.southernregion.fs.fed.us.

Directions: From Lufkin, take Highway 69 south to Highway 63 in Zavalla. Head east on Highway 63 for 7 miles to FSR 303. Turn right on FSR 303 for 7 miles to the recreation area.

2) BOYKIN SPRINGS RECREATION AREA - Leashes

Info: Treat your furry sidekick to an afternoon delight at pupular Boykin Springs. Highlighted by a 10-acre spring-fed lake, this recreation area offers plenty of wet and wild opportunities including boating, fishing and swimming for you and your soon-to-be-dirty dog. If you'd rather stick to clean and dry, then the pine-scented hiking trails will be more to your liking. Sorry Charlie, doggie paddling is not permitted at the designated swimming area, the beach or the springs and no gasoline powered motors are allowed. For more information: (936) 897-1068; www.southernregion.fs.fed.us.

Directions: From Lufkin, take Highway 69 south to Highway 63 in Zavalla. Head east on Highway 63 for 11 miles to the Boykin Springs sign at FSR 313. Turn right on FSR 313 for 2.5 miles to the recreation area.

3) BOYKIN SPRINGS TRAIL HIKE - Leashes

Beginner/0.7 miles

Info: When a little trek will do, this lickety split trail is the one for you. Short and picturesque, this loop-de-loop takes you around the lake and past the springs before depositing you where you began. For more information: (936) 897-1068 or visit their website at www.southernregion.fs.fed.us.

Directions: From Lufkin, take Highway 69 south to Highway 63 in Zavalla. Head east on Highway 63 for 11 miles to the Boykin Springs sign at FSR 313. Turn right on FSR 313 for 2.5 miles to Boykin Springs Recreation Area and the trailhead.

Hotel Pet Policies May Be Subject To Change

4) CANEY CREEK RECREATION AREA - Leashes

Info: A slice of doggie heaven smack dab in the middle of the forest. Bowwow. Get ready to skedaddle on an adventure extraordinaire, an afternoon crammed with everything outdoorsy like hiking, boating, fishing, swimming, tanning and picnicking. Nature lovers can explore the lush woodlands on a hiking trail, while sailing Snoopys float their boats on Sam Rayburn Reservoir. Able anglers can see if a dinner of bass or catfish awaits, while aquapups work on perfecting their doggie paddle. Pick your pleasure and let the good times roll. For more information: (936) 897-1068 or visit their website at www.southernregion.fs.fed.us.

Directions: From Lufkin, take Highway 69 south to Highway 63 in Zavalla. Head east on Highway 63 for 6 miles to FM 2743. Turn left on FM 2743 for 4.5 miles to FSR 336. Make a left on FSR 336 for one mile, following the signs to the recreation area.

5) HARVEY CREEK RECREATION AREA - Leashes

Info: City weary canines can join their country cousins and have a paw-stomping good time at this wonderland of nature, aka Harvey Creek Recreation Area. Located on the high slopes surrounding Sam Rayburn Reservoir, Harvey Creek affords outdoor enthusiasts the chance to escape the crowds and commune with nature. You and Rover can spend the day roving through beautiful pine and hardwood forests or charting your own course on the reservoir. Don't forget your line, the fishing's fine, not to mention the endless paw-dipping opportunities. You won't regret a moment spent in this sweet spot. For more information: (936) 897-1068 or visit their website at www.southernregion.fs.fed.us.

Directions: From Lufkin, take Highway 69 south to Highway 147 in Zavalla. Head north on Highway 147 to Highway 83. Head east on Highway 83 for 4 miles to FM 2390. Turn right on FM 2390 for 5 miles to the recreation area.

Locate Other Dog-Friendly Activities...Check Nearby Cities

6) SANDY CREEK RECREATION AREA - Leashes

Info: Sand, trees and lots of agua fria come together to make this a must-see, must-do recreation oasis. The pristine beach can't be beat for a bit of lazy day sun worshipping. The lush pine and hardwood forests are another story - they provide athletic breeds with five-star hiking adventures. But if you and your wagalot are water dogs, check out Sam Rayburn Reservoir where you can tote a boat and float the day away. Swim, fish and make your own fun in this watery wonderland. Carpe diem Duke. For more information: (936) 897-1068; www.southernregion.fs.fed.us.

Directions: From Lufkin, take Highway 69 south to Highway 63 in Zavalla. Head east on Highway 63 approximately 18 miles to FSR 333. Turn left on FSR 333 for 2 miles to the recreation area.

7) SAWMILL HIKING TRAIL - Leashes

Intermediate/11.0 miles

Info: You and Old Floppy Ears will know your bodies have been maxed out after this lengthy hike. But if the glimmer of shimmering water and the lure of cool, damp forests sends tails a-wagging, then limber up, pack plenty of trail treats and water and move on out. The trail follows a relatively level course along the Neches River, over bridges and through piney woods, connecting Bouton Lake Recreation Area to Boykin Springs Recreation Area. Your shady route is compliments of longleaf pine, bald cypress, loblolly pine, oak and various hardwoods, but it's the lakes, streams and creeks that guarantee gleeful playtime. Birders will go bonkers - over 200 species of birds, including the endangered red-cockaded woodpecker inhabit this region. White rectangular marks on the trees keep you on course. If you're running short on time or energy, slice the hike in half with a pre-planned car shuttle. For more information: (936) 897-1068 or visit their website at www.southernregion.fs.fed.us.

Directions: From Lufkin, take Highway 69 south to Highway 63 in Zavalla. Head east on Highway 63 for 7 miles to FSR 303.

Hotel Pet Policies May Be Subject To Change

Turn right on FSR 303 for 7 miles to Bouton Lake Recreation Area and the trailhead. Or take Highway 63 east for 11 miles to the Boykin Springs sign at FSR 313. Turn right on FSR 313 for 2.5 miles to Boykin Springs Recreation Area and the trailhead.

8) TOWNSEND RECREATION AREA - Leashes

Info: If you've been singing the summer blues, it's time you and your hot diggety dog did something special to lift your spirits. Plan a day on the wet and wild side in this fun recreation area. You'll have it made in the shade as you explore dense woodlands or cool your jets in refreshing Sam Rayburn Reservoir. Who knows, you might even make some fishy dreams come true by catching a batch of bass and catfish. For more information: (936) 897-1068; or visit their website at www.southernregion.fs.fed.us.

Directions: From Lufkin, take Highway 103 east for 28 miles to FM 1277. Turn right on FM 1277 for 3 miles to FM 2923. Make a right on FM 2923 and go 2 miles to the recreation area.

DAVY CROCKETT NATIONAL FOREST

Davy Crockett Ranger District
Rt 1, Box 55-FS, Kennard, TX 75847,
(936) 655-2299; (936) 639-8501

Info: Play tagalong with your wagalong in the dense woodlands of this peaceful region. Comprised of nearly 162,000 acres, Davy Crockett National Forest is the reigning champ of Texas' national forests. Remote sloughs offer one-of-a-kind canoeing adventures, pine woodlands provide bonafido hiking excursions, while the Neches River gives you a chance to hone your fishing skills. This forest rates two paws up as a nature excursion extraordinaire. Pack plenty of snacks and Perrier. For more information: (936) 655-2299; (936) 639-8501; www.southernregion.fs.fed.us.

Directions: The forest lies within the boundaries of Houston and Trinity counties and is easily accessed via Highways 21, 7

Locate Other Dog-Friendly Activities...Check Nearby Cities

and 94. Refer to specific directions following each recreation area and hiking trail.

For more information on recreation in the Davy Crockett National Forest, see listings in Crockett.

1) FOUR C NATIONAL RECREATION TRAIL HIKE - Leashes

Intermediate/1.0-40.0 miles

Info: Whether you backpack or daytrip it, you're in for some terrific Texas touring along this pine-scented trail. Your sniffmeister won't know where to turn his nose first in this big slice of doggie heaven. Shaded woodlands, boggy sloughs, upland forests and hardwood bottomlands are just the beginning. Your journey will also take you past sun drenched lakes, panoramic overlooks, stocked ponds and even protected endangered species colonies. This trail has it all. Designated as a National Recreation Trail, the 20-mile long 4-C is a picturesque route connecting Ratcliff Lake to the Neches Bluff Overlook. A cornucopia of nature, you and your lucky dog will follow a simple course beside abandoned tramways, through second and third growth forests, over sloughs and across streams. Along the way, white rectangular markers nailed to the trees keep you on track.

If splish-splashing antics equate to joyfulness for your wet wagger, this locale will be like paradise found. The forest is dotted with streams, ponds and lakes. Adventurous hounds will positively flip over the 300-foot pedestrian bridge that circles an old millpond and a 480-foot long raised walkway that crosses a boggy slough. Birders might get a chance to see the endangered red-cockaded woodpeckers, while fishing fiends can possibly score a catch in the man-made ponds. A car shuttle is recommended for those determined to hike the trail from beginning to end - you'll cut your mileage in half. For more information: (936) 655-2299; (936) 639-8501 or visit their website at www.southernregion.fs.fed.us.

Directions: From Lufkin, take Highway 103 west for 16 miles to Highway 7. Continue west on Highway 7 to the Ratcliff

Lake Recreation Area. The trailhead is located at the parking lot near the concession stand.

2) KICKAPOO RECREATION AREA - Leashes

Info: When push comes to shove and fun time wins out, set your sights on this forest adventure. Lace up your hiking boots and hit the trails or pack a biscuit basket and dine alfresco on a cushy bed of pine needles. Check out the short, looping interpretive trail where you'll learn some interesting tidbits on the local flora and fauna. Take your time and enjoy the beautiful display of nature that surrounds you before you turn the hound around and are homeward bound. For more information: (936) 655-2299; (936) 639-8501 or visit their website at www.southernregion.fs.fed.us.

Directions: From Lufkin, take Highway 94 southwest to Highway 287. Continue southeast on Highway 287 to the recreation area, located 1.5 miles past the town of Groveton.

3) NECHES BLUFF RECREATION AREA - Leashes

Info: The combination of dense woodlands and Texas-style panoramic vistas makes this recreation area a must-see, must-do experience. Lush pine and hardwood forests will compete for your attention with the gorgeous views from atop skyhigh Neches Bluff. The panoramas of the Neches River Valley form a perfect backdrop for a brown bagger with the wagger. Don't forget your camera and plenty of film. This place eats Kodak. For more information: (936) 655-2299; (936) 639-8501 or visit their website at www.southernregion.fs.fed.us.

Directions: From Lufkin, take Highway 69 north to Highway 21. Head south on Highway 21 to FSR 511-3. Turn left on FSR 511-3 for one mile to the recreation area entrance road, following for one mile to the parking area.

4) RATCLIFF LAKE RECREATION AREA - Leashes

Info: A water woofer's dream come true, 45-acre Ratcliff Lake is the main attraction of the area. From swimming, floating,

fishing and boating, hours of wet and wild fun await you and your dirty dog. Landlubbers won't be disappointed either. Take your pick from several hiking trails where you'll have it made in the shade as you explore thick woodlands. Afishionados, dangle your line, the fishing's just fine. The lake is stocked with bass, bream and catfish. Sorry Charlie, doggie paddling is not permitted at the beach or the designated swimming area. For more information: (936) 655-2299; (936) 629-8501; www.southernregion.fs.fed.us.

Directions: From Lufkin, take Highway 103 west to Highway 7. Continue west on Highway 7 to the recreation area.

5) TALL PINE TRAIL HIKE - Leashes

Beginner/3.0 miles

Info: No bones about it, you and furface will get your share of pine-scented air, and Texercise on this trail through lush woodlands. Après hiking, cool those tootsies in the refreshing lake. For more information: (936) 655-2299; (936) 639-8501 or visit their website at www.southernregion.fs.fed.us.

Directions: From Lufkin, take Highway 103 west to Highway 7. Continue west on Highway 7 to the Ratcliff Lake Recreation Area and the trailhead.

ELLEN TROUT PARK - Leashes

Info: Breathe deeply of the crisp scent of pine as you and the sniffmeister take a walk on the shady side through oak and pine woodlands in this lakeside park. Work out the kinks on the one mile trail or find a grassy knoll where you can kick back and birdwatch with your bird dog.

Directions: From Highway 69 north, take a left on Loop 287 and drive about 2 miles to the park entrance on your left.

LULING

LODGING
COACHWAY INN
1908 E Pierce St (78648)
Rates: $35-$52
(830) 875-5635

LYTLE

LODGING
DAYS INN
19525 McDonald St (78052)
Rates: $36-$60
(830) 772-4777; (800) 329-7466
(800) 833-5243

MADISONVILLE

LODGING
WESTERN LODGE
2007 E Main St (77864)
Rates: $40-$50
(936) 348-7654

MANSFIELD

RECREATION
MCKNIGHT PARK NATURE TRAIL HIKE - Leashes

Beginner/2.0 miles

Info: This mile-long connecter trail links east and west McKnight Parks and offers pooch walkers a great kibble-burning opportunity. The green scenes at either end are pretty and packed with cozy nooks and shaded knolls, perfect R&R locales. For more information: (817) 276-4200.

Directions: The trailhead is located in McKnight Park East at 757 Highway 287.

Locate Other Dog-Friendly Activities...Check Nearby Cities

MARATHON

LODGING

CAPTAIN SHEPARD'S INN
P. O. Box 46 (79842)
Rates: $99-$125
(800) 844-4243

HEATH CANYON RANCH
P. O. Box 386 (79842)
Rates: $30-$125
(432) 371-2235

THE GAGE HOTEL
102 Hwy 90 W (79842)
Rates: $69-$155
(432) 386-4205; (800) 884-4243

MARATHON MOTEL/RV PARK
P. O. Box 141 (79842)
Rates: $55-$85
(432) 386-4241

MARBLE FALLS

LODGING

BEST WESTERN MARBLE FALLS INN
1403 Hwy 281 N (78654)
Rates: $49-$109
(830) 693-5122; (800) 528-1234

HILL COUNTRY MOTEL
1101 Hwy 281 N (78654)
Rates: $59-$120
(830) 693-3637; (866) 693-3637

RECREATION

GRANITE MOUNTAIN OVERLOOK - Leashes

Info: If you and the hound happen to be cruising along FM 1431, plan a stop at the roadside picnic area just north of town. The overlook affords the best view of 866' Granite Mountain. Covering over 180 acres, this towering, pink granite mountain has been forming for nearly 450 billion years. The seemingly endless supply of granite has been used in the construction of many buildings such as the Capitol in Austin, the Coca-Cola Building in Atlanta and the Crocker Building in San Francisco. For more information: (830) 693-4449.

Directions: From Marble Falls, head northwest on FM 1431 to the overlook at the roadside picnic area.

Hotel Pet Policies May Be Subject To Change

MARFA

LODGING

RIATA INN
Hwy 90 E (79843)
Rates: $40-$70
(432) 729-3800

THE HOTEL PAISANO
207 N Highland (79843)
Rates: $79-$275
(866) 729-3669

MARSHALL

LODGING

BEST WESTERN EXECUTIVE INN
5201 E End Blvd S (75672)
Rates: $69-$99
(903) 935-0707; (800) 528-1234

MOTEL 6
300 I-20 E (75670)
Rates: $34-$48
(903) 935-4393; (800) 466-8356

LA MAISON MALFACON COUNTRY INN
700 E Rusk St (75670)
Rates: $45-$60
(903) 938-3600

QUALITY INN
5555 E End Blvd S (75670)
Rates: $65-$75
(903) 935-1941; (800) 228-5151

LA QUINTA INN
5301 East End Blvd (75672)
Rates: $59-$89
(800) 687-6667

RECREATION

AIRPORT PARK - Leashes

Info: Burn some calories as you and furface do the aerobics thing along the jogging trail in this pleasant urban park.

Directions: Located at the end of Warren Drive.

CADDO LAKE STATE PARK - Leashes

Info: Texas is second only to Minnesota in its number of lakes, and Caddo Lake at 7500 acres is the only natural lake of significant size within Texas. Whether you prefer fishing or just lazing, this park makes for a delightful afternoon. On lazy sum-

Locate Other Dog-Friendly Activities...Check Nearby Cities

mer days there's always a shaded nook you can call your own. Work out the kinks along one of the nature trails lacing the area. For more information: (903) 679-3351; (800) 792-1112; www.tpwd.state.tx.us.

Directions: From Marshall, take Highway 43 northeast approximately 14 miles to FM 2198. Turn right on FM 2198 for .5 miles to the park entrance.

Note: Dogs prohibited in cabin area. Entrance fee charged.

The numbered hikes that follow are within Caddo Lake State Park:

1) CADDO FOREST TRAIL HIKE - Leashes

Beginner/0.75 miles

Info: Sofa loafers, this short, shaded hike is a bonafido walk in the park. Pick up a trail brochure and get a quickie education in a grabbag forest of pine, oak, cypress and dogwood along this interpretive trail. For more information: (903) 679-3351.

Directions: From Marshall, take Highway 43 northeast approximately 14 miles to FM 2198. Turn right on FM 2198 for .5 miles to the park entrance.

2) CADDO LAKE STATE PARK HIKING TRAIL - Leashes

Intermediate/2.5 miles

Info: Discover woodlands and swamplands on this looping park trail, a journey to doggie heaven for aquatic pups. Towards the end of the hike, the trail parallels a creek, signaling the start of your wet and wild adventure. If you want to experience the best of what this outing has to offer, plan a visit in springtime when the dogwoods and redbuds are in full and glorious bloom. For more information: (903) 679-3351.

Directions: From Marshall, take Highway 43 northeast approximately 14 miles to FM 2198. Turn right on FM 2198 for .5 miles to the park entrance. The trailhead is located across from the Saw Mill Pond canoe area.

Hotel Pet Policies May Be Subject To Change

CITY PARK - Leashes

Info: Wag Fido's tail with a day of fun in the sun at this neighborhood park.

Directions: Located at the corner of Bomar and Pope Streets.

LIONS PARK - Leashes

Info: Take in some Texas charm as you and the dawgus hightail it through this quaint urban park.

Directions: At the corner of Poplar and Louisiana Streets.

MASON

LODGING
HILL COUNTRY INN
454 Ft. McKavitt St (76856)
Rates: $32-$66
(325) 347-6317

MATHIS

LODGING
MATHIS MOTOR INN
1223 N Front St (78368)
Rates: $30-$39
(361) 547-3272; (800) 251-7531

RECREATION
LAKE CORPUS CHRISTI STATE PARK - Leashes

Info: Rolling hills and dense woodlands create the backdrop in this lovely park. Fishing, frolicking, picnicking and soaking up sunshine are favorite activities among local Fidos and their people. For more information: (361) 547-2635; (800) 792-1112; www.tpwd.state.tx.us.

Directions: Located on FM 1068, 4 miles southwest of Mathis.

Locate Other Dog-Friendly Activities...Check Nearby Cities

McALLEN

LODGING

DRURY INN
612 W Expwy 83 (78501)
Rates: $67-$101
(956) 687-5100; (800) 378-7946

DRURY SUITES
228 W Expwy 83 (78501)
Rates: $93-$113
(956) 682-3222; (800) 378-7946

HAMPTON INN
300 W Expwy 83 (78501)
Rates: $82-$112
(956) 682-4900; (800) 426-7866

HOLIDAY INN CIVIC CENTER
200 W Expwy 83 (78501)
Rates: $69-$94
(956) 686-2471; (800) 465-4329

LA COPA INN
1010 W Houston Ave (78501)
Rates: $49-$99
(956) 682-1190

LA QUINTA INN
1100 S 10th St (78501)
Rates: $68-$72
(956) 687-1101; (800) 687-6667

MOTEL 6
700 Expwy 83 (78501)
Rates: $38-$45
(956) 687-3700; (800) 466-8356

POSADA ANA INN
620 W Expwy 83 (78501)
Rates: $55-$75
(956) 631-6700

RAMADA LIMITED AIRPORT
1505 S 9th St (78501)
Rates: $55-$65
(956) 686-4401; (800) 272-6232

RENAISSANCE CASA DE PALMAS HOTEL & SUITES
101 N Main St (78501)
Rates: $69-$239
(800) 228-9290

RESIDENCE INN BY MARRIOTT
220 W Expwy 83 (78501)
Rates: $89-$94
(956) 994-8626; (800) 331-3131

SUPER 8 MOTEL
1420 E Jackson Ave (78503)
Rates: $59-$99
(956) 682-1190; (800) 800-8000

RECREATION

McALLEN BOTANICAL GARDENS - Leashes

Info: A rolling savannah and a grabbag of interesting flora and fauna are the hallmarks of the park. To make your day even more fun, there's a 1.5-mile trail for your strolling pleasure. For more information: (956) 688-3333.

Directions: Located at 4101 West Highway 83 on the left-hand side, just past Ware Road.

Hotel Pet Policies May Be Subject To Change

McKINNEY

LODGING

A TARTAN THISTLE BED & BREAKFAST
513 W Louisiana St (75069)
Rates: $65-$135
(972) 680-2744

DAYS INN
2104 N Central Expwy (75070)
Rates: $55-$75
(972) 548-8888; (800) 329-7466

MCKINNEY INN
1431 N Tennessee St (75070)
Rates: $31-$48
(972) 542-4469

MOTEL 6
2125 White Ave (75069)
Rates: $40-$70
(972) 542-8600; (800) 466-8356

SUPER 8 MOTEL
910 N Central Expwy (75070)
Rates: $51-$75
(972) 658-8880; (800) 800-8000

McLEAN

LODGING

CACTUS INN MOTEL
101 Pine St (79057)
Rates: $33-$52
(806) 779-2346

MEMPHIS

LODGING

EXECUTIVE INN
1600 Boykin Dr (79245)
Rates: $39-$60
(806) 259-3583

Locate Other Dog-Friendly Activities...Check Nearby Cities

MENARD

<u>RECREATION</u>
FORT MCKAVETT STATE HISTORICAL PARK - Leashes

Info: Once referred to as the "prettiest post in Texas" by General Sherman, Fort McKavett has plenty to offer pooch-walkers. Water-loving wagalongs will adore the .25-mile trail which leads to invigorating fresh water springs. Lots of tables dot the park so pack a snack and plan to crunch on lunch. You and your favorite Sherlock can finish your visit with a an investigation of the restored buildings overlooking the head-waters of the San Saba River Valley Bottom. The Fort allows a fascinating peek at the past for you and your nosey pooch. For more information: (325) 396-2358; (800) 792-1112 or visit their website at www.tpwd.state.tx.us.

Directions: From Menard, head west on Highway 190 for 17 miles, then south on RM 864 for 6 miles to the park.

Note: Entrance fee charged.

The numbered hike that follows is within
Fort McKavett State Historical Park:

1) FORT MCKAVETT HISTORICAL TRAIL HIKE - Leashes
Intermediate/0.5 miles

Info: No bones about it, you're gonna have a doggone good time on this mini-trek. The self-guided trail passes lush oak, pecan and black walnut woodlands, as well as a military lime kiln and rock quarry before reaching its destination-"Government Springs." While the short jaunt to the springs is downhill, the uphill return guarantees a bonafido workout. For more information: (325) 396-2358.

Directions: From Menard, head west on Highway 190 for 17 miles, then south on FM 864 for 6 miles to the park entrance.

Hotel Pet Policies May Be Subject To Change

MERCEDES

LODGING

EXECUTIVE INN
Mile 2 W &
Expwy 83 (78570)
Rates: $45-$77
(956) 565-3121

MERIDIAN

RECREATION

MERIDIAN STATE PARK - Leashes

Info: When you're seeking an escape from the hustle and bustle of city life, take your faithful furball to this secluded 503-acre park. Fragrant woodlands and a 72-acre lake provide the backdrop to numerous pathways. Songbirds will be singing, fish might be jumping and ground dwellers will be scurrying throughout the shaded, peaceful shores. For more information: (254) 435-2536; (800) 792-1112; www.tpwd.state.tx.us.

Directions: From Meridian, take Highway 22 west approximately 3 miles to the park entrance.

Note: $3 entrance fee/person.

The numbered hikes that follow are within Meridian State Park:

1) BOSQUE TRAIL HIKE - Leashes

Beginner/2.3 miles

Info: A sun-splashed lake and lush woodlands combine for a pleasant hiking excursion. As you and the pupster circle the lake, you'll cross a footbridge, climb atop Bee Ledge (a limestone shelf overlook) and traipse along a creek bottom before coming full circle. For more information: (254) 435-2536.

Directions: From Meridian, take Highway 22 west approximately 3 miles to the park entrance. The trailhead is at the end of Park Road 7 at the CCC building.

Locate Other Dog-Friendly Activities...Check Nearby Cities

2) JUNIOR FOREST NATURE TRAIL HIKE - Leashes

Beginner/0.7 miles

Info: A quickie sojourn, you'll be surrounded by groves of cedar and oak on this trail, a shady alternative to the park's open green scene. Old Brown Eyes will definitely enjoy the cool change, especially on those hot diggety dog days of summer. For more information: (254) 435-2536.

Directions: From Meridian, take Highway 22 west approximately 3 miles to the park entrance.

3) LITTLE SPRINGS NATURE TRAIL HIKE - Leashes

Beginner/0.4 miles

Info: Even die-hard couch potatoes will give this no-sweat trail the high sign. But if this teaser of a hike gets the juices flowing, check out one of the park's other trails before calling it a day. For more information: (254) 435-2536.

Directions: From Meridian, take Highway 22 west approximately 3 miles to the park entrance.

4) SHINNERY RIDGE TRAIL HIKE - Leashes

Beginner/1.75 miles

Info: This cinchy trail zigzags through cool and aromatic juniper woodlands, home to a cornucopia of nature, including rare golden-cheeked warblers, deer and raccoons. Tote your binoculars and investigate the interesting wildlife found on this delightful walk. Come springtime, a colorful parade of wildflowers paints the landscape and brightens your day. For more information: (254) 435-2536.

Directions: From Meridian, take Highway 22 west approximately 3 miles to the park entrance. The trailhead is at the end of Park Road 7 at the CCC building.

MESQUITE

LODGING

HAMPTON INN
1700 Rodeo Dr (75149)
Rates: $84-$106
(972) 329-3100; (800) 426-7866

SPANISH TRAILS INN
1129 Gross Rd (75149)
Rates: $49-69
(972) 226-9800

RODEO INN
3601 Hwy 80 E (75150)
Rates: $40-$55
(972) 279-6561

SUPER 8 MOTEL
121 Grand Junction (75149)
Rates: $44-$66
(972) 289-5481; (800) 800-8000

RECREATION

BRUTON PARK GREENBELT TO
TRAVIS WILLIAMS PARK GREENBELT HIKE - Leashes

Beginner/2.0 miles

Info: Promenade with the pupface along this lovely trail paralleling South Mesquite Creek. Be serenaded by the soothing sounds of the fast running creek as you savor your surroundings on this pleasant jaunt. Bring some snacks, grills and picnic areas are available at both ends of the trail. For more information: (972) 216-6260.

Directions: Trailhead is located in Hodges Park at the corner of Beltline and Bruton.

CITY LAKE PARK HIKE - Leashes

Beginner/0.5 miles

Info: Laze lakeside or circle the scenic lake on the simple loop trail. Picnic tables dot the park and the pathway, perfect for lunch stops and photo ops. For more information: (972) 216-6260.

Directions: Located at 403 South Galloway.

Locate Other Dog-Friendly Activities...Check Nearby Cities

EASTFIELD TRAIL HIKE - Leashes

Beginner/0.5 miles-3.0 miles

Info: Jog with your dog as long as you'd like on this "do your own thing" kind of trail. Check out the map at the pedestrian bridge and pick your pathway pleasure. The trails lead around the Eastfield College campus where you'll find a green scene ideal for some playtime. For more information: (972) 216-6260.

Directions: Trailhead is on the Eastfield College campus at 3737 Motley.

PALOS VERDES PARK - Leashes

Info: Boogie with Bowser through 16 acres in this expansive park and fill your eyes with the prettiness of a sun-drenched lake. Or kick up some dust along the looping trail.

Directions: Located at 4800 Olympia.

TOWN EAST PARK TRAIL HIKE - Leashes

Beginner/1.2 miles

Info: When walktime calls and tails are wagging, set your sights on this pretty creekside trail. Waterdogs will love the creek crossings where getting wet is half the fun. All along the way, you'll find picnic spots and plenty of shade for chill out time. For more information: (972) 216-6260.

Directions: Trailhead is located in Town East Park at 2724 Town East Boulevard.

VALLEY CREEK TRAIL HIKE - Leashes

Beginner/1.25 miles

Info: You and your canine buddy will wind around baseball fields before reaching a couple of ponds equipped with piers, perfect for some lazy day fishing. Try your luck or just relax pondside. For more information: (972) 216-6260.

Directions: Trailhead is located within Valley Creek Park at 2482 Pioneer Road.

Hotel Pet Policies May Be Subject To Change

WESTOVER GREENBELT PARK - Leashes

Info: Spend an idyllic day exploring this bonafido beautiful park with your best pal beside you. Tails will wag in the breeze as you make your way on the main trail or any of the secondary trails. Whichever route you choose, you'll end your sojourn in a delightful rest area nestled among a grove of trees. For more information: (972) 216-6260.

Directions: Located on South Parkway between Sybil and Forney.

WESTOVER PARK TO DEBUSK PARK TRAIL HIKE - Leashes

Beginner/3.5 miles

Info: Do something different and pencil in a hike on your agenda and then watch that tail wag as you and your hot diggety dog traverse bridges and skedaddle through woodlands on this scenic, shaded trail. Fulfill your calorie burning expectations at the four exercise stations along the way. End your outing at sporty Debusk Park where plenty of action-packed activities equate to lots of people watching. If you've planned a picnic, there are mucho places throughout the park where you can break bread and biscuits with Bowser. For more information: (972) 216-6260.

Directions: Trailheads are located in Debusk Park at South Parkway and Peachtree, or in Westover Park at South Parkway and Sybil.

MEXIA

RECREATION

CONFEDERATE REUNION GROUNDS STATE HISTORICAL PARK - Leashes

Info: Give your pupster something to bark about at this oak-shaded parkland. Pack a pole and try your luck at fishing or tote a brown bagger and do lunch alfresco. Make sure you

include a look-see at the historic buildings. There are also two scenic footbridges that add to the pleasant air of this pretty park. For more information: (254) 562-5751; (800) 792-1112; www.tpwd.state.tx.us.

Directions: From the intersection of Highway 84 and Highway 14 in Mexia, go south on Highway 14 approximately 5 miles. Turn right on FM 2705 to FM 1633. Turn left on FM 1633 to FM 2705. Make a right on FM 2705 to the park entrance.

Note: Entrance fee charged.

The numbered hike that follows is within Confederate Reunion Grounds State Historical Park:

1) MISS MAMIE KENNEDY'S
1914 CONFEDERATE FLIRTATION WALK - Leashes

Beginner/1.0 miles

Info: Grab your mutt and do a strut about this easy trail alongside the Navasota River. Even on those hot diggety dog days of summer, you'll have it made in the shade of large oaks. For more information: (254) 562-5751; (800) 792-1112.

Directions: From the intersection of Highway 84 and Highway 14 in Mexia, go south on Highway 14 approximately 5 miles. Turn right on FM 2705 to FM 1633. Turn left on FM 1633 to FM 2705. Make a right on FM 2705 to the park entrance.

FORT PARKER STATE PARK - Leashes

Info: Jumpstart your day with a visit to this park which includes over 700 acres of gently rolling oak woodlands. Do some Texas dreamin' as you enjoy magnificent views of the 750-acre Lake Fort Parker. For more information: (254) 562-5751; (800) 792-1112; www.tpwd.state.tx.us.

Hotel Pet Policies May Be Subject To Change

Directions: From the intersection of Highway 84 and Highway 14 in Mexia, go south on Highway 14 approximately 8 miles to Park Road 28. Turn right to the park entrance.

Note: $2 entrance fee/person.

The numbered hike that follows is within Fort Parker State Park:

1) FORT PARKER STATE PARK HIKING TRAIL - Leashes

Beginner/3.0 miles

Info: This level, tree-shaded trail begins at the picnic area and meanders across a footbridge, passes an old cemetery and ends at Springfield Lake. Go ahead, dip a paw or two. Birders, bring your binocs - ospreys, orchard orioles, Lincoln's sparrows, blue-winged teals, yellow-billed cuckoos, summer tangers and winter wrens are recognized inhabitants of this park. For more information: (254) 562-5751; (800) 792-1112.

Directions: From the intersection of Highway 84 and Highway 14 in Mexia, go south on Highway 14 approximately 8 miles to Park Road 28. Turn right to the park entrance.

MIDLAND

LODGING

BEST WESTERN ATRIUM INN
3904 W Wall St (79703)
Rates: $59-$89
(432) 694-7774; (800) 528-1234

DAYS INN
1003 S Midkiff Rd (79701)
Rates: $50-$86
(432) 697-3155; (800) 329-7466

HOLIDAY INN
4300 W Wall St (79703)
Rates: $59-$64
(432) 697-3181; (800) 465-4329

LA QUINTA INN
4130 W Wall St (79703)
Rates: $59-$79
(432) 697-9900; (800) 687-6667

PLAZA INN
4108 N Big Spring (79705)
Rates: $65
(432) 686-8733

RAMADA LIMITED
3100 W Wall St (79701)
Rates: $59-$69
(432) 699-4144; (800) 272-6232

SLEEP INN
3828 W Wall St (79703)
Rates: $50-$79
(432) 689-6822; (800) 753-3746

Locate Other Dog-Friendly Activities...Check Nearby Cities

SUPER 8 MOTEL
1000 I-20 W (79701)
Rates: $38-$59
(432) 684-8888; (800) 800-8000

TRAVELODGE
2500 Commerce Dr (79703)
Rates: $49-$99
(432) 694-1300; (800) 578-7878

RECREATION

BIG SPRING STATE PARK - Leashes

Info: Dramatic views combine with limestone bluffs to make this park an extraordinary place to visit. Get some exercise on the 3-mile scenic loop or tickle your toes along the shorter nature trail, where you just might catch sight of a prairie dog or two. Take some time to investigate the carvings in the limestone, some date back to 1888. Bring your binocs, make your way to one of the ponds and surprise yourself with some wildlife viewing. Cottontails and jackrabbits bound over the landscape, while numerous birds soar and sing as they glide through the air. For more information: (432) 263-4931; (800) 792-1112; www.tpwd.state.tx.us.

Directions: From Midland, take Interstate 20 east to Big Spring. Exit at Business 20, heading east to FM 700. Make a right on FM 700 and follow to the park on the right.

Note: $2 entrance fee.

The numbered hikes that follow are within Big Spring State Park:

1) NATURE TRAIL HIKE - Leashes

Beginner/Intermediate/0.6 miles

Info: A delightful combination of flora, wildlife and fresh air equates to a great outing with the dawgus. Some sections of the trail are steep, so you might want to do some stretching beforehand. For more information: (432) 263-4931.

Directions: From Midland, take Interstate 20 east to Big Spring. Exit at Business 20, heading east to FM 700. Make a right on FM 700 and follow to the park on the right.

Hotel Pet Policies May Be Subject To Change

2) SCENIC MOUNTAIN TRAIL HIKE - Leashes

Intermediate/2.5 miles

Info: Give the dogster something to bark home about with an afternoon expedition to this postcardian paradise. All along the trail, you'll encounter scenic overlooks and Texas-style vistas. A photographer's dream come true, the trail loops around the top of a 200-foot high limestone capped mesa, the park and city stretching out below. Pack plenty of Kodak, this place eats film. Be prepared for some steep going, but know that your payback will definitely be worth the effort. If you'd rather sightsee from the comfort of your car, there's a loop road which gives you a terrific look-see. For more information: (432) 263-4931.

Directions: From Midland, take Interstate 20 east to Big Spring. Exit at Business 20, heading east to FM 700. Make a right on FM 700 and follow to the park on the right.

MIDLOTHIAN

LODGING

BEST WESTERN MIDLOTHIAN INN
220 N Hwy 67 (76065)
Rates: $59-$74
(972) 775-1891; (800) 528-1234

MINERAL WELLS

LODGING

AMERICAN INN
3701 E Hubbard (76067)
Rates: $45-$85
(940) 325-6961

BEST WESTERN CLUBHOUSE INN & SUITES
4410 Hwy 180 E (76067)
Rates: $79-$159
(940) 325-2270; (800) 528-1234

BUDGET HOST INN MESA HOTEL
3601 E Hwy 180 (76067)
Rates: $39-$56
(940) 325-3377; (800) 283-4678

EXECUTIVE INN
2809 Hwy 180 W (76067)
Rates: $42-$55
(940) 328-1111

Locate Other Dog-Friendly Activities...Check Nearby Cities

<u>RECREATION</u>

LAKE MINERAL WELLS STATE PARK - Leashes

Info: Birdwatchers are in for a special treat at this delightful 3,282-acre park. Feathered friends are abundant at Lake Mineral Wells and a bird list is available at the ranger station. Anglers, won't be disappointed either. The lake is brimming with black bass, catfish and crappie. And amidst the greenery and scenery, this region is laced with trails and teeming with wildlife. You won't regret a moment spent in this park's 3,000 acres. For more information: (940) 328-1171 or (800) 792-1112; www.tpwd.state.tx.us.

Directions: From Mineral Wells, take Highway 180 east for 3 miles to the park entrance.

Note: $3 entrance fee/person.

The numbered hikes that follow are within Lake Mineral Wells State Park:

1) LAKE MINERAL WELLS HIKING TRAIL - Leashes

Intermediate/5.0 miles

Info: Limber up with your pup before setting out on this somewhat demanding hike. The trail follows a rocky, and at times steep, yoyo-like course above the park's bluffs. Huffing and puffing aside, the views are worth the effort. Pack plenty of Perrier - groves of oak and cedar elm provide the only source of shade. When your workout is over, unwind with your canine at the refreshing lake. Go ahead, dip a paw or two before ending your day. For more information: (940) 328-1171.

Directions: From Mineral Wells, take Highway 180 east for 3 miles to the park entrance.

2) LAKE MINERAL WELLS HIKING TRAIL SYSTEM - Leashes

Beginner/Intermediate/16.0 miles

Info: Do the distance on this inter-looping trail system and you'll feel like a champ at the end of the day. You and your hiking hound will find yourselves in the midst of a beautiful landscape of dense woodlands and rolling hills in a region filled with wildlife and birdlife. Pack some high energy snacks and plenty of Perrier when you do the outdoor thing in this natureland. For more information: (940) 328-1171.

Directions: From Mineral Wells, take Highway 180 east for 3 miles to the park entrance.

3) LAKE TRAIL HIKE - Leashes

Intermediate/5.0 miles

Info: Conditioned wet waggers give this hike the high five. The trail is rugged and involves a series of strenuous ups and downs, but the payoff is endless agua fria fun in the sun-splashed lake. For more information: (940) 328-1171.

Directions: From Mineral Wells, take Highway 180 east for 3 miles to the park entrance.

MISSION

LODGING

COMFORT INN
203 S Shary Rd (78572)
Rates: $59-$130
(956) 583-0333; (800) 228-5150

EL ROCIO RETREAT CENTER
2519 S Inspiration Rd (78572)
Rates: $60-$175
(956) 584-7432

EXECUTIVE INN & SUITES
1786 W Hwy 83 (78572)
Rates: $45-$60
(956) 581-7451

HAWTHORN SUITES LTD
3700 Plantation Grove Blvd (78572)
Rates: $69-$109
(956) 519-9696; (800) 527-1133

INDIAN RIDGE B&B
N Bentsen Palm Dr & W 2 Mile Rd
(78574)
Rates: $75-$175
(956) 519-3305

Locate Other Dog-Friendly Activities...Check Nearby Cities

RECREATION

BENTSEN-RIO GRANDE VALLEY STATE PARK - Leashes

Info: Birders from all over the United States literally flock to this park, hoping to catch a glimpse of least grebes, green-backed herons and gray hawks, just a handful of the 290 bird species that inhabit the region. Hop on one of the trails that lace this unique, subtropical environment or munch on lunch with the dogster in a shaded spot. Wildlife seekers - rare and elusive species like the ocelot and the jaguarundi roam the thick, brushy woodlands. When your travels include the deep south of Texas, be sure to plan a visit to this extraordinary parkland. For more information: (956) 585-1107; (800) 792-1112; www.tpwd.state.tx.us.

Directions: From Mission, head west on Highway 83, exiting at Inspiration Road. Continue west for 3 miles, then take FM 2062 south for three miles to the park.

Note: All plant and animal species within the park are protected by law. Entrance fee charged.

The numbered hikes that follow are within Bentsen-Rio Grande State Park:

1) RIO GRANDE HIKING TRAIL - Leashes

Beginner/2.0 miles

Info: You can do the Texas two-step on this simple self-guided looping trail to the Rio Grande. Teeming with flora and fauna, the varying terrain ranges from brushlands to marshlands and accounts for the wide variety of plantlife. For a quickie education, pick up a trail brochure before heading out - plant descriptions correspond with the numbered posts. For more information: (956) 585-1107.

Directions: From Mission, head west on Highway 83, exiting at Inspiration Road. Continue west for 3 miles, then take FM 2062 south for three miles to the park.

Hotel Pet Policies May Be Subject To Change

2) SINGING CHAPARRAL TRAIL HIKE - Leashes

Beginner / 1.5 miles

Info: A wonderland of nature beckons you and furface on this easy-does-it trail. As you stroll through brushlands and riparian woodlands, melodic bird song fills the air, plantlife blankets the landscape and wildlife scampers about. Bowwow. Take a trail guide along - it corresponds with the posted interpretive signs. For more information: (956) 585-1107.

Directions: From Mission, head west on Highway 83, exiting at Inspiration Road. Continue west for 3 miles, then take FM 2062 south for three miles to the park.

MONAHANS

Lodging
BEST WESTERN COLONIAL INN
702 I-20 W (79756)
Rates: $43-$64
(432) 943-4345; (800) 528-1234

Recreation
MONAHANS SANDHILLS STATE PARK - Leashes

Info: Frolic among 3,800 acres of pristine scenery as you and the pupster enjoy a day of fun time in the sunshine. Race up the sand dunes that sometimes reach a height of 70 feet. Shady areas are scarce, so plan accordingly. Tote your own water and some Scooby snacks - there are plenty of secluded picnic places. For a bit of Texercise, get the lead out along the .25-mile nature trail or find a trail less traveled just about anywhere in this vast region. For more information: (432) 943-2092; (800) 792-1112; www.tpwd.state.tx.us.

Directions: From Monahans, take I-20 northeast approximately 6 miles to the Monahans Sandhills State Park exit (Park Road 41). Follow Park Road 41 to the park entrance.

Note: Entrance fee charged.

The numbered hike that follows is within Monahans Sandhills State Park:

1) NATURE TRAIL HIKE - Leashes
Beginner/0.25 miles

Info: Even telly bellies will love this miniscule trail. For an educational twist, pick up a trail guide and learn a little about the area's flora. For more information: (432) 943-2092.

Directions: From Monahans, take I-20 northeast approximately 6 miles to the Monahans Sandhills State Park exit (Park Road 41) Follow Park Road 41 to the park entrance. The trailhead is at park headquarters.

MOODY

RECREATION
MOTHER NEFF STATE PARK - Leashes
Info: Find tranquility under towering trees at the Leon Riverbottom or hike the upland hills and ravines where rock cliffs, diverse vegetation and wildlife will satisfy your outdoorsy cravings. For a slice of nature, treat Tex to a riverside biscuit break and enjoy a bit of tootsie dipping while you're soothed by silence and serenity. For more information: (254) 853-2389; (800) 792-1112; www.tpwd.state.tx.us.

Directions: Located 8 miles west of Moody off Highway 236.

Note: $2 entrance fee/person.

The numbered hike that follows is within Mother Neff State Park:

1) MOTHER NEFF HIKING TRAIL - Leashes

Intermediate/2.75 miles

Info: Definitely not for the fair of paw, this trail traverses an area that's woodsy, hilly and rocky. But if you and your hiking buddy are up for the challenge, you won't be disappointed. Dense forests canopy the trail, a babbling creek beckons you to partake of some wet and wild antics, a lookout tower offers spectacular aerial vistas and birds and wildlife provide many birding and photo ops. One branch of the trail leads to a waterhole, a springtime riparian oasis. While swimming is not permitted in the waterhole, you can still enjoy the beautiful surroundings before turning the hound around and retracing your steps. For more information: (254) 853-2389.

Directions: Located 8 miles west of Moody off Highway 236.

MOSCOW

RECREATION

MOSCOW TRAIL HIKE - Leashes

Beginner/2.0 miles

Info: Partake of an afternoon delight on this simple trail through a cooling forest of towering pines and then treat your aquapup to a waterful experience. The trail parallels Long King Creek where splish-splashing fun makes for a memorable excursion, one that can't be beat on those dog days of summer. Happy wet wagging to you. For more information: (936) 632-TREE.

Directions: From Moscow, take Highway 59 south for one mile to the trailhead.

MOUNT ENTERPRISE

RECREATION

GRIFF ROSS TRAIL HIKE - Leashes

Beginner/0.75 miles

Info: For a quickie nature outing, set your sights on this short loop of a trail. For more information: (936) 632-TREE.

Directions: From Mount Enterprise, take Highway 84 east approximately 2.2 miles to the trailhead.

MOUNT PLEASANT

LODGING

BEST WESTERN MT. PLEASANT INN
102 E Burton St (75455)
Rates: $74-$84
(903) 572-5051; (800) 528-1234

RAMADA INN
2502 W Ferguson Rd (75455)
Rates: $49-$55
(903) 572-6611; (800) 272-6232

DAYS INN
2501 W Ferguson (75455)
Rates: $50-$72
(903) 577-0152; (800) 329-7466

SUPER 8 MOTEL
204 Lakewood Dr (75455)
Rates: $45-$70
(903) 572-9808; (800) 800-8000

HOLIDAY INN EXPRESS HOTEL & SUITES
2306 Greenhill Rd (75455)
Rates: $76-$110
(903) 577-3800; (800) 465-4329

TANKERSLEY GARDENS B&B
Rt 7, Box 696 (75455)
Rates: $45-$110
(903) 572-0567

RECREATION

DAINGERFIELD STATE PARK - Leashes

Info: Frolic with furface over 551 pine-scented cushy acres in this beautiful, shady park. There's also an 80-acre spring-fed lake which offers excellent fishing opportunities for eager anglers. If you'd rather do something aerobic, kick up some dust on the hiking trail around the water. In springtime, flowering dogwoods, redwoods and wisteria vines will color your world and tickle your noses. In fall, oak and maple trees paint

Hotel Pet Policies May Be Subject To Change

the landscape in autumnal hues. The graceful rolling hills and vivid evergreens create a magnificent backdrop any time of year and provide shelter for several species of woodland dwellers. A definite two paws up kind of place. For more information: (903) 645-2921; (800) 792-1112; or visit their website at www.tpwd.state.tx.us.

Directions: From Highway 30 in Mount Pleasant, exit Ferguson Road and follow Highway 49 southwest about 22 miles to park's entrance on your right.

Note: $2 entrance fee/person.

The numbered hike that follows is within Daingerfield State Park:

1) LAKE DAINGERFIELD NATURE TRAIL HIKE - Leashes
Beginner/2.5 miles

Info: Aquapups will think they've found paradise on this looping trail around 80-acre Lake Daingerfield where the water's cool and the shade's abundant. More than 42 species of trees and other plants have been identified along the trail, including dogwood, pine, redbud, oak, sweetgum, cinnamon fern, hickory and a state champion chinquapin. After your hike, relax lakeside with your faithful one. FYI - the soil and rock are reddish in color due to the area's high concentration of iron. For more information: (903) 645-2921; (800) 792-1112.

Directions: From Highway 30 in Mount Pleasant, exit Ferguson Road and follow Highway 49 southwest about 22 miles to the park's entrance on your right. The trailhead is located at the bathhouse/picnic area parking lot above the lake.

DELLWOOD MUNICIPAL PARK - Leashes

Info: This expansive community park offers plenty of puppy prancing grounds for you and and the pooch. Hike along the designated trails or amble across acres of open parkland. For more information: (903) 572-3512.

Directions: Located off Highway 49 East.

LAKE MONTICELLO PARK - Leashes

Info: Float your boat, fish for dinner or treat the pupster to a picnic along the shores of a shimmering lake where water antics are a definite possibility. For more information: (903) 572-2398.

Directions: Located 5 miles southwest of Mount Pleasant off Highway 127.

MOUNT VERNON

LODGING

SUPER 8 MOTEL
401 W I-30 (75457)
Rates: $45-$59
(903) 588-2882; (800) 800-8000

RECREATION

LAKE BOB SANDLIN STATE PARK - Leashes

Info: Situated on the north side of 9,460-acre Lake Bob Sandlin, this park offers mucho open space and wooded glades where you can make merry. Get the lead out on a frolic through dense forests of dogwood, redbud and maple. Visit in fall and you'll be dazzled by dizzying displays of autumn colors. And if the pooch loves rolling in a crunchy pile of leaves, this place is numero uno. For more information: (903) 572-5531; (800) 792-1112; www.tpwd.state.tx.us.

Directions: From Mount Vernon, take Highway 37 south approximately one mile to Highway 21. Turn left on Highway 21 for 10.2 miles to the park entrance.

The numbered hikes that follow are within Lake Bob Sandlin State Park:

1) INTERPRETIVE TRAIL HIKE - Leashes

Beginner/0.5 miles

Info: A bonafido nature lesson awaits you and the dogster on this short, looping trail. Interpretive posts mark the route, providing interesting tidbits on the area's flora and fauna. For more information: (903) 572-5531.

Directions: From Mount Vernon, take Highway 37 south approximately one mile to Highway 21. Turn left on Highway 21 for 10.2 miles to the park entrance.

2) LAKE BOB SANDLIN HIKING TRAIL SYSTEM - Leashes

Beginner/4.5 miles

Info: If hiking's to your liking say goodbye to the summertime blues on this woodsy trail. Pine, oak, dogwood and sweetgum are just a few of the "shady" characters that canopy the trail as you hike from the day-use area to the camping area or vice-versa. En route, you and the barkmeister can take a break at the lake, where fishy tales are waiting to happen at the stocked trout pond or hike the entire trail via the footbridges. For more information: (903) 572-5531.

Directions: From Mount Vernon, take Highway 37 south approximately one mile to Highway 21. Turn left on Highway 21 for 10.2 miles to the park entrance.

MOUNTAIN HOME

<u>LODGING</u>

Y.O. RANCH
1736 Y O Ranch Rd NW (78058)
Rates: $70-$100
(830) 640-3222; (800) 967-2624

MULESHOE

LODGING

ECONOMY INN
2701 W American Blvd (79347)
Rates: $38-$46
(806) 272-4261

HERITAGE HOUSE INN
2301 W American Blvd (79347)
Rates: $44-$75
(806) 272-7575; (800) 253-5896

RECREATION

CITY PARK - Leashes

Info: When walktime calls, answer with a visit to this pleasant city park. Do a Sunday stroll along the grounds or find a secluded nook in the shade of towering trees.

Directions: Located at East Avenue D and East Fifth Street.

COMMUNITY PARK - Leashes

Info: The main emphasis of this huge park is baseball and softball, so if you're in the neighborhood, come root for the home team. If you'd rather put a twinkle in the ballmeister's eye, bring a tennie along and make your own fun.

Directions: Located at West Avenue D and West Seventeenth Street.

MULESHOE NATIONAL WILDLIFE REFUGE

Info: Not only is the 5,800-acre Muleshoe National Wildlife Refuge the oldest in Texas, but it boasts the nation's largest concentration of wintering sandhill cranes. December through February, these huge birds usually number 100,000. The refuge is also home to over 280 species of birds, so birders will want to pack binocs. If four-legged animals send your pup's tail a-wagging, then wag it will. Prairie dogs, bobcats, porcupines, coyotes, badgers, roadrunners, jackrabbits and cottontails have been sighted in many parts of the refuge. There are more than 25 miles of fire and service roads for your hiking pleasure as well as a 4.5-mile driving tour. For more information: (806) 946-3341.

Hotel Pet Policies May Be Subject To Change

Directions: From Muleshoe, head south on Highway 214 for 20 miles to the refuge. Refuge headquarters are located on a gravel road 2.25 miles west of Highway 214.

Note: Voice control obedience is mandatory.

The numbered hikes and drives that follow are within the Muleshoe National Wildlife Refuge:

1) CAMPGROUND NATURE TRAIL HIKE

Beginner/2.0 miles

Info: For a sampling of what the refuge has on the slate, head to this easy nature trail. Birdwatchers, check out the wooded area beside the campground - it's a favorite hangout for the winged residents. After the hike, break bread and biscuits with your Bowser at the campground's picnic area. For more information: (806) 946-3341.

Directions: From Muleshoe, head south on Highway 214 for 20 miles to the refuge. Refuge headquarters are located on a gravel road 2.25 miles west of Highway 214.

Note: Voice control obedience is mandatory.

2) MULESHOE REFUGE AUTO TOUR

Info: If you prefer the wind in your hair to grass beneath your feet or if you're short on time, then this 4.5-mile driving tour will suit you just fine. En route, stop at the observation turnout where you're bound to see a prairie dog or two. For more information: (806) 946-3341.

Directions: From Muleshoe, head south on Highway 214 for 20 miles to the refuge. Refuge headquarters are located on a gravel road 2.25 miles west of Highway 214.

3) PAULS LAKE TRAIL HIKE

Beginner/1.0 miles

Info: Tails will be twitching in the breeze along this short but

sweet nature hike. Pack a biscuit basket and chill out lakeside with your best buddy before heading home. For more information: (806) 946-3341.

Directions: From Muleshoe, head south on Highway 214 for 20 miles to the refuge. Refuge headquarters are located on a gravel road 2.25 miles west of Highway 214.

Note: Voice control obedience is mandatory.

NACOGDOCHES

LODGING

COMFORT INN
3400 South St (75964)
Rates: $59-$109
(936) 569-8100; (800) 228-5150

LA QUINTA INN
3215 South St (75961)
Rates: $60-$76
(936) 560-5453; (800) 687-6667

THE FREDONIA HISTORIC HOTEL
200 N Fredonia St (75961)
Rates: $65-$100
(936) 564-1234; (800) 594-5323

VICTORIAN INN & SUITES
3612 North St (75961)
Rates: $42-$65
(800) 935-0676

HARDEMAN GUEST HOUSE-HISTORIC B&B
316 N Church St (75961)
Rates: $75-$95
(936) 569-1947; (800) 884-1947

RECREATION

BANITA CREEK NORTH PARK - Leashes

Info: Along with an exercise trail, picnic pavilions and a slew of sporty amenities, you'll find greenery and a woodsy, shaded feeling at this parkland.

Directions: Located at Taylor and Powers.

BANITA CREEK SOUTH PARK - Leashes

Info: This neighborhood park is ideal for your daily constitutional or a brown bagger with the tailwagger.

Directions: Located at Cox and Pecan.

Hotel Pet Policies May Be Subject To Change

CITY PARK - Leashes

Info: Take your special wagalong to the nature trail and step lively through a shaded woodland. Pack a chow basket and do lunch with the biscuitmeister in this city park.

Directions: Located on Maroney Drive.

HISTORIC WALKING TOUR (NACOGDOCHES) - Leashes

Info: Put on some comfortable walking shoes, leash up your history sniffing canine and do your own self-guided tour of Nacogdoches, the "oldest town in Texas." Begin at the Civil Plaza where you can see the stone house erected in 1779 by political chief Antonio Gil Y'Barbo. Continue to the corner of South Pecan and Pillar Streets and check out the Charles Hoya Land Office which was built in 1897. Walk east on Pillar Street to reach the New Orleans Greys' Bivouac at the intersection of Pillar and Lanana. Across the street is the Adolphus Sterne House (aka Hoya Library) constructed in 1830.

Walk north on Lanana Street. When you reach the historic Haden Edwards Inn, you'll have traveled a pooch pleasing mile. Continue along Lanana and past the Oak Grove Cemetery, the final resting place for four signers of the Texas Declaration of Independence. Or shorten your trip by turning west on Price. A quick jaunt north on Mound Street leads to the Indian Mound, an artifact of the area's first settlers. Go west on Arnold Street and look north for a view of the Old University Building. Turn south on Fredonia, to the east you'll see the Roland Jones House, to the west the Milam Lodge No. 2 erected in the 1920s. Continue along Fredonia to return to Pillar, your starting point.

To lengthen your tour, don't turn on Price, but continue along Lanana to the Bois d'Arc and the Zion Hill Baptist Church which was designed by noted architect Dietrich Anton Wilhelm Rulfs. Keep walking on Lanana until Park Street and travel east on Park to the marker that testifies to the "miracle" allegedly performed in the area by Fr. Antonio Margil de Jesus. Just past the marker you'll see the Black Cemetery

established in 1879. Feel a tug on your leash? Your aquapup has probably sniffed out the Lanana Creek Trail access point on the other side of the road. A diversion along this trail will allow you to take in some natural scenery and perhaps a wee bit of wet and wild fun. For your return, head to Price and turn west. For more information: (888) OLDEST TOWN (or 888-653-3788); www.visitnacogdoches.org.

Directions: The tour starts at Civil Plaza.

Note: A detailed walking tour is available from the Nacogdoches Chamber of Commerce, P.O. Box 631918, Nacogdoches TX 75963. Dogs are welcome in the Visitor Center located at 200 E. Main St., but not in the museum.

LAKE NACOGDOCHES WEST PARK - Leashes

Info: The forty acres of rolling hills and lush landscape that comprise this park are perfect antidotes to the summertime blahs. Able anglers, this could be a fishing day you'll long remember. The lake is renowned for its tasty inhabitants, so see if you can snatch a catch. If your fishing expedition proves fruitful, head to one of the pavilions equipped with barbecue pits for dining alfresco. There's also a .75-mile nature trail where you can work off dinner. Bone appetite! For more information: (888) 564-7351.

Directions: Located 11 miles southwest of the city limits off Highway 225.

LAKESIDE PARK - Leashes

Info: This neighborhood park is great for your morning constitutional. Or just get mellow with your fellow beside the lake and do some cloudgazing.

Directions: Located on Pearl Street.

LANANA CREEK TRAIL HIKE - Leashes

Beginner/12.0 miles

Info: Grab your hat, pack your sack and leave your troubles far behind you with a journey to this pretty region. Scenery and

Hotel Pet Policies May Be Subject To Change

exercise make for a memorable adventure on this creekside trail, aka puppy paradise. Complete with footbridges, covered park benches, shade trees and colorful wildflowers, you won't regret a moment spent on Lanana Creek Trail. You'll find tootsie dipping and wet wagging opportunities, secluded nooks and crannies and a sense of serenery amid a peaceful, green oasis. The trail is accessible via many locations, making shorter hikes possible. For more information: (888) 564-7351.

Directions: The trail begins at East Austin Street, runs through the campus of Stephen F. Austin State University and ends at the soccer fields on Pilar Street. The trail is easily accessed from many locations, including Pecan Acres Park and Oak Grove Cemetery.

MILL POND - Leashes

Info: Enjoy some funnery in the sunnery at this quiet park.

Directions: Located on John Street.

PECAN PARK - Leashes

Info: Spend a lazy hazy summer day enjoying the lush landscape of this charming park. Or get the kinks out with a jaunt along the peaceful nature trail.

Directions: Located on Starr Avenue.

PIONEER PARK - Leashes

Info: Play tagalong with your wagalong through the soft grass in this , tree-dotted park.

Directions: Located on Linwood Street.

RITCHIE STREET PARK - Leashes

Info: Pack some grub for the grill and spectate at a neighborhood basketball match while you soak up the sun in this little green scene.

Directions: Located at Ritchie Street and Dolph.

Locate Other Dog-Friendly Activities...Check Nearby Cities

ROBERT MCCRIMMON PARK - Leashes

Info: Satisfy those pleading brown eyes with a sojourn to this petite park. Pack a brown bagger and a chew for the wagger and sup with the pup at one of the picnic tables.

Directions: Located on Wooden Road.

OTHER PARKS IN NACOGDOCHES - Leashes

For more information, contact the Nacogdoches Parks & Recreation Department at (936) 559-2960.

•LAKE NACOGDOCHES EAST PARK, off Highway 225

NASSAU BAY

LODGING

HOLIDAY INN HOUSTON/NASA
1300 NASA Rd One (77058)
Rates: $69-$159
(281) 333-2500; (800) 465-4329

NAVASOTA

LODGING

SUPER 8 MOTEL
9460 Hwy 6 South (77868)
Rates: $39-$79
(409) 825-7775; (800) 800-8000

NEDERLAND

LODGING

BEST WESTERN AIRPORT INN
200 Memorial Hwy 69 (77627)
Rates: $55-$70
(409) 727-1631; (800) 528-1234

Hotel Pet Policies May Be Subject To Change

NEW BOSTON

LODGING

BEST WESTERN INN OF NEW BOSTON
1024 N Center (75570)
Rates: $59-$99
(903) 628-6999; (800) 528-1234

NEW BRAUNFELS

LODGING

ACORN HILL B&B
250 School House (78132)
Rates: $100-$175
(800) 525-4618

ALTA VISTA COMAL RESORTS
350 S Union (78130)
Rates: $99-$325
(800) 227-5883

BEST VALUE INN
375 Hwy 46 S (78130)
Rates: $36-$169
(830) 625-6282

BEST WESTERN INN & SUITES
1493 I-35 N (78130)
Rates: $49-$149
(830) 625-7337; (800) 528-1234

EDELWEISS INN
1063 I-35 N (78130)
Rates: $45-$99
(830) 629-6967

EXECUTIVE INN & SUITES
808 Hwy 46 S (78130)
Rates: $39-$199
(830) 625-3932

FOUNTAIN MOTEL
1210 N Business
I-35 (78130)
Rates: $32-$99
(830) 625-2821

HOLIDAY INN
1051 I-35 E (78130)
Rates: $109-$199
(830) 625-8017; (800) 465-4329

KUEBLER-WALDRIP HAUS B & B
1620 Hueco Springs Loop (78132)
Rates: $120-$200
(830) 625-8372; (800) 299-8372

LA QUINTA INN & SUITES
356 S Hwy 46 (78130)
Rates: $69-$99
(800) 687-6667

MOTEL 6
1275 I-35 (78130)
Rates: $38-$75
(800) 466-8356

RODEWAY INN
1209 I-35 E (78130)
Rates: $49-$129
(830) 629-6991 (800) 228-2000
(800) 967-1168

SUPER 8 MOTEL
510 Hwy 46 S (78130)
Rates: $44-$129
(830) 629-1155; (800) 800-8000

RECREATION

LANDA PARK - Leashes

Info: Pack an old tennie or favorite frisbee and jumpstart the dogster's day with a visit to this expansive, diverse park. Curious Georges will have a tailwagging good time exploring the trails that honeycomb the landscape. And then get mellow with a good read and a great chew beneath the shade of a massive oak. Check out the choo choo train that carries visitors over the 200 acres of this parkland. For more information: (830) 608-2160.

Directions: Take Loop 337 to California Street. Head south on California to the park on the east side of the road.

NATURAL BRIDGE CAVERNS

Info: Get pumped for an out-of-this-world experience amidst a subterranean maze of limestone rooms and corridors. Formed nearly 140 million years ago, the caverns have more than 10,000 spectacular cave formations that are a definite must-see. Some of the more popular formations resemble a chandelier, fried eggs and a king's throne. The pooch can't join you on this unearthly adventure, but the caverns provide a free kennel service. For more information: (210) 651-6101.

Directions: From New Braunfels, take Highway 35 south to Exit 175 (FM 3009/Natural Bridge Caverns Road). Turn right for approximately 8 miles to the caverns. Located at 26495 Natural Bridge Cavern Road.

Note: $14/adult, $8.50/child, $13/seniors. Hours: Daily from 9 am to 4 pm.

NEW CANEY

RECREATION

LAKE HOUSTON STATE PARK - Leashes

Info: Ten miles of trails escort you on a journey through dense woodlands. Sniff out Peach Creek or the San Jacinto River for some paw dipping. For more information: (281) 354-6881; (800) 792-1112; www.tpwd.state.tx.us.

Hotel Pet Policies May Be Subject To Change

Directions: From New Caney, take FM 1485 east to Baptist Encampment Road and turn right. Follow to park entrance.

Note: Dogs are not allowed in the wading/swimming area. $3 entrance fee/person.

The numbered hike that follows is within Lake Houston State Park:

1) LAKE HOUSTON HIKING TRAIL SYSTEM - Leashes

Beginner/Intermediate/10.0 miles

Info: A slice of puppy nirvana is yours for the taking on this diverse interconnecting trail system. You'll find yourself in a water wonderland complete with pine and magnolia woodlands and hardwood bottomlands where your soon-to-be-dirty dog can wet wag the day away. The sweet sounds of songbirds fill the air with nature's music as you travel along your course. Don't be surprised to encounter wildlife, there's always a critter or two scurrying about. Pack plenty of Perrier and lots of high energy trail mix, you and the hiking hound will need the boost. Peach Creek and the San Jacinto River are the main watering holes in this region. For more information: (281) 354-6881; (800) 792-1112.

Directions: From New Caney, take FM 1485 east to Baptist Encampment Road and turn right. Follow to park entrance.

NEW WAVERLY

<u>RECREATION</u>

SAM HOUSTON NATIONAL FOREST

Sam Houston Ranger District
394 FM 1374 W, New Waverly, TX 77358,
(936) 344-6205; (888) 361-6908

Info: Over 160,000 acres of alluring serenity are yours for the taking at this national forest named for the father of Texas- Sam Houston. No tour of Texas would be complete without a visit

to this delightful woodland. So leave your cares and woes in the city and let the good times roll. It doesn't matter what tickles your fancy the most, it's all here. Play tagalong with your wagalong as you journey on the picturesque Lone Star Hiking Trail. Be a lazy bones and vege out under a shade tree in a hidden copse where the air is deliciously pine-scented. Or if water sports are more your speed, tote your boat, pack your gear, and set your sights on 21,000-acre Lake Conroe and 82,600-acre Lake Livingston (gasoline-powered boats are not permitted). Pick your pleasure and then go for it. There's nothing to stop you and furface from having one helluva a good day. Carpe diem Duke. For more information: (936) 344-6205.

Directions: The forest lies within the boundaries of Montgomery, San Jacinto and Walker Counties and is easily accessed via Interstate 45 and Highways 150, 190 and 156. Refer to specific directions following each recreation area and hiking trail.

For more information on recreation in the Sam Houston National Forest, see listings under the following cities: Coldspring, Conroe, Houston, Huntsville and Shepherd.

The numbered recreation areas/hikes that follow are within the Sam Houston National Forest:

1) LITTLE LAKE CREEK WILDERNESS AREA - Leashes

Info: When play's the thing, this area's the stage. Nearly 4,000 acres of hardwood bottomlands and forested uplands contribute to the beauty of this secluded wilderness region. Hightail it on a section of the Lone Star Hiking Trail for a bit of Texercise or do some rock hopping in Little Lake Creek. The soon-to-be-dirty dog will love the wet and wild shenanigans. A brown bagger for you and the wagger would definitely be a nice way to end the day. For more information: (936) 344-6205.

Directions: From New Waverly, head east on FM 1375 for 14 miles to FM 149. Head south on FM 149 for 4 miles to the wilderness parking area.

Hotel Pet Policies May Be Subject To Change

2) STUBBLEFIELD LAKE RECREATION AREA - Leashes

Info: There's always a season and plenty of reason to plan a day of adventure in this slice of nature. Lush forests of southern pine, oak, sweetgum and dogwood promise a shaded, fragrant walk, while hardwood bottomlands are a sure lure for the wet set. Exercise gurus, lace up your hiking boots and burn some kibble on one of the hiking trails. Fishing fiends, snag a bag of crappie, catfish, large-mouth bass and bluegill at pretty Stubblefield Lake and plan your next fish fry. Bird lovers, there's a side trip to the endangered red-cockaded woodpecker colony that you might want to include on your drive to this area. Encompassing 70 acres and 40 cavity trees, the site's sole purpose is to rebuild the woodpecker's population. A doggone good time is guaranteed no matter what you choose to do. For more information: (936) 344-6205.

Directions: From New Waverly, take Highway 1375 west for 11 miles to FSR 215. Turn right on FSR 215 for 3 miles to the recreation area.

3) STUBBLEFIELD LAKE INTERPRETIVE TRAIL HIKE - Leashes

Beginner/1.1 miles

Info: Get an education and a smidgen of a workout on this easy looping trail. As you journey through upland forests and hardwood bottomlands, interpretive markers correspond with a trail guide and provide interesting information on the forest ecosystem. Pick up a guide before setting out. For more information: (936) 344-6205.

Directions: From New Waverly, take Highway 1375 west for 11 miles to FSR 215. Turn right on FSR 215 for 3 miles to Stubblefield Lake Recreation Area. The trailhead is located just south of the campground.

NEWCASTLE

<u>RECREATION</u>
FORT BELKNAP- Leashes

Info: Military mutts with a nose for history will have a great time sniffing around this 20-acre national historic landmark. Once one of the largest North Texan frontier posts, Fort Belknap offers visitors a glimpse of life in the late 1800s. You and the dawgus can check out the exterior of seven of the original buildings, including the commissary store, magazine, corn house, well, kitchen and two infantry quarters. Dogs are not permitted inside the buildings. When the sniffmeister has had his fill, finish off the afternoon with a snack in the picnic area. For more information: (940) 846-3222.

Directions: From Newcastle, take Highway 251 south for 3 miles to the fort.

Note: Hours: Open daily, except Wednesdays. Call ahead for hours.

NEWTON

<u>RECREATION</u>
SYLVAN NATURE TRAIL HIKE - Leashes

Beginner/0.5 miles

Info: Leg stretch with Fletch on a short, looping trail through towering stands of pine on this easy jaunt. For more information: (936) 632-TREE.

Directions: From Newton, take U S 190 southeast for 4 miles. The trailhead is across from the highway roadside park.

WILD AZALEA CANYON TRAILS - Leashes

Info: When spring fever strikes, plan an unforgettable journey to this incredible canyonland. But you and the hound will have to be up to the challenge. The trails are steep and the

going gets tough. Wild Azalea Canyon is a pocket of wilderness filled with native flowering plants, longleaf pines, scenic rock cliffs and namesake wild azaleas, the canyon's main attraction. A system of short trails lace the canyon affording hikers mucho opportunities to view the spectacular blooming azaleas. Please note that due to the blooming nature of the azaleas, the trails are only open from March through April. For more information: (409) 379-5527.

Directions: From Newton, take Highway 87 north about 4.5 miles to FM 1414. Head east on FM 1414 for just under 7 miles. At this point, follow the signs for approximately 2 miles along unpaved roads to the canyon.

NOCONA

LODGING
NOCONA HILLS MOTEL & RESORT
100 E Huron Circle (76255)
Rates: $34-$46
(940) 825-3161

NORTH PADRE ISLAND
(See South Padre Island listings for additonal lodging and recreation.)
LODGING
MOTEL 6
8202 S Padre Island Dr (78412)
Rates: $39-$59
(361) 991-8858; (800) 466-8356

NORTH RICHLAND HILLS

LODGING

LEXINGTON INN-DFW WEST
8709 Airport Frwy (76180)
Rates: $62-$85
(817) 656-8881; (800) 656-8886

RAMADA LIMITED
7920 Bedford-Euless Rd (76180)
Rates: $40-$69
(817) 485-2750; (800) 272-6232

MOTEL 6
7804 Bedford-Euless Rd (76180)
Rates: $38-$54
(817) 485-3000; (800) 466-8356

STUDIO 6
7450 NE Loop 820 (76180)
Rates: $39-$56
(817) 788-6000; (888) 897-0202

RECREATION

FOSSIL CREEK PARK - Leashes

Info: Play tagalong with your wagalong on the 2-mile trail through a woodland oasis. When your workout's over, take a biscuit break creekside and do some Texas daydreaming.

Directions: Located at 6100 Onyx Drive South.

NORICH PARK - Leashes

Info: Your pooch will love starting her day with a jaunt around the ten acres of open fields in this friendly community park or light up the ballmeister's eyes with a game of catch.

Directions: Located at 5500 Finian Lane.

NORTHFIELD PARK - Leashes

Info: When Tex is tugging at the leash, get a move on and let the fun begin at this 29-acre green scene. Finish your outing and share a brown bagger with your wagger. Bone appetite.

Directions: Located at 7800 Davis Boulevard.

RICHFIELD PARK - Leashes

Info: When play's the thing, this park's the stage. You and fur-face will find 42 acres of exploring fun at this grassy urban expanse.

Directions: Located at 7000 Chapman.

Hotel Pet Policies May Be Subject To Change

ODEM

LODGING

DAYS INN
1505 S Hwy 77 (78370)
Rates: $50-$110
(361) 368-2166; (800) 329-7466

ODESSA

LODGING

BEST WESTERN GARDEN OASIS
110 W I-20 (79761)
Rates: $50-$110
(432) 337-3006; (800) 528-1234
(877) 524-9231

CLASSIC SUITES
3031 E Hwy 80 (79761)
Rates: $27-$32
(432) 333-9678

DAYS INN
3075 E Business Loop 20 (79761)
Rates: $50-$64
(432) 335-8000; (800) 329-7466

HOLIDAY INN EXPRESS HOTEL & SUITES
3001 E Business Loop I-20 (79760)
Rates: $58
(432) 333-3931; (800) 465-4329

HOLIDAY INN HOTEL & SUITES
6201 E Business Loop I-20 (79760)
Rates: $64
(432) 362-2311; (800) 465-4329

LA QUINTA INN
5001 E Business Loop I-20 (79761)
Rates: $64-$80
(432) 333-2820; (800) 687-6667

MOTEL ONE
2925 E Hwy 80 (79761)
Rates: $27-$33
(432) 332-4500

MOTEL 6
200 E I-20 Service Rd (79766)
Rates: $31-$48
(432) 333-4025; (800) 466-8356

PARKWAY INN
3071 Hwy 80 E (79761)
Rates: $32-$39
(432) 332-4224; (800) 480-0761

VILLA WEST INN
300 W Pool Road (79760)
Rates: $27-$39
(432) 335-5055

RECREATION

COMANCHE TRAIL PARK - Leashes

Info: Even the padded of paw can enjoy the natural experience afforded visitors at this 160-acre park. The 3.5-mile trail

system is paved and leads you and your sidekick through a cornucopia of nature. Birdwatchers will want to take along binoculars, the pond attracts many feathered friends. Fishing fiends will appreciate the pond for its bony bounty. Sports fans can spectate at a soccer or baseball game. Bring along a fuzzy tennie and let the pooch have some fun too. For more information: (432) 368-3548.

Directions: Located at Interstate 20 and West County Road.

FLOYD GWIN PARK - Leashes

Info: Noted for being the first park built in Odessa, this 40-acre greenland provides plenty of frolicking space for you and the Bowser to browser.

Directions: Located at 10th and West County Road.

JIM PARKER PARK - Leashes

Info: Even if you're not into tennis, volleyball or baseball, you'll still enjoy a visit and a walk through this sports-minded park.

Directions: Located on University and Bonham Streets.

NOEL HERITAGE PLAZA - Leashes

Info: The unusual and beautiful landscaping is the distinguishing feature of this park. A perfect place for a Sunday stroll, be sure to make note of the interesting archways and listen to the sounds of cascading water coming from one of the park's many fountains. If you're visiting Odessa in winter, you and the dogster will be treated to a wonderland alive with twinkling lights and decorations. For more information: (432) 368-3548.

Directions: Located at 320 West 5th.

ODESSA METEOR CRATER SITE - Leashes

Info: An out-of-this-world experience awaits you and Dino in this enormous meteor crater, the second largest in the United States. Approximately 20,000 years ago, a shower of meteors smashed into the earth, shattered the limestone bedrock foun-

Hotel Pet Policies May Be Subject To Change

dation and created the crater. Silted by desert winds, the crater wasn't identified until the 1920s. Although the winds of change and the sands of time have diminished the depth of the crater from 100 feet to about 15 feet, nothing can lessen the impact of this prehistoric phenomenon. So hightail it to this site and moon dance on the self-guided nature trail through the crater. For more information: (432) 381-0946 or (432) 333-7871.

Directions: From Odessa, head west on Interstate 20 to the FM 1936 (south) exit. Follow the signs to the crater site approximately 4 miles southwest of the exit.

OPTIMIST PARK - Leashes

Info: Experience an afternoon of pooch shenanigans at this neighborhood park. You and furface will be rewarded with an eye-pleasing array of seasonal color landscaping as well as plenty of frolicking space.

Directions: Located at 37th and Grandview.

SHERWOOD PARK - Leashes

Info: Perk up a humdrum day with a trip to Odessa's "most active park." Sixty-five acres of stomping ground set the stage. So go ahead, make your dog's day.

Directions: Located at 44th and Dixie.

SLATER PARK - Leashes

Info: This cozy neighborhood park is ideal for a morning jaunt or a playful afternoon.

Directions: Located at 38th and Pleasant.

U.T.P.B. PARK - Leashes

Info: Located on the campus, this friendly community park provides a wonderful verdant scene for your hot diggety dog.

Directions: Located on the University of Texas (Permian Basin campus).

Locate Other Dog-Friendly Activities...Check Nearby Cities

ORANGE

LODGING

BEST VALUE INN
2208 Lutcher Dr (77630)
Rates: $35-$45
(409) 883-6701

BEST WESTERN ORANGE INN
2630 I-10 (77630)
Rates: $80-$125
(409) 883-6616; (800) 528-1234

CAROLINE'S BED & BREAKFAST
808 6th St (77630)
Rates: $75-$85
(409) 883-5860

EXECUTIVE INN & SUITES
4301 27th St (77632)
Rates: $29-$69
(409) 883-9981

LEXINGTON INN
2900 I-10 (77632)
Rates: $50-$70
(409) 988-0110

MOTEL 6
4407 27th St (77630)
Rates: $29-$34
(409) 883-4891; (800) 466-8356

RAMADA INN
2610 I-10 W (77630)
Rates: $65-$150
(409) 883-0231; (800) 272-6232

THE ROGERS HOUSE B&B
907 Pine Ave (77630)
Rates: $40-$95
(409) 697-0911

SUPER 8 MOTEL
2710 I-10 W (77630)
Rates: $50-$59
(409) 882-0888; (800) 800-8000

RECREATION

BLUE BIRD FISH CAMP - Leashes

Info: Tote a boat and float the gentle waters of the lovely lake. Grounded hounds can be lazy bones along the shoreline.

Directions: Located off Simmons Drive.

CITY PARK - Leashes

Info: Dine à la blanket on the grassy knoll beside the bayou or tote a tennie and make your pup's day extra special.

Directions: Located at the intersection of Green Avenue and 16th Street.

Hotel Pet Policies May Be Subject To Change

MEMORIAL FIELD PARK - Leashes

Info: Expansive baseball fields provide plenty of playing ground for you and your ballmeister.

Directions: Located on Eddelman Road.

NAVY PARK - Leashes

Info: Drop in for your pooch's constitutional in this neighborhood bark park.

Directions: Located on the corner of 3rd Street and Morrell Boulevard.

NORTHWAY PARK - Leashes

Info: Your wagalong can tagalong on the mile-long pathway that winds its way through a wooded area.

Directions: Located at Meeks Drive and Clark Lane.

SIMMONS FIELD PARK - Leashes

Info: Catch a softball game and maybe a fly ball as you and the furball soak up some fun in the sun in this quaint little park.

Directions: Located at Simmons Drive and Cypress Avenue.

SUNSET PARK - Leashes

Info: Treat Bowser to a browser in this neighborhood park. If you're visiting at dusk, take a moment and catch a glimpse of the sun fading below the horizon.

Directions: Located on 16th Street.

SUPER GATOR TOURS - Leashes (SMALL DOGS ONLY)

Info: If your little lapdog likes boating, hold on tight and get ready for a whirl through one of the most scenic swamplands in Texas. Travel through tranquil surroundings and watch for wildlife including alligators, frogs, turtles and numerous species of birds. Tote your Kodak, the Spanish moss dangling

from the cypress is definitely photo worthy. For more information: (409) 883-7725. ext. 14 or (800) 241-6390.

Directions: From Interstate 10, exit 878 on North Service Rd.

Note: Call in advance to book tour. Fees vary.

ORANGE GROVE

RECREATION

HAZEL BAZEMORE PARK - Leashes

Info: Do the Texas two-step along the nature trail or be a quiet birder in a photographic blind and see if you can identify the birds that inhabit the park. The Nueces River runs through the park, offering numerous fishing opportunities and plenty of pupportunities to wet your jets. Pack a biscuit basket, you and the dawgus just might decide to spend the day in this beautiful 77-acre green scene. For more information: (361) 384-2322.

Directions: Located on the Nueces River, just off Farm Road 624 and County Road 69.

ORANGEFIELD/BRIDGE CITY

RECREATION

CITY PARK - Leashes

Info: This urban park offers splendor in the grass in a city setting. Plan a quick stop during your day and check it out.

Directions: Located on Bolivar Street.

VIDOR COMMUNITY CENTER PARK - Leashes

Info: The jogging track is just the place to meet your exercise quotient for the day. Or simply spend the afternoon enjoying some outdoor recreation in this community park.

Directions: Located at the Vidor Community Center.

OZONA

LODGING

BEST VALUE INN
820 11th St (76943)
Rates: $39-$60
(325) 392-2631

TRAVELODGE
8 11th St (76943)
Rates: $45-$65
(325) 392-2656; (800) 578-7878

SUPER 8 MOTEL
3330 I-10 E (76943)
Rates: $62-$95
(325) 392-2611; (800) 800-8000

PALESTINE

LODGING

BEST WESTERN PALESTINE INN
1601 W Palestine Ave (75801)
Rates: $42-$70
(903) 723-4655; (800) 528-1234
(800) 523-0121

RAMADA INN
1101 E Palestine Ave (75801)
Rates: $59-$85
(903) 723-7300; (800) 272-6232

EXPRESS INN & SUITES
1100 E Palestine Ave (75801)
Rates: $35-$135
(903) 729-3151; (800) 944-1143

RECREATION

GUS ENGELING WILDLIFE MANAGEMENT AREA - Leashes

Info: When nothing but the best of Mother Nature will do, come see what the Post Oak Region of East Texas has in store at the Gus Engeling Wildlife Management Area (GEWMA). Your canine connoisseur will think he's been transported to puppy paradise as you walk in splendor amid hardwood bottomlands, rolling uplands, deciduous forests and verdant grasslands to spring-fed streams, marshes and swamps, beaver ponds and sphagnum moss bogs. You can experience it all in this 11,000-acre natural wonderland. Wildlife enthusiasts, this is an oppor-

tunity of a lifetime. With a documented 36 mammals, 53 fishes, 140 birds and 54 reptiles and amphibians, the sightings are endless. Fishermen will get a chance to satisfy their fishiest dreams and plan the next neighborhood fish fry. Eight-mile long Catfish Creek is stocked to the brim with channel, flathead, blue and bullhead catfish, large-mouth bass, crappie, carp and a variety of sunfish. Plan a visit in the spring when the dogwoods and wildflowers compete for your attention, their colors a vibrant burst on the lush green landscape. Without a doubt, there's always a season and plenty of reason to plan a visit to this locale. For more information: (903) 928-2251.

Directions: From Palestine, take Highway 287 northwest to the Tennessee Colony exit. Follow the signs to the wildlife management area.

The numbered recreation areas/hikes that follow are within the Gus Engeling Wildlife Management Area:

1) BEAVER POND NATURE TRAIL HIKE - Leashes
Beginner / 1.0 miles

Info: This feel good trail gives you and the dawgus a unique, close-up of a beaver pond. You'll traipse over footbridges and through dense woodlands as you loop around the interpretive trail. Make the most of your excursion by picking up a trail guide before heading out. The guide corresponds with the trail's numbered posts, providing great flora descriptions. Birdwatchers, you've found tweet tweet heaven. Redheaded woodpeckers, great crested flycatchers, prothonotary warblers, yellow-bellied sapsuckers and great blue herons are just a sampling of the birds that fill the skies in this wildlife area. For more information: (903) 928-2251.

Directions: From Palestine, take Highway 287 northwest to the Tennessee Colony exit. Follow the signs to the wildlife management area.

Hotel Pet Policies May Be Subject To Change

2) DEMONSTRATION DRIVING TOUR

Info: If you're short on time but long on yearning, you can still take advantage of all that the Gus Engeling Wildlife Management Area has to offer on the self-guided driving tour that encompasses nearly 8 miles of designated road travel through the wildlife area. To make the most of your tour, pick up a driving guide which highlights the 10 numbered spots along the way and explains the significance of each. For more information: (903) 928-2251.

Directions: From Palestine, take Highway 287 northwest to the Tennessee Colony exit. Follow the signs to the wildlife management area.

3) DOGWOOD NATURE TRAIL HIKE- Leashes

Beginner/2.0 miles

Info: This woodsy snifforama is a must-smell for tree-loving tailwaggers. Even on those dog days of summer, you'll walk in shaded splendor in the midst of a grabbag forest of post oak, huckleberry, yaupon, possumhaw, dogwood, black hickory, beautyberry, white ash and sweetgum. If you'd like to capture the dazzling beauty of flowering dogwoods and the vibrancy of wildflowers, schedule your sojourn during the spring months when bursts of vivid color dot the landscape. Nature lovers won't be disappointed any time of the year - wildlife and birdlife sightings are practically guaranteed. Pick up an interpretive trail guide before setting out and make certain you don't miss a thing. For more information: (903) 928-2251.

Directions: From Palestine, take Highway 287 northwest to the Tennessee Colony exit. Follow the signs to the wildlife management area.

PANHANDLE

LODGING

S & S MOTOR INN
I-40 & SR 207 (79068)
Rates: $35-$47
(806) 537-5111

PARIS

LODGING

BEST WESTERN INN OF PARIS
3755 NE Loop
286 (75460)
Rates: $50-$68
(903) 785-5566; (800) 528-1234

VICTORIAN INN OF PARIS
425 NE 35th St (75460)
Rates: $45-$66
(903) 785-3871; (800) 935-0863

RECREATION

BYWATERS PARK - Leashes

Info: Strut your mutt through this lovely park where you can catch sight of the incredible peristyle that mimics the unique style of a grecian temple. Lucky dogs might even be visiting during one of the many summer concerts that are performed in the park.

Directions: Located in the 300 block of South Main Street.

CULBERTSON PARK - Leashes

Info: This expansive park spells fun for you and Fido. Bustling with activity, you can spectate at one of the ball games or brown bag it and do lunch alfresco.

Directions: Located on Neatherly, Heron and East Washington Streets.

DRAGON PARK - Leashes

Info: Joggers, lace up those tennies and share a morning workout with the dawgus. Dragon Park is home to the Wells

Hotel Pet Policies May Be Subject To Change

Fargo Gamefield Jogging Course, so be prepared to burn some calories.

Directions: Located at the intersection of Jefferson Road and 24th S.E., one-half mile south of Paris Junior College.

ELLIS PARK - Leashes

Info: Take a break from a busy day and treat your canine to an outdoor interlude in this relaxing park.

Directions: Located on East Houston and 13th N.E. Streets.

JOHNSON PARK - Leashes

Info: Grab your gadabout and do a turnabout in this friendly neighborhood park. You're sure to meet up with the locals and their pups. Great for a morning or evening sojourn.

Directions: Located on Johnson Street.

OAK PARK - Leashes

Info: Bring some "joie de vive" into your pooch's life by leading him along the .5 mile cinder walking track in this park.

Directions: Located on the 2600 block of Bonham Street.

RECORD PARK - Leashes

Info: Set tails twitching with a visit to this quaint community park. An ideal spot for your daily dose of Texercise.

Directions: Located on Henderson Street.

WADE PARK - Leashes

Info: Just say yes to your pooch's pleading eyes. And then put some biscuits in your picnic basket and head out for lunch alfresco in this pleasant park.

Directions: Located in the 2300 block of East Price Street.

WALKER PARK - Leashes

Info: Some outdoor fun in the sun awaits you and furface in this small local park.

Directions: Located in the 1700 block of West Shilo Street.

PASADENA

LODGING
RAMADA INN
114 S Richy (77506)
Rates: $57-$89
(713) 477-6871
(800) 272-6232

PEARLAND

LODGING
BEST WESTERN INN
1855 N Main St (77581)
Rates: $65-$79
(281) 997-2000
(800) 528-1234

PEARSALL

LODGING
EXECUTIVE INN
613 North Oak (78061)
Rates: $35-$55
(830) 334-3693

PECOS

LODGING

BEST WESTERN SWISS CLOCK INN
900 W Palmer (79772)
Rates: $59-$86
(432) 447-2215; (800) 528-1234

LAURA LODGE
1000 E Business 20 (79772)
Rates: $35-$48
(432) 445-4924

MOTEL 6
3002 S Cedar St (79772)
Rates: $30-$51
(432) 445-9034; (800) 466-8356

OAK TREE INN
22 N Frontage Rd (79772)
Rates: $59-$91
(432) 447-0180

QUALITY INN
4002 S Cedar St (79772)
Rates: $56-$86
(432) 445-5404; (800) 228-5151

PHARR

LODGING

**LA QUINTA INN & SUITES
RIO GRAND VALLEY**
4603 N Cage (78577)
Rates: $70-$120
(800) 687-6667

RAMADA LIMITED SUITES
1130 E Expy 83 (78577)
Rates: $59-$75
(956) 702-3330; (800) 272-6232

SUPER 8 MOTEL
4401 N Cage (78577)
Rates: $65-$82
(956) 782-8880; (800) 800-8000

PINEHURST

RECREATION
LARK STREET PARK - Leashes

Info: This friendly city park offers a delightful change of pace and a perfect place for your daily dose.

Directions: Located on Lark Street.

Locate Other Dog-Friendly Activities...Check Nearby Cities

WEST PARK - Leashes

Info: Several acres of greenery provide you and the pooch with the opportunity to burn some calories as you hot diggety dog it along the jogging trail equipped with exercise bars.

Directions: Located on West Park Avenue.

PIPE CREEK

LODGING
LIGHTNING RANCH (DUDE RANCH)
818 FM 1283 (78063)
Rates: $85-$135
(800) 994-7373

PITTSBURG

LODGING
CARSON HOUSE INN & GRILLE
302 Mt Pleasant St (75686)
Rates: $69-$79
(903) 856-2468

PLAINVIEW

LODGING

BEST WESTERN CONESTOGA INN
600 I-27 N (79072)
Rates: $37-$99
(806) 293-9454; (800) 528-1234

BUDGET INN
2001 W 5th St (79072)
Rates: $27-$39
(806) 293-2578

DAYS INN
3600 Olton Rd (79072)
Rates: $41-$70
(806) 293-2561; (800) 329-7466

HOLIDAY INN EXPRESS HOTEL & SUITES
4213 W 13th St (79072)
Rates: $90-$150
(806) 296-9900; (800) 465-4329

PLAINVIEW HOTEL
4005 Olton Rd (79072)
Rates: $55-$70
(806) 293-4181

WARRICK INN
800 Broadway (79072)
Rates: $32-$49
(806) 293-4266

Hotel Pet Policies May Be Subject To Change

PLANO

LODGING

AMERISUITES
3100 Dallas Pkwy (75093)
Rates: $89-$109
(972) 378-3997; (800) 833-1516

BEST WESTERN PARK SUITES HOTEL
640 Park Blvd E (75074)
Rates: $85-$100
(972) 578-2243; (800) 528-1234

CANDLEWOOD SUITES
4701 Legacy Dr (75024)
Rates: $69-$99
(972) 618-5446; (800) 465-4329

HAMPTON INN
4901 Old Shepherd Pl (75093)
Rates: $79-$89
(972) 519-1000; (800) 426-7866

HEARTHSIDE SUITES BY VILLAGER
4704 W Plano Pkwy (75093)
Rates: $59-$99
(972) 758-8888

HOLIDAY INN
700 Central Pkwy E (75074)
Rates: $89-$119
(972) 881-1881; (800) 465-4329

HOMESTEAD STUDIO SUITES-LEGACY PARK
4709 W Plano Pkwy (75093)
Rates: $64-$84
(972) 596-9955; (800) 782-9473

HOMEWOOD SUITES
4705 Old Shepard Pl (75093)
Rates: $129
(972) 758-8800; (800) 225-5466

LA QUINTA INN
1820 N Central Expwy (75074)
Rates: $55-$75
(972) 423-1300; (800) 687-6667

LA QUINTA INN & SUITES
4800 W Plano Pkwy (75091)
Rates: $60-$110
(972) 599-0700; (800) 687-6667

RAMADA LIMITED
621 Central Pkwy E (75074)
Rates: $43-$55
(972) 424-5568; (800) 272-6232

RED ROOF INN
301 Ruisseau Dr (75032)
Rates: $34-$70
(972) 881-8191; (800) 843-7663

RESIDENCE INN BY MARRIOTT
5001 Whitestone Ln (75024)
Rates: $132-$189
(972) 473-6761; (800) 331-3131

SLEEP INN
4801 W Plano Pkwy (75093)
Rates: $45-$89
(972) 867-1111; (800) 753-3746

SOUTHFORK HOTEL
1600 N Central Expwy (75074)
Rates: $69-$79
(972) 578-8555

SUPER 8 MOTEL
1704 N Central Expwy (75074)
Rates: $45-$59
(972) 423-8300; (800) 800-8000

TOWNEPLACE SUITES
5005 Whitestone Ln (75024)
Rates: $84-$94
(972) 943-8200; (800) 257-3000

WELLESLEY INN & SUITES
2900 Dallas Pkwy (75093)
Rates: $79-$109
(972) 378-9978; (800) 444-8888

Locate Other Dog-Friendly Activities...Check Nearby Cities

<u>RECREATION</u>

BEVERLY PARK - Leashes

Info: Stroll the open space with pooch-face in this pleasant 8-acre parkland.

Directions: Located at the intersection of Custer Road and Legacy Drive.

BUCKHORN PARK - Leashes

Info: Create your own fun in the sun as you and Fido make tracks along the .4-mile walkway that wiggles through this 8-acre park.

Directions: The park is a half mile west of Independence Parkway between Parker Road and Spring Creek Parkway.

CITY OF PLANO OFF-LEASH DOG PARK

Info: This 2-acre, double-gated fenced area is doggie nirvana. You and Snoopy will find park benches, picnic tables and separate water stations for people and their furry companions. Dog park hours are 7:00 am to sunset daily. For more information: (972) 941-7250; www.planoparks.org.

Directions: Located at Bluebonnet Trail near its intersection with Chisholm Trail in the central part of Plano. Parking is available along Pleasant Valley Drive and off-street parking at Jack Carter Park.

Note: Dogs should always be leashed outside of the Off-Leash area.

ENFIELD PARK - Leashes

Info: Get your daily dose of Texercise as you mosey with Rosey along the 1.6-mile trail.

Directions: Located on the south side of Legacy Drive just after Alma Drive.

EVANS PARK - Leashes

Info: Make your own way on the short trail in this attractive woodsy region. Or pack a tennie and get an adoring look from the ballmeister.

Directions: Located at 15th Street and Independence Parkway.

HOBLITZELLE PARK - Leashes

Info: Take advantage of the 2.7-mile trail and stay in shape or make your own tracks creekside in this beautiful 145-acre area. Pack a picnic and repast waterside or find a grassy knoll to call your own and do lunch the outdoor way.

Directions: The park can be accessed from Hedgecoxe Road or Legacy Drive between Custer Road and Alma Drive.

HORSESHOE PARK - Leashes

Info: Visit this park in early morning or late evening and treat your pal to a quiet saunter through 9 acres.

Directions: Located a half mile south of Spring Creek Parkway between Independence Parkway and Custer Road.

LONE STAR PARK - Leashes

Info: Get mellow with your fellow in this lovely urban oasis or wag your pup's tail by leading him along the trail.

Directions: Located off the Bluebonnet Trail between Coit Road and Independence Parkway.

SCHELL PARK - Leashes

Info: If green is your scene, then this 31-acre region is the place for you. Play tagalong with your wagalong through woodsy acres or plan lunch alfresco on the soft grass. Whatever your pleasure, you're sure to find it here.

Directions: Located off Jupiter between Parker Road and Park Boulevard.

Locate Other Dog-Friendly Activities...Check Nearby Cities

SHAWNEE PARK - Leashes

Info: Bowser will be thrilled to accompany you as you throw a round of disc golf on the 18-hole course. If frisbee's not your thing, there's a one miler that enhances your exercise options in this pleasant park.

Directions: Located on the north side of Parker Road between Avenue K and Jupiter.

STEEPLECHASE PARK - Leashes

Info: Don't forget to pack a fun attitude along with a biscuit basket when you and the pupster plan an outing in this 18-acre expanse.

Directions: Located a half mile south of Park Boulevard between Ventura and Parkwood Boulevard.

STEINDHAM PARK - Leashes

Info: For a doggone terrific afternoon, take the lickmeister to this neighborhood park.

Directions: Located a quarter mile west of the Preston Ridge Trail between Hedgecoxe Road and Legacy Drive.

TEJAS PARK - Leashes

Info: Lollygag with your lucky dog at this 11-acre urban green scene.

Directions: Located a quarter mile east of Alma Drive, just before the intersection of Alma Drive and Hedgecoxe Road.

WOODRUFF PARK - Leashes

Info: This massive expanse offers one great way to get away from it all in a beautiful setting. Pack the pup's basket, lace up those tennies and get pumped for a day of play. A quickie education awaits along the interpretive trail as well.

Directions: Access points are all along Shiloh Road.

Hotel Pet Policies May Be Subject To Change

OTHER PARKS IN PLANO - Leashes

For more information, contact the Plano Parks & Recreation Department at (972) 941-7250.

- ARROWHEAD PARK, off Ohio Drive
- BIG LAKE PARK, between Parker Road & Spring Creek Pkwy
- BLUE RIDGE PARK, off Blue Ridge Trail between Custer Road & Alma Drive
- CADDO PARK, intersection of Parker Road, Park Boulevard, Custer Road & Independence Parkway
- CLEARVIEW PARK, intersection of Highway 75, Alma Drive, Parker Road & Spring Creek Parkway
- HACKBERRY PARK, 1/4 mile north of 15th Street between Custer Road & Alma Drive
- INDIAN CREEK PARK, just south of Parker Road between Midway Road & Marsh Lane
- LIBRARY SPORTS FIELD, 14th Street & Park Boulevard
- LONGHORN PARK, 1/4 mile south of 15th Street between Coit Road and Independence Parkway
- PRAIRIE MEADOW PARK, off Parkway just south of Hedgcoxe Road
- RUSTIC PARK, Park Boulevard & Custer Road
- SHOSHONI PARK, off 14th Street 1/2 mile west of Shiloh Road
- WAGON WHEEL PARK, off Bluebonnet Trail, 1/4 mile west of Alma Drive
- WESTWOOD PARK, off Plano Parkway at the northwest tip of Overland Trail
- WINDHAVEN PARK, off Parker Road 1/4 mile east of Parkwood Boulevard

PORT ARANSAS

LODGING

BEACH HOUSE RENTALS
2122 On The Beach (78373)
Rates: $135-$250
(361) 749-5434

BELLE'S INN MOTEL
710 S Station (78373)
Rates: $35-$65
(361) 749-6138

HARBORVIEW MOTEL
121 W Cotter (78373)
Rates: $35
(361) 749-6391

LONE PALM MOTEL
306 S Alister (78373)
Rates: $28-$80
(361) 749-5450

PARADISE ISLE MOTEL
314 Cutoff Rd (78373)
Rates: $40
(361) 749-6993

ROCK COTTAGES
603 E Ave G (78373)
Rates: $39-$45
(361) 749-6360

SEA HORSE LODGE
503 E Ave G (78373)
Rates: $65-$95
(361) 749-5513

SEA & SANDS COTTAGES
410 10th St (78373)
Rates: $65-$110
(361) 749-5191

SEASIDE MOTEL
841 Sandcastle Dr (78373)
Rates: $39-$180
(361) 749-4105; (800) 765-3101

SUNDAY VILLAS
1900 S 11th St (78373)
Rates: $70
(361) 749-6113

TROPIC ISLAND MOTEL
315 Cutoff Rd (78373)
Rates: $55-$105
(361) 749-6128

RECREATION

MUSTANG ISLAND STATE PARK - Leashes

Info: Give your canine connoisseur something to bark home about with a voyage to this beautiful region. You and Sandy can savor the shoreline and enjoy the sunshine in this vast, 3,900-acre park situated on the south end of Mustang Island. The dunes are sometimes as tall as 35 feet, but the winds and tides are constantly changing these sand formations. Please keep furface away from designated swimming areas and avoid the temptation to let the pooch run free - it's too easy to

Hotel Pet Policies May Be Subject To Change

lose sight of him in this duney area. For more information: (361) 749-5246; (800) 792-1112; www.tpwd.state.tx.us.

Directions: From Port Aransas, take State Highway 361 south (Park Road 53) 14 miles to park entrance.

Note: Entrance fee charged.

PORT ARANSAS PARK - Leashes

Info: Anglers will love this 167-acre park where a lighted pier and drop-in spots offer many opportunities to try your luck. Or forget your fishy dreams and take a walk along the grounds of this beautiful region. For more information: (361) 749-6117.

Directions: Located on the northernmost point of Mustang Island on the outskirts of the City of Port Aransas.

PORT ARTHUR

LODGING

RAMADA INN
3801 Hwy 73 (77642)
Rates: $55-$69
(409) 962-9858; (800) 272-6232

STUDIO 6 MOTEL
3000 Jimmy Johnson Blvd (77642)
Rates: $55-$65
(409) 729-6611; (888) 897-0202

RECREATION

SEA RIM STATE PARK - Leashes

Info: Birdwatching, picnicking and surf fishing are the main attractions in this gulfside park. Listen to the waves lap against the shore or pound the ground with the hound along the trailway. For more information: (409) 971-2559; (800) 792-1112; www.tpwd.state.tx.us.

Directions: From Port Arthur, take Highway 87 southwest approximately 23 miles to the park's Beach Unit entrance.

Note: $2 entrance fee/person.

Locate Other Dog-Friendly Activities...Check Nearby Cities

The numbered hike that follows is within Sea Rim State Park:

1) GAMBUSIA NATURE TRAIL HIKE - Leashes
Beginner/0.7 miles

Info: Your pooch will jump at the chance of joining you on this educational jaunt. The nature trail covers the 3 basics, it's short, simple and scenic. As you stroll through the marshlands via an elevated boardwalk, be alert for the dens of nutria and muskrat and for the trail's namesake - 2-inch-long gambusia fish. Wildlife enthusiasts, don't miss the three wildlife observation rest stops. Add to your nature experience by picking up a trail guide, the boardwalk is equipped with numbered posts that correspond with the pamphlet. For more information: (409) 971-2559.

Directions: From Port Arthur, take Highway 87 southwest approximately 23 miles to the park's Beach Unit entrance.

PORT ISABEL

LODGING

FAMILY COURTS & MARINA
133 Bridge St (78578)
Rates: n/a
(956) 943-7881

YACHT CLUB HOTEL
700 Yturria St (78578)
Rates: $39-$102
(956) 943-1301

SOUTHWIND INN
600 Davis St (78578)
Rates: $40-$120
(956) 943-3392

PORT LAVACA

LODGING

BEST WESTERN PORT LAVACA INN
2202 N I-35 (77979)
Rates: $59-$87
(361) 553-6800; (800) 528-1234

Hotel Pet Policies May Be Subject To Change

PORT MANSFIELD

<u>LODGING</u>
CASA GRANDE MOTEL/RV PARK
1144 S Port Dr (78598)
Rates: $50-$200
(956) 944-2182

PORTLAND

<u>LODGING</u>
COMFORT INN
1703 N Hwy 181 (78374)
Rates: $47-$75
Tel: (361) 643-2222; (800) 221-2222

POST

<u>LODGING</u>
RIATA INN
N Hwy 67 (79788)
Rates: $40-$70
(432) 229-2528

PRESIDIO

<u>RECREATION</u>
FORT LEATON STATE HISTORICAL PARK - Leashes

Info: Regarded as one of the most scenic highway routes in the southwest, the road to Fort Leaton is indeed a lovely drive. Perched on the edge of an alluvial terrace above the Rio Grande, the Fort is a pleasant and pretty leg-stretching spot for you and your wagalong. Pick up a pamphlet and have a friendly chat with the well-informed staff members. You'll come away from the excursion significantly more knowledge-able about the region which is steeped in history, folklore and

Locate Other Dog-Friendly Activities...Check Nearby Cities

tales of mayhem, murder and intrigue. For more information: (432) 229-3613; (800) 792-1112; www.tpwd.state.tx.us.

Directions: Located 4 miles southeast of Presidio off FM 170 (River Road).

Note: Dogs are not allowed in buildings. $2 entrance fee.

QUANAH

LODGING

CASA ROYALE INN
1500 W 11th St (79252)
Rates: n/a
(940) 663-6341

QUANAH PARKER INN
1415 W 11th St (79252)
Rates: $29-$43
(940) 663-6366

RECREATION

COPPER BREAKS STATE PARK - Leashes

Info: Tote your own H_2O, we're talking primitive trails. Copper Breaks is an incredible combination of geology, serenity and wildlife. Shake a leg on the trail and prepare yourself for an unforgettable day in the great outdoors. Afishionados, there's something fishy at this stocked lake namely, catfish, bass and perch, Naturalists can partake of a self-guided tour along an interpretive trail. For more information: (940) 839-4331; (800) 792-1112; www.tpwd.state.tx.us.

Directions: From Quanah, take Highway 6 south for 13 miles to the park entrance.

Note: $2 entrance fee/person.

The numbered hikes that follow are within Copper Breaks State Park:

1) BULL CANYON TRAIL HIKE - Leashes

Beginner/3.0 miles

Info: This trail is actually two in one, a short and a long loop. Mellow mutts will prefer the easy one-miler - it's smooth strutting all the way. Canyon canines will prefer the 2-mile loop that laces through woodlands and the picturesque rugged terrain of Bull Canyon. Heartier hounds - go for the gold and do both. For more information: (940) 839-4331.

Directions: From Quanah, take Highway 6 south for 13 miles to the park entrance. The trailhead is located at the south edge of Lake Copper Breaks on the east shore.

2) JUNIPER RIDGE NATURE TRAIL HIKE - Leashes

Beginner/0.5 miles

Info: You and Old Brown Eyes can learn as you turn around this easy looping trail. Pick up a descriptive trail guide from park headquarters and then do an educational stroll from one numbered post to the next. For more information: (940) 839-4331.

Directions: From Quanah, take Highway 6 south for 13 miles to the park entrance. The trailhead is located at the south edge of Lake Copper Breaks on the east shore.

QUEEN CITY

LODGING

EXPRESS INN
301 Hwy 59 (75572)
Rates: $36-$55
(903) 796-7195

QUITAQUE

RECREATION

CAPROCK CANYONS STATE PARK & TRAILWAY - Leashes

Info: A memorable day is in the making when you plan an excursion to this Edenesque slice of Mother Nature. Formed by powerful geologic forces, the canyon separates the table-lands of the Southern High Plains from the easterly Rolling Plains. Stark contrasts of white and red rock create a stunning panorama for you and the dawgus to peruse. Get some R&R in the shade of a Mohrs oak. Or get the lead out on one of the trails that lace the woodlands. Lake Theo and numerous streambeds will answer your wet wagger's dreams. Don't forget to pack the binoculars, the canyon is a haven to many species of furry and feathered friends. Pack a biscuit basket and spend the day. Ahh! Two paws up for this outing. For more information: (806) 455-1492; (800) 792-1112; www.tpwd.state.t.x.us.

Directions: From Quitaque, head north on FM 1065 for 3 miles to the park entrance.

Note: $2 entrance fee/person.

The numbered hikes that follow are within Caprock Canyons State Park:

1) EAGLE POINT TRAIL HIKE - Leashes

Intermediate/4.0 miles

Info: If your woofer's a hoofer, put this trail at the top of your wish list and ready yourself to rack up some tough hiking miles. You'll cram your RAM with primitive beauty on this trek through scenic and rugged badlands country - a place where beauty has its price. Tote lots of agua fria, mucho munchies and an adventurous spirit. For a little wet and wild fun, take an R&R moment and treat the dog to some splish-splashing antics at the lake. Pack a camera and lots of Fuji, you'll want to remember the day. For more information: (806) 455-1492.

Hotel Pet Policies May Be Subject To Change

Directions: From Quitaque, head north on FM 1065 for 3 miles to the park entrance. The trailhead is accessed from the day-use area at Lake Theo.

2) LOWER CANYON TRAIL HIKE - Leashes
Intermediate/5.0 miles

Info: This high energy trail leads you on a yoyo-like journey through postcardian red rock canyons. You and your Herculean hound should be prepared for some rock hopping; the trail passes through the badlands and crosses several arroyos. Depending upon the season's rainfall, the arroyos may provide some dirty dog shenanigans for you and the wet wagger. By trail's end, your legs may feel like jello, but you'll feel like a champ. The trail lacks an abundance of shade so top off your water bottles before heading out, especially in the hotter months. Trail mix might give you the extra boost this hike requires. For more information: (806) 455-1492.

Directions: From Quitaque, head north on FM 1065 for 3 miles to the park entrance. The trailhead is accessed from the main parking area.

3) UPPER CANYON TRAIL HIKE - Leashes
Expert/6.0 miles

Info: Definitely not for the fair of paw, this odyssey promises and delivers a first-class workout. As you and your hardy hoofer ascend and descend South Prong and North Prong Canyons, you'll collect memorable views of the red rocks and surrounding landscape - talk about Kodak moments. In addition to typical badlands vegetation, the trail passes through canyons that are lined with cottonwoods, oaks and Rocky Mountain junipers. As with the other trails in the area, shade is scarce so bring lots of agua fria. Visit in the fall for a sparkling splash of autumn colors. For more information: (806) 455-1492.

Directions: From Quitaque, head north on FM 1065 for 3 miles to the park entrance. The trailhead is accessed from the main parking area.

QUITMAN

RECREATION

GOVERNOR HOGG SHRINE HISTORIC SITE - Leashes

Info: Dollars to dog biscuits, you and the lickmeister are gonna love a visit to this 26-acre park. Sun-dappled and tree-strewn, you'll find lots of shaded areas where a bit of R&R awaits. This place is definitely for the birds, so tote those binocs, you won't be disappointed. There's even a .5-mile nature course for a peanut dose of Texercise. Pack a biscuit basket, find a cozy spot and break bread with Bowser at day's end. Bone appetite. For more information: (903) 763-0405; (800) 792-1112; www.tpwd.state.tx.us.

Directions: From Quitman, follow Highway 37 about 6 blocks south of the Wood County Courthouse to the park entrance.

Note: Entrance fee charged.

The numbered hike that follows is within Governor Hogg Shrine Historic Site:

1) OLD SETTLERS NATURE TRAIL HIKE - Leashes

Beginner/0.5 miles

Info: Short, sweet and shaded, this interpretive trail is a favorite with couch slouches and hot diggety dogs. As you stroll under a canopy of pine, oak, cedar and elm, expand your knowledge of the native flora by reading the corresponding trail guide. For more information: (903) 763-0405.

Directions: From Quitman, follow Highway 37 about 6 blocks south of the Wood County Courthouse to the park entrance.

RANGER

LODGING

DAYS INN
I-20 Ex 349,
Box 160-C (76470)
Rates: $50-$69
(254) 647-1176; (800) 329-7466

RANKIN

LODGING

RIATA INN
509 E Hwy 67 (79778)
Rates: $40-$70
(432) 693-2300

RAYMONDVILLE

LODGING

BEST WESTERN EXECUTIVE INN
118 N Expwy 77 (78580)
Rates: $59-$89
(956) 689-4141; (800) 528-1234

RICHARDSON

LODGING

HAMPTON INN
1577 Gateway Blvd (75080)
Rates: $59-$89
(972) 234-5400; (800) 426-7866

HOMESTEAD STUDIO SUITES
901 E Campbell Rd (75080)
Rates: $64-$79
(972) 479-0500; (800) 782-9473

RENAISSANCE HOTEL
900 E Lookout Dr (75082)
Rates: $139-$270
(972) 367-2000; (800) 468-3571
(800) 228-9290

RESIDENCE INN BY MARRIOTT
1040 Waterwood Dr (75081)
Rates: $99-$159
(972) 669-5888; (800) 331-3131

Locate Other Dog-Friendly Activities...Check Nearby Cities

RICHMOND

LODGING

EXECUTIVE INN
26035 Southwest Frwy (77469)
Rates: $35-$45
(281) 342-5387

RECREATION

BRAZOS BEND STATE PARK - Leashes

Info: If you're into wildlife watching, look no further than this park. More than 270 species of birds flutter about the skies while 21 species of reptiles and 23 species of mammals slither and scurry on the terra firma. You and the hiking hound can traipse over 21 miles of trails or do the lazy day thing and break bread beneath the shade of an enormous, moss-draped oak. Seven lakes and two rivers run through the region, home to many fishing dreams. But use caution, this is gator country. Pick up a brochure at park headquarters and practice "alligator etiquette." For more information: (979) 553-5101; (800) 792-1112; www.tpwd.state.tx.us.

Directions: From Richmond, take FM 762 southeast approximately 20 miles to the park.

Note: $3 entrance fee/person. As a safety precaution, please follow these park rules:
1) Do not enter the water or let your dog off his leash, alligators abound.
2) Do not let your dog drink the water (carry your own water).
3) Do not venture off unmarked trails.

The numbered hikes that follow are within Brazos Bend State Park:

1) CREEKFIELD LAKE NATURE TRAIL HIKE - Leashes
Beginner/0.5 miles

Info: Take a little time and get a little smarter. One turnabout on this nature trail and you'll come away with newfound knowledge of the flora and fauna of the Texas wetlands. And while you're at it, you and the dawgus will be squeezing a little exercise into your day. For more information: (979) 553-5101.

Hotel Pet Policies May Be Subject To Change

Directions: From Richmond, take FM 762 southeast approximately 20 miles to the park.

Note: Keep dogs leashed and away from water, alligators abound.

2) ELM LAKE TRAIL HIKE - Leashes

Beginner/1.7 miles

Info: This cinchy trail leads you and furface through hardwood forests to the trail's destination - Elm Lake. Along the route, you'll pass numerous raised viewing platforms where bird and alligator watching is the #1 pastime. Speaking of alligators, this lake is a favorite hangout for these ancient reptiles. They sun on the lake's banks and float lazily in the water with only their eyes and noses showing. Keep Fido's leash taut and keep your distance. Gators are fierce predators. If you want to extend your outing, hightail it to the short .7-mile connector trail across the levee to Forty-Acre Lake. For more information: (979) 553-5101.

Directions: From Richmond, take FM 762 southeast approximately 20 miles to the park.

Note: Keep dogs leashed and away from water, alligators abound.

3) FORTY-ACRE LAKE LOOP TRAIL HIKE - Leashes

Beginner/1.2 miles

Info: Bring a sense of wonder along on this excursion through hardwood bottomlands and freshwater marshes. The trail follows a relatively flat course to Forty-Acre Lake. Birdwatchers and shutterbugs won't want to miss the 30-foot observation tower where the views from the top are the best in the park. Hook up with the short .7-mile connector trail across the levee to Elm Lake and take a peek at another section of this unusual region. For more information: (979) 553-5101.

Directions: From Richmond, take FM 762 southeast approximately 20 miles to the park.

Note: Keep dogs leashed and away from water, alligators abound.

Locate Other Dog-Friendly Activities...Check Nearby Cities

4) HALE LAKE TRAIL HIKE - Leashes

Beginner/1.6 miles

Info: For a doggone terrific journey, try this simple trail through lush hardwood forests to horseshoe-shaped Hale Lake. Park your barker under a moss-draped live oak and do lunch alfresco before retracing your steps. FYI, the fishing pier/viewing platform allows you a look-see at the park's most famous residents, the American alligator. For more information: (979) 553-5101.

Directions: From Richmond, take FM 762 southeast approximately 20 miles to the park.

Note: Keep dogs leashed and away from water, alligators abound.

5) PILANT SLOUGH TRAIL HIKE - Leashes

Beginner/2.0 miles

Info: Treat your hoofer to a pleasant jaunt through a dense forest of cottonwood, black willow, sycamore, hickory and sweetgum. The trail skirts Pilant Slough and ends at Elm Lake. If you have the time, take the 1.7-mile loop around the lake; otherwise, turn the hound around and retrace your steps. For more information: (979) 553-5101.

Directions: From Richmond, take FM 762 southeast approximately 20 miles to the park.

Note: Keep dogs leashed and away from water, alligators abound.

ROANOKE

LODGING

COMFORT SUITES
801 Byron Nelson Blvd (76262)
Rates: $69-$300
(817) 490-1455; (800) 228-5150

SPEEDWAY SLEEP INN & SUITES
13471 Raceway Dr (76262)
Rates: $60-$90
(817) 491-3120; (800) 753-3746

Hotel Pet Policies May Be Subject To Change

ROBSTOWN

LODGING

DAYS INN
320 Hwy 77 S (78380)
Rates: $45-$100
(361) 387-9416; (800) 329-7466

ROCKPORT

LODGING

ANCHOR MOTEL
1114 E Market (78382)
Rates: $40-$60
(361) 729-3249

ANTHONY'S BY THE SEA B&B
732 S Pearl St (78382)
Rates: $75-$95
(361) 729-6100; (800) 460-2557

HOLIDAY LODGE MOTEL
1406 I-35 N (78382)
Rates: $34-$40
(361) 729-3433

HUNT'S CASTLE-WATERFRONT
725 S Water St (78382)
Rates: $85-$169
(361) 729-5002; (888) 345-4868

KEY ALLEGRO ISLAND CONDO RENTALS
1798 Bayshore (78382)
Rates: $125+
(361) 729-2333; (800) 348-1627

KONTIKI BEACH RESORT
2290 N Fulton Beach Rd (78382)
Rates: $55-$205
(361) 729-4975; (800) 388-0649

LAGUNA REEF CONDO HOTEL-ON THE BAY
1021 Water St (78382)
Rates: $80-$350
(361) 729-1742; (800) 248-1057

OCEAN VIEW MOTEL
1131 S Water St (78382)
Rates: $35-$65
(361) 729-3326

ROCKPORT INN
813 S Church St (78382)
Rates: $40
(361) 729-9591

ROD AND REEL MOTEL
1105 E Market St (78382)
Rates: $31-$54
(361) 729-2028; (888) 729-2028

SANDOLLAR RESORT MOTEL & RV PARK
919 N Fulton Beach Rd (78382)
Rates: $44-$59
(361) 729-2381

SANDRA BAY COTTAGES
1801 Broadway (78382)
Rates: $45+
(361) 729-6257

Locate Other Dog-Friendly Activities...Check Nearby Cities

SEAVIEW MOTEL
1155 I-35 N (78382)
Rates: $35-$55
(361) 729-9112

THE VILLAGE INN MOTEL
503 N Austin St (78382)
Rates: $55-$120
(361) 729-6370; (800) 338-7539

SUN-TAN MOTEL
1805 Broadway (78382)
Rates: $39-$60
(361) 729-2179

RECREATION

DEMO GARDEN AND WETLANDS POND - Leashes

Info: For a touch of serenery, wander with your wagalong to this nature wonderland. The garden and pond comprise a community-based project with a two-fold purpose: to promote plants as indispensible natural resources and to develop and maintain cost efficient landscapes that provide food for birds. Talking about food, plan ahead and pack a biscuit basket for lunch alfresco. For more information: (361) 729-6445.

Directions: Located at the rest area of the Texas Department of Transportation just north of Rockport on Highway 35.

GOOSE ISLAND STATE PARK - Leashes

Info: Binoculars are a definite bonus in this 314-acre park where birdwatching is the numero uno activity. Not only can you view waterfowl, shore birds and passerines, but you just might catch a glimpse of an endangered whooping crane. As a side diversion, check out the famed "Big Tree." This huge spreading oak has survived the elements for over 1,000 years. Or bring your line, the fishing's fine. For more information: (361) 729-2858; (800) 792-1112; www.tpwd.state.tx.us.

Directions: From Rockport, take Highway 35 north for 10 miles to Park Road 13. Head east on Park Road 13 for 2 miles to the park entrance.

Note: $2 entrance fee/person.

The numbered hike that follows is within Goose Island State Park:

Hotel Pet Policies May Be Subject To Change

1) GOOSE ISLAND NATURE TRAIL HIKE - LEASHES
Beginner/2.0 miles

Info: For a delightful, feel good journey, boogie with Bowser across the bridge and check out this cinchy nature trail. As you prance through the oak-redbay forest, keep an ear out for the trail's resident musicians. For more information: (361) 729-2858.

Directions: From Rockport, take Highway 35 north for 10 miles to Park Road 13. Head east on Park Road 13 for 2 miles to the park entrance.

ROCKWALL

LODGING
SUPER 8 MOTEL
1130 I-30 (75087)
Rates: $44-$55
(972) 722-9922; (800) 800-8000

ROMA

RECREATION
FALCON STATE PARK - Leashes

Info: This delightfully diverse region offers a little something for everyone. You and the gadabout can roam about the rolling hills and step lively through thickets of mesquite, huisache, ebony, wild olive, cactus and native grasses. Or make your fishy dreams come true at the reservoir where black and white bass, catfish, crappie and stripers are sure to provide a satisfying catch. Birders, tote your binoculars, you won't be disappointed either. For more information: (956) 848-5327; (800) 792-1112; www.tpwd.state.tx.us.

Directions: From Roma, take Highway 83 north for 13 miles, following the signs to Falcon Reservoir. Access is off Park Road 46.

Locate Other Dog-Friendly Activities...Check Nearby Cities

The numbered hikes that follow are within Falcon State Park:

1) NATURE TRAIL HIKE #1 - Leashes

Beginner/1.0 miles

Info: Interpretive signs and trail benches are just two of the highlights of this simple trail. Even couch slouches will enjoy this pleasant stroll through nature. For more information: (956) 848-5327.

Directions: From Roma, take Highway 83 north for 13 miles, following the signs to Falcon Reservoir. Access is off Park Road 46.

2) NATURE TRAIL HIKE #2 - Leashes

Beginner/0.5 miles

Info: This mini nature trail spells easy from the get-go. Birders, bring your binocs and espy what's a-fly. Many species call this park home. For more information: (956) 848-5327.

Directions: From Roma, take Highway 83 north for 13 miles, following the signs to Falcon Reservoir. Access is off Park Road 46.

ROSENBERG

LODGING

HOLIDAY INN EXPRESS HOTEL & SUITES
27927 SW Freeway (77471)
Rates: $69-$89
(281) 342-7888; (800) 465-4329

Hotel Pet Policies May Be Subject To Change

ROTAN

<u>Recreation</u>

ROTAN CITY PARK - Leashes

Info: Keep Fido in shape by taking him for a jaunt on the one-mile fitness trail that skirts the golf course.

Directions: Located on Sammy Ball Avenue.

ROUND ROCK

<u>Lodging</u>

AMERISUITES
2340 I-35 N (78681)
Rates: $69-$139
(512) 733-2599; (800) 833-1516

BAYMONT INN & SUITES
150 Parker Dr (78728)
Rates: $74-$129
(512) 246-2800; (800) 301-0200

BEST WESTERN EXECUTIVE INN
1851 N I-35 (78664)
Rates: $55-$79
(512) 255-3222; (800) 528-1234
(888) 821-5578

CANDLEWOOD SUITES
521 S I-35 (78664)
Rates: $64-$109
(512) 828-0899; (800) 465-4329

DAYS INN & SUITES
1802 I-35 S (78681)
Rates: $49-$89
(512) 246-0055; (800) 329-7466
(877) 295-3189

LA QUINTA INN
2004 I-35 N (78681)
Rates: $70-$90
(512) 255-6666; (800) 687-6667

RED ROOF INN
1990 N I-35 (78681)
Rates: $42-$77
(512) 310-1111; (800) 843-7663

RESIDENCE INN BY MARRIOTT
2505 S I-35 (78664)
Rates: $89-$119
(512) 733-2400; (800) 331-3131

STAYBRIDGE SUITES
520 I-35 S (78681)
Rates: $109-$179
(512) 733-0942; (800) 238-8000

WINGATE INN
1209 N I-35 (78664)
Rates: $69-$125
(512) 341-7000

ROUND TOP

<u>LODGING</u>

ROUND TOP INN BED & BREAKFAST
102 Bauer Rummell (78954)
Rates: $95-$145
(979) 249-5294
(888) 356-8946

RUSK

<u>RECREATION</u>

JIM HOGG HISTORICAL SITE - Leashes

Info: Dedicated to Texas' first native-born governor, this lovely park is an ideal setting for a leisurely afternoon. Sunday stroll through dense stands of shady trees or dine with your canine at a secluded picnic spot. The replica of Hogg's birthplace is a fine example of a southern "dog-run" house. Atop a hill on the nature trail, an interpretive display explains the strip mine beneath you. For more information: (903) 683-4850; (800) 792-1112; www.tpwd.state.tx.us.

Directions: From Rusk, take Highway 84 east for 2 miles to the park.

Note: Park is closed on Tuesday and Wednesday. Entrance fee charged.

The numbered hike that follows is within Jim Hogg Historical Site:

1) MOUNTAIN HOME NATURE TRAIL HIKE - Leashes

Beginner/1.5 miles

Info: When you crave serenity and an easy-does-it trail, you can't go wrong with this outing. As you and furface saunter along the gentle terrain, you'll find yourselves ensconced in a lush forest of oak, pine, redbud and dogwood. Savor the shade, the whisper-quiet surroundings and the beautiful hilltop vistas before calling it a day. Visit in springtime when the dogwood blooms accentuate the lush greenery. Two paws up for this one. For more information: (903) 683-4850.

Directions: From Rusk, take Highway 84 east for 2 miles to the park.

RUSK AND PALESTINE STATE PARKS - Leashes

Info: These two train depots offer some quietude for you and the pooch. Between the delightfully cooling tree canopy and the hushed surroundings, you'll enjoy a sense of complete serenery. Rusk, the larger of the two, contains a 16-acre lake stocked with big mouth bass, catfish and trout in season. Both parks have cool, shaded grassy areas where you and the dogster can spread out the checkered cloth and do lunch. For more information: (903) 683-5126; (800) 792-1112; www.tpwd.state.tx.us.

Directions: Rusk Depot is located within the city limits of Rusk off Highway 84. Palestine Depot is located off Highway 84, 26 miles west of Rusk.

Note: Entrance fee charged.

The numbered hikes that follow are within Rusk and Palestine State Parks:

1) PALESTINE NATURE TRAIL HIKE - Leashes

Beginner/0.5 miles

Info: Three words describe this short trail - piece-of-cake. You'll walk in shaded splendor through a forested area of pines and hardwoods, loop around a pond and scamper across a footbridge before ending up where you began. For a quickie flora and fauna education, take some time to read the interpretive signs posted along the trail. For more information: (903) 683-5126.

Directions: This trail is found in the Palestine Depot, located off Highway 84, 26 miles west of Rusk.

2) RUSK NATURE TRAIL HIKE - Leashes

Beginner/0.25 miles

Info: You'll find yourself amidst shaded paths and gentle terrain on this mini-hike. A self-guided interpretive trail, you'll loop through lush pine woodlands, passing a bird blind and viewing area along the way. Pack your binocs and test your avian acumen. For more information: (903) 683-5126.

Locate Other Dog-Friendly Activities...Check Nearby Cities

Directions: This trail is found in the Rusk Depot, located within the city limits of Rusk off Highway 84.

SABINE NATIONAL FOREST

Sabine Ranger District
201 South Palm, Hemphill, TX 75948,
(409) 787-3870; (409) 787-2791; (866) 235-1750

Info: With over 160,000 acres of dense woodlands blanketing the terrain, the Sabine National Forest is a slice of heaven for hiking hounds and outdoor enthusiasts. Add to that the water wonderland of the 65-mile-long Toledo Bend Reservoir and you'll understand why Fido's tail is in overdrive. Encompassing over 137,000 acres, and marking the Texas/Louisiana state line, the adjacent reservoir guarantees aquapups hours of wet and wild fun. If you've got an electric motorboat, a flat-bottom boat or a canoe, you can float the day away. Sorry, no gasoline motored boats allowed. So, pick your pleasure from one of the numerous recreation areas and happy wet wagging to you. For more information: (409) 787-3870.

Directions: The forest lies within the boundaries of Jasper, Sabine, San Augustine, Newton and Shelby counties and is easily accessible via Highways 21, 103 and 87. Refer to specific directions following each recreation area and hiking trail.

For more information on recreation in the Sabine National Forest, see listings under the following cities: Center and Hemphill.

SABINE PASS

<u>RECREATION</u>
SABINE PASS BATTLEGROUND STATE PARK & HISTORIC SITE -
Leashes
Info: Constructed to honor the courage of a handful of Texas war heroes, Sabine Pass is a pleasant place for an afternoon

interlude. Wander along the .25 miles of shoreline or try your fly for a fishy dinner. Marvel at the monument and be haunted by the barracks as you ponder the historical significance of the park. Ensconced on 56 acres of stunning scenery, numerous places beckon you and Bowser to browser. For more information: (409) 971-2559; (409) 971-2451; (800) 792-1112; www.tpwd.state.tx.us.

Directions: Take Dowlen Road south for 1.5 miles to park entrance.

SAM HOUSTON NATIONAL FOREST

Sam Houston Ranger District
394 FM 1375 West, New Waverly, TX 77358,
(936) 344-6205; (888) 361-6908

Info: Over 160,000 acres of alluring serenity are yours for the taking at this national forest named for the father of Texas-Sam Houston. No tour of Texas would be complete without a visit to this delightful woodland. So leave your cares and woes in the city and let the good times roll. It doesn't matter what tickles your fancy, it's all here. Play tagalong with your wagalong as you journey on the picturesque Lone Star Hiking Trail. Be a lazy bones and vege out under a shade tree in a hidden copse where the air is deliciously pine-scented. Or if water sports are more your speed, tote your boat, pack your gear, and set your sights on 21,000-acre Lake Conroe and 82,600-acre Lake Livingston (gasoline-powered boats are not permitted). Pick your pleasure and then go for it. There's nothing to stop you and furface from having one helluva a good day. Carpe diem Duke. For more information: (936) 344-6205.

Directions: The forest lies within the boundaries of Montgomery, San Jacinto and Walker Counties and is easily accessed via Interstate 45 and Highways 150, 190 and 156.

Locate Other Dog-Friendly Activities...Check Nearby Cities

Refer to specific directions following each recreation area and hiking trail.

For more information on recreation in the Sam Houston National Forest, see listings under the following cities: Coldspring, Conroe, Houston, Huntsville, New Waverly and Shepherd.

SAN ANGELO

LODGING

BENCHMARK COMFORT INN
2502 Loop 306 (76904)
Rates: $70-$105
(325) 944-2578

BEST WESTERN SAN ANGELO
3017 W Loop 306 (76904)
Rates: $65-$75
(325) 223-1273; (800) 528-1234

DAYS INN
4613 S Jackson (76903)
Rates: $45-$75
(325) 658-6594; (800) 329-7466

EL PATIO MOTEL
1901 W Beauregard St (76901)
Rates: $25-$40
(325) 655-5711; (800) 677-7735

EXECUTIVE INN & SUITES
4205 S Bryant Blvd (76903)
Rates: $48-$75
(325) 653-6966

HOLIDAY INN CONVENTION CENTER HOTEL
441 Rio Concho Dr (76903)
Rates: $109-$169
(325) 658-2828; (800) 465-4329

HOWARD JOHNSON
415 W Beauregard St (76901)
Rates: $54-$65
(325) 653-2995; (800) 446-4656

INN OF THE CONCHOS
2021 N Bryant Blvd (76903)
Rates: $59-$89
(325) 658-2811; (800) 621-6041

LA QUINTA INN
2307 Loop 306 (76904)
Rates: $54-$91
(325) 949-0515; (800) 687-6667

MOTEL 6
311 N Bryant Blvd (76903)
Rates: $34-$52
(325) 658-8061; (800) 466-8356

SANTA FE JCT MOTOR INN
410 W Ave L (76903)
Rates: $29-$60
(325) 655-8101; (800) 634-2599

SUPER 8 MOTEL
1601 S Bryant Blvd (76903)
Rates: $44-$57
(325) 653-1323; (800) 800-8000

<u>RECREATION</u>

CIVIC LEAGUE PARK - Leashes

Info: There's something remarkably soothing in the contemplation of a lily pond. It's quiet beauty represents a romantic and tranquil era. If you and your canine connoisseur are partial to ponds, you won't want to miss an excursion to the International Water Lily Collection, a focal point of this lovely park. The pond boasts water lilies from around the world, including rare and near extinct species. But the gem of all lilies is "Victoria," the world's largest water lily. Pads spanning eight feet in diameter make a visit to the park unforgettable. This lily blooms daily at dusk, so plan accordingly. To enhance the splendor of your outing even more, visit from March through September, between 10:30 am and 2:30 pm for primo blooming time. For more information: (325) 653-1206.

Directions: Located at West Beauregard and N. Park Streets.

CONCHO RIVER WALK - Leashes

Beginner/9.0 miles

Info: Skirting the Concho River, this trail escorts you and the pupster through sections of San Angelo that comprise the best of this charming town. You'll traverse landscaped parks and aesthetically pleasing manicured gardens. Take some time to smell the flowers that color the path along the way. FYI- the shade that cools you on your journey is compliments of the massive pecan trees. Pretty waterfalls and noteworthy riverside homes also add to the allure of this interesting and inviting walk. For more information: (325) 653-1206.

Directions: Concho Street provides many access points to the river walk. Also accessible from Highway 87 by exiting at Park Drive.

FORT CONCHO NATIONAL HISTORIC LANDMARK - Leashes

Info: Military mutts will salute this 40-acre historic army post. Recognized at Texas' best preserved Indian Wars frontier fort, you'll find 23 original and restored buildings, including

Headquarters, Officers' Quarters, Soldiers' Barracks, the Chapel and the Hospital. The fort is popular with local canines, so be prepared to meet and greet other four-pawed buddies. For more information: (325) 481-2646; (325) 657-4444.

Directions: Located at 630 S. Oakes Street.

Note: Entrance fee charged. Hours: Tuesday - Saturday 10-5, Sundays 1-5.

SAN ANGELO STATE PARK - Leashes

Info: A birdwatcher's delight, San Angelo State Park harbors some 300 species of feathered fellows as well as 50 species of mammals. Laden with shade trees and spacious open areas, the parkland is a great place to spend the day with Tex. Happy tails to you. For more information: (325) 949-4757; (800) 792-1112; www.tpwd.state.tx.us.

Directions: The park is located on O.C. Fisher Reservoir, adjacent to San Angelo. Access the park entrance via FM 2288.

Note: $2 entrance fee/person.

The numbered hikes that follow are within San Angelo State Park:

1) NATURE/INTERPRETIVE TRAIL HIKE - Leashes
Beginner/1.0 miles

Info: Take your gadabout and do a roundabout on this gentle trail. As you dawdle through lush forests of mesquite, hackberry and juniper ashe, read the interpretive posts and come away a little smarter. For more information: (325) 949-4757.

Directions: The park is located on the O.C. Fisher Reservoir, adjacent to San Angelo. Access the park entrance via FM 2288.

2) SAN ANGELO HIKING TRAIL SYSTEM - Leashes
Beginner/Intermediate/Expert/1.0-50.0 miles

Info: This interconnecting trail system has something special for everyone. Spend hours or days exploring a wonderland of nature. Situated at the junction of four ecologic zones, the

Hotel Pet Policies May Be Subject To Change

High Plains, the Texas Hill Country, the Rolling Plains and the Trans-Pecos, the park offers visitors a smorgasbord of flora, wildlife and terrain that is truly worth a look-see. From lush woodlands to cactus clusters, hardwood bottomlands to mesquite brush, sun-splashed lakes to raging rivers, towering buttes and cliffs to low-lying creekbeds, you and the wagalong can experience it all. But unless you've packed the camping gear and plan to make a night of it, keep an eye on the time and allow enough daylight hours for your return trek. Don't forget the Perrier and plenty of high energy snacks. Bowwow! For more information: (325) 949-4757.

Directions: The park is located on the O.C. Fisher Reservoir, adjacent to San Angelo. Access the park entrance via FM 2288.

SAN ANTONIO

LODGING

A BASIC HOME- VACATION RENTAL
7423 Dell Oak (78218)
Rates $99-$195
(800) 227-5883

A BLANSETT BARN GUEST HOUSE
206 Madison St (78204)
Rates: $125-$250
(800) 221-1412

ALAMO TRAVELODGE-RIVERWALK
405 Broadway (78205)
Rates: $45-$149
(210) 222-1000; (800) 578-7878

ALOHA INN
1435 Austin Hwy (78209)
Rates: $40-$70
(210) 828-0933; (800) 752-6354

AMERISUITES AIRPORT
7615 Jones Maltsberger Rd (78216)
Rates: $69-$135
(210) 930-2333; (800) 833-1516

AMERISUITES NORTHWEST
4325 AmeriSuites Dr (78230)
Rates: $89-$129
(210) 561-0099; (800) 833-1516

AMERISUITES RIVERWALK
601 S. St. Mary's St (78205)
Rates: $109-$199
(210) 227-6854; (800) 833-1516

ANTONIO INN & SUITES
2131 N I-35 (78208)
Rates: $55-$165
(210) 354-2998

ARBOR HOUSE INN & SUITES B & B
109 Arciniega St (78205)
Rates: $95-$225
(210) 472-2005; (888) 272-6700

BEST WESTERN FIESTA INN
13535 I-10 W (78249)
Rates: $50-$130
(210) 696-2400; (800) 528-1234
(800) 662-9607

Locate Other Dog-Friendly Activities...Check Nearby Cities

BEST WESTERN INGRAM PARK INN
6855 NW Loop 410 (78238)
Rates: $50-$130
(210) 520-8080; (800) 528-1234
(888) 889-3444

BEST WESTERN LACKLAND INN & SUITES
6815 Hwy 90 W (78227)
Rates: $59-$120
(210) 675-9690; (800) 528-1234
(888) 227-2313

BEST WESTERN POSADA ANA INN-MEDICAL CENTER
9411 Wurzbach Rd (78240)
Rates: $67-$110
(210) 561-9300; (800) 528-1234

BEST WESTERN SHETLAND INN & SUITES
3602 SE Military Dr (78223)
Rates: $55-$95
(210) 798-5000; (800) 528-1234

BRACKENRIDGE HOUSE B&B
230 Madison St (78204)
Rates: $110-$200
(210) 271-3342; (800) 221-1412

BUDGET SUITES MEDICAL DISTRICT
7880 Fredericksburg Rd (78240)
Rates: $49-$59
(877) 822-5272

CANDLEWOOD SUITES HOTEL
9350 I-10 W (78230)
Rates: $109
(210) 615-0550; (800) 465-4329

CLARION SUITES
13101 E Loop 1604 N (78233)
Rates: $99-$199
(210) 655-9491; (800) 252-7466

CLASSIC INN & SUITES
9603 I-35 N (78233)
Rates: $29-$89
(210) 655-2120

COACHMAN INN BROOKS FIELD
3180 Gollard Rd (78223)
Rates: $39-$56
(210) 337-7171

COMFORT INN EAST
4403 I-10 E (78219)
Rates: $59-$175
(210) 33-9430; (800) 228-5150

COMFORT INN-FIESTA PARK/ SIX FLAGS
6755 N Loop 1604 W (78249)
Rates: $59-$139
(210) 696-4766; (800) 228-5150

COMFORT INN SEA WORLD
4 Plano Pl (78229)
Rates: $54-$75
(210) 684-8606; (800) 228-5150

COUNTRY HEARTH INN
7500 Louis Pasteur (78229)
Rates: $54-$78
(210) 616-0030; (888) 325-7821

DAYS INN
1500 S Laredo St (78204)
Rates: $49-$109
(210) 271-3334; (800) 329-7466

DAYS INN/COLISEUM
3443 I-35 N (78219)
Rates: $50-$110
(210) 225-4430; (800) 329-7466
(800) 548-2626

DAYS INN-EAST
4039 E Houston St (78220
Rates: $29-$44
(210) 333-9100; (800) 329-7466

DRURY INN EAST
8300 I-35 N (78239)
Rates: $70-$100
(210) 654-1144; (800) 378-7946

Hotel Pet Policies May Be Subject To Change

DRURY INN & SUITES/AIRPORT
95 NE Loop 410 (78216)
Rates: $72-$107
(210) 308-8100; (800) 378-7946

DRURY INN & SUITES-NW
9806 I-10 W (78230)
Rates: $75-$122
(210) 561-2510; (800) 378-7946

ECONO LODGE
2635 NE Loop 410 (78217)
Rates: $47-$74
(210) 247-4774; (800) 553-2666

FOUR POINTS BY SHERATON/RIVERWALK N.
110 Lexington Ave (78205)
Rates: $89-$119
(210) 223-9461

GARDENIA INN B&B
307 Beauregard St (78204)
Rates: $90-$140
(800) 356-1605

HAMPTON INN AIRPORT
8818 Jones Maltsberger Rd (78216)
Rates: $80-$120
(210) 366-1800; (800) 426-7866

HAMPTON INN SIX FLAGS AREA
11010 I-10 W (78230)
Rates: $69-$99
(210) 561-9058; (800) 426-7866

HAWTHORN SUITES RIVERWALK
830 N St. Marys Street (78205)
Rates: $119-$189
(210) 527-1900; (800) 527-1133

HILL COUNTRY INN & SUITES
2383 NE Loop 410 (78217)
Rates: $56-$66
(210) 599-4204

HILTON SAN ANTONIO AIRPORT
611 NW Loop 410 (78216)
Rates: $79-$265
(210) 340-6060; (800) 445-8667

HILTON PALACIO DEL RIO
200 S Alamo St (78205)
Rates: $98-$256
(210) 222-1400; (800) 445-8667

HOLIDAY INN-CROCKETT HOTEL
320 Bonham (78205)
Rates: $89-$189
(210) 225-6500; (800) 465-4329
(800) 292-1050

**HOLIDAY INN-DOWNTOWN-
MARKET SQUARE**
318 W Durango (78204)
Rates: $119-$139
(210) 225-3211; (800) 465-4329

HOLIDAY INN EXPRESS
11939 N I-35 (78233)
Rates: $69-$209
(210) 599-0999; (800) 465-4329

HOLIDAY INN EXPRESS AIRPORT
91 NE Loop 410 (78216)
Rates: $93-$123
(210) 308-6700; (800) 465-4329

HOLIDAY INN NORTHEAST
3855 I-35 N (78219)
Rates: $95
(210) 226-4361; (800) 465-4329

HOLIDAY INN RIVERWALK
217 N St. Mary's St (78205)
Rates: $149-$179
(210) 224-2500; (800) 465-4329

**HOLIDAY INN SELECT-
INT'L AIRPORT**
77 NE Loop 410 (78216)
Rates: $109-$129
(210) 349-9900; (800) 465-4329

**HOMEGATE
STUDIOS & SUITES-AIRPORT**
11221 San Pedro Ave (78216)
Rates: $49-$89
(210) 342-4800; (888) 456-4283

Locate Other Dog-Friendly Activities...Check Nearby Cities

HOMESTEAD STUDIO SUITES/AIRPORT
1015 Central Pkwy S Loop 410 (78232)
Rates: $50-$74
(210) 491-9009; (888) 782-9473

HOWARD JOHNSON COLISEUM
2755 N Pan Am Expwy (78208)
Rates: $50-$120
(210) 229-9220; (800) 446-4656

HOWARD JOHNSON EXPRESS INN FIESTA
13279 IH-10 W (78249)
Rates: $49-$99
(210) 558-7152; (800) 446-4656

KNIGHTS INN WINDSOR PARK
6370 I-35 N (78218)
Rates: $49-$89
(210) 646-6336; (800) 843-5644

LA MANSION DEL RIO HOTEL
112 College St (78205)
Rates: $219-$1900
(210) 518-1000; (800) 531-7208
(800) 292-7300

**LA QUINTA INN
CONVENTION CENTER**
1001 E Commerce St (78205)
Rates: $105-$155
(210) 222-9181; (800) 687-6667

LA QUINTA INN INGRAM PARK
7134 NW Loop 410 (78238)
Rates: $55-$122
(210) 680-8883; (800) 687-6667

LA QUINTA INN-LACKLAND
6511 Military Dr W (78227)
Rates: $65-$91
(210) 674-3200; (800) 687-6667

LA QUINTA INN MARKET SQUARE
900 Dolorosa St (78207)
Rates: $79-$139
(210) 271-0001; (800) 687-6667

LA QUINTA INN SAN ANTONIO AIRPORT
850 Halm (78216)
Rates: $89-$109
(210) 342-3738; (800) 687-6667

LA QUINTA INN SOUTH PARK
7202 S Pan Am Expwy (78224)
Rates: $65-$90
(800) 687-6667

LA QUINTA INN TOPPERWEIN
12822 N I-35 (78233)
Rates: $70-$90
(800) 687-6667

LA QUINTA INN VANCE JACKSON
5922 NW Expwy (78201)
Rates: $65-$95
(210) 734-7931; (800) 687-6667

LA QUINTA INN WINDSOR PARK
6410 I-35 N (78218)
Rates: $65-$101
(210) 653-6619; (800) 687-6667

LA QUINTA INN-WURZBACH
9542 I-10 W (78230)
Rates: $69-$99
(210) 593-0338; (800) 687-6667

LITTLE FLOWER INN B&B
225 Madison St (78204)
Rates: $85-$110
(210) 354-3116

MARRIOTT PLAZA HOTEL
555 S Alamo (78205)
Rates: $99-$274
(800) 727-3239

MARRIOTT RIVERCENTER
101 Bowie St (78205)
Rates: $129-$324
(210) 223-1000 (800) 228-9290
(800) 648-4462

Hotel Pet Policies May Be Subject To Change

MARRIOTT RIVERWALK
711 E Riverwalk (78205)
Rates: $129-$324
(210) 224-4555; (800) 228-9290
(800) 648-4462

MOTEL 6-EAST
138 N WW White Rd (78219)
Rates: $37-$53
(210) 333-1850; (800) 466-8356

MOTEL 6-FIESTA
16500 I-10 W (78257)
Rates: $35-$60
(210) 697-0731; (800) 466-8356

MOTEL 6 NORTHEAST
4621 E Rittiman Rd (78218)
Rates: $31-$55
(210) 653-8088; (800) 466-8356

MOTEL 6 -FT. SAM HOUSTON
5522 N Pan Am Expwy (78218)
Rates: $31-$50
(210) 661-8791; (800) 466-8356

MOTEL 6-NORTH
9503 I-35 N (78233)
Rates: $33-$51
(210) 650-4419; (800) 466-8356

MOTEL 6-NW MEDICAL CENTER
9400 Wurzbach Rd (78240)
Rates: $39-$59
(210) 593-0013; (800) 466-8356

MOTEL 6-RIVERWALK
211 N Pecos St (78207)
Rates: $39-$71
(210) 225-1111; (800) 466-8356

MOTEL 6 SOUTH
7950 S Pan Am Expwy (78224)
Rates: $36-$69
(210) 928-2866; (800) 466-8356

MOTEL 6-WEST SEA WORLD
2185 SW Loop 410 (78227)
Rates: $42-$58
(210) 673-9020; (800) 466-8356

O'CASEYS BED & BREAKFAST
225 W Craig Place (78212)
Rates: $69-$115
(800) 738-1378

OMNI HOTEL SAN ANTONIO
9821 Colonnade Blvd (78230)
Rates: $89-$169
(210) 669-5884; (800) 843-6664

PAINTED LADY INN ON BROADWAY B&B
620 Broadway (78215)
Rates: $79-$189
(210) 220-1092

PEAR TREE INN
143 NE Loop 410 (78216)
Rates: $68-$94
(210) 366-9300; (800) 282-8733

**PLAZA SAN ANTONIO-
A MARRIOTT HOTEL**
555 S Alamo St (78205)
Rates: $169-$500
(210) 229-1000; (800) 421-1172
(800) 727-3239

QUALITY INN & SUITES
222 South W W White Rd (78219)
Rates: $79-$99
(210) 359-7200; (800) 228-5151

QUALITY INN & SUITES COLISEUM
3817 I-35 N (78219)
Rates: $49-$59
(210) 224-3030; (800) 228-5151

RADFORD INN
13575 I-10 W (78201)
Rates: n/a
(210) 690-5500

RADISSON RESORT HILL COUNTRY
9800 Westover Hills Blvd (78251)
Rates: $129-$189
(210) 509-9800; (800) 333-3333

Locate Other Dog-Friendly Activities...Check Nearby Cities

RED ROOF INN AIRPORT
333 Wolf Rd &
US 281 (78216)
Rates: $48-$73
(210) 340-4055; (800) 843-7663

RED ROOF INN DOWNTOWN
1011 E Houston St (78205)
Rates: $49-$94
(210) 229-9973; (800) 843-7663

RED ROOF INN LACKLAND
6861 Hwy 90 W (78227)
Rates: $39-$66
(210) 675-4120; (800) 843-7663

RED ROOF INN NW-SEAWORLD
6880 NW Loop 410 (78238)
Rates: $46-$78
(210) 509-3434; (800) 843-7663

RELAY STATION MOTEL
5530 I-10 E (78219)
Rates: $32-$47
(210) 662-6691; (800) 735-2981

RESIDENCE INN BY MARRIOTT AIRPORT
1014 NE Loop 410 (78209)
Rates: $134-$229
(210) 805-8118; (800) 331-3131

RESIDENCE INN BY MARRIOTT
628 S Santa Rosa Blvd (78204)
Rates: $149-$299
(210) 231-6000; (800) 331-3131

**RESIDENCE INN BY MARRIOTT-
ALAMO PLAZA**
425 Bonham St (78205)
Rates: $169-$236
(210) 212-5555; (800) 331-3131

RESIDENCE INN NW-SIX FLAGS
4041 Bluemel Rd (78240)
Rates: $109-$199
(210) 561-9660; (800) 331-3131

RODEWAY INN SIX FLAGS/FIESTA
19793 I-10 W (78257)
Rates: $58-$109
(210) 698-3991; (800) 228-2000

SEVEN OAKS RESORT
1400 Austin Hwy (78209)
Rates: $50-$65
(210) 824-5371; (800) 346-5866

SLEEP INN NW MEDICAL CENTER
8318 I-10 W (78230)
Rates: $50-$95
(210) 344-5400; (800) 753-3746

**STAYBRIDGE SUITES BY HOLIDAY INN
NW COLONNADE**
4320 Spectrum One (78230)
Rates: $96-$208
(210) 558-9009; (800) 238-8000

STAYBRIDGE SUITES AIRPORT
66 NE Loop 410 (78216)
Rates: $138-$178
(210) 341-3220; (800) 238-8000

STUDIO 6-MEDICAL CENTER
7719 Louis Pasteur Ct (78229)
Rates: $45-$74
(210) 349-3100; (888) 897-0202

STUDIO 6-SIX FLAGS
11802 I-10 W (78230)
Rates: $45-$74
(210) 691-0121; (888) 897-0202

SUPER 8 MOTEL
11027 I-35 N (78233)
Rates: $35-$85
(210) 637-1033; (800) 800-8000

SUPER 8 MOTEL DOWNTOWN
3617 N Pan Am Expwy (78219)
Rates: $42-$88
(210) 227-8888; (800) 800-8000

SUPER 8-SIX FLAGS FIESTA
5319 Casa Bella (78249)
Rates: $54-$94
(210) 696-6916; (800) 800-8000

Hotel Pet Policies May Be Subject To Change

VILLAGER LODGE
1126 E Elmira St (78212)
Rates: $34-$50
(800) 584-0800

WELLESLEY INN AIRPORT
2635 NE Loop 410 (78217)
Rates: $55-$95
(210) 653-9110; (800) 444-8888

WESTIN RIVERWALK HOTEL
420 W Market St (78205)
Rates: $329-$419
(210) 224-6500; (800) 228-3000

WOODFIELD SUITES-DOWNTOWN
100 W Durango Blvd (78204)
Rates: $79-$169
(210) 212-5400; (800) 338-0008
(877) 211-0103

Recreation

ARNOLD PARK - Leashes

Info: Wiggle your way along the .5-mile pathway or cloud-gaze from a soft, grassy spot in this pleasant 24-acre park.

Directions: Located at 1011 Gillette Road.

BRACKENRIDGE PARK - Leashes

Info: Set aside plenty of time to explore this incredible 343-acre park. Several trails honeycomb the area and lead you through a grabbag of scenery. Do a little toe dipping in the river and then cool off under the tall bald cypress trees that skirt the shore. Tote a good read and a favorite chew and spend some quality time with the pupster. If your woofer's a hoofer, take to the terra firma on a woodland trail for a mini-workout. Concessions are available, but pack the pup's goodie bag - biscuits aren't on the menu. For more information: (210) 207-8592; (210) 207-7275.

Directions: Located at 3910 North St. Mary's Street.

COPERNICUS PARK - Leashes

Info: For a good time of astronomical proportions, circle this pretty park on the .5-mile trail or just sit and soak up some sunshine.

Directions: Located at 5003 Lord Road.

EISENHOWER PARK - Leashes

Info: The developed trails of this peaceful 317-acre expanse beckon you to lose yourself in a natural setting. Keep your cool under the shade of savory cedars and munch on lunch with your best friend.

Directions: Located at 19399 Northwest Military Highway.

The numbered hike that follows is within Eisenhower Park:

1) EISENHOWER PARK TRAIL HIKE - Leashes

Beginner/4.1 miles

Info: Get the lead out and burn some calories as you and the dawgus just do it around this exercise trail. Or check out the park's shorter 1.6-mile trail. When the workout's over, spend some idle moments in this pretty park before saying adieu. For more information: (210) 207-7275.

Directions: Located at 19000 Northwest Military Highway.

GUADALUPE RIVER STATE PARK - Leashes

Info: You and the pupster are in for a hot diggety dog day if your destination is the Guadalupe River in the heart of rugged Hill Country. Three miles of hiking trails traverse this beautiful terrain and give you an up close glimpse of the wild and the wildlife. Don't be surprised to see white-tailed deer, mallard ducks, raccoons, armadillos and squirrels as you focus in on the lush landscape. Able fishermen can make fishy tales happen and then grill up the day's catch at one of fifty picnic sites.

For an unusual experience, canoe with your canine along the tranquil waters of the Guadalupe, but please - no doggie paddling. Travel light, you'll have to carry your own watercraft from the day-use parking lot. Whatever you do, you'll be awestruck by the splendor of your surroundings in this diverse parkland. For more information: (830) 438-2656; (800) 792-1112; www.tpwd.state.tx.us.

Hotel Pet Policies May Be Subject To Change

Directions: From San Antonio, take Highway 281 north approximately 20 miles to Highway 46. Turn left on Highway 46 for 7 miles to Park Road 31. Make a right on Park Road 31 for about 3 miles to park headquarters.

Note: $3 entrance fee/person. No dogs allowed in the swimming area or in the river.

The numbered hike that follows is within Guadalupe River State Park:

1) GUADALUPE RIVER TRAIL HIKE - Leashes

Beginner/3.0 miles

Info: Over grasslands and through the woods to the Guadalupe River you go. Dense groves of oak, ash, juniper, cedar-elm and cypress keep the trail well-shaded, making it a cool summertime retreat. For more information: (830) 438-2656.

Directions: From San Antonio, take Highway 281 north approximately 20 miles to Highway 46. Turn left on Highway 46 for 7 miles to Park Road 31. Make a right on Park Road 31 for about 3 miles to park headquarters.

JOHN JAMES PARK - Leashes

Info: Acre upon acre of postcardian scenery await you in this enormous urban park. Pack a blanket, uncover a secluded spot and spend a lazy bones afternoon stretched out atop the soothing dewy grass.

Directions: Located at 1300 Rittiman Road.

The numbered hike that follows is within John James Park:

1) JOHN JAMES PARK TRAIL HIKE - Leashes

Beginner/0.25 miles

Info: For a quickie excursion in the great outdoors, set tails wagging on this piece-of-cake trail. For more information: (210) 207-8480.

Directions: Located at 1300 Rittiman Road.

Locate Other Dog-Friendly Activities...Check Nearby Cities

KENNEDY PARK - Leashes

Info: Your pup will think he's found Camelot when he sniffs out Kennedy Park. Romp through 35 acres or lounge with the hound in this urban green scene.

Directions: Located at 3101 Roselawn.

The numbered hike that follows is within Kennedy Park:

1) KENNEDY PARK TRAIL HIKE - Leashes

Beginner/0.5 miles

Info: Do a couple of laps on this feel-good walking trail. Short and sweet, the trail has most hikers and hounds coming back for seconds and thirds. For more information: (210) 207-7275.

Directions: Located at 3101 Roselawn.

KING WILLIAM HISTORICAL DISTRICT WALKING TOUR - Leashes

Beginner/2.0 miles

Info: Do something different for a change with a little city exploring. Treat your canine companion to a sightseeing stroll through Texas' first designated historic district - an area steeped in history, culture and architecture. Settled by prosperous German merchants, the century-old King William District was once San Antonio's most elegant residential section. Today, this quaint part of town maintains the beauty and charm reminiscent of a time gone by. Restored Victorian mansions and cottages allow visitors a glimpse of life in the late 1800s. Stop by the San Antonio Conservation Society for a trail guide/map, complete with site descriptions and trail directions. For more information: (210) 224-6163.

Directions: The tour begins at the San Antonio Conservation Society, 107 King William Street.

LA VILLITA WALKING TOUR - Leashes

Beginner / 1.0 miles

Info: History and quaintness go hand-in-hand at San Antonio's "Little Village." Get a jumpstart on a cool morning with a tour of this charming area. Follow the interpretive markers through a village proud of its Mexican heritage, as well as its diversity. As you pass historic sites and arts and crafts boutiques, take note of the variety of German, Spanish, French, Mexican, American and Texan influences. If your timing is right, you can help celebrate La Villita's colorful past during one of the many fiestas and cultural events held throughout the year. Stop by the San Antonio Conservation Society for a trail guide/map, complete with site descriptions and trail directions. For more information: (210) 207-8610; (210) 224-6163.

Directions: The tour begins at the Cos House on Villita Street. The entire village is bounded by S. Alamo, Presa and Nueva Streets.

M.L. KING PARK - Leashes

Info: Transform your city slicker canine into a parkhound at this 160-acre green scene.

Directions: Located at 3500 Martin Luther King.

MCALLISTER PARK - Leashes

Info: Put this park at the top of your day's doings and you'll set tails thumping. Enveloping over 850 acres with 450 developed for citified Fidos, this woodsy expanse is an outdoor enthusiast's dream come true. Get the kinks out along one of the trails or get lazy in the shade with a good read and a favorite chew for the chompmeister. Binoculars provide some close-ups of the deer that often graze in the area, especially at sundown. For more information: (210) 207-7275; www.wildtexas.com.

Directions: Located at 13102 Jones Maltsberger.

Locate Other Dog-Friendly Activities...Check Nearby Cities

The numbered hike that follows is within McAllister Park:

1) MCALLISTER PARK TRAIL HIKE - Leashes

Beginner/3.0 miles

Info: You and Tex can get your daily dose of exercise on this cinchy park pathway. The trail is a pupular one, so brush up on your social skills and get ready to meet and greet some new-found friends and canines. For more information: (210) 207-7275.

Directions: Located at 13102 Jones Maltsberger.

MISSION TRAIL AUTO TOUR

Info: Sunday drivers, rev up those engines and buckle in your Buddy, the missions of San Antonio await. Return to the days of yesteryear with a trip along the Mission Trail to an era of Spanish settlement, the foundation of present-day San Antonio. Your trip will include four missions at various intervals en route as well as an agreeable little picnicking park for you and the pup. The highlights are described below. For more information: (210) 534-8833; (210) 932-1001; www.sanantoniocvb.com.

The numbered missions that follow are part of the Mission Trail Auto Tour:

1) MISSION CONCEPCION (807 Mission Road)

Completed in 1755, 14 years after the establishment of the mission, the church is the oldest unrestored stone church still standing in the United States. Two identical towers rise to the sky, while beautifully manicured grounds beckon your perusal. A sidetrip west on Theo Avenue will take you and your pooch to a delightful riverside park. Plan ahead, pack some snacks and enjoy a biscuit break before returning to the trail and continuing on your way.

2) MISSION SAN JOSE (6539 San Jose Drive at Mission Road)

"Queen of Missions," San Jose is the largest and best known in Texas. Except for the limestone walls of the church, this awe-inspiring structure has been completely restored. Speaking of

churches, check out the dome-shaped chapel - an interesting adjunct to the mission and Texas' first flour mill. (just outside the north wall of San Jose).

3) MISSION SAN JUAN (Graf Road off Mission Road)

Tails will be swinging in the breeze as you stroll the scenic grounds of this pretty mission. The river tumbles and rolls through the landscape, creating soothing sounds for you and the hound. The beauty of the restored mission is a sight to behold and one you'll want to capture on film. A cross stands above three bells that ring out over the tranquil tree-strewn landscape. Don't leave the camera in the car, you'll want to take home some memories of this picturesque place.

4) MISSION ESPADA (Southern tip of Espada Road)

A favorite for photo hounds, Mission Espada towers over the lush terrain. Investigate the interesting arched doorway and see what comes to your mind to explain the broken arch. Enjoy the beauty of your surroundings as you compose some memorable Kodak moments.

Directions: Head south on Alamo Street to South St. Mary's Street, continuing to the fork and veering right to Mission Road. Follow National Park Service signs to the missions.

Note: Dogs must be leashed at all time on the grounds. Donations appreciated. Dogs are prohibited from entering the buildings or structures.

NATURAL BRIDGE WILDLIFE RANCH

Info: Drive through diverse terrain while you keep an eye out for several exotic animal species. You'll cruise over 200 acres of scenic ranchland, while the sounds of nature serenade. Tote a camera, you might come across a Rhesus Macaque, a wildebeest, or a docile giraffe. Some lucky dogs have witnessed horn-to-horn combat, newborns being nursed and unique mating rituals. So, pack an adventurous spirit and get set for an African safari, Texas-style. For more information: (830) 438-7400; www.nbwildliferanchtx.com.

Locate Other Dog-Friendly Activities...Check Nearby Cities

Directions: From San Antonio, head northeast on Highway 35 and exit FM 3009, heading north to the park. Located at 26515 Natural Bridge Caverns Road.

Note: Feeding animals is prohibited if you have dogs in the car. Wildlife sightings may be inhibited due to the route you must take if you drive through with your pet.

PEARSALL PARK OFF-LEASH AREA

Info: This is San Antonio's newest park and it boasts a half-acre off-leash area for the dogmeister. Opened in April 2004, this grassy, fenced area is the city's first dog park. For more information: (210) 207-7275.

Directions: Located at 4700 Old Pearsall Road.

Note: Dogs should always be leashed outside of the Off-Leash area.

RIVER WALK (Paseo del Rio) - Leashes

Info: Experience a taste of European bistro life on San Antonio's premier attraction - the very popular Paseo del Rio. A bonafido happening place, over two miles of cobblestone and flagstone paths skirt the San Antonio River and escort you on a journey through the heart of downtown, sans traffic. The River Walk is one flight below street level. Since the walkways are somewhat narrow, and therefore easily crowded, you might want to plan your visit to avoid peak periods. We're talking heavy foot traffic here, but this is a sojourn you won't want to miss. If yours is a social pup, he won't know where to look or smell first.

Music from the river theater and nightclub scene greets you at various intervals, while aromatic scents from the cafes and ever present floating dinner boats will definitely tickle your taste buds. Everywhere you turn, you'll be greeted with tropical foliage, flowering shrubs and lush botanical gardens - definitely delights to behold. With the River Walk open 24 hours a day, San Antonio is a city that never sleeps, attracting early birds and night owls alike. So go where the action is and saunter beside the river, the place to window shop and people

watch. Dollars to dog biscuits, you'll come back for seconds and thirds. Happy tails to you and the wagger. For more information: (210) 207-8480; (210) 212-7602.

Directions: Accessed from Alamo Plaza, Rivercenter Mall and city streets including South Alamo, South Broadway, Presa, Navarro, St. Mary's, Market, Commerce and Crockett.

ROSEDALE PARK - Leashes

Info: For some good old-fashioned playtime, head out to this little park.

Directions: Located at 303 Dartmouth.

The numbered hike that follows is within Rosedale Park:

1) ROSEDALE PARK TRAIL HIKE - Leashes

Beginner/0.5 miles

Info: Even the most devoted couch slouch will give this pipsqueak trail two paws up. For more information: (210) 207-8480; (210) 207-7275.

Directions: Located at 303 Dartmouth.

SCHNABEL PARK - Leashes

Info: Ah, splendor in the grass- this park is an idyllic setting for an afternoon interlude. City escapees will find over 200 acres to choose from.

Directions: Located at 9606 Bandera Road.

SOUTHSIDE LIONS PARK - Leashes

Info: You'll have a roaring good time romping with Rover in this , 345-acre park. Mostly undeveloped, there's no shortage of wide open spaces where a game of catch can be the highlight of your dog's day.

Directions: Located at 900 Hiawatha.

Locate Other Dog-Friendly Activities...Check Nearby Cities

THE TEXAS STAR TRAIL HIKE - Leashes

Beginner/2.6 miles

Info: You and the pupster will definitely get an education on this 2.6-mile trail that journeys to 80 historic sites. Instead of the yellow brick road, you'll follow blue disks in the sidewalks. Whether you walk the entire trail or just a section, you'll definitely enhance your knowledge of this history-laden region. Before beginning your self-guided tour, stop by the San Antonio Conservation Society at 107 King Williams Street for a trail brochure/map which gives a brief description of each site. If you're short on time you can drive the route as well. The brochure/map contains the necessary street addresses for each locale. If you prefer the challenge of finding your own way, "mapless" sites are identified by a red and blue Texas Star Plaque. For more information: (210) 224-6163; www.saconservation.org.

Directions: The trail begins at Alamo Plaza.

WALKING TOUR OF SCULPTURE - Leashes

Beginner/5.0 miles

Info: If artwork in the form of sculpture turns you on, this outdoor museum in downtown San Antonio should not be missed. A self-guided loop escorts you past 49 works of art, some dating to 1899. The sculptures are made from an incredibly diverse selection of materials, including bronze, copper, marble, glass and limestone. The works represent a myriad of approaches from abstract portrait to non-objective and symbolic. As a whole, they represent San Antonio's history, culture and taste. Stop by the San Antonio Conservation Society for a trail guide/map, complete with site descriptions and trail directions. For more information: (210) 222-2787; (210) 224-6163; www.saconservation.org.

Directions: The tour begins at the Moses Austin sculpture at City Hall.

WOODLAWN LAKE - Leashes

Info: Make your aquapup's dreams come true with a visit to Woodlawn Lake. You'll have a memorable day of sun-dappled scenery and splish-splashing fun. A favorite with locals, the lake offers social breeds a tailwagging good time. For more information: (210) 207-8592.

Directions: Located at 1103 Cincinnati.

OTHER PARKS IN SAN ANTONIO - Leashes
For more information, contact the San Antonio Parks & Recreation Department at (210) 207-3120.

- ACME PARK, 500 Acme Road
- HEMISFAIR PARK, off East Durango Boulevard
- TRAVIS PARK, Pecan & Jefferson Streets

SAN AUGUSTINE

<u>LODGING</u>
SAN AUGUSTINE INN
1009 Hwy 21 W (75972)
Rates: $36-$46
(936) 275-3452

SAN BENITO

<u>LODGING</u>
VIEH'S BED & BREAKFAST
18413 Landrum Park Rd (78586)
Rates: $65-$95
(956) 425-4651

Locate Other Dog-Friendly Activities...Check Nearby Cities

SAN MARCOS

LODGING

BEST WESTERN SAN MARCOS
917 I-35 N (78666)
Rates: $59-$99
(512) 754-7557; (800) 528-1234

DAYS INN
1005 I-35 N (78666)
Rates: $35-$125
(512) 353-5050; (800) 329-7466

LA QUINTA INN
1619 I-35 N (78666)
Rates: $60-$105
(512) 392-8800; (800) 687-6667

LONESOME DOVE BED & BREAKFAST
407 Oakwood Loop (78666)
Rates: $65-$85
(512) 392-2921

MOTEL 6
1321 I-35 N (78666)
Rates: $34-$55
(512) 396-8705; (800) 466-8356

RAMADA LIMITED
1701 I-35 N (78667)
Rates: $34-$129
(512) 395-8000; (800) 272-6232

RED ROOF INN
817 I-35 N (78666)
Rates: $39-$149
(512) 754-8899; (800) 843-7663

STRATFORD INN
1601 I-35 N (78666)
Rates: $39-$79
(512) 396-3700

SUPER 8 MOTEL
1429 I-35 N (78666)
Rates: $69-$75
(512) 396-0400; (800) 800-8000

UNIVERSITY INN
1507 I-35 N (78666)
Rates: $29-$100
(512) 396-6060

RECREATION

CHILDREN'S PARK - Leashes

Info: Plan a picnic or a quick stroll with furface in this 6-acre park.

Directions: Located on Bugg Lane.

DUNBAR PARK - Leashes

Info: Cloudgaze from a grassy knoll or try a game of catch and fetch with a fuzzy tennie in this friendly 7-acre park.

Directions: Located at Martin Luther King Drive and Endicott.

Hotel Pet Policies May Be Subject To Change

MEMORIAL PARK - Leashes

Info: Home to the new town library, what better place to have a good read while the dogster enjoys a tough chew.

Directions: Located on Hopkins Street.

RAMON LUCIO PARK - Leashes

Info: A bit of tennie fetching will surely put a grin on the ballmeister's face. Or hightail it on the jogging trail for a smidgen of Texercise in this 22-acre park.

Directions: Located at Interstate Highway Access and C.M. Allen Parkway.

RIO VISTA PARK - Leashes

Info: Exercise your canine with a run and a bit of playtime over this park's 13 acres.

Directions: Located at Hopkins and C.M. Allen Parkway.

WONDER WORLD - Leashes/Small Dogs Only

Info: If yours is a small lapdog, head on out for an afternoon of geologic phenomena. Journey 160 feet beneath the earth's surface to explore incredible Wonder Cave, formed over 30 million years ago by an earthquake. And then, all aboard for a train adventure through Mystery Mountain, Crystal Falls and Wildlife Park. When day is done, share a brown bagger with your wee wagger. For more information: (512) 392-3760.

Directions: From Interstate 35, exit at the Wonder World Drive exit and follow the signs to the park.

Note: Entrance fee charged. Hours: Daily 9 am to 5 pm March through October. Extended summer hours from 8 am to 8 pm

OTHER PARKS IN SAN MARCOS - Leashes

For more information, contact the San Marcos Parks & Recreation Department at (512) 393-8400.

- BICENTENNIAL PARK, C.M. Allen Parkway
- CITY PARK, Bugg Lane
- VERAMENDI PLAZA, Hopkins and C.M. Allen Parkway
- VETERAN'S PARK, Hopkins and C.M. Allen Parkway

SANDERSON

LODGING

BUDGET INN
Hwy 90 E (79848)
Rates: $28-$48
(432) 345-2541

OUTBACK OASIS MOTEL
800 W Hwy 90 (79848)
Rates: $29-$59
(888) 466-8822

DESERT AIR MOTEL
806 W Oak (79848)
Rates: $30-$39
(432) 345-2572

SANDIA

LODGING

**KNOLLE FARM & RANCH-
BED, BARN & BREAKFAST**
Rt 1, Box 681 (78387)
Rates: $85-$175
(361) 547-2546

SANGER

RECREATION

RAY ROBERTS LAKE STATE PARK - Leashes

Info: Expand your horizons with a day of exploration at this beautiful 1,300-acre park. Find yourself a cozy spot lakeside and just enjoy some R&R, or venture on one of the hiking trails that zig zag the area. Waterdogs are sure to love a little paw dipping. If you've got a boat, take to the shimmering

waters and do your exploring the wet way. The fishing's fine to drop a line, so bring your rod along. For more information: (940) 686-2148; (800) 792-1112; www.tpwd.state.tx.us.

Directions: From Sanger, take FM 455 east for 10 miles. The park is the second entrance on the left after crossing the dam.

Note: $5 entrance fee/person.

The numbered hike that follows is within Ray Roberts State Park:

1) RAY ROBERTS HIKING TRAIL SYSTEM - Leashes

Intermediate/16.5 miles

Info: From shady woodlands, open grasslands, and rolling hills to flat terrain, babbling creeks and sun-splashed lakes, this idyllic trail region has something for every breed. Hardy hikers and conditioned canines will enjoy the challenge of the 12-mile trail that runs from the Elm Fork Park Unit through the Isle du Bois Unit to the Jordan Park Unit. More mellow fellows will probably prefer the 4.5-mile paved trail. This shady trail wiggles through thick woodlands of cedar, black hickory, winged elm and various species of oak. Even couch potato pups can experience this slice of nature with a lickety split stroll on the 2.2-mile loop of the 4.5-mile trail. Go ahead, pick your pathway and make your dog's day. For more information: (940) 686-2148.

Directions: From Sanger, take FM 455 east for 10 miles. The park is the second entrance on the left after crossing the dam.

SCHULENBURG

LODGING

OAKRIDGE MOTOR INN
I-10 & Hwy 77 (78956)
Rates: $42-$64
(979) 743-4192

SEALY

RECREATION

STEPHEN F. AUSTIN STATE PARK & HISTORIC SITE - Leashes

Info: Commemorating one of the founders of Texas, this state park is your wagalong's dream come true. Trails honeycomb the lush, riverside green scene and escort you through a cornucopia of nature. History sniffing canines can take a gander at a bronze statue of Stephen Austin, an early colonial well and the old ferry approach where Atascosito Road crosses the Brazos River. Top off your day with a visit to the 12-acre site set aside to honor the region first colonized by Austin and 297 families. For more information: (979) 885-3613; (800) 792-1112; www.tpwd.state.tx.us.

Directions: From Sealy, take Highway 10 east to FM 1458. Head north on FM 1458 to Park Road 38. Turn left (west) on Park Road 38 to the park entrance.

Note: $3 entrance fee/person.

The numbered hikes that follow are within
Stephen F. Austin State Park & Historic Site:

1) COTTONWOOD TRAIL HIKE - Leashes

Beginner/2.0 miles

Info: Woodsy and flat, this easy-does-it trail leaves little room for complaints. A river runs through it, so if you're in the fishing mode, bring a rod and reel. If you're more into birding, tote the binocs. But whatever you do, pack a fun attitude and you won't go wrong. For more information: (979) 885-3613.

Directions: From Sealy, take Highway 10 east to FM 1458. Head north on FM 1458 to Park Road 38. Turn left (west) on Park Road 38 to the park entrance.

2) NATURE TRAIL HIKE - Leashes

Beginner/0.5 miles

Info: Couch pooch alert. This self-guided interpretive trail is your kinda trail. You'll meander through lush woodlands, stroll across a pretty creek via a footbridge and, zap, before you know it, the hike's over. For more information: (979) 885-3613.

Directions: From Sealy, take Highway 10 east to FM 1458. Head north on FM 1458 to Park Road 38. Turn left (west) on Park Road 38 to the park entrance.

SEGUIN

LODGING

BEST WESTERN OF SEGUIN
1603 I-10, Hwy 46 (78155)
Rates: $55-$99
(830) 379-9631; (800) 528-1234

HOLIDAY INN
2950 N123 Bypass (78155)
Rates: $86-$116
(830) 372-0860; (800) 465-4329

SUPER 8 MOTEL
1525 N Hwy 46 (78155)
Rates: $45-$120
(830) 379-6888; (800) 800-8000

RECREATION

CENTRAL PARK - Leashes

Info: Get along with your little doggie to this lovely and informative parkland where you'll discover historically significant markers and stones as well as a stunning, multi-colored fountain.

Directions: Located on Austin Street.

STARCKE PARK - Leashes

Info: Towering oaks and pecan trees will shade you and the dawgus as you strut your stuff in this exceptional municipal park. A popular, activity-filled green scene, you'll find plenty of romping room.

Directions: Located at the south edge of Seguin off Highway 123.

Locate Other Dog-Friendly Activities...Check Nearby Cities

WORLD'S LARGEST PECAN - Leashes

Info: Novelty nuts and mutts will want to boogie on down to the courthouse to view the massive pecan on display. Well worth the trip, the giant nut (1000 lbs.) is a tribute to the industry and is surrounded by a pretty setting of lush grass and shady trees. For more information: (830) 379-6382.

Directions: Located at 101 E. Court Street in front of the Courthouse.

SEMINOLE

LODGING
RAYMOND MOTOR INN
301 W Ave A (79360)
Rates: $37-$45
(432) 758-3653

SEYMOUR

LODGING
SAGAMAR INN
1101 N Main St (76380)
Rates: $40-$65
(940) 888-5507

SHAFTER

LODGING
CIBOLO CREEK RANCH
US Hwy 67 N (79850)
Rates: n/a
(432) 229-3737

Hotel Pet Policies May Be Subject To Change

SHAMROCK

LODGING

BUDGET HOST BLARNEY INN
402 E 12th St (79079)
Rates: $28-$45
(806) 956-2101; (800) 283-4678

IRISH INN
301 I-40 E (79079)
Rates: $45-$58
(806) 256-2106; (800) 538-6747

ECONO LODGE
1006 E 12th St (79079)
Rates: $45-$70
(806) 256-2111; (800) 553-2666

THE WESTERN MOTEL
104 E 12th St (79079)
Rates: $39-$59
(806) 256-3244

RECREATION

ELMORE PARK - Leashes

Info: May the Luck O' the Irish be yours after a visit to this small park that is green in more ways than one. Elmore Park affords you and your Irish Setter the opportunity to touch a genuine piece of Blarney Stone from Blarney Castle in County Cork, Ireland. Don't forget to wear your green. For more information: (806) 256-2501.

Directions: Located at 100 E. 1st Street.

SHEFFIELD

RECREATION

FORT LANCASTER STATE HISTORIC SITE - Leashes

Info: Savor the flavor of an old fort by visiting this park where you'll encounter remnants of a time gone by. Sniff out the .75-mile self-guided trail that loops around the ruins, or take to the interpretive nature trail located behind the picnic area. Learn as you sojourn through this 81-acre expanse. For more information: (432) 836-4391; (800) 792-1112; www.tpwd.state.tx.us.

Directions: From Sheffield, take Highway 290 east for 8 miles to park.

Note: $2 entrance fee.

The numbered hikes that follow are within Fort Lancaster State Historic Site:

1) FORT LANCASTER NATURE TRAIL HIKE - Leashes

Beginner/0.25 miles

Info: With barely an effort, you can get a smidgen of an education on the local flora and fauna if you take the time to read the interpretive posts along this nature trail. For more information: (432) 836-4391.

Directions: From Sheffield, take Highway 290 east for 8 miles to park.

2) FORT LANCASTER RUINS TRAIL HIKE - Leashes

Beginner/0.75 miles

Info: Return to the days of the wild, wild west as you loop around the parade grounds with your hound. History buffs can see for themselves what life was like 100 years ago. Tiptoe through the ruins then branch off on a sidetrip to one of the fort's standing structures. For detailed descriptions on the ruins and structures, pick up a trail guide at the trailhead. For more information: (432) 836-4391.

Directions: From Sheffield, take Highway 290 east for 8 miles to park.

SHENANDOAH

LODGING

LA QUINTA INN
28673 N I-45 (77384)
Rates: $69-$75
(281) 367-7722; (800) 687-6667

SPRING INN & SUITES
29007 N I-45 (77381)
Rates: $39-$90
(281) 363-3933

Hotel Pet Policies May Be Subject To Change

SHEPHERD

RECREATION

SAM HOUSTON NATIONAL FOREST

Sam Houston Ranger District
394 FM 1375 West, New Waverly, TX 77358,
(936) 344-6205; (888) 361-6908

Info: Over 160,000 acres of alluring serenity are yours for the taking at this national forest named for the father of Texas-Sam Houston. No tour of Texas would be complete without a visit to this delightful woodland. So leave your cares and woes in the city and let the good times roll. It doesn't matter what tickles your fancy, it's all here. Play tagalong with your wagalong as you journey on the picturesque Lone Star Hiking Trail. Be a lazy bones and vege out under a shade tree in a hidden copse where the air is deliciously pine-scented. Or if water sports are more your speed, tote your boat, pack your gear, and set your sights on 21,000-acre Lake Conroe and 82,600-acre Lake Livingston (gasoline-powered boats are not permitted). Pick your pleasure and then go for it. There's nothing to stop you and furface from having one helluva a good day. Carpe diem Duke. For more information: (936) 344-6205.

Directions: The forest lies within the boundaries of Montgomery, San Jacinto and Walker Counties and is easily accessed via Interstate 45 and Highways 150, 190 and 156. Refer to specific directions following each recreation area and hiking trail.

For more information on recreation in the Sam Houston National Forest, see listings under the following cities: Coldspring, Conroe, Houston, Huntsville and New Waverly.

SHERMAN

LODGING

COMFORT SUITES OF SHERMAN
2900 Hwy 75 N (75090)
Rates: $79-$129
(903) 893-0499; (800) 228-5150

CROSSROADS INN MOTEL
2424 Texoma Pkwy (75090)
Rates: $30+
(903) 893-0184

DAYS INN
1831 Texoma Pkwy (75090)
Rates: $45-$66
(903) 892-0433; (800) 329-7466

EXECUTIVE INN
2105 Texoma Pkwy (75090)
Rates: $49-$77
(903) 892-2161; (800) 723-4194

HOLIDAY INN
3605 Hwy 75 S (75090)
Rates: $59-$72
(903) 868-0555; (800) 465-4329

LA QUINTA INN & SUITES
2912 Hwy 75 N (75090)
Rates: $80-$110
(903) 870-1122; (800) 687-6667

SUPER 8 MOTEL
111 E Hwy 1417 (75090)
Rates: $40-$55
(903) 868-9325; (800) 800-8000

RECREATION

HAGERMAN NATIONAL WILDLIFE REFUGE - Leashes

Info: Containing over 3,000 acres of water and marsh along with 8,000 acres of uplands, this refuge is a birder's paradise. From migrating geese, wading birds, ducks and shorebirds to pelicans, doves, blue herons and snowy egrets, you'll go out of your bird at this refuge which harbors over 300 seasonal species of feathered friends. The refuge's self-guided driving tour offers the most popular route of exploration, but a handful of hiking trails make for great leg-stretching jaunts with the dogster. If you choose to investigate on the terra firma, you'll undoubtedly encounter one of the area's 200 oil producing wells, some dating back to the 1950s. Able anglers, don't leave your rods at home. You'll definitely want to try your luck in Lake Texoma. You'll have some competition to deal with though. The winged inhabitants of the refuge have been known to take advantage of a fisherman's good fortune and call it dinner. And they don't even need a grill. For more information: (903) 786-2826; www.recreation.gov.

Hotel Pet Policies May Be Subject To Change

Directions: From Sherman, head north on Highway 75 to FM 691 west. Follow FM 691 to FM 1417. Take FM 1417 north approximately 1.5 miles to Refuge Road. Turn west on Refuge Road, following the signs to the Office/Visitor Center.

Note: Insect repellent is highly recommended.

HERMAN BAKER PARK - Leashes

Info: This huge park surrounds Pickens Lake and offers fabulous recreation opportunities for people and their pooches. Hiking trails lace the verdant, shaded woodlands that are alive with songbirds and forest dwellers. Great lake fishing and idyllic picnic spots also highlight the scene. For more information: (903) 892-7344.

Directions: Take State Highway 56 west until you reach Baker Park Drive. Head south on Baker Park Drive and continue to the park entrance.

LOY LAKE PARK - Leashes

Info: Pack a snack and plan a blanket brunch with the biscuit-meister or just chill out lakeside and try your fly on the fish.

Directions: Located off Highway 75 on Loy Lake Road.

MARTIN LUTHER KING JR. MEMORIAL PARK - Leashes

Info: Take a leisurely stroll through this memorial park where the centerpiece is a monument dedicated to the civil rights leader.

Directions: Located at 922 N. East Street.

OTHER PARKS IN SHERMAN - Leashes

For more information, contact the Sherman Parks & Recreation Department at (903) 892-7344.

- CHERRY STREET PARK, 401 Cherry Park Drive
- ELY PARK, 919 S. Austin
- FAIRVIEW PARK, 1121 W. Taylor

Locate Other Dog-Friendly Activities...Check Nearby Cities

- FIELDER PARK, 1100 E. Pecan
- HAWN PARK, 1202 S. Dewey
- HILLCREST PARK, 1205 Hillcrest Street near WNJ Hospital
- OLD SETTLERS PARK, 1609 N. Harrison
- ROSEDALE PARK, 1400 S. Gribble

SILVERTON

RECREATION

LAKE MACKENZIE PARK - Leashes

Info: A riparian oasis awaits your playtime pleasure. Whether you pound your paws on the half-mile trail or beat the summer heat and do lunch alfresco in a cozy nook, you and your hound are bound to have a fun interlude.

Directions: Located off Highway 207, 12 miles northwest of Silverton.

Note: Entrance fee may be required.

SMITHVILLE

LODGING

THE KATY HOUSE BED & BREAKFAST
201 Ramona St (78957)
Rates: $90-$140
(512) 237-4262; (800) 843-5289

9E RANCH BED & BREAKFAST
21558 Hwy 304 (78957)
Rates: $95-$135
(512) 497-9502

RECREATION

BUESCHER STATE PARK - Leashes

Info: Savor the serenity of your surroundings in this 1,200-acre park. Plenty of grass and shade will please the pooch, while diverse species of fish and fowl will please anglers and birdwatchers. For more information: (512) 237-2241; (800) 792-1112; www.tpwd.state.tx.us.

Hotel Pet Policies May Be Subject To Change

Directions: From Smithville, head west on FM 153 for 2 miles to park's entrance.

Note: Entrance fee charged.

The numbered hike that follows is within Buescher State Park:

1) BUESCHER STATE PARK HIKING TRAIL - Leashes

Intermediate/7.7 miles

Info: If you've got the time and energy, this trail's got the forests and pond. You'll boogie with Bowser through the Lost Pines of Texas, the state's most westerly pine-oak woodland. The canopy of the dense forest provides plenty of bonafido picnic areas and shaded nooks, while the refreshing pond gives you and the pupster a chance to cool your jets with some swim-time shenanigans. To keep you on track, the trail is marked by aluminum directional rectangles that are nailed to the trees. For more information: (512) 237-2241.

Directions: From Smithville, head west on FM 153 for 2 miles to park's entrance.

SNYDER

LODGING

BEACON LODGE
1900 E Hwy 180 (79549)
Rates: $39-$47
(325) 573-8526

BEST WESTERN SNYDER INN
810 E Coliseum Dr (79549)
Rates: $65-$95
(325) 574-2200; (800) 528-1234

DAYS INN
800 E Coliseum Dr (79454)
Rates: $42-$55
(325) 573-1166; (800) 329-7466

PURPLE SAGE MOTEL
1501 E Coliseum Dr (79549)
Rates: $48-$70
(325) 573-5491; (800) 545-5792

WILLOW PARK INN
1137 E Hwy 180
& 84 (79549)
Rates: $45-$75
(325) 573-1961; (800) 854-6818

SOMERVILLE

LODGING
SUPER 8 MOTEL
152 Ave B South (77879)
Rates: $45-$85
(979) 596-3884; (800) 800-8000

RECREATION
WELCH PARK - Leashes

Info: Nestled between a dense woodland and a cool, soothing lake, Welch Park offers you and the dawgus a delightful afternoon respite in Mother Nature. Tote a boat and float atop the lake. Hike amidst breezy forests and listen to the birds. Or plan a picnic alfresco. One thing's certain, you're sure to discover plenty of outdoor enjoyment in this idyllic setting. For more information: (979) 596-2286.

Directions: From Somerville , head northwest on 8th Street to Thornberry. Turn left and proceed across the dam to the park.

SONORA

LODGING
BEST VALUE INN-TWIN OAKS MOTEL
907 N Crockett Ave (76950)
Rates: $36-$50
(325) 387-2551

DAYS INN-DEVIL'S RIVER
1312 N Service Rd (76950)
Rates: $49-$69
(325) 387-3516; (800) 329-7466

BEST WESTERN SONORA INN
270 Hwy 277 N (76950)
Rates: $64-$90
(325) 387-9111; (800) 528-1234

HOLIDAY HOST MOTEL
127 Loop 467 (76950)
Rates: $34-$50
(325) 387-2532

RECREATION
CAVERNS OF SONORA

Info: Spelunkers, this is one adventure you don't want to miss. Venture into Sonora's phenomenal underworld of stalag-

Hotel Pet Policies May Be Subject To Change

mites, stalactites and helictites and you'll wonder if you're still earthbound. As you wander along the 1.5-mile trail, you'll be left speechless by the caverns' indescribable beauty and unbelievable formations. Dogs are not permitted in the caverns, but a free kennel service is provided. For more information: (325) 387-3105; www.cavernsofsonora.com.

Directions: From Sonora, head west on I-10 approximately 8 miles to the Caverns of Sonora Road exit (FM 1989). Follow Caverns of Sonora Road south for 7 miles to the entrance.

Note: Entrance fee charged. Call for hours.

SOUTH PADRE ISLAND

(See North Padre Island listings for additonal lodging.)

LODGING

ALL ON BEACH- VACATION RENTALS
2700 Gulf Blvd (78597)
Rates: $99-$395
(800) 227-5883

BEST WESTERN FIESTA ISLES
5701 Padre Blvd (78597)
Rates: $39-$249
(956) 761-4913; (800) 528-1234

CASA DE SIESTA B&B INN
4610 Padre Blvd (78597)
Rates: $99-$150
(956) 761-5656

CASTAWAYS CONDOMINIUMS
3700 Gulf Blvd (78597)
Rates: $95+
(956) 761-1903; (800) 892-6278

COMFORT SUITES
912 Padre Blvd (78597)
Rates: $79-$249
(956) 772-9020; (800) 228-5150

CONTINENTAL CONDOMINIUMS
4908 Gulf Blvd (78597)
Rates: $84+
(956) 761-1306; (800) 426-6530

DAYS INN
3913 Padre Blvd (78597)
Rates: $59-$250
(956) 761-7831; (800) 329-7466

ECONO LODGE
3813 Padre Blvd (78597)
Rates: $29-$299
(956) 761-8500; (800) 553-2666

ISLAND INN ON THE BEACH
5100 Gulf Blvd (78597)
Rates: $59-$249
(956) 761-7677

LA INTERNATIONAL
5008 Gulf Blvd (78597)
Rates: $75+
(956) 761-1306; (800) 426-6530

MOTEL 6
4013 Padre Blvd (78597)
Rates: $37-$75
(956) 761-7911; (800) 466-8356

PALMS RESORT
3616 Gulf Blvd (78597)
Rates: $44+
(956) 761-1316; (800) 221-5218

Locate Other Dog-Friendly Activities...Check Nearby Cities

RAMADA LIMITED
4109 Padre Blvd (78597)
Rates: $49-$299
(956) 761-4097; (800) 272-6232

SAND CASTLE MOTEL
208 W Kingfish (78597)
Rates: $46-$64
(956) 761-1321; (800) 426-6530

SOUTH BEACH INN
120 E Jupiter (78597)
Rates: $39-$99
(956) 761-2471

SOUTH PADRE BEACH HOUSES
5009 Padre Blvd (78597)
Rates: $80-$360
(956) 761-6554

SUPER 8 MOTEL
4205 Padre Blvd (78597)
Rates: $40-$340
(956) 761-6300; (800) 800-8000

THE TIKI CONDOMINIUM HOTEL
6608 Padre Blvd (78597)
Rates: $79-$155
(956) 761-2694

TRAVELODGE
6200 Padre Blvd (78597)
Rates: $39-$295
(956) 761-4744; (800) 578-7878

TRES PALMAS BEACH HOUSE RENTALS
116 E Kingfish (78597)
Rates: $95-$200 per night/
$550-$1100 wk/ $900-$2200 month
(956) 761-5607

RECREATION

ANDY BOWIE COUNTY PARK - Leashes

Info: For a vehicle-free beach and a chance to chill out ocean-side, plan a day's outing with the wagalong to this beautiful county park. Stroll beside the shoreline and tickle your paws in the salty ocean water. For more information: (956) 761-2639.

Directions: Located across from the South Padre Island Convention Center on the northern tip of the town of South Padre Island.

Note: Entrance fee charged.

LAGUNA MADRE NATURE TRAIL HIKE - Leashes

Beginner/0.5 miles

Info: You and the furface will pawsitively love this excursion across 4 acres of natural wetlands. As you stroll the "boards," see how many birds and assorted wildlife you can recognize. Increase your knowledge of the local region by reading the posted interpretive signs. They provide interesting tidbits about the dune systems and various bird species that inhabit

Hotel Pet Policies May Be Subject To Change

the area. Before you call it quits for the day, check out the Convention Center's Whaling Wall. Painted by Wyland, a world-renowned environmental artist, it's dedicated to educating the public on the importance of marine conservation. For more information: (956) 761-6433.

Directions: The nature walk is accessible from the Convention Center at the north end of South Padre Island.

SPRING

LODGING

MOTEL 6
19606 Cypresswood Ct (77388)
Rates: $37-$46
(281) 350-6400; (800) 466-8356

STAFFORD

LODGING

BEST WESTERN FORT BEND INN & SUITES
11206 W Airport Blvd (77477)
Rates: $60+
(281) 575-6060; (800) 528-1234

DAYS INN
4630 Techniplex Dr (77477)
Rates: $38-$45
(281) 240-8100; (800) 329-7466

LA QUINTA INN
12727 Southwest Frwy (77477)
Rates: $60-$86
(281) 240-2300; (800) 687-6667

RESIDENCE INN BY MARRIOTT
12703 Southwest Frwy (77477)
Rates: $129+
(281) 277-0770; (800) 331-3131

STUDIO 6
12827 Southwest Frwy (77477)
Rates: $41-$58
(281) 240-6900; (888) 897-0202

WELLESLEY INN & SUITES
4726 Sugar Grove Blvd (77477)
Rates: $79-$89
(241) 240-0025; (800) 444-8888

STEPHENVILLE

LODGING

BEST WESTERN CROSS TIMBERS
1625 S Loop (76401)
Rates: $50-$85
(254) 968-2114; (800) 528-1234

COMFORT INN
2925 W Washington (76401)
Rates: $59-$99
(254) 965-7162; (800) 228-5150

DAYS INN
701 E South Loop (76401)
Rates: $48-$74
(254) 968-3392; (800) 329-7466

HOLIDAY INN
2865 W Washington (76401)
Rates: $89-$99
(254) 968-5256; (800) 465-4329

TEXAN INN
3030 W Washington (76401)
Rates: $36-$46
(254) 968-5003

STONEWALL

LODGING

COUNTRY CABINS B&B
P. O. Box 421 (78671)
Rates: $95-$130
(830) 868-7447

STRATFORD

LODGING

STRATFORD INN
402 Texas Ave (79084)
Rates: $39-$59
(806) 366-5574

Hotel Pet Policies May Be Subject To Change

SUGAR LAND

LODGING

DRURY INN & SUITES
13770 Southwest Frwy (77478)
Rates: $81-$111
(281) 277-9700; (800) 378-7946

HOLIDAY INN EXPRESS
14444 Southwest Frwy (77478)
Rates: $79
(281) 565-6655; (800) 465-4329

HEARTHSIDE SUITES BY VILLAGER
13420 Southwest Frwy (77478)
Rates: $59-$99
(281) 494-6699

STUDIO 6
12827 Southwest Frwy (77477)
Rates: $199-$279
(281) 240-6900; (888) 897-0202

SULPHUR SPRINGS

LODGING

BEST WESTERN TRAIL DUST INN
1521 Shannon Rd (75482)
Rates: $74-$109
(903) 885-7515; (800) 528-1234
(800) 980-2378

HOLIDAY INN
1495 E Industrial (75482)
Rates: $79-$99
(903) 885-0562; (800) 465-4329

COMFORT SUITES
1521 E Industrial (75483)
Rates: $74-$99
(903) 438-0918; (800) 228-5150

RECREATION

COOPER LAKE STATE PARKS (South Sulfer Unit) - Leashes

Info: Sniff the cedars, enjoy the elms and ogle the oaks in this beautiful, 2,500 acre expanse. Make your fishy dreams come true with a cruise atop the reservoir and a fish fry for dinner. If hiking's to your liking, strap on the pedometer and skedaddle along one of the nature trails for your daily dose of Texercise. Or be a lazy bones and merely chill out lakeside with your hot diggety doggie. For more information: (903) 945-5256; (800) 792-1112; www.tpwd.state.tx.us.

Locate Other Dog-Friendly Activities...Check Nearby Cities

Directions: From I-30, take exit for Highway 19 just west of Sulphur Springs. Travel north on Highway 19 for 14 miles. Go west on Highway 71 for 4 miles to FM 3505, turning north for 1 mile to the park entrance.

Note: Entrance fee charged.

SWEETWATER

LODGING

COMFORT INN
216 S Georgia St (79556)
Rates: $59-$125
(325) 235-5234; (800) 228-5150

HOLIDAY INN
500 NW Georgia St (79556)
Rates: $79-$119
(325) 236-6887; (800) 465-4329

MOTEL 6
510 NW Georgia St (79556)
Rates: $31-$40
(325) 235-4387; (800) 466-8356

MULBERRY MANSION B&B
1400 Sam Houston (79556)
Rates: $65-$225
(325) 235-3811; (800) 235-3911

RAMADA INN
701 SW Georgia St (79556)
Rates: $50-$60
(325) 235-4853; (800) 272-6232

RANCH HOUSE MOTEL
301 SW Georgia St (79556)
Rates: $39-$65
(325) 236-6341; (800) 622-5361

TRAVELERS MOTEL
1413 E Broadway (79556)
Rates: $25-$35
(325) 235-2850

TAYLOR

LODGING

REGENCY INN
2007 N Main (76574)
Rates: $40-$49
(512) 352-2666

Hotel Pet Policies May Be Subject To Change

RECREATION

MURPHY PARK - Leashes

Info: Put a little touch of nature in your morning with a short excursion to this pleasant park. And then perk up your pooch's tail on the one-mile trail.

Directions: Located off Lake Drive.

NOBEL E. YOUNG PARK - Leashes

Info: Jog with your dog on the one miler or get cozy on a grassy knoll where you can enjoy a tad of R&R.

Directions: Located at Luther and Seaton.

TEMPLE

LODGING

DAYS INN
1104 N General Bruce Dr (76504)
Rates: $59-$79
(254) 774-9223; (800) 329-7466

MOTEL 6
1100 N General Bruce Dr (76504)
Rates: $34-$50
(254) 778-0272; (800) 466-8356

ECONO LODGE
1001 N General Bruce Dr (76504)
Rates: $39-$79
(254) 771-1688; (800) 553-2666

STRATFORD HOUSE INN
1602 N General Bruce Dr (76502)
Rates: $75+
(254) 771-1495

HOWARD JOHNSON EXPRESS INN
1912 S 31st St (76504)
Rates: $59-$64
(254) 778-5521; (800) 446-4656

SUPER 8 MOTEL
5505 S General Bruce Dr (76502)
Rates: $45-$60
(254) 778-0962; (800) 800-8000

LA QUINTA INN
1604 W Barton Ave (76504)
Rates: $60-$85
(254) 771-2980; (800) 687-6667

TRAVELODGE
802 N General Bruce Dr (76504)
Rates: $40-$70
(254) 778-4411; (800) 578-7878

Locate Other Dog-Friendly Activities...Check Nearby Cities

TERLINGUA

LODGING

BIG BEND MOTOR INN
300 N Jim Wright Frwy (79852)
Rates: $70-$87
(432) 371-2218; (800) 848-2363

CHISOS MINING COMPANY MOTEL
Box 228, Hwy 170 (79852)
Rates: $40-$75
(432) 371-2254

EL DORADO MOTEL
P. O. Box 394 (79852)
Rates: $89-$150
(432) 371-2111

LAJITAS ON THE RIO GRANDE B&B
Star Rt 70, Box 400 (79852)
Rates: $48-$65
(432) 424-3471

TERLINGUA RANCH LODGE
HC 65, Box 600 (79830)
Rates: $42-$59
(432) 371-2416

TERRELL

LODGING

BEST INN
309 I-20 E (75160)
Rates: $45-$65
(972) 563-2676; (800) 237-8466

BEST WESTERN COUNTRY INN
1604 Hwy 34 W (75160)
Rates: $52-$62
(800) 528-1234; (800) 346-1580

MOTEL 6
101 Mira Place (75160)
Rates: $39-$47
(972) 563-0300; (800) 466-8356

SUPER 8 MOTEL
1705 Hwy 34 S (75160)
Rates: $50-$99
(972) 563-1511; (800) 800-8000

Hotel Pet Policies May Be Subject To Change

TEXARKANA (Arkansas)

LODGING

BAYMONT INN & SUITES
5102 N State Line Ave (71854)
Rates: $46-$89
(870) 773-1000; (877) 229-6668

BEST WESTERN KINGS ROW INN
4200 N State Line Ave (71854)
Rates: $55-$65
(870) 774-3851; (800) 528-1234

HOLIDAY INN-HOLIDOME
5100 N State Line Ave (71854)
Rates: $98
(870) 774-3521; (800) 465-4329

HOUSE OF WADLEY
618 Pecan (71854)
Rates: $99-$129
(870) 773-7093

QUALITY INN
5210 N State Line Ave (71854)
Rates: $49-$79
(870) 772-0070; (800) 228-5151

TEXARKANA (Texas)

LODGING

AMERI-STAR INN & SUITES
5105 State Line Ave (75501)
Rates: $50-$90
(903) 792-6688

**BEST WESTERN NORTHGATE
MOTOR LODGE**
400 W 53rd St (75502)
Rates: $55-$69
(903) 793-6565; (800) 528-1234
(800) 262-0048

ECONO LODGE
4505 N State Line Ave (75503)
Rates: $39-$79
(903) 793-5546; (800) 553-2666

FOUR POINTS HOTEL SHERATON
5301 N State Line Ave (75503)
Rates: $75-$105
(903) 792-3222; (800) 325-3535

HOLIDAY INN EXPRESS
5401 N State Line Ave (75503)
Rates: $71-$79
(903) 792-3366; (800) 465-4329

LA QUINTA INN
5201 N State Line Ave (75503)
Rates: $65-$81
(903) 794-1900; (800) 687-6667

MOTEL 6-WEST
1924 Hampton Rd (75503)
Rates: $35-$50
(903) 793-1413; (800) 466-8356

Locate Other Dog-Friendly Activities...Check Nearby Cities

RECREATION

SPRING LAKE PARK - LEASHES

Info: Start your day with a lakeside stroll or plan an afternoon of lazy day fishing. There's also a .5-mile walkway in this pretty park where you can limber up with the pup.

Directions: From Interstate 30, take the Summerhill Road exit and turn right. Proceed to the first light (Mall Drive) and turn left to Spring Lake Park.

WRIGHT PATMAN LAKE - Leashes

Info: Your wet wagger's tail will be whisking in the breeze when he catches sight of this massive lake surrounded by several small parks, blissful retreats for pupster shenanigans. Spend the day making your fishy dreams a reality or hightail it through the vast landscape for a day of exploration. Plenty of open space, shade and cushy green grass are bound to please the hound. A trip to this lake is a wonderful way to make your dog's day. Carpe diem Duke. For more information: (903) 838-8781; (800) 792-1112; www.tpwd.state.tx.us.

Directions: Located 9 miles southwest of Texarkana off Highway 59.

Note: Dogs are prohibited on beaches. Entrance fees may be required.

TEXAS CITY

LODGING

LA QUINTA INN
1121 Hwy 146 N (77590)
Rates: $65-$85
(409) 948-3101; (800) 687-6667

THE COLONY

<u>LODGING</u>

COMFORT SUITES
4796 Memorial Dr (75056)
Rates: $79-$90
(972) 668-5555; (800) 228-5150

THE WOODLANDS

<u>LODGING</u>

BUDGET INN & SUITES
19565 N I-45 (77384)
Rates: $55-$69
(936) 298-8140

DRURY INN & SUITES
28099 I-45 N (77381)
Rates: $72-$102
(281) 362-7222; (800) 378-7946

RED ROOF INN
24903 I-45 N (77380)
Rates: $48-$65
(281) 367-5040; (800) 843-7663

RESIDENCE INN I BY MARRIOTT
1040 Lake Front Cr (77380)
Rates: $105
(281) 292-3252; (800) 331-3131

RESIDENCE INN II BY MARRIOTT
9333 Six Pines Dr (77380)
Rates: $79-$159
(281) 419-1542; (800) 331-3131

THREE RIVERS

<u>LODGING</u>

BEST WESTERN
900 N Harborth Ave (78071)
Rates: $65-$85
(361) 786-2000; (800) 528-1234

NOLAN RYAN'S BASS INN
Hwy 72 W (78071)
Rates: $37-$99
(361) 786-3521; (800) 803-3340

<u>RECREATION</u>

CHOKE CANYON STATE PARKS (South Shore Unit) - Leashes

Info: Put a twinkle in the pup's eye with an excursion to this region. Partake of some relaxing shoreline serenity or make

Locate Other Dog-Friendly Activities...Check Nearby Cities

tracks along the trails through the delightfully shaded woodlands. Ground dwellers and sky soarers are abundant, so pack the binoculars and get ready for some interesting sightings. For more information: (361) 786-5358; (800) 792-1112; www.tpwd.state.tx.us.

Directions: From Three Rivers, head west on Highway 72 for 3.5 miles.

Note: Entrance fee charged.

TOMBALL

LODGING

LA QUINTA INN & SUITES
14000 Medical Complex Dr (77377)
Rates: $69-$109
(800) 687-6667

TRINITY

LODGING

WHISPERING PINES DUDE RANCH
933 FM 230 (75862)
Rates: $175-$300
(936) 594-3986

TULIA

LODGING

SELECT INN
Rt 1, Box 60 (79088)
Rates: $49-$64
(806) 995-3248

TYLER

LODGING

BEST WESTERN INN & SUITES
2828 W NW Loop 323 (75702)
Rates: $65-$99
(903) 595-2681; (800) 528-1234
(800) 298-9537

COMFORT SUITES
303 Rieck Rd (75703)
Rates: $79-$129
(903) 534-0999; (800) 228-5150

DAYS INN
12732 Hwy 155 N (75708)
Rates: $38-$75
(903) 877-9227; (800) 329-7466

ECONO LODGE
2739 WMW Loop 323 (75702)
Rates: $49-$99
(903) 531-9513; (800) 553-2666

HOLIDAY INN SELECT
5701 S Broadway (75703)
Rates: $129-$139
(903) 561-5800; (800) 465-4329

LA QUINTA INN
1601 W SW Loop 323 (75701)
Rates: $70-$99
(903) 561-2223; (800) 687-6667

MOTEL 6
3236 Gentry Pkwy (75702)
Rates: $31-$45
(903) 595-6691; (800) 466-8356

RADISSON HOTEL
2843 W NW Loop 323 (75702)
Rates: $79-$99
(903) 597-1301; (800) 333-3333

RAMADA TYLER CONFERENCE CENTER
3310 Troup Hwy (75701)
Rates: $48-$109
(903) 593-3600; (800) 272-6232

RESIDENCE INN BY MARRIOTT
3303 Troup Hwy (75701)
Rates: $76-$125
(903) 595-5188; (800) 331-3131

STRATFORD HOUSE INN MOTEL
2600 W NW Loop 323 (75702)
Rates: $31-$35
(903) 597-2756

RECREATION

TYLER STATE PARK - Leashes

Info: Pack a wet and wild attitude and put this beautiful park at the top of the day's destination. Furface can cool his paws as long as he's not in a designated swimming area or on the beach. A 2.5-mile trail leads terra firma Fidos around the lake, while a .75-mile nature trail laces the woodlands, the ideal locale to savor the serenity of East Texas. Bring binocs - the birdwatching is noteworthy. Pack a brown bagger or a fancy biscuit basket and dine alfresco when day is done. For more information: (903) 597-5338; (800) 792-1112; www.tpwd.state.tx.us.

Locate Other Dog-Friendly Activities...Check Nearby Cities

Directions: From Tyler, take FM 14 north to the park entrance approximately 2 miles north of the I-20 junction.

Note: $2 entrance fee/person.

The numbered hikes that follow are within Tyler State Park:

1) LAKE TRAIL HIKE - Leashes

Beginner/2.5 miles

Info: There's nothing quite as calming as a pretty stroll through nature. And that's exactly what you can expect on this hiking trail that circles part of the park's 65-acre lake. Move on out through lush forests of birch, ash and maple and let your spirits soar. Plan a trip in the fall and your hound will bound with glee through crispy, crunchy leaves while you take the time to appreciate the splendid autumnal colors. When hike time's over, your aquapup can practice his doggie paddle in the spring-fed lake, while you work on your backstroke. This is a two paws up kind of day. For more information: (903) 597-5338.

Directions: From Tyler, take FM 14 north to the park entrance approximately 2 miles north of the I-20 junction.

2) WHISPERING PINES NATURE TRAIL HIKE - Leashes

Beginner/0.75 miles

Info: Even telly bellies will like this simple, gentle trail amidst a shaded woodland. Pick up a trail guide before you head out and follow along as you make your way from one numbered post to the next. Come in springtime, the budding dogwood and redbud make this a numero uno trail for the sniffmeister set. For more information: (903) 597-5338.

Directions: From Tyler, take FM 14 north to the park entrance approximately 2 miles north of the I-20 junction.

MUNICIPAL ROSE GARDEN - Leashes

Info: Pine-scented air, the sweet fragrance of roses - that's what you'll find in this charming garden park. Stroll beneath towering pines, around fountains and ponds, through gazebos and archways, and stop to smell the flowers at the country's largest rose garden. With 38,000 rose bushes representing close to 500 varieties, this 22-acre garden is a rose connoisseur's dream come true. Blooming season is May through October, so plan accordingly. For more information: (903) 531-1212.

Directions: Located on W. Front Street at 420 Rose Park Drive.

UNCERTAIN

LODGING

MOSSY BRAKE LODGE B&B
151 Mossy Brake Dr S (75661)
Rates: $65+
(903) 789-3440; (800) 607-6002

SPATTERDOCK GUEST HOUSE
168 Mossy Brake D (75661)
Rates: $100
(903) 789-3268

UNIVERSAL CITY

LODGING

CLARION SUITES HOTEL
13191 E Loop, 1604 N (78233)
Rates: $69-$159
(210) 655-9491; (800) 252-7466

UTOPIA

LODGING

BBEAR CREEK CABINS
P. O. Box 453, Hwy 1050 (78884)
Rates: $85-$95
(800) 483-7593

Locate Other Dog-Friendly Activities...Check Nearby Cities

UVALDE

LODGING

BEST WESTERN CONTINENTAL INN
701 E Main St (78801)
Rates: $55-$80
(830) 278-5671; (800) 528-1234

INN OF UVALDE
920 E Main St (78801)
Rates: $88-$93
(830) 278-4511

FRIDAY RANCH (Working ranch)
P O Box 1 (78802)
Rates: $110-$225
(830) 597-2257; (877) 374-3298

RECREATION

FORT INGE COUNTY PARK - Leashes

Info: Originally built as a U.S. Cavalry post in 1849, the fort is an interesting site to visit. You can boogie with Bowser on one of the hiking trails that honeycomb the area or find an out-of-the-way spot beside the scenic Leona River and nestle in for an afternoon of peaceful serenery. Your wet wagger will get his fill of fun with some paw dipping or ball fetching. To enhance the picture, there's an 80-million-year-old extinct volcano standing guard over the 42-acre park. For more information: (800) 588-2533.

Directions: Located 1.5 miles north of Uvalde on Highway 90 West.

JARDIN DE LOS HEROES PARK - Leashes

Info: Named "Garden of the Heroes," this park was created to honor Vietnam War veterans. You and the dawgus can stroll through the lovely grounds on the jogging trail and then nibble on some kibble at one of the picnic benches. For more information: (830) 278-6155.

Directions: Located at 801 West Main.

Hotel Pet Policies May Be Subject To Change

UVALDE MEMORIAL PARK & RECREATIONAL COMPLEX - Leashes

Info: Situated on the banks of the picturesque Leona River, this tree-lined park is perfect for a morning or afternoon gad-about. Picnic tables provide the ideal place to munch on lunch alfresco and numerous pathways lead the way for active breeds to frolic in the woods. For more information: (830) 278-6155.

Directions: Located at 337 East Main.

VAN

LODGING
VAN INN
P. O. Box 956 (75790)
Rates: $32-$70
(903) 963-8381

VAN HORN

LODGING

BEST WESTERN AMERICAN INN
1309 W Broadway (79855)
Rates: $49-$95
(432) 283-2030; (800) 528-1234
(800) 621-2478

BEST WESTERN INN VAN HORN
1705 W Broadway (79855)
Rates: $45-$89
(432) 283-2410; (800) 528-1234
(800) 367-7589

BUDGET INN
1303 W Broadway (79855)
Rates: $25-$45
(432) 283-2019

COMFORT INN
1601 W Broadway (79855)
Rates: $45-$79
(432) 283-2211; (800) 228-5150

DAYS INN
600 E Broadway St (79855)
Rates: $52-$62
(432) 283-1007; (800) 329-7466

ECONOMY INN
1500 W Broadway St (79855)
Rates: $25-$55
(432) 283-2754; (800) 826-0778

HOLIDAY INN EXPRESS
1905 SW Frontage Rd (79855)
Rates: $69-$99
(432) 283-7444; (800) 465-4329

RAMADA LIMITED
200 Golf Course Dr (79855)
Rates: $48-$88
(432) 283-2780; (800) 272-6232

MOTEL 6
1805 W Broadway St (79855)
Rates: $45-$55
(432) 283-2992; (800) 466-8356

SUPER 8 MOTEL
1807 E Service Rd (79855)
Rates: $52-$62
(432) 283-2282; (800) 800-8000

VANDERPOOL

RECREATION

LOST MAPLES STATE NATURAL AREA - Leashes

Info: Aqua pups will go gaga over this lush riparian oasis. Babbling brooks, bubbling springs, rugged canyons, plateau grasslands and wooded slopes characterize this stunning landscape smack dab in the heart of picturesque Hill Country. Bigtooth maples are among the park's most outstanding features. Come November, the terrain explodes in a fiery kaleidoscope of red, yellow and orange. Pooches who love to roll in piles of crunchy leaves won't want to leave.

Lost Maples is also home to some of the state's most interesting and secretive little critters. The Texas salamander, the rare barking frog and the Texas cliff frog dwell within the region. Or look skyward and see if you catch sight of a rare golden-cheeked warbler, black-capped vireo or green kingfisher. Listen carefully too - what sounds like a rippling stream may actually be the cry of a canon wren. Visit in winter and you might get lucky and see a golden eagle. No matter when you visit, plan to spend the day. You and the dawgus are gonna love this spectacular natural playground. For more information: (830) 996-3413; (800) 792-1112; www.tpwd.state.tx.us.

Directions: From Vanderpool, take Ranch Road 187 north for 5 miles to the park.

Note: Entrance fee charged.

The numbered hikes that follow are within Lost Maples State Park:

1) EAST TRAIL HIKE - Leashes

Intermediate/Expert/4.2 miles

Info: If you've got a fair amount of hiking miles under your belt and your canine's up to the challenge, this trek will make you feel like a champ. Leave the hustle and bustle of life behind and commune with Old Mother Nature in this pretty region. You and old tough paws can traipse through groves of bigtooth maples, cool your jets in fast running creeks and zig zag steep-walled canyons before looping back to your starting point. Certain sections of the trail are steep and rocky, so make sure your hiking boots have plenty of traction. If yours is a water-loving wagger, he'll think he's found paradise. This waterful, adventurous hike encompasses the Sabinal River, Hale Hollow Creek, and Can Creek, very special oases. Don't forget to pack power snacks and plenty of Perrier, you'll need both. For more information: (830) 996-3413.

Directions: From Vanderpool, take Ranch Road 187 north for 5 miles to the park.

2) MAPLE TRAIL HIKE - Leashes

Beginner/1.0 miles

Info: If the sound of leaves crunching underfoot is music to your mutt's ears, then this hike's for you. Canopied by the park's famous bigtooth maples, the interpretive trail skirts the scenic Sabinal River. If the area's rainfall has been good, your wagalong will have a wet and wild adventure, especially on those dog days of summer. Fall aficionados, don't miss the autumn spectacular starring the bigtooth maples appearing daily from late October through mid-November. For more information: (830) 966-3413.

Directions: From Vanderpool, take Ranch Road 187 north for 5 miles to the park.

3) WEST TRAIL HIKE - Leashes

Intermediate/Expert/4.2 miles

Info: This demanding canyon hike is definitely not for the fair of paw or out of shape. The trail takes you on a yoyo-like journey through steep, rugged Mystic Canyon, where spectacular bigtooth maples dot the landscape. If you and your hardy hiking hound can tough it out to trail's end, you'll find a number of refreshing waterholes at Can Creek and the surrounding ponds. Chill out in the shade with a brown bagger before retracing your steps. For more information: (830) 966-3413.

Directions: From Vanderpool, take Ranch Road 187 north for 5 miles to the park.

VEGA

LODGING

BEST WESTERN COUNTRY INN
1800 W Vega Blvd (79092)
Rates: $59-$89
(806) 267-2131; (800) 528-1234

VERNON

LODGING

BEST WESTERN VILLAGE INN
1615 Expressway (76384)
Rates: $59-$69
(940) 552-5417; (800) 528-1234
(800) 600-5417

SUPER 8 MOTEL
1829 Exp Hwy 287 (76384)
Rates: $36-$52
(940) 552-9321; (800) 800-8000

WESTERN MOTEL
715 Wilbarger St (76384)
Rates: $28-$45
(940) 552-2531

Hotel Pet Policies May Be Subject To Change

VICTORIA

LODGING

COMFORT INN
1906 Houston Hwy (77901)
Rates: $59-$130
(361) 574-9393; (800) 228-5150

HOLIDAY INN HOLIDOME
2705 E Houston Hwy (77901)
Rates: $90-$145
(361) 575-0251; (800) 465-4329

LA QUINTA INN
7603 N Navarro St (77904)
Rates: $65-$91
(361) 572-3585; (800) 687-6667

MOTEL 6
3716 E Houston Hwy (77901)
Rates: $35-$40
(361) 573-1273; (800) 466-8356

QUALITY INN
3112 Houston Hwy (77901)
Rates: $69-$129
(800) 228-5151

RECREATION

COLETO CREEK RESERVOIR & PARK - Leashes

Info: Fido's ears will be flapping in the breeze if you choose to cruise across the 3,100-acre reservoir. Pick a spot and try your line, there's definitely something fishy going on in these parts, like bass, crappie, catfish, and coppernosed blue gill perch. If terra firma's more your style, you and your tagalong will love the nature trail which laces a splendid shaded woodland. End the afternoon under century-old oaks as you dine with the canine in this vast and picturesque park. For more information: (361) 575-6366.

Directions: Located at the midway point between Victoria and Goliad on Highway 59 South.

VIDOR

RECREATION

CLAIBORNE WEST COUNTY PARK - Leashes

Info: Gander at the Gulf of Mexico or see what an exploration of the bayou uncovers in this vast region. Several trails honey-

comb the area and offer great birdwatching and nature study-ing opportunities. For more information: (409) 745-2255.

Directions: Located at 4105 North Street.

OTHER PARKS IN VIDOR - Leashes
For more information, contact the City of Vidor at (409) 745-2255.
•RAYMOND GOULD WALKING PARK, 385 Claiborne Street

WACO

LODGING

BEST WESTERN OLD MAIN LODGE
I-35 & 4th St (76706)
Rates: $84-$99
(254) 753-0316; (800) 528-1234
(800) 299-9226

BEST WESTERN WACO MALL
6624 Hwy 84 W (76712)
Rates: $62-$75
(254) 776-3194; (800) 528-1234
(800) 346-1581

CLARION HOTEL
801 S 4th St (76706)
Rates: $59-$149
(254) 757-2000; (800) 252-7466

DAYS INN
1504 I-35 N (76705)
Rates: $69-$89
(254) 799-8585; (800) 329-7466

HAWTHORN SUITES
1508 I-35 N (76705)
Rates: $85-$110
(254) 799-9989; (800) 527-1133

HOLIDAY INN
1001 Martin Luther King Blvd (76704)
Rates: $90-$100
(254) 753-0261; (800) 465-4329

LA QUINTA INN
1110 S 9th St (76706)
Rates: $70-$99
(254) 752-9741; (800) 687-6667

MOTEL 6 SOUTH
3120 Jack Kultgen Frwy (76706)
Rates: $38-$58
(254) 662-4622; (800) 466-8356

RESIDENCE INN BY MARRIOTT
501 S University Parks Dr (76706)
Rates: $120
(254) 714-1386; (800) 331-3131

RODEWAY INN
3912 Jack Kultgen Frwy (76709)
Rates: $39-$79
(254) 662-3320; (800) 228-2000

SUPER 8 MOTEL
1320 S Jack Kultgen Frwy (76706)
Rates: $59-$79
(254) 754-1023; (800) 800-8000

Hotel Pet Policies May Be Subject To Change

<u>RECREATION</u>

CAMERON PARK - Leashes

Info: This massive, 416-acre park is the perfect prescription for what ails you. You'll find tons of fun in the sun as you journey along the simple riverside trail and explore the ancient cliffs. Make note too of the regional vegetation. Rare Dog's Tooth Violets and a diversity of other colorful wildflowers paint the landscape. Numerous picnic areas and shade trees dot the region, providing blanket-spreading opportunities for biscuit breaks. For more information: (254) 750-5996.

Directions: There are several access points to the park from Lake Brazos Drive/Martin Luther King Jr. Boulevard and off Cameron Park Drive.

WAXAHACHIE

<u>LODGING</u>

BEST WESTERN GINGERBREAD INN
200 N I-35 E (75165)
Rates: $66-$82
(972) 937-4202; (800) 528-1234

RAMADA LIMITED
795 S I-35 E (75165)
Rates: $38-$155
(972) 937-4982; (800) 272-6232

BONNYNOOK INN B&B
414 W Main (75165)
Rates: $75-$105
(972) 938-7207; (800) 486-5936

SUPER 8 MOTEL
400 I-35 E (75165)
Rates: $60-$75
(972) 938-9088; (800) 800-8000

WEATHERFORD

<u>LODGING</u>

BEST WESTERN SANTA FE INN
1927 Santa Fe Dr (76086)
Rates: $69-$89
(817) 594-7401; (800) 528-1234
(800) 229-3400

DAYS INN
1106 W Park Ave (76087)
Rates: $49-$159
(817) 594-3816; (800) 329-7466

HAMPTON INN
2524 S Main St (76087)
Rates: $70-$150
(817) 599-4800; (800) 426-7866

HOLIDAY INN EXPRESS & SUITES
2500 S Main St (76087)
Rates: $70-$160
(817) 599-3700; (800) 465-4329

LA QUINTA INN
1915 Wall St (76086)
Rates: $79-$129
(800) 687-6667

SUPER 8 MOTEL
720 Adams Dr (76087)
Rates: $50-$70
(817) 598-0852; (800) 800-8000

WEATHERFORD COMFORT SUITES
210 Alford Dr (76086)
Rates: $75-$159
(817) 599-3300

WEBSTER

LODGING

MOTEL 6
1001 W NASA Rd One (77598)
Rates: $40-$55
(281) 332-4581; (800) 466-8356

WELLESLEY INN & SUITES
720 W Bay Area Blvd (77598)
Rates: $85-$139
(281) 338-7711; (800) 444-8888

WEIMAR

LODGING

SUPER 8 MOTEL
102 Townsend Ln (78962)
Rates: $55-$85
(979) 725-9788; (800) 800-8000

WELLINGTON

LODGING

CHEROKEE INN & RESTAURANT
1105 Houston (79095)
Rates: $32-$48
(806) 447-2508

Hotel Pet Policies May Be Subject To Change

WESLACO

Lodging

**BEST WESTERN PALM AIRE
MOTOR INN & SUITES**
415 S Int'l Blvd (78596)
Rates: $48-$111
(956) 969-2411; (800) 528-1234
(800) 248-6511

DELUXE INN & SUITES
601 N Westgate Dr (78596)
Rates: $35-$75
(956) 968-0606

SUPER 8 MOTEL
1702 E Expwy 83 (78596)
Rates: $45-$69
(956) 969-9920; (800) 800-8000

WEST COLUMBIA

Lodging

BEST WESTERN INN
714 Columbia Dr (77486)
Rates: $55-$68
(800) 528-1234
(888) 325-7819

Recreation

VARNER-HOGG PLANTATION STATE HISTORIC SITE - Leashes

Info: As long as you're the outdoorsy type (no pooches allowed in the buildings) you and your canine companion can have it all in this 66-acre park. Learn about the past along a self-guided tour of the history-rich plantation or keep your paws in the present with a picnic by the stream. Fishing fiends can try their luck on a hapless catfish or two. Grassy areas and plenty of shade will cool you even on a doggone hot day. And birders will go bonkers with the avian opportunities. For more information: (979) 345-4656; (800) 792-1112; www.tpwd.state.tx.us.

Directions: From West Columbia, head north on FM 2852 for 2 miles to the park entrance.

Note: Free to the public. Open 8:00 am to dusk.

Locate Other Dog-Friendly Activities...Check Nearby Cities

The numbered hike that follows is within Varner-Hogg State Historic Site:

1) VARNER-HOGG HISTORIC TRAIL HIKE - Leashes
Beginner/0.5 miles

Info: History is the name of the game on this loop-de-loop trail. Simply buy a trail guide from headquarters and blast back to the past with your Curious George. The guide, which corresponds with trail posts, gives detailed information on the historic sites and ruins that you'll encounter on your expedition. For more information: (979) 345-4656.

Directions: From West Columbia, head north on FM 2852 for 2 miles to the park entrance.

WESTLAKE

LODGING
MARRIOTT SOLANA DALLAS/FW
5 Village Cir (76262)
Rates: $75-$151
(817) 430-3848; (800) 228-9290

WHITNEY

RECREATION
LAKE WHITNEY STATE PARK - Leashes

Info: Etched on the eastern shores of the state's fourth largest reservoir, Lake Whitney State Park can be the afternoon excursion you and furface have been hankering for. Afishionados, your wildest fishing dreams might come true at this lake where the state record for small-mouth bass was recorded. Landlubbers, white-tailed deer, armadillo and opossum are often seen scurrying this way and that. Birders, you might just get the opportunity to add to your sightings. Pack a brown bagger for you and your wagger and make a memorable day

Hotel Pet Policies May Be Subject To Change

of it in this 1,280-acre slice of nature. For more information: (254) 694-3793; (800) 792-1112; www.tpwd.state.tx.us.

Directions: From Whitney, take FM 1244 west for 3 miles to the park entrance.

Note: $2 entrance fee/person.

The numbered hike that follows is within Lake Whitney State Park:

1) NATURE TRAIL HIKE - Leashes

Beginner/1.0 miles

Info: If you and Bowser are fixin' to spend some time outdoors, you can't beat this looping nature trail. Dense woodlands of oak, cedar, elm and mesquite shade your path, while Lake Whitney answers your aquapup's wet and wild dreams. Complete with benches and foot bridges, this trail gets the high-five. For more information: (254) 694-3793.

Directions: From Whitney, take FM 1244 west for 3 miles to the park entrance.

WICHITA FALLS

LODGING

BEST WESTERN WICHITA FALLS INN
1032 Central Frwy (76305)
Rates: $59-$136
(940) 766-6881; (800) 528-1234

COMFORT INN & SUITES
1740 Maurine St (76304)
Rates: $69-$99
(940) 767-5653; (800) 228-5150

ECONO LODGE
1700 Fifth St (76301)
Rates: $55-$70
(940) 761-1889; (800) 553-2666

HAMPTON INN
1317 Kenley Ave (76305)
Rates: $59-$89
(940) 766-3300; (800) 426-7866

HAWTHORN SUITES LTD
1917 N Elmwood Ave (76308)
Rates: $84-$149
(940) 692-7900; (800) 527-1133

KINGS INN
1211 Central Expwy (76305)
Rates: $36-$55
(940) 723-5541

Locate Other Dog-Friendly Activities...Check Nearby Cities

LA QUINTA INN
1128 Central
Frwy N (76305)
Rates: $63-$79
(940) 322-6971; (800) 687-6667

MOTEL 6
1812 Maurine St (76304)
Rates: $39-$57
(940) 322-8817; (800) 466-8356

QUALITY INN & SUITES
1750 Maurine St (76306)
Rates: $59-$69
(940) 322-2477; (800) 228-5151

RADISSON HOTEL
100 Central Frwy (76305)
Rates: $79-$99
(940) 761-6000; (800) 333-3333

RAMADA LIMITED
3209 Northwest Frwy (76305)
Rates: $55+
(940) 855-0085; (800) 272-6232

TOWNE CREST INN
1601 8th St (76301)
Rates: $37-$49
(940) 322-1182

RECREATION

CITY VIEW PARK - Leashes

Info: Bring a book, a biscuit basket and picnic with your pooch in this pleasant 6-acre park.

Directions: Located at Grandview and Viewpark.

EDGEMERE PARK - Leashes

Info: Make your buddy gleeful with a walk in the park or put a grin on the ballmeister's face with a game of catch in this 6-acre green scene.

Directions: Located at Mesquite and Augusta.

EXPRESSWAY VILLAGE PARK - Leashes

Info: Strut with the mutt and set tails thumping with a scamper amidst 10 acres of open space.

Directions: Located at Missile and Castle.

HURSH PARK - Leashes

Info: Catch a local game of hoops and then enjoy a game of tagalong with your wagalong in this neighborhood park.

Directions: Located at Bert and Kelly.

Hotel Pet Policies May Be Subject To Change

JAYCEE PARK - Leashes

Info: A happening place, there's always some sporting game going on at this 234-acre park. Whether you root, root, root for the home team or admire the skill of grounded model airplane pilots, you and furface are guaranteed a doggone terrific time.

Directions: Located at Fairway and Lakeside.

JEFFERSON PARK - Leashes

Info: When the indoor doldrums hit, fight back with an afternoon away from it all at this 16-acre parkland.

Directions: Located at Lindale and Mistletoe.

JONES PARK - Leashes

Info: You and Fido will get that aristocratic feeling on a snifforama stroll in this small park that is highlighted by a formal garden.

Directions: Located at Ninth and Broad.

LAKE ARROWHEAD STATE PARK - Leashes

Info: Every dog must have his day. Make yours a glorious one in this Edenesque setting on the Little Wichita River. With over 524 acres of parkland and 106 miles of shoreline, Lake Arrowhead will delight your senses in every way imaginable. Sun worshippers can soak up the rays lakeside while hiking hounds can rack up some serious miles along the trails. Fishing fiends, try your luck and snatch a catch. This pick-your-pleasure kind of day is bound to be a memorable one for you and your hot diggety dog. Canine connoisseurs give this region the high five. For more information: (940) 528-2211; (800) 792-1112; www.tpwd.state.tx.us.

Directions: From Wichita Falls, take US 281 south to FM 1954. Head east on FM 1954 for 8 miles to the park entrance.

Note: $2 entrance fee/person.

The numbered hike that follows is within Lake Arrowhead State Park:

Locate Other Dog-Friendly Activities...Check Nearby Cities

1) LAKE ARROWHEAD NATURE TRAIL HIKE - Leashes

Beginner/0.5 miles

Info: Education is the name of the game on this short, interpretive trail. Simply pick up a trail guide and get set for a quickie tree and plant lesson. When class is over, reward your furry classmate with some old fashioned tootsie dipping at the lake. For more information: (940) 528-2211.

Directions: From Wichita Falls, take U.S. 281 south to FM 1954. Head east on FM 1954 for 8 miles to the park entrance.

LAMAR PARK - Leashes

Info: Munch on lunch with the dogster before tackling an exploration of the 18 acres of open space you'll discover in this park. It's a sure bet that tails will be wagging in the breeze..

Directions: Located at Best and Lucas.

LUCY PARK - Leashes

Info: Say adios to the afternoon doldrums and howdy to a good time with a visit to this 167-acre park. Do something different for a change. Rent a canoe and paddle your way amidst a tree-lined river. Investigate turf and shrub, wildflower and xeriscape exhibits. Or do some plain old cloudgazing beside the waterfall as the soothing sounds wash away your cares. There's also a disc golf course and a ducky pond to round out your enjoyment of this scenic expanse.

Directions: Located at Sunset and Williams, adjacent to the Big Wichita River.

LYNWOOD EAST PARK - Leashes

Info: Fun and games are a no-cost way to enjoy the day with your pal at this 11-acre green scene. Take advantage of the half-mile trail and burn a few calories while you're at it.

Directions: Located at Roanoke and Redfox.

Hotel Pet Policies May Be Subject To Change

MARTIN PLAZA PARK - Leashes

Info: Laze away the day lakeside or wander with your gadabout in this 10-acre park.

Directions: Located at Harrison and Ellingham.

ROTARY PARK - Leashes

Info: If you've always had a fascination with trains, tickle your toes and chug chug on down to this 10-acre park, home to a locomotive.

Directions: Located at Phillips and Hughes, adjacent to Cunningham School.

SCOTLAND PARK - Leashes

Info: Walk off the kibble on the concrete trail that winds around the ballfields in this sporty 28-acre park. And then cheer for the home team.

Directions: Located at Central Expressway and Lynwood, adjacent to Huey School.

SUNSET TERRACE PARK - Leashes

Info: A laid-back interlude is yours for the grabbing in this 18-acre park. Take a break on one of the swinging benches before ending your day.

Directions: Located at Cimarron and Covington.

WESTOVER PARK - Leashes

Info: Lollygag with the wagger at this 7-acre park.

Directions: Located at Wenonah and 10th.

WILLIAMS PARK - Leashes

Info: Shake a leg along the concrete pathway that snakes through this expansive 38-acre sports-oriented park.

Directions: Located at Williams and Jackson.

Locate Other Dog-Friendly Activities...Check Nearby Cities

WOOD PARK - Leashes

Info: Become a kid again and do a little rock skimming before you settle in for a lakeside lunch with your kibble nibbler in this lovely 6-acre park.

Directions: Located at Maplewood and Miller Roads.

OTHER PARKS IN WICHITA FALLS - Leashes

For more information, contact the Wichita Falls Parks & Recreation Department at (940) 761-7491.

- BELAIR PARK, Opal & Lesley
- BEN DONNELL PARK, Wichita & Calhoun
- BRIDWELL PARK, Harrison & Avenue C
- BUD DANIEL PARK, Ninth & Ohio
- CONOCO PARK, Old Burk Road & Eastside Drive
- FANNIN PARK, Bridge & Washington
- FRONT AND INDIANA PARK, Front & Indiana
- GRANT STREET PARK, Grant & Avenue L
- HAMILTON PARK, Hamilton & Midwestern
- INDIAN HEIGHTS PARK, Indian Heights & Onaway
- JALONICK PARK, Jalonick & South Rosewood
- JARRATT PARK, Cumberland & Lebanon
- KIWANIS PARK, Southwest Parkway & Hughes
- LINCOLN PARK, Roosevelt & Homes
- LIONS PARK, Joann & Katherine
- LOCH LOMAND PARK, Loch Lomand & Colleen
- MORNINGSIDE PARK, Morningside & Pembroke
- O'REILLY PARK, Front & Lee
- ROSELAWN PARK, Roselawn & Speedway
- SOUTHERN HILLS PARK, Armory & Montgomery
- SPUDDER PARK, 7th & Tulsa
- TESCO PARK, Arthur & Avenue Z
- WEEKS PARK, Hamilton & Midwestern

WIMBERLEY

LODGING

A CREEK RUNS THROUGH IT GUESTHOUSE
3200 FM3237 (78676)
Rates: $95-$225
(512) 847-6887; (877) 327-9138

HILL COUNTRY ACCOMMODATIONS
14015 Ranch Rd 12 (78676)
Rates: $75-$650
(512) 847-5388; (800) 926-5028

HOMESTEAD COTTAGES B & B
RR 2 at Scudder Ln (78676)
Rates: $85-$99
(512) 847-8788; (800) 918-8788

**LONESOME DOVE RIVER INN
AT CLIFFSIDE B&B**
600 River Rd (78676)
Rates: $85+
(512) 392-2921; (800) 690-3683

7A RANCH RESORT
333 Wayside Dr (78676)
Rates: $50-$86
(512) 847-2517

SINGING CYPRESS GARDENS
400 Mill Race Ln (78676)
Rates: $75-$150
(512) 847-9344; (800) 827-1913

SOUTHWIND B&B INN AND CABINS
2701 FM 3237 (78676)
Rates: $75-$90
(800) 508-5277

WINNIE

LODGING

BEST WESTERN GULF COAST INN
46318 I-10 East (77665)
Rates: $50-$75
(409) 296-9292; (800) 528-1234

WINNSBORO

LODGING

THEE HUBBELL HOUSE BED & BREAKFAST
307 W Elm St (75494)
Rates: $89-$175
(800) 227-0639

Locate Other Dog-Friendly Activities...Check Nearby Cities

WOODVILLE

LODGING

WOODVILLE INN
201 N Magnolia (75979)
Rates: $36-$45
(409) 283-3741

RECREATION

DOGWOOD TRAIL HIKE - Leashes

Beginner/1.5 miles

Info: This looping trail is short, sweet and best hiked in spring when the gorgeous dogwoods are in glorious bloom. Dollar to dog biscuits, your hot diggety dog will love some paw dipping in Theuvenin Creek. Hey wet your own tootsies too. For more information: (936) 632-TREE.

Directions: From Woodville, take Highway 190 east approximately 3 miles to Dogwood Drive and trailhead.

YOAKUM

LODGING

BUDGET HOST LA MANCHA INN
606 S Hwy 77A (77995)
Rates: $40-$75
(361) 293-5211; (800) 283-4678

ZAPATA

LODGING

BEACON LODGE
313 Lakeshore Dr (78076)
Rates: n/a
(956) 765-4616

BEST WESTERN INN BY THE LAKE
Hwy 83 S (78076)
Rates: $68-$85
(956) 765-8403; (800) 528-1234
(800) 399-1558

FALCON MOTOR HOTEL
Hwy 83 S (78076)
Rates: n/a
(956) 765-4373

SIESTA MOTEL
Hwy 73 & 5th St (78076)
Rates: n/a
(956) 765-4362

ZAVALLA

RECREATION

ANGELINA NATIONAL FOREST

Angelina Ranger District
111 Walnut Ridge Rd, Zavalla, TX 75980,
(936) 897-1068

Info: The Angelina may be the smallest national forest in Texas, but it packs a large recreational punch. Named for the legendary Indian woman who befriended early Spanish and French missionaries, this forest encompasses over 154,000 acres with 10 developed recreation areas and 560 miles of shoreline, making it a naturalist's dream come true. Lace up for an invigorating hike through thick pine forests or set sail for a waterful adventure on Texas' largest lake - 114,000-acre Sam Rayburn Reservoir. When play's the thing, this forest is the stage. For more information: (936) 897-1068 or visit their website at www.southernregion.fs.fed.us.

Directions: The forest lies within the boundaries of Angelina, San Augustine, Jasper and Nacogdoches counties and is accessible from a handful of secondary highways in Zavalla. Refer to specific directions following each recreation area and hiking trail.

For more information on recreation in the Angelina National Forest, see listings under Lufkin.

The numbered hikes/recreation areas that follow are within the Angelina National Forest:

1) BOUTON LAKE RECREATION AREA - Leashes

Info: A favorite with the wet set, 12-acre Bouton Lake is the main attraction of this recreation area. Watch the sunlight dance across the water from a pretty lakeside setting or break out the checkered blanket and chow down under a shady river-bottom hardwood. If you're fixin' to burn some kibble, hustle your butt to the Sawmill Hiking Trail. Anglers can fish to their heart's content and snag a bag of bream, bass, catfish and crappie. Remember, no gasoline powered motors. Or play Sherlock and do your own investigation of this diverse landscape. For more information: (936) 897-1068 or visit their website at www.southernregion.fs.fed.us.

Directions: From Zavalla, take Highway 63 east for 7 miles to FSR 303. Turn right on FSR 303 for 7 miles to the recreation area.

2) BOYKIN SPRINGS RECREATION AREA - Leashes

Info: Treat your furry sidekick to an afternoon delight at pupular Boykin Springs. Highlighted by a 10-acre spring-fed lake, this recreation area offers plenty of wet and wild opportunities including boating, fishing and swimming for you and your soon-to-be-dirty dog. If you'd rather stick to clean and dry, then the pine-scented hiking trails will be more to your liking. Sorry Charlie, doggie paddling is not permitted at the designated swimming area, the beach or the springs and no gasoline powered motors allowed. For more information: (936) 897-1068; www.southernregion.fs.fed.us.

Directions: From Zavalla, take Highway 63 east for 11 miles to the Boykin Springs sign at FSR 313. Turn right on FSR 313 for 2.5 miles to the recreation area.

Hotel Pet Policies May Be Subject To Change

3) BOYKIN SPRINGS TRAIL HIKE - Leashes

Beginner/0.7 miles

Info: When a little trek will do, this lickety split trail is the one for you. Short and picturesque, this loop-de-loop takes you around the lake and past the springs before depositing you where you began. For more information: (936) 897-1068 or visit their website at www.southernregion.fs.fed.us.

Directions: From Zavalla, take Highway 63 east for 11 miles to the Boykin Springs sign at FSR 313. Turn right on FSR 313 for 2.5 miles to Boykin Springs Recreation Area and the trailhead.

4) CANEY CREEK RECREATION AREA - Leashes

Info: A slice of doggie heaven smack dab in the middle of the forest. Bowwow. Get ready to skedaddle on an adventure extraordinaire, an afternoon crammed with everything outdoorsy like hiking, boating, fishing, swimming, tanning and picnicking. Nature lovers can explore the lush woodlands on a hiking trails, while sailing Snoopys float their boats on Sam Rayburn Reservoir. Able anglers can see if a dinner of bass or catfish awaits, while aquapups work on perfecting their doggie paddle. Pick your pleasure and let the good times roll. For more information: (936) 897-1068 or visit their website at www.southernregion.fs.fed.us.

Directions: From Zavalla, take Highway 63 east for 6 miles to FM 2743. Turn left on FM 2743 for 4.5 miles to FSR 336. Make a left on FSR 336 for 1 mile, following the signs to the recreation area.

5) HARVEY CREEK RECREATION AREA - Leashes

Info: City weary canines can join their country cousins and have a paw-stomping good time at this wonderland of nature, aka Harvey Creek Recreation Area. Located on the high slopes surrounding Sam Rayburn Reservoir, Harvey Creek affords outdoor enthusiasts the chance to escape the crowds and commune with nature. You and Rover can spend the day roving

through beautiful pine and hardwood forests or charting your own course on the reservoir. Don't forget your line, the fishing's fine, not to mention the endless paw-dipping opportunities. Go for it. You won't regret a moment spent in this sweet spot. For more information: (936) 897-1068 or visit their website at www.southernregion.fs.fed.us.

Directions: From Zavalla, take Highway 147 north to Highway 83. Head east on Highway 83 for 4 miles to FM 2390. Turn right on FM 2390 for 5 miles to the recreation area.

6) SANDY CREEK RECREATION AREA - Leashes

Info: Sand, trees and lots of agua fria come together to make this a must-see, must-do recreation oasis. The pristine beach can't be beat for a bit of lazy day sun worshiping. The lush pine and hardwood forests are another story- they provide athletic breeds with five-star hiking adventures. But if you and your wagalot are water dogs, check out Sam Rayburn Reservoir where you can tote a boat and float the day away. Swim, fish and make your own fun in this watery wonderland. Carpe diem Duke. For more information: (936) 897-1068 or visit their website at www.southernregion.fs.fed.us.

Directions: From Zavalla, take Highway 63 east approximately 18 miles to FSR 333. Turn left on FSR 333 for 2 miles to the recreation area.

7) SAWMILL HIKING TRAIL - Leashes

Intermediate/11.0 miles

Info: You and Old Floppy Ears will know your bodies have been maxed out after this lengthy hike. But if the glimmer of shimmering water and the lure of cool, damp forests sends tails a-wagging, then limber up, pack plenty of trail treats and water and move on out. The trail follows a relatively level course along the Neches River, over bridges and through piney woods, connecting Bouton Lake Recreation Area to Boykin Springs Recreation Area. Your shady route is compliments of longleaf pine, bald cypress, loblolly pine, oak and

Hotel Pet Policies May Be Subject To Change

various hardwoods, but it's the lakes, streams and creeks that guarantee gleeful playtime. Birders will go bonkers - over 200 species of birds, including the endangered red-cockaded woodpecker inhabit this region. White rectangular paint marks on the trees keep you on course. If you're running short on time or energy, slice the hike in half with a pre-planned car shuttle. For more information: (936) 897-1068 or visit their website at www.southernregion.fs.fed.us.

Directions: From Zavalla, take Highway 63 east for 7 miles to FSR 303. Turn right on FSR 303 for 7 miles to Bouton Lake Recreation Area and the trailhead. Or take Highway 63 east for 11 miles to the Boykin Springs sign at FSR 313. Turn right on FSR 313 for 2.5 miles to Boykin Springs Recreation Area and the trailhead.

8) TOWNSEND RECREATION AREA - Leashes

Info: If you've been singing the summer blues, it's time you and your hot diggety dog did something special to lift your spirits. Plan a day on the wet and wild side in this fun recreation area. You'll have it made in the shade as you explore dense woodlands or cool your jets in refreshing Sam Rayburn Reservoir. Who knows, you might even make some fishy dreams come true by catching a batch of bass and catfish. For more information: (936) 897-1068 or visit their website at www.southernregion.fs.fed.us.

Directions: From Zavalla, take Highway 69 north to Lufkin. From Lufkin, take Highway 103 east for 28 miles to FM 1277. Turn right on FM 1277 for 3 miles to FM 2923. Make a right on FM 2923 and go 2 miles to the recreation area.

GET READY TO TRAVEL

TRAVEL TRAINING

A well-trained, well-behaved dog is easy to live with and especially easy to travel with. There are basics other than sit, down and stay which you might want to incorporate into your training routine. Whenever you begin a training session, remember that your patience and your dog's attention span are the key elements to success. Training sessions should be 5-10 minutes each. Don't let yourself become discouraged or frustrated. Stick with it. After just a few lessons, your dog will respond. Dogs love to learn, to feel productive and accomplished. Training isn't punishment. It's a gift. A gift of love. You'll quickly see the difference training can make. Training sessions with your dog will become a pleasant experience, something you'll anticipate, not dread. Most of all, keep a sense of humor. It's not punishment for you either.

Throughout this section, many references are made to puppies. But it's never too late for training to begin. The adage that you can't teach an old dog new tricks just isn't true. Patience and consistency combined with a reward system will provide excellent results.

Let's get social

When it comes to travel training, not enough can be said about the benefits of socialization. I regard the lessons of socialization as the foundation of a well-trained, well-behaved dog.

Whenever possible socialize your dog at an early age. Allow your puppy to be handled by many different people. Include men and children since puppies are inherently more fearful of both. At three months, you can join a puppy class. These classes are important because they provide puppies with the experience of being with other dogs. Your puppy will have the opportunity of putting down other dogs without inflicting harm and he'll also learn how to bounce back after being put down himself. Socialization can also be accomplished through walks around your neighborhood, visits to parks frequented by other dogs and children, or by working with friends who have dogs they also want to socialize.

<u>FIDO FACT:</u>

- *Dog ownership is a common bond and the basis of impromptu conversations as well as lasting friendships.*

Walking on a leash

It's very natural for a puppy to pull at his leash. Instead of just pulling back, stop walking. Hold the leash to your chest. If your dog lets the leash slacken, say GOOD DOG. If he sits, say GOOD SIT. Then begin your walk again. Stop every ten feet or so and tell your dog to sit. Knowing he'll only be told to sit if he pulls, he'll eventually learn to pay attention to the next command. It makes sense to continue your training while on walks because your dog will learn to heed your commands under varying circumstances and environments. This will prove especially important when traveling together. The lack

of "tug of war" can mean the difference between enjoying or disliking the company of your pooch at home or away.

Chewing

Most dogs chew out of boredom. Teach your dog constructive chewing and eliminate destructive chewing by teaching your dog to chew on chew toys. An easy way to interest him in chewing is to stuff a hollow, nonconsumable chew toy with treats such as peanut butter, kibble or a piece of hard cheese. Once the toy is stuffed, attach a string to it and tempt your dog's interest by pulling the toy along. He'll take it from there.

Until you're satisfied that he won't be destructive, consider confining your pooch to one room or to his crate with a selection of chew toys. This is a particularly important training tool for dogs who must be left alone for long periods of time, and for dogs who travel with their owners. If your pooch knows not to chew destructively at home, those same good habits will remain with him on the road.

Bite inhibition

The trick here is to keep a puppy from biting in the first place, not break the bad habit after it's formed, although that too can be accomplished. Your puppy should be taught to develop a soft mouth by inhibiting the force of his bites. As your dog grows into adolescence, he should continue to be taught to soften his bite and as an adult dog should learn never to mouth at all.

Allow your puppy to bite but whenever force is exhibited, say OUCH! If he continues to bite, say OUCH louder and then leave the room. When you return to the room, let the puppy come next to you and calm down. Your pup will begin to associate the bite and OUCH with the cessation of playtime and will learn to mouth more softly. Even when your puppy's bites no longer hurt, pretend they do. Once this training is finished, you'll have a dog that will not mouth. A dog who will not accidentally injure people you meet during your travels.

Jumping dogs

Dogs usually jump on people to get their attention. A fairly simple way to correct this habit is to teach your dog to sit and stay until released. When your dog is about to meet new people, put him in the sit/stay position. Be sure to praise him for obeying the command and then pet him to give him the attention he craves. Ask friends to help reinforce the command. I've also found that ignoring a dog's advances and turning your back to an overzealous pup has a calming effect and often prevents jumping.

Come

The secret to this command is to begin training at an early age. But as I've said before, older dogs can also learn. It might just take a little longer. From the time your pup's brought home, call him by name and say COME every time you're going to feed him. The association will be simple. He'll soon realize that goodies await him if he responds to your call. Try another approach as well. Sit in your favorite armchair and call to your dog every few minutes. Reward him with praise and sometimes with a treat. Take advantage of normally occurring circumstances, such as your dog approaching you. Whenever you can anticipate that your dog is coming toward you, command COME as he nears you. Then reward him with praise for doing what came naturally.

NEVER order your dog to COME for a punishment. If he's caught in the act of negative behavior, walk to him and then reprimand as needed.

Pay attention

Train your dog to listen to you during his normal routines. For example, when your dog is at play in the yard, call him to you. When he comes, have him sit and praise him. Then release him to play again. It will quickly become apparent that obeying will not mean the end of playtime. Instead it will mean that he'll be petted and praised and then allowed to play again.

Communication - talking to your dog

Training isn't just about teaching your dog to sit or give his paw. Training is about teaching your pooch to become an integral part of your life. To fit into your daily routine and into your leisure time. Take notice of how your dog studies you, anticipates your next move. Incorporate his natural desire to please into your training. Let him know what you're thinking, how you're feeling. Talk to him as you go about your daily routines. He'll soon come to understand the differences in your voice, your facial expressions, hand movements and body language.

He'll know when you're happy or angry with him or with any-one else. If you want him to do something, speak to him. For example, if you want him to fetch his ball, ask him in an emphatic way, stressing the word ball. He won't understand at first, so fetch it yourself and tell him ball. Put the ball down and then later repeat the command. He'll soon know what you want when you use the term ball with specific emphasis.

Training Do's & Don'ts

- Never hit your dog.

- Praise and reward your dog for good behavior. Don't be embarrassed to lavish praise upon a dog who's earned it.

- Unless you catch your dog in a mischievous act, don't pun-ish him. He will not understand what he did wrong. And when you do punish, go to your dog. Never use the com-mand COME for punishment.

- Don't repeat a command. Say the command in a firm voice only once. Dogs have excellent hearing. If he doesn't obey, return to the training method for the disobeyed command.

- Don't be too eager or too reticent to punish. Most of all, be consistent.

- Don't encourage fearfulness. If your dog has a fear of people or places, work with him to overcome this fear rather than ignoring it, or believing it can't be changed.

- Don't ignore or encourage aggression.

- Don't use food excessively as a reward. Although food is useful in the beginning of training, it must be phased out as the dog matures.

CRATE TRAINING IS GREAT TRAINING

Many people erroneously equate the crate to jail. But that's only a human perspective. To a dog who's been properly crate trained, the crate represents a private place where your dog will feel safe and secure. It is much better to prevent behavioral problems by crate training than to merely give up on an unruly dog.

4 Reasons why crate training is good for you

1. You can relax when you leave your dog home alone. You'll know that he is safe, comfortable and incapable of destructive behavior.

2. You can housebreak your pooch faster. The confinement to a crate encourages control and helps establish a regular walk time routine.

3. You can safely confine your dog to prevent unforeseen situations. For example, if he's sick, if you have workers or guests that are either afraid of or allergic to dogs, or if your canine becomes easily excited or confused when new people enter the scene. In all cases, the crate provides a reasonable method of containment.

4. You can travel with your pooch. Use of a crate eliminates the potential for distraction and assures that your dog will not get loose during your travels.

5 Reasons why crate training is good for your dog

1. He'll have an area for rest when he's tired, stressed or sick.

2. He'll be exposed to fewer bad behavior temptations which can result in punishment.

3. He'll have an easier time learning to control calls of nature.

4. He'll feel more secure when left alone.

5. He'll be able to join you in your travels.

Some do's and don'ts

- DO exercise your dog before crating and as soon as you let him out.

- DO provide your pooch with his favorite toy.

- DO place the crate in a well-used, well-ventilated area of your home.

- DO make sure that you can always approach your dog while he is in his crate. This will insure that he does not become overly protective of his space.

- DON'T punish your dog in his crate or banish him to the crate.

- DON'T leave your pooch in the crate for more than four hours at a time.

- DON'T let curious kids invade his private place. This is his special area.

- DON'T confine your dog to the crate if he becomes frantic or completely miserable.

- DON'T use a crate without proper training.

10
Ways To Prevent Aggression in Your Dog

1. Socialize him at an early age.

2. Set rules and stick to them.

3. Under your supervision, expose him to children and other animals.

4. Never be abusive towards your dog by hitting or yelling at him.

5. Offer plenty of praise when he's behaving himself.

6. Be consistent with training. Make sure your dog responds to your commands before you do anything for him.

7. Don't handle your dog roughly or play aggressively with him.

8. Neuter your dog.

9. Contact your veterinarian for persistent behavior problems.

10. Your dog is a member of the family. Treat him that way. Tied to a pole is not a life.

Take your dog's temperament into account:

- Is he a pleaser?
- Is he the playful sort?
- Does he love having tasks to perform?
- Does he like to retrieve? To carry?

Dogs, like people, have distinct personalities...mellow, hyper, shy or outgoing. Take advantage of your dog's unique characteristics. A hyper dog can amuse you with hours of playful frolicking. A laid-back pooch will cuddle beside you offering warm companionship. An outgoing dog will help you make friends.

If you can combine what you know of your dog's personality with what you want to teach, your dog will train more easily. Together you will achieve a unique compatibility.

WHAT AND HOW TO PACK FOR YOUR POOCH

Be prepared

Dogs enjoy the adventure of travel. If your dog is basically well behaved and physically healthy, he will make an excellent traveling companion. But traveling times will be more successful with just a little common sense and preparation.

Just as many children (and adults I might add) travel with their own pillow, your pooch will also enjoy having his favorites with him. Perhaps you'll want to include the blanket he sleeps with or his favorite toy. Not only will a familiar item make him feel more at ease but it will keep him occupied.

To keep things simple from vacation to vacation, I restock Max and Rosie's travel bags at the end of each trip. That way, I'm always prepared for the next adventure. "My Pooch's Packing List" is found on page 486. You'll want to include some or all of the items listed on the next page.

- A blanket to cover the back seat of your car.
- Two or three old towels for emergencies.
- Two bowls, one for water, the other for food.
- Plastic clean up bags (supermarket produce bags work well).
- Paper towels — for spills, clean up and everything in between.
- A long line of rope. You'll be surprised how often you'll use this very handy item.
- An extra collar and lead.
- Can opener and spoon.
- Flashlight.
- An extra flea and tick collar.
- Dog brush.
- Small scissors.
- Blunt end tweezers — great for removing thorns and cactus needles.
- Chew toys, balls, frisbees, treats — whatever your pooch prefers.
- Nightlight.
- A room deodorizer.
- A handful of zip-lock bags in several sizes.
- Pre-moistened towelettes. Take along two packs. Put one in your suitcase, the other in the glove compartment of your car.
- Dog food — enough for a couple of days. Although most brands are available throughout the country — either at pet stores, supermarkets or veterinary offices — you'll want to take enough to eliminate finding a store that's open the first night or two of your vacation.
- Water — a full container from home. Top off as needed to gradually accustom your dog to his new water supply.

Packing made easy...12 tips.

I've said it before but I'll say it again. No matter where your travels take you, whether it's to the local park or on a cross-country trip, never leave home without your dog's leash and a handful of plastic bags or pooper scooper. I still remember those awful moments when I ended up without one or both.

1. Consolidate. Even if you're traveling as a family, one tube of toothpaste and one hair dryer should suffice.

2. Avoid potential spills by wrapping perfume, shampoo and other liquids together and placing them in large zip-lock plastic bags.

3. When packing, layer your clothing using inter-locking patterns. You'll fit more into your suitcase and have less shifting and wrinkling.

4. Write out your itinerary, including flight info, car rental confirmation numbers, travel agent telephone numbers, lodging info, etc., and keep a copy handy. Keep a duplicate in a safe place.

5. Take along a night light, especially if you're traveling with a child.

6. Stash a supply of zip-lock plastic bags, moist towelettes, trash bags, an extra leash (or rope) and a plastic container in an accessible place.

7. If you plan to hike with children, give each a whistle; they're great for signaling help.

8. Include a can opener and a flashlight.

9. Comfortable walking shoes are a must. If you plan on hiking, invest in a sturdy pair of hiking boots, but be sure to break them in before your trip. Take along an extra pair of socks whenever you hike.

10. Don't forget to include first aid kits. One for dogs and one for people.

11. Include an extra pair of glasses or contact lenses. And don't forget to take a copy of your eyeglass prescription.

12. Keep medications in separate, clearly marked containers.

MY POOCH'S PACKING LIST

1 _____ 16 _____

2 _____ 17 _____

3 _____ 18 _____

4 _____ 19 _____

5 _____ 20 _____

6 _____ 21 _____

7 _____ 22 _____

8 _____ 23 _____

9 _____ 24 _____

10 _____ 25 _____

11 _____ 26 _____

12 _____ 27 _____

13 _____ 28 _____

14 _____ 29 _____

15 _____ 30 _____

GET READY TO TRAVEL BY CAR

"Kennel Up"...the magical, all-purpose command

When Rosie's and Maxwell's training began, I used a metal kennel which they were taught to regard as their spot, their sleeping place. Whenever they were left at home and then again when they were put to bed at night, I used the simple command, "Kennel Up," as I pointed to and touched their kennel. They quickly learned the command. As they outgrew the kennel, the laundry room became their "kennel up" place. As full-grown dogs, the entire kitchen became their "kennel up" area. Likewise, when they began accompanying me on trips, I reinforced the command each time I told them to jump into the car. They soon understood that being in their "kennel up" place meant that I expected them to behave, whether they were at home, in the car or in a hotel room. Teaching your dog the "kennel up" command will make t r a v e l times easier a n d m o r e pleasurable.

Old dogs can learn new tricks

When we first began vacationing with Rosie and Max, some friends decided to join us on a few of our local jaunts. Their dog Brandy, a ten year-old Cocker Spaniel, had never traveled with them. Other than trips to the vet and the groomer, she'd never been in the car. The question remained... would Brandy adjust? We needn't have worried. She took to the car immediately. Despite her small size, she quickly learned to jump in and out of the rear of their station wagon. She ran through the forests with Rosie and Max, playing and exploring as if she'd always had free run. To her owners and to Brandy, the world took on new meaning. Nature as seen through the eyes of their dog became a more exciting place of discovery.

Can my pooch be trained to travel?

Dogs are quite adaptable and responsive and patience will definitely have its rewards. Your pooch loves nothing more than to be with you. If it means behaving to have that privilege, he'll respond.

Now that you've decided to travel and vacation with your dog, it's probably a good idea to get him started with short trips. Before you go anywhere, remember two of the most important items for happy dog travel, a leash for safety and the

proper paraphernalia for clean up. There's nothing more frustrating or scary than a loose, uncontrolled dog. And nothing more embarrassing than being without clean-up essentials when your dog unexpectedly decides to relieve himself.

Make traveling an enjoyable experience. Stop every so often and do fun things. As you lengthen travel times, don't think that you have to stop every hour or so. Handle your dog as you would at home. He won't have to walk any more frequently. But when you do stop to let him out, leash him before you open the car doors.

When the walk or playtime is over, remember to use the "Kennel Up" command when you tell your pooch to get into the car or into his kennel. And use lots of praise when he obeys the command.

You'll find that your dog will most likely be lulled to sleep by the motion of the car. Rosie and Maxwell fall asleep after less than fifteen minutes. I stop every few hours, give them water and let them "stretch their legs." They've become accustomed to these short stops and anticipate them. The moment the car is turned off and the hatch-back popped open, they anxiously await their leashes. When our romping time is over and we're back at the car, a simple "kennel up" gets them into their travel area.

To kennel or not to kennel?

Whether or not you use a kennel for car travel is a personal choice. Safety should be your primary concern. Yours and your dog's. Whatever method of travel you choose, be certain that your dog will not interfere with your driving. If you plan to use a kennel, line the bottom with an old blanket, towel or shredded newspaper and include a favorite toy. When you're vacationing by car and not using a kennel, consider a car harness.

If it's your habit not to use a kennel or harness, confine your dog to the back seat and command him to "kennel up." Protect your upholstery by covering the rear seat with an old blanket. The blanket will make cleanup easier at the end of your trip. To keep my car fresh smelling and free from doggie odors, I stash a deodorizer under the front seat.

How often should I stop?

Many people think that when their dogs are in the car, they have to "go" more often. Not true. Whenever you stop for yourself, let your pooch have a drink and take a walk. It's not necessary to make extra stops along the way unless your dog has a physical problem and must be walked more often. Always pull your car out of the flow of traffic so you can safely care for your pooch. Never let your dog run free. Since your pooch is in unfamiliar territory, he can bolt into traffic, be injured, become lost or run away Use a leash at all times.

Can my dog be left alone in the car?

Weather is the main factor you have to consider in this situation. Even if you think you'll only be gone a few minutes, that's all it takes for a dog to become dehydrated in warm weather. Even if all the windows are open, even if your car is parked in the shade, even when the outside temperature is only 85°, the temperature in a parked car can reach 100° to 120° in just minutes. Exposure to high temperatures, even for short periods, can cause your dog's body temperature to skyrocket.

NEVER LEAVE YOUR DOG UNATTENDED IN WARM WEATHER.

During the winter months, be aware of hypothermia, a life threatening condition when an animal's body temperature falls below normal. In particular, short-haired dogs and toys are very susceptible to illness in extremely cold weather.

What about carsickness?

Just like people, some dogs are queasier than others. And for some reason, puppies suffer more frequently from motion sickness. It's best to wait a couple of hours after your dog has eaten before beginning your trip. Or better yet, feed your dog after you arrive at your destination. Keep the windows open enough to allow in fresh air. If your pooch has a tendency to be carsick, sugar can help. Give your dog a tablespoon of honey or a small piece of candy before beginning your trip (**NO CHOCOLATE**). That should help settle his stomach. If you notice that he still looks sickly, stop and allow him some additional fresh air or take him for a short walk. Most dogs will outgrow car sickness.

What about identification if my dog runs off?

As far as identification, traveling time is no different than staying at home. Never allow your pooch to be anywhere without proper identification. ID tags should provide your dog's name, your name, address and phone number. Most states require dog owners to purchase a license every year. The tag usually includes a license number that is registered with your state. If you attach the license tag to your dog's collar and you become separated, your dog can be traced. There are also local organizations that help reunite lost pets and owners. The phone numbers of these organizations can be obtained from local police authorities.

Use the form on the facing page to record your pooch's description so that the information will be handy should the need arise.

MY POOCH'S IDENTIFICATION

In the event that your dog is lost or stolen, the following information will help describe your pooch. Before leaving on your first trip, take a few minutes to fill out this form, make a duplicate, and then keep them separate but handy.

Answers to the name of: ———————————————

Breed or mix: ——————————————————

Sex: ———————— Age: ———————— Tag ID#: ——————

Description of hair (color, length and texture): ——————

———————————————————————————

Indicate unusual markings or scars: ——————————

———————————————————————————

———————————————————————————

TAIL: () Short () Screw-type () Bushy () Cut

EARS: () Clipped () Erect () Floppy

Weight: ———————————— Height: ——————————

If you have a recent photo of your pet, attach it to this form.

TRAVELING BY PLANE

Quick Tips:

- Always travel on the same flight as your dog. Personally ascertain that your dog has been put on board before you board the plane.

- Book direct, nonstop flights.

- Upon boarding, inform a flight attendant that your pooch is traveling in the cargo hold.

- Early morning or late evening flights are best in the summer, while afternoon flights are best in the winter.

- Fill the water tray of your dog's travel carrier with ice cubes rather than water. This will prevent spillage during loading.

- Clip your dog's nails to prevent them from hooking in the crate's door, holes or other openings.

Dog carriers/kennels

Most airlines require pets to be in specific carriers. Airline regulations vary and arrangements should be made well in advance of travel. Some airlines allow small dogs to accompany their owners in the passenger cabins. The carrier must fit under the passenger's seat and the dog must remain in the carrier for the duration of the flight. These regulations also vary and prior arrangements should be made.

Airlines run hot and cold on pet travel

Many airlines won't allow pets to travel in the cargo hold if the departure or destination temperatures are over 80°. The same holds true if the weather is too cold. Check with the airlines to ascertain specific policies.

What about the size of the carrier?

Your dog should have enough room to stand, lie down, sit and turn around comfortably. Larger doesn't equate to more comfort. If anything, larger quarters only increase the chances of your dog being hurt because of too much movement. Just as your dog's favorite place is under the kitchen desk, a cozy, compact kennel will suit him much better than a spacious one.

Should anything else be in the carrier?

Cover the bottom with newspaper sheets and cover that with shredded newspaper. This will absorb accidents and provide a soft, warm cushion for your dog. Include a soft blanket or an old flannel shirt of yours; articles that will remind your pooch of home and provide a feeling of security. You might want to include a hard rubber chew, but forget toys, they increase the risk of accidents.

How will my pooch feel about a kennel?

Training and familiarization are the key elements in this area. If possible, buy the kennel (airlines and pet stores sell them) several weeks before your trip. Leave it in your home in the area where your dog spends most of his time. Let him become accustomed to its smell, feel and look. After a few days, your pooch will become comfortable around the kennel. You might even try feeding him in his kennel to make it more like home. Keep all the associations friendly. Never use the kennel for punishment. Taking the time to accustom your dog with his traveling quarters will alleviate potential problems and make vacationing more enjoyable.

What about identification?

The kennel should contain a tag identifying your dog and provide all pertinent information including the dog's name, age, feeding and water requirements, your name, address and phone number and your final destination. In addition, it should include the name and phone number of your dog's vet. A "luggage-type" ID card will function well. Use a waterproof

marker. Securely fasten the ID tag to the kennel. Your dog should also wear his state ID tag. Should he somehow become separated from his kennel, the information will travel with him. Using a waterproof pen, mark the kennel "LIVE ANI-MAL" in large letters of at least an inch or more. Indicate which is the top and bottom with arrows and more large lettering of "THIS END UP."

How can I make plane travel comfortable for my pooch?

If possible, make your travel plans for weekday rather than weekend travel. Travel during off hours. Direct and nonstop flights reduce the potential for problems and delays. Check with your airline to determine how much time they require for check in. Limiting the amount of time your dog will be in the hold section will make travel time that much more comfortable. Personally ascertain that your dog has been put on board your flight before you board the aircraft.

Will there automatically be room on board for my pooch?

Not always. Airline space for pets is normally provided on a first-come, first-served basis. As soon as your travel plans are decided, contact the airline and confirm your arrangements.

What will pet travel cost?

Prices vary depending on whether your dog travels in the cabin or whether a kennel must be provided in the hold. Check with the airlines to determine individual pricing policies.

What about food?

It's best not to feed your dog at least six hours before departure.

What about tranquilizers?

Opinions vary on this subject. Discuss this with your vet. But don't give your dog any medication not prescribed by a vet. Dosages for animals and humans vary greatly.

What about after we land?

If your pooch has not been in the passenger cabin with you, you will be able to pick him up in the baggage claim area along with your luggage. Since traveling in a kennel aboard a plane is an unusual experience, he may react strangely. Leash him before you let him out of the kennel. Having his leash on will avoid mishaps. Once he's leashed, give him a cool drink of water and then take him for a walk.

Dogs who shouldn't fly

In general, very young puppies, females in heat, sickly, frail or pregnant dogs should not be flown. In addition to the stress of flying, changes in altitude and cabin pressure might adversely effect your pooch. Also, pug-nosed dogs are definite "no flys". These dogs have short nasal passages which limit their intake of oxygen. The noxious fumes of the cargo hold can severely limit their supply of oxygen, leaving them highly susceptible to injury.

Health certificates - will I need one?

Although you may never be asked to present a health certificate, it's a good idea to have one with you. Your vet can supply a certificate listing the inoculations your dog has received, including rabies. Keep this information with your travel papers.

Airlines have specific regulations regarding animal flying rights. Make certain you know your dog's rights.

36
WAYS TO HAVE A BETTER VACATION WITH YOUR POOCH

Some tips and suggestions to increase your enjoyment when you and the pooch hit the road.

1. Don't feed or water your pooch just before starting on your trip. Feed and water your dog approximately two hours before you plan to depart. Better still, if it's a short trip, wait until you arrive at your destination.

2. Exercise your pooch before you leave. A tired dog will fall off to sleep more easily and adapt more readily to new surroundings.

3. Take along a large container of water to avoid potential stomach upset. Your dog will do better drinking from his own water supply for the first few days. Having water along will mean you can stop wherever you like and not worry about finding water. Gradually accustom your pooch to his new source of water by topping off your water container with local water.

4. Plan stops along the way. Just like you, your pooch will enjoy stretching his legs. As you travel, you'll find many areas conducive to a leisurely walk or a bit of playtime. If you make the car ride an agreeable part of the journey, your vacation will begin the moment you leave home - not just when you reach your ultimate destination.

5. While driving, keep windows open enough to allow the circulation of fresh air but not enough to allow your dog to jump out. If you have air conditioning, that will keep your dog cool enough.

6. Don't let your dog hang his head out of the window. Eyes, ears and throats can become inflamed.

7. Use a short leash when walking your pooch through public areas — he'll be easier to control.

8. Take along your dog's favorite objects from home. If they entertain him at home, they'll entertain him on vacation.

9. Before any trip, allow your pooch to relieve himself.

10. Cover your back seat with an old blanket or towel to protect the upholstery.

11. A room freshener under the seat of your car will keep it smelling fresh. Take one along for your room also.

12. If your dog has a tendency for carsickness, keep a packet of honey in the glove compartment or carry a roll of hard candy — like Lifesavers — with you. Either remedy might help with carsickness.

13. Use a flea and tick collar on your pooch.

14. When traveling in warm weather months, drape a damp towel over your dog's crate. This allows ventilation and the moist, cooler air will reduce the heat.

15. Before you begin a trip, expose your pooch to experiences he will encounter while traveling; such as crowds, noise, people, elevators, walks along busy streets, and stairs (especially those with open risers).

16. Shade moves. If you must leave your dog in the car for a short period of time, make sure the shade that protects him when you park will be there by the time you return. As a general rule though, it's best not to leave your dog in a parked car. <u>NEVER LEAVE YOUR DOG IN THE CAR DURING THE WARM SUMMER MONTHS</u>. In the colder months, beware of hypothermia, a life threatening condition that occurs when an animal's body temperature falls below normal. Short-haired dogs and toys are very susceptible to illness in extremely cold weather.

17. Take along a clip-on minifan for airless hotel rooms.

18. When packing, include a heating pad, ice pack and a few safety pins.

19. A handful of clothespins will serve a dozen purposes, from clamping motel curtains together to sealing a bag of potato chips, they're great.

20. A night light will help you find the bathroom in the dark.

21. Don't forget that book you've been meaning to read.

22. Include a journal and record your travel memories.

23. Pack a roll of duct tape. Use it to repair shoes, patch suitcases or strap lunch onto the back of a rented bicycle.

24. Never begin a vacation with a new pair of shoes.

25. Pooper scoopers make clean up simple and sanitary. Plastic vegetable bags from the supermarket are great too.

26. FYI, in drier climates, many accommodations have room humidifiers available for guest use. Arrange for one when you make your reservation.

27. Use unbreakable bowls and storage containers for your dog's food and water needs.

28. Don't do anything on the road with your pooch that you wouldn't do at home.

29. Brown and grey tinted sun lenses are the most effective for screening bright light. Polarized lenses reduce the blinding glare of the sun.

30. Before you leave on vacation, safeguard your home. Ask a neighbor to take in your mail and newspapers, or arrange with your mail carrier to hold your mail. Stop newspaper delivery. Use timers and set them so that a couple of lights go on and off. Unplug small appliances and electronics. Lock all doors and windows. Place steel bars or wooden dowels in the tracks of sliding glass doors or windows. Ladders or other objects that could be used to gain entrance into your home should be stored in your garage or inside your home. Arrange to have your lawn mowed. And don't forget to take out the garbage.

31. Pack some snacks and drinks in a small cooler.

32. As a precaution when traveling, once you arrive at your final destination, check the yellow pages for the nearest vet and determine emergency hours and location.

33. NEVER permit your dog to travel in the bed of a pickup truck. If you must, there are safety straps available at auto supply stores that can be used to insure the safety of your dog. Never use a choke chain, rope or leash around your dog's neck to secure him in the bed of a pickup.

34. Take along a spray bottle of water. A squirt in your dog's mouth will temporarily relieve his thirst.

35. Heavy duty zip-lock type bags make great traveling water bowls. Just roll down edges, form a bowl and fill with water. They fold up into practically nothing. Keep one in your purse, jacket pocket or fanny pack. Keep an extra in your glove compartment.

36. Arrange with housekeeping to have your room cleaned while you're present or while you're out with your pooch.

Great packing/travel tip

When hiking with your dog, large zip-lock bags make great portable water bowls. Just roll down the sides to form a bowl and add water.

TEXAS ROAD SAFETY TIPS

- Don't drink and drive - a blood alcohol level of .08% or higher is considered legally intoxicated.

- Texas law prohibits the driver of a vehicle to consume an alcoholic beverage while operating a vehicle.

- A blood alcohol test is mandatory for anyone arrested while under the influence.

- Seatbelts are the law for all front seat occupants of cars and light trucks.

- Infants under age 2 must be in a federally approved child safety seat; children between 2-4 must be secured in a safety seat or in a standard seatbelt whenever they are passengers in a vehicle.

- Children under the age of twelve are prohibited from riding in the open area of vehicles, such as truck beds, at speeds in excess of 35 mph.

- Helmets are the law for all motorcyclists and passengers.

For travel assistance and emergency road condition information,

Statewide..(800) 452-9292

TDD for hearing impaired only...................(800) 687-5288

To report traffic accidents, intoxicated drivers, criminal activities and other emergencies call: (800) 525-5555 or dial 911

GATOR GUIDELINES

An inherent part of Texas culture, alligators are remarkable creatures, both feared and revered since the days of dinosaurs. Whenever you plan a trip that includes travel to alligator territory, consider the following:

1. Do not feed alligators. Feeding alligators causes them to associate humans with food.

2. Do not get too close to an alligator Contrary to belief, they are not slow moving or sluggish. Generally, 30 feet constitutes a safe distance from an alligator.

3. Do not approach an alligator sunning itself in the middle of a trail or on a water bank. Immediately retrace your steps and contact a park ranger or wildlife authority. Sunning alligators are most abundant in the spring.

4. Do not approach a nest of baby gators. They may seem cute and harmless, but their mothers are protective and will attack.

5. Do not swim or fish in or near alligator inhabited waters.

6. Do not play catch with your pooch near alligator infested waters. Alligators are better swimmers than canines.

7. Keep your dog leashed at all times. Curious dogs can end up as lunch.

8. When an alligator stands its ground, opens its mouth and hisses, you have come too close. Immediately do the following:

 - Plan an escape route.
 - Retreat slowly. Do not run.
 - Keep retreating until the alligator no longer demonstrates aggressive behavior.
 - Never take your eyes off or turn your back on the alligator.
 - Retreat uphill wherever possible. Alligators are faster on flat surfaces, hills slow them down.

Note: You can estimate the length of an alligator by guessing the number of inches between its eyes and nostrils. Transpose inches to feet and you'll have a pretty good idea of the alligator's length, i.e., distance between eyes 6 inches, length 6 feet.

FIRST-AID EMERGENCY TREATMENT

Having a bit of the Girl Scout in me, I like being prepared. Over the years, I've accumulated information regarding animal emergency treatment. Although I've had only one occasion to use this information, once was enough. I'd like to share my knowledge with you.

Whether you're the stay-at-home type who rarely travels with your dog, or a gadabout who can't sit still, every dog owner should know these simple, but potentially lifesaving procedures.

The following are only guidelines to assist you during emergencies. Whenever possible, seek treatment from a vet if your animal becomes injured and you don't feel qualified to administer first aid.

Allergies: One in five dogs suffers from some form of allergy. Sneezing and watery eyes can be an allergic reaction caused by pollen and smoke. Inflamed skin can indicate a sensitivity to grass or to chemicals used in carpet cleaning. See your vet.

Bites and stings: Use ice to reduce swelling. If your animal has been stung in the mouth, take him to the vet immediately. Swelling can close the throat. If your dog experiences an allergic reaction, an antihistamine may be needed. For fast relief from a wasp or bee sting, dab the spot with plain vinegar and then apply baking soda. If you're in the middle of nowhere, a small mud pie plastered over the sting will provide relief. Snake bites: seek veterinary attention ASAP.

Bleeding: If the cut is small, use tweezers to remove hair from the wound. Gently wash with soap and water and then bandage (not too tightly). Severe bleeding, apply direct pressure and seek medical attention ASAP.

Burns: First degree burns: Use an ice cube or apply ice water until the pain is alleviated. Then apply vitamin E, swab with honey or cover with a freshly brewed teabag.

Minor burns: Use antibiotic ointment.

Acid: Apply dampened baking soda.

Scalds: Douse with cold water. After treatment, bandage all burns for protection.

Earache: A drop of warm eucalyptus oil in your dog's ear can help relieve the pain.

Eye scratches or inflammation: Make a solution of boric acid and bathe eyes with soft cotton.

Falls or impact injuries: Limping, pain, grey gums or prostration need immediate veterinary attention. The cause could be a fracture or internal bleeding.

Fleas: Patches of hair loss, itching and redness are common signs of fleas, particularly during warm months. Use a flea bath and a flea collar to eliminate and prevent infestation. Ask your vet about new oral medication now available for flea control.

Heatstroke: Signs include lying prone, rapid breathing and heartbeat, difficulty in breathing, rolling eyes, panting, high fever, a staggering gait. Quick response is essential. Move your pooch into the shade. Generously douse with cold water or if possible, partially fill a tub with cold water and immerse your dog. Remain with him and check his temperature. Normal for dogs: 100°-102°. Don't let your dog's temperature drop below that.

Prevent common heatstroke by limiting outdoor exercise in hot or humid weather, and providing plenty of fresh, cool water and access to shade. Never leave your dog in a car on a warm day, even for "just a few minutes."

Heartworm: Mosquitos can be more than pests when it comes to the health of your dog. They are the carriers of heartworm disease, which can be life threatening to your furry friend. There is no vaccine. However, daily or monthly pills can protect your pet from infection. In areas with high mosquito populations, like Texas, use a heartworm preventative. Contact your local veterinarian about testing and medication.

In the case of heartworm, "an ounce of prevention equals a pound of cure."

Poisons: Gasoline products, antifreeze, disinfectants, and insecticides are all poisonous. Keep these products tightly closed and out of reach. Vomiting, trembling, and convulsions can be symptoms of poisoning. If your dog suffers from any of these symptoms, get veterinary attention. (See listings on Poison Control Centers in section "Everything You Want to Know About Pet Care...".)

Poison ivy: Poison ivy or oak on your dog's coat will not bother him. But the poison can be passed on to you. If you believe your dog has come in contact with poison ivy or oak use rubber gloves to handle your dog. Rinse him in salt water, then follow with a clear water rinse. Shampoo and rinse again.

Shock: Shock can occur after an accident or severe fright. Your animal might experience shallow breathing, pale gums, nervousness or prostration. Keep him still, quiet and warm and have someone drive you to a vet.

Skunks: The following might help you avoid a smelly encounter.

1. Don't try to scare the skunk away. Your actions might provoke a spray.

2. Keep your pooch quiet. Skunks have an unforgettable way of displaying their dislike of barking.

3. Begin an immediate retreat.

If you still end up in a stinky situation, try one of these three home remedies.

1. Saturate your dog's coat with tomato juice. Allow to dry, then brush out and shampoo.

2. Combine 5 parts water with one part vinegar. Pour solution over your dog's coat. Let soak 10-15 minutes. Rinse with clear water and then shampoo.

3. Combine 1 quart of 3% hydrogen peroxide with 1/4 cup of baking soda and a squirt of liquid soap. Pour solution over your dog's coat. Let soak 10-15 minutes. Rinse with clear water and then shampoo.

Snake bites:

1. Immobilization and prompt medical attention are the key elements to handling a poisonous snake bite. Immediate veterinary care (within 2 hours) is essential to recovery.

2. If the bite occurs while in a remote area, immediately immobilize the bitten area and carry your dog to the vehicle. Don't allow your dog to walk, the venom will spread more quickly.

3. Most snake bites will be to the head or neck area, particularly the nose. The second most common place will be a dog's front leg.

 • Severe swelling within 30 to 60 minutes of the bite is the first indication that your dog is suffering from a venomous snake bite.

 • Excessive pain and a slow, steady bleeding are other indicators. Hemotoxins in the venom of certain snakes prevent blood from clotting.

- If your dog goes into shock or stops breathing, begin CPR. Cardiopulmonary resuscitation for dogs is the same as for humans. Push on your dog's chest to compress his heart and force blood to the brain. Then hold his mouth closed and breathe into his nose.

- DO NOT apply ice to the bite - venom constricts the blood vessels and ice only compounds the constriction.

- DO NOT use a tourniquet - the body's natural immune system fights off the venom. By cutting off the blood flow you'll either minimize or completely eliminate the body's natural defenses.

- DO NOT try to clean the bite or administer medication.

Ticks: Use lighter fluid (or other alcohol) and loosen by soaking. Then tweeze out gently. Make sure you get the tick's head.

Winter woes: Rock salt and other commercial chemicals used to melt ice can be very harmful to your dog. Not only can they burn your dog's pads, but ingestion by licking can result in poisoning or dehydration. Upon returning from a walk through snow or ice, wash your dog's feet with a mild soap and then rinse. Before an outdoor excursion, spray your dog's paws with cooking oil to deter adherence.

FITNESS FOR FIDO

A daily dose of exercise is as important for the pooch's health as it is for yours. A 15-30 minute walk twice daily is a perfect way to build muscles and stamina and get you and the dogster in shape for more aerobic workouts. If you're a summer hound, beat the heat by walking in the early hours of the morning or after sundown. Keep in mind that dogs don't sweat, so if you notice your pooch panting excessively or lagging behind, stop in a cool area for a water break.

Be especially careful when beginning an exercise program with a young dog or an overweight pooch. Consult your veterinarian about a fitness program that would be best for your furry friend before leashing him up and pooping him out. Obese dogs may have other health problems which should be considered before taking to the trail. Young dogs are still developing their bones and may not be ready for rigorous programs. Use common sense when beginning any exercise program.

FIDO FACT:
- *Fido's fitness counts towards insuring a longer, healthier life. The most common cause of ill health in canines is obesity. About 60% of all adult dogs are or will become overweight due to lack of physical activity and overfeeding.*

MASSAGE, IT'S PETTING WITH A PURPOSE

After a tough day of hiking, nothing is more appealing than a soak in a hot tub. Since that won't work for your pooch, consider a massage. All it takes is ten to twenty minutes and the following simple procedures:

1. Gently stroke the head.
2. Caress around the ears in a circular fashion.
3. Rub down both the neck and the shoulders, first on one side of the spine, and then the other continuing down to the rump.
4. Turn Rover over and gently knead the abdominal area.
5. Rub your dogs legs.
6. Caress between the paw pads.

After his massage, offer your pooch plenty of fresh, cool water to flush out the toxins released from the muscles.

Massages are also therapeutic for pooches recovering from surgery and/or suffering from hip dysplasia, circulatory disorders, sprains, chronic illnesses and old age. Timid and hyperactive pooches can benefit as well.

FIDO FACT:

- *Is your pooch pudgy? Place both thumbs on your dog's backbone and then run your fingers along his rib cage. If the bony part of each rib cannot be easily felt, your dog may be overweight. Another quickie test - stand directly over your dog while he's standing. If you can't see a clearly defined waist behind his rib cage, he's probably too portly.*

STEPS TO BETTER GROOMING

Grooming is another way of saying "I love you" to your pooch. As pack animals, dogs love grooming rituals. Make grooming time an extension of your caring relationship. Other than some breeds which require professional grooming, most canines can be groomed in about 10 minutes a day.

1. Designate a grooming place, preferably one that is not on the floor. If possible, use a grooming table. Your dog will learn to remain still and you won't trade a well-groomed pooch for an aching back.

2. End every grooming session with a small treat. When your dog understands that grooming ends with a goodie, he'll behave better.

3. Brush out your dog's coat before washing. Wetting a matted coat only tightens the tangles and makes removal more difficult.

4. Using a soft tissue, wipe around your dog's eyes daily, especially if his eyes tend to be teary.

5. When bathing a long-haired dog, squeeze the coat, don't rub. Rubbing can result in snarls.

6. To gently clean your dog's teeth, slip your hand into a soft sock and go over each tooth.

Fido Fact:

- ***Stroke a dog instead of patting it. Stroking is soothing. Patting can make a dog nervous.***

Grooming tips...sticky problems

Chewing gum: There are two methods you can try. Ice the gum for a minimum of ten minutes to make it more manageable and easier to remove. Or use peanut butter. Apply and let the oil in the peanut butter loosen the gum from the hair shaft. Leave on about 20 minutes before working out the gum.

Tar: This is a tough one. Try soaking the tarred area in vegetable or baby oil. Leave on overnight and then bathe your dog the following day. The oil should cause the tar to slide off the hair shaft. Since this method can be messy, shampoo your dog with Dawn dishwashing soap to remove the oil. Follow with pet shampoo to restore the pH balance.

Oil: Apply baby powder or cornstarch to the oily area. Leave on 20 minutes. Shampoo with warm water and Dawn. Follow with pet shampoo to restore the pH balance.

Burrs:

1. Burrs in your dog's coat may be easier to remove if you first crush the burrs with pliers.

2. Slip a kitchen fork under the burr to remove.

3. Soak the burrs in petroleum jelly before working them out.

Keep cleaning sessions as short as possible. Your dog will not want to sit for hours. If your dog's skin is sensitive, you might want to simply remove the offending matter with a scissors. If you don't feel competent to do the removal yourself, contact a grooming service in your area and have them do the job for you.

<u>FIDO FACT:</u>
- *Inflamed skin can indicate a sensitivity to grass or chemicals used in carpet cleaning. Patches of hair loss, itching and redness are common signs of fleas, particularly during warm months.*

12
TIPS ON MOVING WITH YOUR DOG

During this coming year, one out of five Americans will be moving. Of those, nearly half will be moving with their pets. If you're part of the "pet half", you should understand that your dog can experience the same anxiety as you. The following tips can make moving less stressful for you and your dog.

1. Although moving companies provide information on how to move your pet, they are not permitted to transport animals. Plan to do so on your own.

2. Begin with a visit to your vet. Your vet can provide a copy of your dog's medical records and possibly be able to recommend a vet in the city where you'll be moving.

3. If you'll be traveling by plane, contact the airlines ASAP. Many airlines offer in-cabin boarding for small dogs, but only on a first-come, first-served basis. The earlier you make your reservations, the better chance you'll have of securing space.

4. If you'll be driving to your new home, use **Doin' Texas With Your Pooch** (or our national lodging directory, **Vacationing With Your Pet!)** for your lodging reservations. By planning ahead, your move will proceed more smoothly .

5. Buy a special toy or a favorite chew that's only given to your dog when you're busy packing.

6. Don't feed or water your pooch for several hours before your departure. The motion of the ride might cause stomach upset.

7. Keep your dog kenneled up on moving day to avoid disasters. Never allow your pet to run free when you're in unfamiliar territory.

8. Pack your dog's dishes, food, water, treats, toys, leash and bedding in an easy-to-reach location. Take water and food from home. Drinking unfamiliar water or eating a different brand of food can cause digestion problems. And don't forget those plastic bags for clean-up.

9. Once you're moved in and unpacked, be patient. Your pooch may misbehave. Like a child, he may resent change and begin acting up. Deal with problems in a gentle and reassuring manner. Spend some extra time with your canine during this upheaval period and understand that it will pass.

10. If your pet requires medication, pack plenty for your journey and keep a copy of your pet's medical records with you.

11. Always carry your current veterinarian's phone number. You never know when an emergency may arise or when your new veterinarian will need additional health information

12. Learn as much as you can about your new area, including common diseases, unique laws and required vaccinations.

10

REASONS WHY DOGS
ARE GOOD FOR YOUR HEALTH

Adding a dog to your household can improve your health and that of your family. In particular, dogs seem to help the very young and seniors. The following is based on various studies.

1. People over 40 who own dogs have lower blood pressure. 20% have lower triglyceride levels. Talking to dogs has been shown to lower blood pressure as well.

2. People who own dogs see their doctor less than those who don't.

3. Dogs have been shown to reduce depression, particularly in seniors.

4. It's easier to make friends when you have a dog. Life is more social with them.

5. It's healthier too. Seniors with dogs are generally more active because they walk more.

6. Dogs are friends. Here again, seniors seem to benefit most.

7. Dogs can help older people deal with the loss of a spouse. Seniors are less likely to experience the deterioration in health that often follows the stressful loss of a mate.

8. Dogs ease loneliness.

9. Perhaps because of the responsibility of dog ownership, seniors take better care of themselves.

10. Dogs provide a sense of security to people of all ages.

FIDO FACTS

The following facts, tidbits and data will enhance your knowledge of our canine companions.

- Gain the confidence of a worried dog by avoiding direct eye contact or by turning away, exposing your back or side to the dog.

- When dogs first meet, it's uncommon for them to approach each other head on. Most will approach in curving lines. They'll walk beyond each other's noses sniffing at rear ends while standing side by side.

- Dog ownership is a common bond and the basis of impromptu conversations as well as lasting friendships.

- Chemical salt makes sidewalks less slippery but can be harmful to your dog's footpads. Wash you dog's paws after walks to remove salt. Don't let him lick the salt either. It's poisonous.

- Vets warn that removing tar with over-the-counter petroleum products can be highly toxic.

- Although a dog's vision is better than humans in the dark, bright red and green are the easiest colors for them to see.

- Puppies are born blind. Their eyes open and they begin to see at 10 to 14 days.

- The best time to separate a pup from his mother is seven to ten weeks after birth.

- It's a sign of submission when a dog's ears are held back close to his head.

- Hot pavement can damage your dog's sensitive footpads. In the summer months, walk your pooch in the morning or evening or on grassy areas and other cool surfaces.

- Never leave your dog unattended in the car during the warm weather months or extremely cold ones.

- Always walk your dog on a leash on hotel/motel grounds.

- Want to register your puppy, or locate a breeder in your area? The American Kennel Club has a new customer service line at (919) 233-9767 or website at www.akc.org Their interactive voice processing telephone system is open twenty-four hours a day, seven days a week. Information is available on dog and litter registrations. You can also use the number to order registration materials, certified pedigrees, books and videos. If you want to speak with a customer service rep, call during business hours.

- Stroke a dog instead of patting it. Stroking is soothing. Patting can make some dogs nervous.

- If your dog is lonely for you when he's left alone, try leaving your voice on a tape and let it play during your absence.

- When a dog licks you with a straight tongue, he's saying "I Love You."

- Don't do anything on the road with your dog that you wouldn't do at home.

- Never put your dog in the bed of a pickup truck as a means of transportation.

- Black dogs and dark colored ones are more susceptible to the heat.

- When traveling, take a spray bottle of water with you. A squirt in your dog's mouth will temporarily relieve his thirst.

- Changing your dog's water supply too quickly can cause stomach upset. Take along a container of water from home and replenish with local water, providing a gradual change.

- One in five dogs suffers from some form of allergy. Sneezing and watery eyes can be an allergic reaction caused by pollen or smoke.

- Inflamed skin can indicate a sensitivity to grass or chemicals used in carpet cleaning.

- Patches of hair loss, itching and redness are common signs of fleas, particularly during warm months.

- Normal temperature for dogs: 100° to 102°.

- No matter how much your dog begs, do not overfeed him.

- Housebreaking problems can sometimes be attributed to diet. Consult with your vet about one good dog food and be consistent in feeding. A change in your dog's diet can lead to digestive problems.

- Spay/neuter your dog to prevent health problems and illnesses that plague the intact animal. Contrary to popular belief, spaying/neutering your canine will not result in weight gain. Only overfeeding and lack of exercise can do that.

- Spend ample quality time with your canine every day. Satisfy his need for social contact.

- Obedience train your dog; it's good for his mental well being and yours.

- If you make training fun for you and Fido, he'll learn faster.

- Always provide cool fresh drinking water for your dog.

- If your pooch lives outdoors, make sure he has easy access to shade and plenty of water.

- If your pooch lives indoors, make certain he has access to cool moving air and ample fresh water.

- In the summertime, avoid exercising your dog during the hottest parts of the day.

- Never tie your dog or let him run free while he's wearing a choke collar. Choke collars can easily hook on something and strangle him.
- The Chinese Shar-Pei and the Chow have blue-black tongues instead of pink ones.

- The smallest breed of dog is the Chihuahua.

- Poodles, Bedlington Terriers, Bichon Frises, Schnauzers and Soft-Coated Wheaten Terriers don't shed.

- Terriers and toy breeds usually bark the most.

- The Basenji is often called the barkless dog.

- Golden Labs and Retrievers are fast learners, making them easy to train.

- Climate counts when deciding on a breed. Collies and Pugs will be unhappy in hot, humid climates. But the Italian Greyhound and Chihuahua originated in hot climes. The heat won't bother them, but winter will. They'll need insulation in the form of dog apparel to protect them from the cold. And as you might think, heavy-coated dogs like the Saint Bernard, Siberian Husky and the Newfy thrive in cooler weather.

- Apartment dwellers, consider the Dachshund and Cairn Terrier. Both can be content in small quarters.

- Fido's fitness counts towards insuring a longer, healthier life. In this arena, you're the one in control. The most common cause of ill health in canines is obesity. Approximately 60% of all adult dogs are overweight or will become overweight due to lack of physical activity and overfeeding. Much like humans, the medical consequences of obesity include liver, heart and orthopedic problems. As little as a few extra pounds on a small dog can lead to health-related complications.

- Is your pooch pudgy? Place both thumbs on your dog's backbone and then run your fingers along his rib cage. If the bony part of each rib cannot be easily felt, your dog may be overweight. Another quickie test - stand directly over your dog while he's standing. If you can't see a clearly defined waist behind his rib cage, he's probably too portly.

- The infamous Red Baron owned a Great Dane named Moritz who lived on the military base with the pilot. The Red Baron fondly referred to Moritz as his "little lapdog."

- Frederick the Great owned an estimated 30 Greyhounds. His love of these animals led him to coin the saying: "The more I see of men, the more I love my dogs."

- It's easier than you might think to help your dog lose those extra pounds. Begin by eliminating unnecessary table scraps. Cut back a small amount on the kibble or canned dog food you normally feed your pooch. If he's accustomed to two full cups each day, reduce that amount to 1 3/4 cups instead. If you normally give your pooch biscuits every day, cut the amount in half. And don't feel guilty. Stick with the p r o - gram and you'll eventually see a reduction in weight. Slow and steady is the best approach. And don't let yourself imagine that your dog is being deprived of anything. Even when he looks at you with a woebegone expression, remember you're doing him a favor by helping him reduce and you're adding years of good health to his life.

- Exercise. Not enough can be said about the benefits. Establish a daily exercise routine. Awaken twenty minutes earlier every morning and take a brisk mile walk. Instead of watching TV after dinner, walk off some calories. Your pooch's overall good health, as well as your own, will be vastly enhanced.

- According to a survey, 90% of dog owners speak to their dogs like humans, walk or run with their dogs and take pictures of them; 72% take their pups for car rides; 51% hang Christmas stockings for their dogs; 41% watch movies and TV with their pooches; 29% sign Rover's name to greeting cards and more than 20% buy homes with their dogs in mind, carry photos of Fido with them and arrange the furniture so FiFi can see outside.

- Lewis and Clark traveled with a 150-pound Newfoundland named "Seamen". The pooch was a respected member of the expedition, and his antics were included in the extensive diaries of these famous explorers.

- The English have a saying: The virtues of a dog are its own, its vices those of its master.

- Lord Byron, in his eulogy to his dog Boatswain, wrote, "One who possessed beauty without vanity, strength without insolence, courage without ferocity, and all the virtues of man without his vices."

- "Be Kind To Animals Week" (May 7-13) was established in 1915. Recognized by Congress, it is the oldest week of its kind in the nation.

- The "Always Faithful" Memorial, which honors Dogs of War, was unveiled on June 20, 1994. It now stands on the US Naval Base in Orote Point, Guam.

- During WWII, Dobermans were official members of the US Marine Corps combat force.

- The domestic dog dates back more than 50,000 years.

- Ghandi once said, "The greatness of a nation and its moral progress can be judged by the way its animals are treated."

- England's Dickin Medal is specifically awarded to dogs for bravery and outstanding behavior in wartime.

- Napoleon's wife, Josephine, had a Pug named Fortune. She relied on the animal to carry secret messages under his collar to Napoleon while she was imprisoned at Les Carnes.

- Former First Lady Barbara Bush said: "An old dog that has served you long and well is like an old painting. The patina of age softens and beautifies, and like a master's work, can never be replaced by exactly the same thing, ever again."

- Dogs and Halloween don't mix. Even the mellowest of pooches can become frightened and overexcited by all the commotion. Save the candy collecting and chocolate for the kids, and leave the dog at home.

- Most outdoor dogs suffer from unnoticed parasites like fleas.

- In winter, the water in an outdoor dog dish can freeze within an hour.

- In summer, dogs consume large quantities of water. Bowls need frequent refilling.

EVERYTHING YOU WANT TO KNOW ABOUT PET CARE AND WHO TO ASK

Whether you've always had dogs or you're starting out with your first, the following organizations, hotlines and websites can provide information on the care, feeding and protection of your loyal companions. Also visit www.rainbowsbridge.com.

Pet behavior information

Tree House Animal Foundation: If you are concerned with canine aggression, nipping, biting, housebreaking or other behavioral problems, the Tree House Animal Foundation will try to help. But don't wait until the last minute. Call for advice early on and your animal's problems will be easier to correct. Consultation is free, except for applicable long distance charges. Call (773) 784-5488, 9AM to 5PM CST, seven days a week.

Animal Behavior Helpline: This organization is sponsored by the San Francisco Society for the Prevention of Cruelty to Animals. It will assist you in solving canine behavioral problems. Staffed by volunteers, you may reach a recorded message. However, calls are returned within 48 hours by volunteers trained in animal behavior. Problems such as chewing, digging and barking are cited as the most common reason dog owners call. Housebreaking tips, how to deal with aggression and other topics are covered. The consultation is free, except for applicable long distance charges or collect call charges when a counselor returns your call. Messages can be left any time. Call (415) 554-3075.

Pet Loss Helpline - (630) 325-1600: The Chicago Veterinary Medical Association is a non-profit organization that promotes the health and well being of animals through veterinary care. Veterinarians, by their concern for and knowledge of animal health and behavior, help pet owners and their pets enjoy long and rewarding relationships. There is no charge. These services are funded primarily by donation. If you wish to make a donation in the name of your pet it would be greatly appreciated. We would also be interested in poems, drawings, prose or any creative expressions of the love for your pet. CVMA, 120 East Ogden Avenue, Suite 22, Hinsdale, IL 60521, (630) 325-1231.

Poison Control Center: There are two telephone numbers for this organization. The 800 emergency number is for veterinarians and pet owners for emergency poisoning information. Calls are taken by the veterinarian-staffed National Animal Poison Control Center at the University of Illinois. When calling the 800 number, there is a charge of $30 per case. Every call made to the 800 number is followed up by the NAPCC. If the product is manufactured by a company that is a member of the Animal Product Safety Service - the company may pay the charge. In all other cases, you pay for the consultation.

For emergencies only, call (800) 548-2423. Major credit cards are accepted. For non-emergency questions, call (800) 222-1222. The Poison Control Center offers poison control information by veterinarians 24 hours a day, 7 days a week.

PET POEMS, PROCLAMATIONS, PRAYERS...& HOMEMADE DOG BISCUITS!

Ode to Travel with Pets

We're all set to roam

Going far from home

With doggies in tow

Off shall we go

To wander and gadabout

Since travel we're mad about

With Rosie and Max by my side

We'll all go for a ride

As we travel for miles

And bring about smiles

Rosie will grin

Max will chime in

Driving into the sunset

Odometers all set

But enough of these word rhymes

Let's roll with the good times!

— Eileen Barish, November 1994

Alone Again

I wish someone would tell me what it is
That I've done wrong.
Why I have to stay chained up and
Left alone so long.
They seemed so glad to have me
When I came here as a pup.
There were so many things we'd do
While I was growing up.
They couldn't wait to train me as a
Companion and a friend.
And told me how they'd never fear
Being left alone again.
The children said they'd feed me and
Brush me every day.
They'd play with me and walk me
If only I could stay.
But now the family "Hasn't time,"
They often say I shed.
They do not even want me in the house
Not even to be fed.
The children never walk me.
They always say "Not now!"
I wish that I could please them.
Won't someone tell me how?
All I had, you see, was love.
I wish they would explain
Why they said they wanted me
Then left me on a chain?

— Anonymous

A Dogs Bill of Rights

I have the right to give and receive unconditional love.
I have the right to a life that is beyond mere survival.
I have the right to be trained so I do not become
the prisoner of my own misbehavior.
I have the right to adequate food and medical care.
I have the right to fresh air and green grass.
I have the right to socialize with people
and dogs outside my family.
I have the right to have my needs and wants respected.
I have the right to a special time with my people .
I have the right to only be bred
responsibly if at all.
I have the right to be foolish and silly, and
to make my person laugh.
I have the right to earn my person's trust
and be trusted in return.
I have the right to be forgiven.
I have the right to die with dignity.
I have the right to be remembered well.

A Dog's Prayer

Treat me kindly, my beloved master, for no heart in all the world is more grateful for kindness, than the loving heart of mine.

Do not break my spirit with a stick, for though I should lick your hand between the blows, your patience and understanding will more quickly teach me the things you would have me do.

Speak to me often, for your voice is the world's sweetest music as you must know by the fierce wagging of my tail when your footstep falls up on my waiting ear.

When it is cold and wet, please take me inside...for I am now a domesticated animal, no longer used to bitter elements...and I ask no greater glory than the privilege of sitting at your feet beside the hearth...though had you no home, I would rather follow you through ice and snow, than rest upon the softest pillow in the warmest home in all the land...for you are my God...and I am your devoted worshipper.

Keep my pan filled with fresh water, for although I should not reproach you were it dry, I cannot tell you when I suffer thirst. Feed me clean food, that I may stay well, to romp and play and do your bidding, to walk by your side, and stand ready willing and able to protect you with my life, should your life be in danger.

And beloved master, should the Great Master see fit to deprive me of my health or sight, do not turn away from me. Rather hold me gently in your arms, as skilled hands grant me the merciful boon of eternal rest...and I will leave you knowing with the last breath I draw, my fate was ever safest in your hands.

Homemade dog biscuits

(Makes about 8 dozen biscuits)

<u>Ingredients</u>

3 1/2 cups all-purpose flour

2 cups whole wheat flour

1 cup rye flour

1 cup cornmeal

2 cups cracked wheat bulgur

1/2 cup nonfat dry milk

4 tsp. salt

1 package dry yeast

2 cups chicken stock or other liquid

1 egg and 1 tbsp. milk (to brush on top)

Combine all the dry ingredients except the yeast. In a separate bowl, dissolve the yeast in 1/4 cup warm water. To this, add the chicken stock. (You can use bouillon, pan drippings or water from cooking vegetables.) Add the liquid to the dry ingredients. Knead mixture for about 3 minutes. Dough will be quite stiff. If too stiff, add extra liquid or an egg. Preheat oven to 300 degrees. Roll the dough out on a floured board to 1/4"

thickness, then immediately cut into shapes with cookie cutters. Place on an ungreased cookie sheet and brush with a wash of egg and milk. Place in oven. After 45 minutes, turn off the heat and leave biscuits overnight in the oven to get bone hard.

INDEX

City Names Are In ALL CAPITAL LETTERS

City Names Are In ALL CAPITAL LETTERS

City Names Are In ALL CAPITAL LETTERS

City Names Are In ALL CAPITAL LETTERS

City Names Are In ALL CAPITAL LETTERS

City Names Are In ALL CAPITAL LETTERS

City Names Are In ALL CAPITAL LETTERS

City Names Are In ALL CAPITAL LETTERS

City Names Are In ALL CAPITAL LETTERS

City Names Are In ALL CAPITAL LETTERS

City Names Are In ALL CAPITAL LETTERS

City Names Are In ALL CAPITAL LETTERS

City Names Are In ALL CAPITAL LETTERS

City Names Are In ALL CAPITAL LETTERS

City Names Are In ALL CAPITAL LETTERS

City Names Are In ALL CAPITAL LETTERS